Paris in Ruins

Paris
in Ruins

Love, War, and the Birth
of Impressionism

Sebastian Smee

W. W. NORTON & COMPANY
Independent Publishers Since 1923

Quotations from *Pages from the Goncourt Journal*, edited and
translated by Robert Baldick, published by New York Review Books,
reproduced by permission of David Higham Associates.

For information about permission to reproduce selections from this book, write to
Permissions, W. W. Norton & Company, Inc., 500 Fifth Avenue, New York, NY 10110

For information about special discounts for bulk purchases, please contact
W. W. Norton Special Sales at specialsales@wwnorton.com or 800-233-4830

Manufacturing by Lakeside Book Company
Book design by Beth Steidle
Production manager: Lauren Abbate

ISBN 978-1-324-00695-4

W. W. Norton & Company, Inc., 500 Fifth Avenue, New York, N.Y. 10110
www.wwnorton.com

W. W. Norton & Company Ltd., 15 Carlisle Street, London W1D 3BS

1 0 9 8 7 6 5 4 3 2

Contents

Author's Note

THIS BOOK IS ABOUT HOW THE CITY OF PARIS ENDURED two military and political disasters in one year and how those events formed the backdrop both for an affair of the heart between two great artists and for the early days of the Impressionist movement. The story focuses on the events of 1870–71 (famously dubbed "The Terrible Year" by Victor Hugo). It's premised on the conviction that we cannot see Impressionism clearly without grasping the impact of that tumultuous time on the movement's leading artists.

At the heart of the story are the experiences of the painters Berthe Morisot and Édouard Manet. Of all the painters who lived through the events of 1870–71 and came to be associated with Impressionism, only Manet, Morisot, and Edgar Degas had the misfortune of being trapped in Paris during its long winter siege. (The other Impressionists were elsewhere in France or in London.) But it wasn't these artists' mere presence in Paris that was important. Both Manet and Morisot were also entangled in the period's convulsive politics, not least through their personal connections with some of the period's leading political actors.

Students of art history know that Manet's example inspired the other Impressionists: Monet, Renoir, Pissarro, Sisley, Bazille, Morisot, and Cézanne all learned from his brushwork, his treatment of light, and his choices of subject matter. They were also, inevitably, affected by his attractive personality and his politics. Manet was an ardent republican. He loathed authoritarianism generally and he especially loathed the regime of Napoleon III, who had made himself emperor

of France after a coup in 1851. He was explicit about his convictions, not only in his life as a citizen but in his art. Those who championed or followed Manet tended to share his politics, while those who opposed him also opposed republicanism.

Morisot's crucial role in the story of Impressionism is less well known. Lovers of Impressionism know that she exhibited in seven of the eight Impressionist exhibitions held between 1874 and 1886, and that she was the only woman to play a central role in the movement from the start. But Morisot also exemplified, and in some ways led, the great Impressionist liberation.

Manet's friend Charles Baudelaire, a prophet of modern art, had famously urged artists to paint "the heroism of modern life." But inevitably, ideas about heroism changed during the Terrible Year, and Morisot's response to the upheavals of that period is immensely revealing. Her decision to paint women, girls, and interiors was not merely a reflection (as it has often been cast) of her limited access, as a woman, to the parts of Paris and its environs painted by the other Impressionists. It was a deliberate decision. As she came into her own, artistically, in the years immediately following the Terrible Year, the style she forged appeared as a pointed and poignant response to her experiences during that time. She painted not only the flux and transience of light but the profound fragility of life itself, emphasizing the lives of women and children. She took some aspects of the Impressionist style further—into a more radically "incomplete" and broken mode of painting—than any of her peers. Her canvases show that her interest was in what the great scholar of American literature Robert D. Richardson called "the workshop phase, the birthing stage of art, not the museum moment, the embalming phase." It's clear, moreover, that her special feeling not only for happiness and grace but for the vulnerability that inheres in moments of transition helped effect a transformation in Manet's painting in the 1870s (although the two were so close at the time, and looked so avidly at each other's work, that it's impossible to say precisely who affected whom).

The friends of Manet who were both artists and republicans had a picture in their head of what France might look like without an auto-

cratic leader and with republican freedoms. They were aligned with many other republican constituencies who all had their own ideological beliefs and practical reform wish lists, but naturally enough, they cared especially about artistic freedoms. They imagined, among other things, a dismantled government art bureaucracy and a radical overhaul of the state-sponsored system of education, patronage, and reception of art (primarily the annual Salon), which all bore the stamp of Napoleon III's regime. So to understand the achievement of Manet and the Impressionists, it's vital to gauge how their political hopes and convictions were affected by the military and civic catastrophes of 1870–71.

Manet and Morisot were both demoralized and appalled by what had transpired. "I have come out of this siege absolutely disgusted with my fellow men, even with my best friends," wrote Morisot early in 1871. "Selfishness, indifference, prejudice—that is what one finds in nearly everyone." As the 1871 insurrection broke out in his beloved Paris, Manet was similarly disillusioned. People's motives, he observed, had been revealed as fundamentally selfish. No one was truly principled and committed; there were no "great citizens," no genuine republicans, only those ambitious for power and pathetically nostalgic for that earlier Commune (1789–1795) established during the first French Revolution, which had degenerated, during the Terror, into a grotesque travesty of its own stated ideals. Such people, he went on, had put the whole idea of a true republic in grave jeopardy. After the crushing of the insurrection, which had dismayed Manet with its brutality, he felt outright despair. "How are we going to come out of all this?" he wondered. Everyone was blaming someone else, but the truth was that everyone was responsible for the disaster they had all just lived through.

Contained in the question *How are we going to come out of all this?* was another: *How, as artists, shall we respond?*

In the story that follows, I try to convey the ways in which the events of 1870–71 put under tremendous strain the "innocence" of political clarity. Those events impressed on everyone who experienced them a profound sense of precariousness. Of course, the entire nineteenth century in France was an extended lesson in political instability. But many who lived through the Terrible Year succumbed to a

new and suddenly deeper sense of existential fragility, and it is hard not to see Impressionism's emphasis on fugitive light, shifting seasons, glimpsed street scenes, and transient domesticity as expressions of this heightened awareness of change and mortality.

One of the striking things about Impressionist paintings of the 1870s is their conspicuous refusal to depict the Terrible Year. Despite living through the Siege of Paris, Manet, Morisot, and Degas were all plainly under too much duress to pull out brushes, paints, and canvas. The others, as noted, were out of Paris and disinclined to paint things they hadn't witnessed. But large parts of central Paris were burned-out rubble when they all returned. The absence of almost any depictions of this rubble by the Impressionists, or of other subjects explicitly addressing the recent violence, needs to be accounted for.

The Terrible Year did not diminish the Impressionists' republican dreams, but in its aftermath, they had reason to be as wary of the consequences of radicalism as of reactionary backlash. Their convictions now existed in a more complicated context. They had seen the violent, anguished thrashings of the political sphere and they wanted—and wanted to picture—something different. They watched their more conventional contemporaries depict the razed and fire-gutted buildings of Paris in paintings that groaned with moral rhetoric and were designed to win the approval of a revived conservative establishment. They themselves, however, seemed to say no to history. (Manet, as ever, was something of an exception. His journalistic instincts had always attracted him to the idea of modern history painting, so he made a few attempts at addressing both the siege and the Commune. But his efforts were lithographs, etchings, and watercolors, not paintings. They were reworkings, moreover, of older images. After that, he gave up.)

In the aftermath of the Terrible Year, the new painters, including Manet, wanted more than ever to express the physical world through color and light. The places they painted near the Seine, west of Paris, had seen some of the worst chaos and carnage. Their own paintings, however, emphasized serenity. They had grasped above all the prin-

ciple of flux: that everything is always in motion, always on the edge of decay or dissolution. They accepted mortality and complication as part of this principle, but they rejected the dark and opaque past, preferring to picture a transparent, peaceable present. Their new style idealized transitions and contingency even as it attempted to dispel grief. Their dream—and it was a dream they sought to tie to empirical fact—was for everything (in the words of Ralph Waldo Emerson) to be "resolved into light."

Paris in Ruins

Paris, October 7, 1870

LÉON GAMBETTA HAD ONE WORKING EYE. THE OTHER HE had lost as a child when a laborer's tool broke as he was passing by and metal fragments flew into his face. The damaged eye was later replaced by a glass sphere. Cosmetically, this artificial eye was a success, but monocular vision made it hard for Gambetta to judge distances. He had begun his career as a lawyer but was now a famous politician, and when photographers, painters, and illustrators made portraits of him, they tended to show him in profile.

One of those portraits was taken by Nadar, the pioneering photographer, cartoonist, and balloonist and one of the nineteenth century's great self-promoters. Gaspard-Félix Tournachon was his real name. (He had a joking habit of adding the syllable *dar* to the ends of words, so his friends turned *Tournachon* into *Tourna-dar*, which was in turn shortened to *Nadar*.) He had a square, heavy head and dark, darting eyes. He was myopic. His doughy face was punctuated by a small mole in the center of his left cheek and another, larger one above his right cheekbone. It became almost fantastically expressive when he was impassioned.

That was often. Nadar did everything with maximum urgency, total conviction. And he had giant, history-shaping plans for Gam-

betta. On the morning of October 7, 1870, he was going to realize them. But before he did, he had to pay a visit to the writer Victor Hugo, another lion of public life whose photograph he had taken. Hugo had only recently returned to Paris from the island of Guernsey in the English Channel. An unforeseen change in government and a moment of national peril had prompted his sudden return after two decades in exile. His mere presence in the French capital lent its citizens a heightened sense of valor and purpose.

Hugo and Nadar went back years together. When, five years earlier, Nadar wrote *The Right to Flight*—a polemic on behalf of ballooning—he had sent the manuscript to Hugo in Guernsey. Designing his magnanimous reply for wide consumption, Hugo praised Nadar's courage, comparing him not only to Christopher Columbus but to Voltaire. Looking to the future, he predicted that human flight would achieve a "magnificent transfiguration" and even a "colossal pacifist revolution."

Now, however, just five years later, Paris was under martial law. The city was besieged. And Gambetta's balloon flight was the first, desperate step in a critical mission—preserving France from humiliation.

NADAR HAD SPENT the last few weeks camped in a bell tent at the Place Saint-Pierre on the Butte Montmartre. From here, over chimneys and rooftops, you could see the immensity of Paris spreading grayly to the south. Hugo, who was staying just down the hill at the home of his friend Paul Meurice on the curving, sloping Avenue Frochot, greeted the photographer that crisp October morning with his usual engulfing affability. Nadar reciprocated, asking the great writer if he had any mail he wanted sent out of the city and making sure to mention that bundles of the writer's pamphlets were at that very moment being loaded into two balloons being prepared for launch. If Hugo was curious, he added, he should come up and watch. Nadar's plan had been for the balloons to launch the previous day, but the sky had been cloudy and it was difficult to tell which way the air currents were moving. Nothing was ideal, frankly—the balloons were

certainly not what they should be—but at least the winds seemed more promising now.

The writer thanked Nadar profusely, and the two men bade each other farewell. At around ten o'clock, Hugo, sixty-eight, with shortish hair and a full bushy beard, his feral eyes pinched and glassy with late-life intent, made his way up the hill and soon found himself on the wide-open Place Saint-Pierre, his white hair mussed by a gusting wind. Hugo had unusually keen eyesight. He was renowned for his ability to make out tiny details at great distances. The legendary author and poet was a cultural figure "so vast," as the author Lucy Sante has written, "that no lens can frame him." He wanted to be remembered not just as one of the architects of French Romanticism but as his nation's moral conscience. But by the 1860s, many in the younger generation of writers and artists regarded Hugo skeptically. Among them were the novelist Émile Zola and his friend, the painter Édouard Manet. In their eyes, the great man was always on the cusp, as Sante put it, of becoming "a grandiloquent hack, a sagging balloon leaking the tepid air of dated pomposity." On the other hand, they admired not just his extraordinary literary achievements but his staunch republicanism and his brave opposition to authoritarianism. He had refused, on principle, an offer to return to France if he agreed to refrain from criticizing Napoleon III. To the poet and critic Charles Baudelaire, Hugo was "great, terrible, as immense as a mythic being, Cyclopean." In the eyes of many of his fellow Parisians, he was all but untouchable.

When he wasn't writing, Hugo liked to draw and paint. He worked on his pictures in private, but he hung his favorite pieces on the walls of his home and gave some to his friends. Still, when critics who knew him urged him to exhibit his work, he resisted, not wanting anything to get in the way of his reputation as a writer. Making art was, for him, a private, peripheral activity. He worked quickly, using anything that was to hand: not just ink but powdered charcoal, crushed grease paint, black coffee, and sprays of water. He would apply marks with his fingers, matchsticks, stencils, crumpled cloth, or lace. Romantic to the core, he had a penchant for dreamlike, Gothic imag-

ery, inspired in part by an interest in the occult. There were shades of Francisco Goya's later Black paintings in his work, which anticipated the later imaginings of Odilon Redon and the Surrealists. Hugo's most productive period as an artist had been in the years after the European revolutions of 1848 and before his exile to the Channel Isles in 1851. One moody ink drawing, from 1850, was a view from above of a boundless expanse—a sort of imaginary, deserted cityscape—into the middle of which he inserted a looming tower. Another view, this one of Paris, could almost have been made on the Butte Montmartre, where Hugo now stood: it showed, from an elevated perspective, a vanishing jumble of houses framed, in the middle distance, by two vast buildings in shadow. In the foreground, fitfully illuminated by a thwarted sun, are fences, fortifications, and a forking road. A moody, impressionistic fantasy, it evoked what the historian Henri Focillon later called the "debris of civilization."

The wind mussing Hugo's hair now, as he again looked out over Paris, seemed promising. The scene was neither imaginary nor amorphous. It was concrete and tangible. At the center of the square, which was really a flat area of dusty wasteground, two enormous balloons drew everyone's gaze. They resembled upside-down bottle vases cradled by taut rigging. One was off-white. Opalescent light skittered off it. The other, its underside in shadow under the blue sky, was a dirty yellow, like the tarnished whites of Hugo's eyes. Through a scattered crowd of soldiers and civilians, Hugo saw one-eyed Gambetta, crouching on the pavement, pulling on fur-lined boots. Surveying the scene, the writer felt a lightness around the heart, an almost coltish excitement. What he was about to watch would go down in history—he could smell it. It would mark the beginning of the embattled new French republic's deliverance from peril—a Genesis story to match the midnight ride of Paul Revere in the American colonists' War of Independence, almost a century earlier; an unlikely vindication; a victory against the odds.

As the minutes elapsed, his mind conjured with words, sentences, poetry. He watched Gambetta, who was less than half his age, get to his feet. His dark, unkempt hair flowed back from his brow in tur-

bulent waves. At thirty-two, the proud republican, of Genoese-Jewish descent, was showing early signs of corpulence. In intimate settings, he was very congenial; the painter Pierre-Auguste Renoir would later call Gambetta "the simplest and most courteous man I ever met." At rest, his face had a wide-open, almost somnolent look. But at a podium, righteously aroused, he was dynamic, indignant, unforgettable.

Before all this recent upheaval, he had been a regular at the Café de Londres, near the Place Vendôme and the Madeleine, where he occasionally met up with Manet, a fellow staunch republican and another friend of Nadar. (On one of his early Spanish-themed paintings, Manet had scrawled "to my friend Nadar" above his signature.) In his early days at the bar, Gambetta had been employed by Manet's cousin Jules de Jouy, and he used to meet up with Manet's brother Gustave, whom he also knew through the law, at the Café Procope on the Left Bank, once a haunt of the Jacobins.

Gambetta found Édouard Manet to be delightful company. "Few men," claimed Manet's friend from childhood, Antonin Proust, "have ever been so captivating." The painter's eyes had a squinting, amused expression, and his cheeks were covered by a soft blond beard. They said he was one of the few men left who knew how to talk to women. But Manet was also one of France's most notorious artists. For almost a decade, he had been exhibiting his bold, bizarre-looking paintings at the annual Salon, courting controversy, creating friction with government authorities, and gradually—by his mercurial personal influence as much as by his audacity on canvas—seeding a new school of artists. Hugo had certainly heard of him, just as he had heard much about Gambetta from his dearest friend, Paul Meurice. Gambetta and Manet had both frequented Meurice's home on the Avenue Frochot, where Manet had also attended the salon of Meurice's notorious neighbor, the courtesan and artists' model Apollonie Sabatier. Sabatier had been the muse and lover of Manet's close friend Baudelaire from 1857 to 1862. Among those invited to her salon were Hugo, the writers Gustave Flaubert and Edmond de Goncourt (who nicknamed her "La Présidente"), the composer Hector Berlioz, the painter Ernest Meissonier, and the sculptor Auguste Clésinger, whose sculpture of a

naked Sabatier writhing in ecstasy—or from the pain of a snakebite—
had been carved after a plaster cast taken directly from her body.

Gambetta wore an arctic overcoat. He held a fur cap in one hand,
and a leather bag was slung over his shoulder. As Hugo looked on,
he strode toward the dirty yellow balloon, which had been named
the *Armand Barbès* after an ardent republican, a hero of the revolu-
tion of 1848, who had died earlier that year. (After an insurrection
in 1839, Armand Barbès had been sentenced to death, but thanks to
an intervention by Hugo, his sentence was commuted.) Gambetta
squeezed through the rigging and into the basket. Alongside him,
already aboard, were his secretary, Jacques-Eugène Spuller, and the
balloon's pilot, a young man named Trichet, who now took Gam-
betta's bag and tied it to the rigging. The basket itself was cramped.
At their feet was a 220-pound packet of mail. Suspended from a ring
above the basket was a cage holding sixteen clucking and bobbling
pigeons. A pigeon fancier approached the balloon to give the crew
last-minute instructions: when to feed the birds, how to roll letters
around their tail feathers. He stepped back, his counsel delivered, and
now Gambetta leaned out to acknowledge the crowd who had come
to see him off. They filled the square. Those hoping for better views
formed loose lines that crisscrossed the steep, bare hill behind it up to
the Solferino Tower.

Nadar stood back beside a nearby lamppost. Behind him were the
bell tents in which he and his team had been sleeping these past few
weeks. He was accustomed to spectacles. His life's purpose, in fact,
was to generate them—and he liked being the center of attention.
But he looked anxious. He, more than anyone, was responsible for
what was about to happen. Nadar wasn't just a pioneer of balloon-
ing; he had also been at the forefront of exploiting the commercial
potential of photography, a medium still in its infancy. Twelve years
earlier, combining his passions, he had risen in a tethered balloon 260
feet above a village on the outskirts of Paris to take the world's first-
ever aerial photograph. This show, this spectacle, felt different. It was
about something bigger than ballooning, or photography, or his own

renown. Nadar held the fate of France in his hands. And he worried it would end badly.

The second balloon—the white one—had been named the *George Sand*, after the writer—also a republican—who was as famous as Hugo and had in fact written a preface to *The Right to Flight*. (If nothing else, Nadar knew how to get his story out.) The *George Sand* carried two Americans, William Reynolds and George May. Both were employees of the firearms dealer Schuyler, Hartley, and Graham, a firm that had just brokered a one-million-franc deal to supply arms to the fledgling French government. Reynolds and May were glad to have closed the deal; they were less pleased to have to rely on one of Nadar's battered old balloons to get them out of Paris.

Earlier that morning, after his visit to Hugo, Nadar had made a trial ascent in a tethered balloon, hoping to get a better sense of the wind. It was gusting, but by and large he thought the conditions favorable. Much depended on getting Gambetta, the Americans, and their bundle of mail out of Paris. Now was the time to act. He checked again on the readiness of the pilots and their passengers—all seemed in order—then gave the signal. A team of sailors untied the anchor ropes. Slowly, fitfully, the balloons began to rise. Still clinging to the ropes, the sailors tried to guide and steady the craft as they ascended. It was important that their trajectory be as close to vertical as possible. If they drifted too quickly to one side, they could collide with the Montmartre rooftops. Now in the fluky wind, the *Armand Barbès* began to swing like a jerky pendulum. Gambetta gripped the side of the basket as it swung. The spectators shouted "*Vive la République!*" and "*Vive Gambetta!*" Steadying himself, Gambetta extended one arm in a kind of salute. Seconds later both balloons were in the clear, Trichet cried "*Lachez tout!*" and the moorings were cast off.

The balloons rose beautifully for several minutes. But then the wind shifted and began to take them northward—toward a danger graver than rooftops. As the *Armand Barbès* rose and gently rotated in the brisk fall air, Gambetta twisted his body and swiveled his head to take it all in. The sight that met his monocular vision was mes-

merizing; it was like nothing he had ever seen. It was Paris, but from a wholly fresh perspective. Its massy architectural landmarks, the thrusting new boulevards, the grand elevations and intimate sight lines—all of it reduced to a strange flat, not quite legible pattern. All those intimate textures of tree branch, gable, and attic window had been ironed out, rendered tiny and trivial. Gambetta was "stupefied," he said later, "at the total obliteration of the picturesque in the boundless expanse beneath."

As his eye roved in the slowly spinning basket, he could make out the Seine and Notre-Dame on Île de la Cité and then the adjacent Île Saint-Louis. He could see the long lines of Baron Haussmann's boulevards like bold, slashing stripes. Somewhere down there was the Café de Londres. He could see the Bois de Boulogne like a shaved scalp, its massy trees lately cut down for firewood, its pastures dotted with animals that, to Gambetta's eye, appeared like colonies of drugged insects. He could see, too, the lines of fortification defining Paris's perimeter and, beyond the suburban belt, a conspicuous ring of forts. Beyond the forts was unoccupied land, wooded in places and open in others. And beyond that—all the way around, in a line implied by the mind where it was not strictly visible—the entrenched lines of an enemy army.

Many of the soldiers in this army—they were German speakers— were looking up at Gambetta as he drifted over them in his patched-together balloon. They had guns—surely a grave concern for anyone floating in a calico balloon filled with coal gas. Their commanders, Otto von Bismarck and his unflinching chief of staff, Helmuth von Moltke, had issued orders to shoot the balloons down.

PART I

Salon of 1869

The Balcony

TYPICALLY (IT WAS MANET'S PERENNIAL PROBLEM), PARTS of *The Balcony* don't work. Yet what does work is so fresh, so brisk, so almost sly, that the effect is disarming—like a mild insult that, received in the right spirit, could almost be read as a flirtation. You look at the picture, and you're not quite certain of whether Manet even wants you to believe in it. Most of it is more or less black and white: two voluminous white dresses and a man's black jacket blended with a pitchy interior. So it's surprising that the arresting thing about *The Balcony*—the thing everyone remembers—is the intense, almost sparkling effect of green. Manet used subtly different shades of it for the open window shutters, the bars of the balcony balustrade, the leaves of a plant, a neck ribbon, and a folded-up umbrella. Where the green is cool, its minty freshness is accentuated by touches of blue and purple (the man's tie, the purple hydrangeas). Where it is warmer, its gilded glow is brought out by pale or tawny yellows (the woman's yellow gloves).

The painting shows three adult figures on a balcony, with a fourth, younger person behind, barely visible in the interior gloom. It's a very odd tableau. We see the two prominent standing figures, both stiff and lifeless, on a level, as if we were across the street on a

balcony at the same height. The hands of the man, one of them hold-ing a cigarette, are frozen in a gesture of surprise or hesitation, his gaze directed out over the head of the woman who stands to his left. With her gloves and umbrella, she looks directly at us. But her expres-sion, like his, is emphatically blank. The modeling of both their faces is minimal—just dark notations (eyes, nostrils, lips) against a light ground, with almost no transitions.

The third figure, by contrast, is unforgettably vivid. With dark eyes and eyebrows and glossy black hair falling in loose ringlets to her shoulders, she has a kind of absolute presence. Her face is charged with a luster that makes everything around her shimmer, fade, and fall away, as if aware of its own insubstantiality, its insignificance. Something off to her right has caught her attention. And while it barely occurs to us to wonder what the man behind her is looking at, in her case it seems vital that we find out.

The woman is the painter Berthe Morisot.

BERTHE LIKED TO LEAN AGAINST the iron balustrade of the terrace behind her parents' home in Passy, from where she could look out over Paris. The railing, guarding against a steep drop over large boulders, was supported by a square pilaster, on top of which stood a neoclassical stone vase. (Berthe later made several paintings of the terrace and its panoramic view.) Even in broad daylight on a clear day, the city appeared to her as a loose patchwork of grays rather than a grid of sharp lines. It was grand and vast. But like Manet's paintings, there remained something blurred and precarious about it, something unfinished—and not just physically.

The Morisots were well-off and had impressive connections, but in the tumultuous political environment of nineteenth-century France, no social status was entirely secure. The city itself had been subject to unremitting change since 1853, when Baron Georges-Eugène Hauss-mann had been appointed by Napoleon III to head a major redevelop-ment campaign. Haussmann's dramatic restructuring of the city had transformed it into an enormous building site. The booming and clat-tering sounds of demolition and construction carried up to the Mori-

sot home, in a hamlet just off the Rue Benjamin Franklin. The family of Berthe's mother, Cornélie, had owned a number of homes in Passy, and on the Rue Franklin specifically, since 1832. Berthe's parents had settled in what was then still just a village on the capital's outskirts in 1852. They had moved to the house at 16 Rue Franklin from number 12, just across a side street, in 1864, when Tiburce Morisot, Berthe's father, was named chief counselor at the state accounting office. By then, aided by new railways, Passy had grown into an affluent suburb, a place where, as one historian put it, men might "set up the home of the family in the good air and in the semi-country, while keeping their offices in the central part of the city." Along with fifteen other outer suburbs, Passy had been officially incorporated into the city in 1860, but it still felt like part of the countryside, with Versailles to the southwest and the Bois de Boulogne to the west. Some breezes, depending on the wind's direction, carried city stench and construction dust, others the soothing scents of farmland and forest.

Large and square and painted white, the Morisot home commanded a view out over the city from the Chaillot foothills. One of Haussmann's more labor-intensive projects had been to flatten the adjacent part of the hill to create the Place du Roi-de-Rome, now the Place du Trocadéro. This massive job wasn't completed until 1869, by which time Paris was a city of 1.5 million—double what it had been at the end of the first Napoleon's reign in 1815. It was the wealthiest, the most glamorous city in Europe. It had been known as the "City of Light" since the eighteenth century because of its prominent role in fostering the Enlightenment.

But the moniker had taken on new meaning in the 1840s and '50s when the boulevards were lit up at night and the city flourished, as Charles Baudelaire wrote, "in the light of the gas lamps, illuminated . . . and as if drunk on it." Gaslight allowed for the emergence of a truly nocturnal city. At sunset, twenty thousand lampposts ignited automatically, fed from fuel lines connected to subterranean gas mains. Scores of lamplighters lit another three thousand streetlights manually. These new lights could illuminate a far larger area than before—a boon to safety that also transformed Parisians' sense

of their city's potential, enhancing the culture of spectacle for which it was already famous, and leaving giddy visitors with an impression of ineffable modernity. The capital, wrote Joachim Schloer, became "like an island of light against the surrounding darkness."

The year after the coup d'état that established him as emperor, Napoleon III had overseen the transformation of the Bois de Boulogne into an English-style park with lakes, waterfalls, mounds, and at its northern end, a zoo. He had next worked with Haussmann on an ambitious overhaul of the old medieval city. The changes were drastic. "In every quarter," as a contemporary guidebook for travelers put it, "at every level, Paris rises astonishingly anew."

Throughout the years of demolition and construction, Haussmann met with the emperor almost daily. On these two men's instructions, twenty thousand buildings were demolished and thirty thousand new ones built. Haussmann had convinced Napoleon III that Paris needed to be a center of intellectual and artistic activity, so new theaters were prioritized over factories, which were moved to the edges of the city. Paris, with its operettas, puppet shows, and café concerts became Europe's capital of entertainment and pleasure.

A modernized market with eight new pavilions emerged at Les Halles, the so-called belly of Paris. To address what issued from the other end of the digestive process, Haussmann installed a new sewage system so impressively modern that it became a tourist attraction. Two new systems of water distribution were also introduced. One, for drinking water, relied on a new aqueduct bringing water from the Vanne River to an enormous reservoir, from which hundreds of miles of new pipes distributed water throughout the city. Another system, for washing the streets and watering the parks and gardens, brought water from the Seine and the Ourse.

Haussmann's long, sweeping boulevards—more than forty miles of them—were an attempt to straighten out the city's kinks, modernize its infrastructure, and scrub away its more anarchic elements. Lined with uniform buildings of cream-colored stone and new foot pavements, these long, straight streets yielded a stately sense of decorum as well as thrillingly long perspectives.

And yet the "anarchic element"—by which was meant the real lives of real people at the lower end of the economic spectrum—was not so easily swept away. For all its glamour in the eyes of foreigners, and despite almost two decades of stable rule, Paris remained riven by class tensions. Politically, it was more unstable than even its residents quite realized. Haussmann's project was a massive stimulant to the economy, and many workers benefited. But it also severely disrupted livelihoods, neighborhood bonds, and old routines, and many people, displaced and aggrieved, passionately wanted their city back. The Latin Quarter was vibrant with the angry static of students leading precarious, improvised lives. The working poor were displaced to Belleville and Montmartre, where antigovernment, anticlerical, and antibourgeois sentiments, aired in cafés and meeting houses, were given more voice each year.

Those who hated the emperor, be they workers, political dissidents, or stifled artists, despised the heavy-handedness of the imperial aesthetic. It was in evidence everywhere—in the art favored by the Salon jury, in public statues and buildings, and in the massive, heavily ornamented form of Charles Garnier's as yet unfinished Opéra, the facade of which had been launched, to great fanfare, at the 1867 Exposition Universelle. Begun in 1862 and described by the writer Louis Veuillot as "a monstrous fetus, conceived in nights of orgies," the Opéra Garnier was the flagship monument of the Second Empire. But for republicans, it was the hideous centerpiece and despised symbol of what they saw as Napoleon III's corrupt and gaudy empire.

STANDING ON THE TERRACE, Berthe could see the gleaming gold dome of Les Invalides and, farther in the distance, the recently restored Notre-Dame. Turning to the left, looking past the spire of the Church of Saint-Augustin (inaugurated just the previous year), she could make out the Batignolles district at the foot of the Butte Montmartre, about an hour's walk away. Somewhere over there, she knew, Édouard Manet and his companions and acolytes congregated on Friday nights at the Café Guerbois, a smoky, billiards-and-beer-style venue that had become a gathering place and nerve center

for Manet and his brilliant circle. Berthe envied those nights at the Guerbois, the young painters and writers, most of them republicans, spending time with Manet, the bold, uncensored talk of painting and politics.

Manet was intoxicating company. His friend, the journalist Théodore Duret, described him as "overflowing with vivacity, . . . with a gaiety, an enthusiasm, a hope, a desire to throw light on what was new, which made him very attractive." And with his dirty-blond beard, high forehead, and swept-back hair, he was marvelous to look at. Although he dressed stylishly, he liked to disport himself casually, and he spoke with deliberate coarseness, as if shrugging off (with conscious irony) the expectations of his upper bourgeois class. Other traits, too, seemed contradictory. He was ferociously independent and at the same time disarmingly insecure; he was urbane and ironic yet earnest and sincere. Beneath his outwardly confident veneer, he was also vulnerable. His social manner could be maddening: many things seemed simply to glance off him, as if nothing could touch him. But it was entirely possible that this was a decoy and that beneath Manet's alluringly complex surface lurked doubt, shame, and passion.

Modeling himself in no small part on the ideas of his close friend, Charles Baudelaire, Édouard thought of himself as a *flâneur*—a wryly detached observer of the city's constantly changing countenance, a diviner of its hidden relations. On his wanderings, he would pop into the swank Café Tortoni on the Boulevard des Italiens, famous for its velvety ice creams, or Café de Suède, a meeting place for radicals, journalists, artists, and writers. He lived on the Rue de Saint-Pétersbourg, near the recently expanded train station, the Gare Saint-Lazare, with his Dutch wife Suzanne and their son Léon. It was a comfortable residence that they shared with Manet's widowed mother, Eugénie-Désirée. The daughter of a French consul in Sweden, Eugénie-Désirée was also the goddaughter of Charles Bernadotte, Napoleon's general, marshal, and ambassador, who was offered, then took, the Swedish crown, thereby founding the house of Bernadotte. Her husband Auguste, a high-ranking judge, had died

in 1862 after a cruel period of muteness and physical paralysis brought on by advancing syphilis—the same disease that would later torment his son. Since Auguste's death, Eugénie had gradually adapted to her new role as widow. Édouard's affection for her was more than just filial, as Léon would later write—it was a "real obsession." She liked to host Thursday-evening musical soirées, which Berthe and various members of the Morisot family had lately been invited to attend.

Manet's friend Edgar Degas was another regular at these weekly soirées. The two men, mutual admirers, had lately been growing closer. They had much in common. Degas, too, was from a well-off family, although his mother, who came from a prominent Creole family in Louisiana, had died when he was thirteen, and he grew up in a household and immediate milieu of men. Degas had been educated at the best school in Paris, but he was a gifted draftsman and had chosen, with his father's initially reluctant support, to take up art. He had a morose, ironic intelligence, little time for small talk, and a hatred of cant.

The previous winter, 1868, he had taken his easel and paints to the Manets' Rue de Saint-Pétersbourg apartment, where Édouard and his wife had posed for a double portrait by Degas. Portraiture, at this time, was becoming ever more central to Degas's art, but he wasn't interested in portraiture that advertised status and family connections. Rather, he was trying to make modern, psychologically acute portraits that coolly appraised people's characters. Degas's marriage portrait of the Manets showed Édouard lounging on the sofa, bored, frustrated, or lost in reverie (it's hard to tell which), and Suzanne sitting at the piano. Something about the painting bothered Édouard. Perhaps he saw it as a less-than-flattering portrayal of his wife or perhaps (and more distressingly) as a slightly too-revealing commentary on what Degas perceived as the disaffected or alienated state of his marriage. Édouard accepted the painting as a gift. But back in his studio, anger unaccountably flared, and he took a knife and sliced away half of Suzanne's face and body. Degas, when he discovered what his friend had done, was astonished and retrieved the picture. The incident had a chilling effect on their friendship, and for a while

they didn't speak. Berthe, like everyone else, could only guess at why Édouard had done it. But she half-worried that her recent entry into their circle might have had something to do with it. Both men had been lightly flirting with her. She was stimulated by a bit of tumult and gossip, but she recoiled from open conflict.

Degas could certainly be prickly. He had an aloof, impregnable quality that she found at once admirable and off-putting. Édouard, no paragon himself, could be by turns frustratingly breezy and a little too bold. But both men had depth, talent, and palpable self-belief. And each, in his very different way, possessed a species of intelligence that she had never previously encountered. She knew instinctively that, as a painter, she had much to learn from them. She may also have sensed (as they both intuited) that she had things to teach them.

Now, thankfully, in the spring of 1869, the rift seemed to be healing. Cornélie Morisot, who had seen them together, reported that they seemed to have "patched things up." (Degas would later make light of the affair: "How could you expect anyone to stay on bad terms with Manet?" he said.) A delightful circle had lately formed. To complement Eugénie Manet's weekly entertainments, Degas's widowed father also hosted musical soirées where various musicians—some of them illustrious, like the singer and guitar player Lorenzo Pagans—performed in the intimacy of his spare but elegant apartment. Berthe's mother, meanwhile, had established reciprocal evenings at the Morisot home, to which both the Manet and Degas families had standing invitations.

Berthe envied her new friends' freedom to roam the city. She was by no means under lock and key, but as an unmarried woman from the upper bourgeoisie, she couldn't be seen in the kinds of places they frequented without compromising herself. So she spent many nights at home. She liked to emerge onto the balcony in the evenings as the sun set behind her. The softer light was easier on her eyes, which had lately been giving her trouble. The nature of the malady was unknown, but it had reduced her to staying indoors, with poultices over her closed lids during daylight hours.

"Here I am, trapped because of my eyes," she wrote to her sister Edma in Brittany. "I was not expecting this and my patience is very limited."

OUTSIDE, THE LILACS were blooming and the chestnut trees were about to burst forth, so the trouble may have been connected to spring allergies. But could it also have been related to the tears she had shed over Edma? Her sister's departure was still fresh, and Berthe was grieving. *Grief*, perhaps, is too strong a word. It wasn't as if Edma had died. She had simply married. The groom, in Edma's case, was a naval ship's lieutenant, Adolphe Pontillon. He happened to be an old acquaintance of Édouard. The two had befriended each other when Édouard, as a young man trying to gain admission to the naval academy, had crossed the Atlantic on a training vessel bound for Rio de Janeiro. That was twenty years ago. Manet had since become a notorious painter, while Pontillon was still in the navy. His wedding to Edma took place at the town hall in Passy on March 9, 1869.

According to Berthe's biographer Anne Higonnet, one of the witnesses was the statesman Adolphe Thiers, a friend of Edma's and Berthe's parents (since his name is not on the marriage certificate, he may have been just a guest). Three decades earlier, as minister of the interior serving under King Louis-Philippe, Thiers had taken on a silk weavers' (*canuts*) revolt in Lyon, the second in three years. Workers had erected barricades across the city, storming army barracks and an arsenal and turning parts of the city into fortified enclaves. Thiers, a patient man, made a calculated decision to withdraw his troops and station them around Lyon. He ordered artillery to shell the city, then sent his soldiers back in with instructions to methodically retake the areas controlled by insurgents using cannons, explosives, bullets, and bayonets—whatever it took. The tactics worked. The revolt was suppressed. But hundreds of Lyonnais were killed in several massacres—people referred to those few days as "Bloody Week"—and the uprising captured the imagination of some of France's greatest writers, including Honoré de Balzac, Victor Hugo, and George Sand. (Sand not only attended the 1835 trial of the rebels but had an affair with the

trial advocate, Michel de Bourges.) The Canut revolts, as they became known, would inspire a cast of far-left political thinkers, among them Louis Blanqui, Karl Marx, and Friedrich Engels.

After exchanging vows, Edma and Adolphe Pontillon moved to the harbor town of Lorient, where Pontillon was stationed. Berthe, twenty-eight and still single, missed her sister desperately. It was the first time in their lives that they had been separated. Her mother noticed that Berthe, as she pined for Edma, was eating less and had fallen into helpless lassitude. The Salon, where Manet's *The Balcony* would be revealed to the public, would be opening in a few short weeks. Berthe hoped to be there. But the thought of attending without Edma by her side was too awful to contemplate. Every time she tried to visualize the day, wavelets of nerves convulsed and soured her stomach.

The Salon was an exhibition held each summer in the vast halls of the Palais de l'Industrie, situated between the Seine and the Champs-Élysées. A vast and spectacular showcase of contemporary art that an appointed jury deemed worthy of display, it drew crowds of hundreds of thousands as well as fervent press interest. If your work was accepted and you were lucky with its placement, you stood to gain a great deal. There were reviews and illustrations in every Paris daily newspaper and in the weeklies, too. Certain pictures sustained society gossip for months.

The Salon was not supposed to be a commercial exhibition, but the publicity it generated provided the best opportunity for painters to find clients. Succeeding there was almost the only practical way for a young artist to forge a viable career, so every year painters and sculptors carefully planned their submissions. If you had been awarded a distinction at two or more previous Salons, or if you were already a member of the government-sponsored Académie des Beaux-Arts (men only), you could exhibit whatever you chose without submitting it to the jury. Otherwise, you had to submit, and hope.

A portion of the jury, varying in size from year to year, was selected by the state. The remainder of the places on the jury were elected—by a circle of artists who had previously won honors. For all these reasons, the jury skewed conservative, and painters who wanted

to stir things up—to paint modern subjects instead of old myths and Bible stories, for instance, or to complicate the established hierarchies of genre, or simply to paint in fresh, unconventional styles—were repeatedly denied and frustrated.

Stimulated by what they read and heard, many people who attended the Salon went *looking* for things to mock or jeer. And for the better part of a decade, as Berthe was aware, they had rarely had to look further than the latest concoction by Manet.

BERTHE HAD FIRST MET Édouard in 1868, in the galleries at the Louvre—one of the few public places where painters of both sexes could freely mingle as peers. Berthe was there with her painter friend, Rosalie Riesener, in the great gallery devoted to Rubens's Marie de' Medici cycle. She was copying Rubens's *Exchange of the Two Princesses*, focusing all her attention on the figure of the naiad in the foreground, when she heard voices and footfalls approaching. She turned to see a familiar face. It was Henri Fantin-Latour, a painter in his late thirties known for his refined and harmonious flower paintings. Berthe had first met Fantin in the Louvre almost a decade earlier. More recently, he had finished a full-length portrait of his close friend, Édouard. Before Edma's engagement to Pontillon, Berthe had heard a rumor that Fantin was smitten by her sister. He wasn't the only one.

Fantin now introduced Berthe to Édouard. He had already heard about the Morisot sisters and had even seen their landscapes, both at the annual Salon and at the gallery of Alfred Cadart. They were fresh and sensitive, with shades of Camille Corot, the elder statesman of French landscape painting. Berthe had obviously seen Édouard's paintings, too (his notoriety would have made them hard to avoid), but she wasn't particularly interested in secondhand opinions of them. In a letter to Edma, she described the effect that Édouard's work had on her: they "produce the impression," she wrote, "of a wild or even a somewhat unripe fruit. I do not in the least dislike them."

Having been introduced, Berthe and Édouard got to talking. Their January birthdays were one week apart, but he was nine years her senior. We don't know what they spoke about. The journalist Paul

Alexis would later describe Manet as "one of the five or six men of our present-day Parisian society who still knows how to talk to a woman." ("The rest of us," he added, "are too bitter, too distracted, too deep in our obsessions: our forced gallantries make us resemble bears dancing the polka.") Berthe, for her part, conversed easily. She combined a forthright intelligence with something disarmingly vulnerable. She moved with the physical confidence of a painter, accustomed to wielding brushes and palettes and to wearing paint-splattered smocks. She noticed Édouard's blondish beard, his high forehead with its sweptback hair, and his generous, laughing eyes. Perhaps one of them commented on the Rubens in front of them, or on Rubens's huge influence on Édouard's hero Delacroix (a close friend of Rosalie's father), or on the nearby *Madonna of the Rabbit*, a lovely painting by Titian that both Rubens, in the seventeenth century, and Édouard, when he was still a student, had copied. Or perhaps Berthe and Édouard spoke about things entirely unrelated to art. Regardless, the space between them seemed unaccountably charged, and for several minutes, it was as if Fantin-Latour and Riesener did not exist.

LOOKING BACK MANY YEARS LATER, Berthe reflected on her state of mind in the 1860s, prior to this first meeting with Édouard. "I'd like to know what I was thinking when I was 20," she wrote. "I think I was very silly, and yet I identified very much with Shakespeare's women; in any case, I had a wild desire to taste life, which is always attractive." It's clear, from the way Édouard later painted her, that he perceived in her precisely this desire to "taste" life. Her vitality amplified her attractiveness. Picking up on her intriguing nervous energy, Édouard saw all kinds of potential in it. "I agree with you," he wrote, in a mischievous mood, to a mutual friend soon after meeting her. "The Morisot sisters are charming. It's too bad they're not men. Nonetheless, they might, as women, serve the cause of painting by each marrying an academician and sowing strife in the camp of those old fellows." Edma was impressive, but it was Berthe to whom Édouard was really drawn. With her dark eyes—Spanish, he liked to think—and fine features, she could, he thought, have come straight

out of a painting by Goya. And as soon as this idle notion crossed the scrim of his painter's mind, he decided to make it true, more or less: He asked her to pose for a painting that would be an homage to Goya.

The story goes—and it may be true—that Manet wanted to paint *The Balcony* after glimpsing people gathered on a balcony during his family's summer vacation at Boulogne in 1868. But he was undoubtedly also thinking of Goya's *Majas on a Balcony*, which shows two attractive young women seeming to confer as they look out at the viewer. Both women, in the Goya, are courtesans. Two threatening men lurk in the shadows behind them, dressed in capes and cocked hats.

Goya had been dead for forty years, but he was all the rage in Paris in the late 1860s. By this time, Édouard was entering the final stages of a decade-long infatuation with all things Spanish. He was particularly besotted by the Spanish painters Diego Velázquez and Goya. Writers and artists of the generation before Édouard—figures like Victor Hugo and Théophile Gautier, Delacroix and Courbet—had all helped inspire his Spanish obsession. Gautier, in his widely read accounts of traveling in Spain, had romanticized Spanish poverty, marveling at how "the least beggar is draped in his coat like a Roman emperor in his purple." Édouard loved this idea. He had read both Gautier's travel writing and his art criticism, in which the older man of letters had ardently championed Goya. Gautier's descriptions of bullfights dovetailed in Édouard's imagination with Goya's paintings and etchings of the same subject; they would inspire many future paintings, including Manet's *Incident at a Bullfight* and *Mademoiselle V . . . in the Costume of an Espada*. Also inspired by Goya's portrayals, the writer Alfred de Musset, in a youthful account of his own travels in Spain, played up the special allure of Spanish women. When de Musset's lover, George Sand, had sat for a portrait by Delacroix, the artist first showed her a copy of Goya's *Los Caprichos*, whereupon she, too, immediately fell under the Spanish artist's spell. And when Sand and de Musset parted for the final time, Sand fantasized about being transformed into one of Goya's women in order to win him back.

Delacroix and other Romantic painters were not only responding to Goya's technique. They were roused, too, by the political dimen-

sion in his work, and they wanted to apply Goya's explicit, often sar-donic condemnation of injustice and folly to French society. They were especially affected by the idea of Goya as an active participant in the worlds he depicted: he was not just an aloof observer.

So if Édouard was susceptible to what he saw as Berthe's "Spanish look," it was mixed up with all this. *Majas on a Balcony* had gone on display in 1838 when a Spanish gallery opened at the Louvre. Baron Isidore Taylor, a philanthropist, artist, dramatist, soldier, traveler, and pioneer of Romanticism who had come to France with his English father and Belgian mother during the Revolution, created the gallery at the behest of France's hispanophile king Louis-Philippe, and he had acquired the painting directly from Goya's son. He also acquired *Old Women (Time)*, the arresting work that Goya painted as a pen-dant to *Majas on a Balcony*, transforming the pretty young *majas* in the first picture into the haggard and conniving old women they were destined (in Goya's scathingly satirical imagination) to become. Art-ists flocked to see the works that Taylor had brought back from Spain. They remained on view until January 1849, after Louis-Philippe was dethroned. Édouard's friend, the poet Baudelaire, lamented the loss. "The Spanish museum," he had written in 1846, "had the effect of increasing the volume of general ideas that you had to have about art." Not only that, but it had, he claimed, a pacific effect: "A museum of foreign art is an international place of fellowship, where two peoples, observing and studying each other in a more relaxed fashion, come to know each other and fraternize without arguing."

Goya might have smiled wryly at this notion. A witness to loot-ing, rape, starvation, and pitiless cycles of violence, he knew more than most about "international friendship."

One of the things France's progressive artists liked about Spanish art was its refusal to idealize. Unlike the artists of the Italian Renais-sance, the great Spanish artists were not in thrall to standards of beauty and decorum dictated by Greece and Rome. "No other nation has borrowed less from antiquity," as the art critic Charles Blanc put it. Édouard responded powerfully to this willingness to see what other art traditions shied away from. *Old Women (Time)*, for instance, was

as far from the French classical ideal as it was possible to get. Édouard also liked the way not only Goya but especially Ribera and Velázquez projected dignity onto individuals from all classes. It fed into his instinctive egalitarianism, his feeling for justice, his republicanism.

THROUGHOUT THE 1860S, Édouard painted one arresting canvas after another, all in a distinctive style that was brisk and unfussy, sensuous, witty, and self-aware. He dispensed with a lot of what his contemporaries had assumed to be necessary to great art—not just high-minded subject matter and clear narratives (Édouard's subjects were more often nonchalantly ironic, if not downright bizarre) but also subtle tonal transitions, richly conceived space, and licked-smooth surfaces, with all evidence of the brush concealed. Édouard's works, by contrast, were flat, like posters, and brushy—you could see the paint textures, which had a brisk, sensuous gleam. He loved to place bright, light-reflecting surfaces right up against black shadows with no gradations in between. To his young admirers, his style looked dashing and modern. His art was probing, poetic, allergic to cliché, and open to experiment. But most others noticed everything that was missing: the patient buildup from dark to light, the anodyne displays of technical skill, the kitschy sentiments. And it incensed them. Critics thought his paintings looked crude, slapdash, and vulgar. They read his efforts, moreover, as callow provocations, as insults. He was assailed with abuse.

All this was hard, not only on Édouard but also on his family and on those who treasured his friendship. And there were many. Édouard was congenial, he was charming. He seemed to know instinctively how to insinuate himself into the most volatile, susceptible parts of people. But to the extent that he realized he had this knack, he never exploited it. Instead, he bolstered his friends' confidence. His manner could be breezy and debonair, but he was stubbornly committed to his course. His confidence was contagious. And yet he never seems to have felt himself on solid ground. The up-and-down lurches of his artistic career made him flighty and self-doubting. He craved applause. More often, however, he aroused jeers.

Édouard's first submission to the Salon, in 1859, *The Absinthe Drinker*, had revealed the impact of the Spanish painters on him. It was a self-consciously modern take on Velázquez and on what Gautier had called "the wretches in the teeming ranks of the underclass." The Salon rejected it. Two years later, in his next attempt to win over the jury, he made the Spanish connection more explicit. *The Spanish Singer*—a young guitar-wielding man with conspicuously battered shoes—combined Realism with Romantic appeal. That was enough to earn high-spirited praise from the influential Gautier: "Caramba!" wrote the critic in his review of the Salon. Velázquez, he opined, would have saluted Édouard's guitar-wielding songster with a friendly wink, "and Goya would ask him for a light for his papelito," his hand-rolled cigarette. This was precisely the lineage in which Édouard craved to be included. The painting was given an honorable mention and moved down to a more prominent place on the Salon wall.

The surprise success of *The Spanish Singer* made Édouard suddenly magnetic to a coterie of young artists looking for alternatives to the stultifying conventions promoted by the Salon. They began to watch his every move. "Manet has his admirers, quite fanatic ones," observed Gautier. "Already some satellites are circling around this new star and describing orbits of which he is the center." Further tributes by Édouard to both Velázquez and Goya soon followed. When a troupe of Spanish dancers came to Paris in the second half of 1862, Édouard—a lover, like Baudelaire, of crowds and crowd scenes—somehow convinced them all to pose for him. He painted a portrait of the troupe's star, Lola de Valence, in costume. Both pictures were open homages to Velázquez. To Édouard, the Spanish court painter's brushwork, so fresh and vital, was the perfect antidote to the labored finish and sooty chiaroscuro of other old masters. "Now that's good clean work," he said when he saw *Gathering of Gentlemen* (a painting then believed to be by Velázquez). "It puts you off the brown sauce school," he added.

Édouard had not even been to Spain at this point, let alone seen a bullfight. (They were banned in France under Napoleon III.) But the Spanish vogue had by now so soaked into French culture that as he

embarked on his broader project—to sweep away the "brown sauce school"—he could take for granted a certain familiarity with Goya and Velázquez. He owned a copy of Goya's *Disasters of War* etchings and had begun to look closely at Goya's *Tauromaquia*, his series of etchings of bullfights. Between 1862 and 1864, he made a series of indelible works portraying bullfighters and bullfights, all informed by an improvised, playful quality that knowingly blurred reality and make-believe. Neither the critics nor the public knew quite what to make of them. Perhaps the most bizarre of his efforts was *Mademoiselle V . . . in the Costume of an Espada* (1862)—a depiction of his new favorite model, Victorine Meurent, dressed in a bullfighter's costume and posing in front of a bullfighting scene straight out of Goya. Was it a sly allusion, also, to Napoleon III's wife, Empress Eugénie? In many ways the power behind the imperial throne, Eugénie was herself a Spanish aristocrat and an aficionado of bullfighting. Celebrated for her extravagant costumes, she occasionally liked to appear at events in masculine outfits.

Throughout the 1860s, Meurent had been Édouard's most important model. Nicknamed "Le Crevette" (the Shrimp) because of her red hair and small stature, she had begun modeling at the age of sixteen in the studio of his teacher Thomas Couture. (She may also have studied painting in a separate studio reserved by Couture for women.) By the time Meurent arrived at the studio, Édouard had left. He most likely met her through the painter Alfred Stevens, and as soon as he did, he asked her to model for him. Meurent first posed for *The Street Singer*, and she went on to pose for some of his greatest, most notorious canvases. To the 1863 Salon, Édouard submitted *Mademoiselle V . . . in the Costume of an Espada*, *The Luncheon on the Grass*, and a painting of Édouard's brother, in which Gustave wore the same Spanish bullfighter's costume worn by Meurent in *Mademoiselle V.*

This nonchalant attitude toward roles and identity was typical of the way Édouard worked in those years. He was like the director of an amateur theater troupe made up of friends, family, and anyone he could rope in. They wore their assigned costumes with varying degrees of conviction, addressing an audience that was assumed to be

in on the game. But wrongly, it turned out—all three paintings were rejected. The jury was unusually brutal that year, knocking back fully two-thirds of the submissions. The upshot was an uproar in the artistic community. So to placate the aggrieved artists, Napoleon III sanctioned an exhibition of all the rejected paintings—the so-called Salon des Refusés. Thousands came to see this now legendary display of the "rejected" on the first day alone. But the public came less in sympathy, it seems, than in a spirit of schadenfreude, and they directed much of their mirth at Manet. His three paintings certainly stood out: they were as vivid and bold in style as they were bewildering in subject matter. But audiences were also following the lead of Napoleon III who, on his official visit to the exhibition, paused in front of *The Luncheon on the Grass*, which depicted Meurent seated freshly naked (her clothes make a pile in the picture's lower left corner) at a bizarre picnic in the company of two fully clothed men (possibly art students with mischief in mind). The emperor made a gesture of moral revulsion and moved silently on.

OLYMPIA, MANET'S MOST FAMOUS painting, was exhibited at the Salon of 1865, although he had begun painting it in 1863—the same year as *The Luncheon on the Grass*. It was another portrayal of Meurent, this time playing the role of a courtesan. The effect was almost shockingly immediate, but at the same time it was lightly ironized, as if Édouard had painted a nude, then placed it in quotation marks. Meurent wears a black neck ribbon, earrings, and a bracelet. A flouncy pink flower is tucked behind her ear. A satin slipper dangles suggestively from the end of one foot; the other has fallen off. Meurent's starkly undifferentiated skin is pale and unblemished, as in a photograph taken in strong light, the contours of her figure darkly outlined against the light background. A black cat comically arches its back at her feet, and a Black maid, modeled by Laure—family name unknown—who lived in the Batignolles district ten minutes from Manet, presents her with a bouquet of parti-colored flowers. These—in the fiction Édouard knowingly constructed—are meant to be read as a gift from a client.

Olympia's art-historical source was *Venus of Urbino*, Titian's painting of a Renaissance courtesan posing as the goddess of love. But in literature, its source was "The Jewels," a poem by Baudelaire. A few years earlier "The Jewels" had been one of six poems snipped by government censors from Baudelaire's *The Flowers of Evil* for being, in essence, too sexy. ("The darling one was naked," the poet had written, "and, knowing my wish / had kept only the regalia of her jewelry.") Large-scale female nudes were commonplace in nineteenth-century French art. But *Olympia* was painted in a way that resembled nothing previously exhibited at the Salon. You could look at it and concoct a cute little story about a glamorous courtesan if you wanted. But Manet made sure that you would also see Victorine Meurent and Laure, two identifiable, contemporary women knowingly playing parts. By drawing attention to the fiction's flimsiness, he exposed the mechanisms of belief as contingent, and this had the effect of making his models, as co-conspirators in the game of creation, more solidly real.

No nineteenth-century painting had a more explosive effect. To people who thought they recognized good painting, *Olympia* looked unfinished or, as Morisot had written, "unripe." Yet its impact was unignorable—and sharply erotic, in ways that got mixed up in more prurient minds with filth and death. One critic, Jean Ravenel, described *Olympia* as "fatigued" and "corrupted." Meurent's expression, he wrote, had "the sourness of someone prematurely aged." Four critics directly compared the picture to an image of a cadaver in the morgue.

This strange association may have been connected to the fact that a gleaming new morgue had opened in Paris the previous year. Situated on the Quai Napoléon on the Île de la Cité, it was bigger and had better sanitation than the old morgue, which had been a magnet for rats. The new morgue was part of Napoleon III's attempt to make Paris cleaner and more efficient. It featured a Salle du Public—an exhibition room where cadavers were laid out, behind a glass partition, on two rows of black marble tables, naked but for a piece of leather covering their loins. Here visitors could come to identify them. The tables were inclined toward the viewer and cooled by running

water. An average of two bodies came in each day, most of them men, many hideously disfigured. About a third were suicides by drowning, their bloated bodies scooped from the Seine. Others had shot or hanged themselves. Some were murder victims, but a good number had simply expired on the street from hunger, untreated illness, or exposure. The bodies would stay on display for three days unless they were claimed. Most never were. But the Salle du Public had turned the morgue into a macabre tourist site. "A perpetual stream of men, women, and children is running in and out of this horrible exhibition," wrote the author of a contemporary travelers' guide, "and there they stand gazing at the hideous objects before them, usually with great indifference."

People streamed in and out of 1865 Salon, hoping, it seemed, to have their sensibilities offended. Their desires were fulfilled when they saw *Olympia*. Édouard usually loved attention; the positive reaction to his *Street Singer*, four years earlier, had been a massive boost, and he'd fully expected that, as his ambition grew, more praise would shower upon him, vindicating his decision to become an artist against his parents' wishes. He had wanted his art to sparkle with freshness, as if he had opened the window of a stale-smelling bedroom onto a bright autumn morning. He hoped that his paintings would set him apart as an authentic original—a new Delacroix, a Courbet, someone genuinely transformative. He liked being provocative—Courbet had set a stimulating example in that way—and he didn't mind some controversy.

But *Olympia*'s reception at the Salon was like an anxiety dream unfolding in slow motion, and he was quite unprepared for it. The volume, the intensity, and the sheer ill will had something lurid about it, and it almost overwhelmed him. In the public imagination, Manet's name came to be surrounded by the sour, dead odor of a cheap spectacle, a murder plot that everyone knew by heart.

To get away from the *Olympia* scandal, Édouard made his first trip to Spain. Departing Paris by train at the end of August 1865, he went via Bordeaux and Bayonne. After crossing the border at Irún and traveling through Burgos (where he saw an El Greco in the

famous cathedral) and Valladolid, he arrived in Madrid. The journey took more than thirty-six hours. He made his first visit to the Prado on September 1, 1865, and all but fell to his knees. His infatuation with Velázquez, in particular, reached a new peak of intensity during this trip. He described the court painter's full-length portrait of the jester Pablo de Valladolid as "possibly the most extraordinary piece of painting that has ever been done. . . . The background disappears, there's nothing but air around the fellow, who is all in black and appears alive." In the same letter, he raved not only about *Las Meninas*, Velázquez's masterpiece, but also about his two paintings of philosophers and his several portraits of court dwarfs—"one in particular seen sitting full face with his hands on his hips, a choice picture for a true connoisseur." And then there was Goya. What Édouard had seen of his work on his first day in Madrid didn't greatly impress him. But over the next few days he saw other Goyas, including his portrait of the "Duchess of Alba dressed as a maja"—"a stunning invention," as he wrote to his friend Zacharie Astruc—and love bloomed.

Still, traveling in Spain at the end of summer was exhausting. The heat was oppressive, and the food, he complained, didn't agree with him. So after drinking his fill in the museums, he returned to Paris earlier than planned, refreshed and ready to paint on. He had discovered "the fulfillment of my own ideals in painting," he wrote to Astruc, "and the sight of those masterpieces gave me enormous hope and courage."

Two years later, shortly after the publication of a monograph on Goya, a painted copy of the Spaniard's *Majas on a Balcony* appeared at an auction in Paris. So Goya's portrayals of courtesans on a balcony were certainly sluicing around in Édouard's mind as he looked for a new composition to submit to the Salon. When he encountered Berthe—with her dark eyes and, to his highly suggestible mind, her strikingly "Spanish" look—he knew he had to embark on the painting that would become *The Balcony*.

WE DON'T KNOW IF Berthe agreed to Édouard's proposal to sit for him right away. They had only just met, and the invitation likely

presented her with a dilemma. She was no bohemian artist's model, after all; she was an unmarried woman in her late twenties, from an extremely well-connected family. Moreover, she wanted to be taken seriously as a *painter*, not as a passive model and (inevitably) a subject of gossip. For a woman in her position, to model for any artist—let alone an artist as notorious as Manet—was to run a grave risk. At stake was something more serious than gossip: it was reputation. If she made a poor decision, Berthe might not only embarrass her family but compromise her chance to marry.

The stakes were made higher by evolving social realities that were unique to Second Empire Paris. Under Napoleon III, the city had become a magnet for pleasure-seekers. Stark economic inequalities and high demand had led tens of thousands of Parisian women into various forms of prostitution. The government made attempts to regulate the sex industry, hoping to limit the spread of venereal disease (especially syphilis), but their efforts had largely backfired. Haussmann's remodeling of the city forced streetwalkers and brothels to move from the Palais-Royal area to the new center, around the unfinished Opéra Garnier.

On the unfinished building's facade, a sculpture by Jean-Baptiste Carpeaux, commissioned by Garnier, was unveiled. It depicted an upright male figure with angel's wings surrounded by a tight ring of lurching naked bacchantes. Critics attacked it as vulgar, even disgraceful. The dancers' grinning, mobile expressions and ungainly body postures were compared to a ring of delirious dancers from the Opéra's ballet corps, stripped of their costumes. At the end of August 1869, after an evening flare-up of rioting in working-class Montmartre, someone threw black ink over the sculpture, which set off a sustained uproar in the press. Artists and a few critics protested the vandalism, but others continued to decry the sculpture's indecency. Against a backdrop of rumbling class tensions, exacerbated by the late summer heat, the sculpture was interpreted as a representation of women, likely from Montmartre, dancing the "can-can," in those days a freer, wilder, and openly lubricious set of improvised movements in which women flashed glimpses of their genitals by raising

their skirts and petticoats while kicking up their legs. So the dance was associated not only with prostitution and "wanton women" but with a still more threatening form of energy: the potential anarchy and violence of the working class.

Just as unremitting social turbulence had scrambled old assumptions about class in Paris, creating subtle forms of panic, the explosion in sex work stirred up social perils for *all* women, not just sex workers. Registering as a sex worker in Paris involved submitting to regular medical inspections and following strictly mandated guidelines. The requirements were so onerous and humiliating that most opted out. So the system broke down, and freelance mercenary sex—much of it targeted at tourists—exploded. Women who worked in low-paying jobs as souvenir and flower sellers, department store assistants, waitresses, tobacconists, ballet dancers, and artists' models (like Meurent) were presumed to be also available for sex, and there were so many subtle varieties of pay-for-sex relations that it became confusing. Unmarried bourgeois women were severely constrained, because of a class imperative, to hold the line against this rising tide of social and sexual ambiguity. A bourgeois woman could not risk being mistaken for a freelance prostitute, so it was essential that she not allow herself to arouse suspicion. Impediments arose everywhere. It was hard for women to work, to speak freely, to dress comfortably, to socialize unguardedly, or even simply to be seen enjoying themselves in public. On the scale of permissible activities, accepting an invitation to pose for any artist, let alone one with a reputation like Manet's, was somewhere near the bottom.

This code of decorum should have caused Berthe to decline Édouard's invitation. But there were two loopholes. The first was Berthe's status as a dedicated painter who had already shown at the Salon. This gave her a legitimate pretext to accept. Artists were always painting fellow artists. The second was that her family and Édouard's had much in common and enjoyed similar social standing. The proviso, of course, was that, were Berthe to pose for Édouard, she must be suitably attired and *always* chaperoned. When the sittings for *The Balcony* began, it was Berthe's mother who performed this role.

The sessions were held in Édouard's studio on the Rue Guyot, up the Avenue de Wagram from the Arc de Triomphe, in the Batignolles district. They had been thrilling at first. Édouard was great company. Just being around him, you felt connected to something bigger, riskier. When he got on a roll, he was hilarious. But he was also wayward and needy. He could be calm and amiable one moment, then suddenly ardent the next. The painting itself took months rather than weeks to complete. The longer Édouard worked on it, the more insecure he seemed to grow.

Berthe was fascinated by the fact that he made no preparatory drawings. Instead, he painted directly onto the canvas. *Was this the source of his problems?* she wondered. Because there were problems! In agonies of indecision, Édouard changed his conception of the picture several times. The woman standing beside Berthe in the painting was the twenty-two-year-old violinist Fanny Claus, the best friend of Édouard's wife Suzanne. They often played music together. Édouard had originally thought to make a portrait of her alone; but then he met Berthe. And as the idea for a painting based on the Goya took hold (Berthe rests her forearm on the railing in exactly the manner of one of the *majas* in the Goya), he decided to paint in the two male figures, too.

The painter Antoine Guillemet, who had studied under some of the same teachers as Berthe and Edma, stands immediately behind the two women, looking stunned and slightly idiotic. Édouard had made him pose for fifteen sessions and still couldn't get him right. Behind him, lost almost in shadow, stands young Léon, Édouard's son by Suzanne. The figure of Claus, thought Guillemet, was "atrocious." But both models were so sick of posing on their feet that in Édouard's presence, they declared the picture perfect. "There's nothing more to be done," they insisted. Eventually, Édouard acquiesced. *The Balcony* was deemed complete. It would soon be revealed at the Salon.

〽 〽 〽

CHAPTER 2

𝔐 𝔐 𝔐

The Salon of 1869

IN THE SEVENTY YEARS SINCE THE 1789 REVOLUTION, France had lurched from a republic to an empire (via a bloodthirsty dictatorship) to a restored absolute monarchy, followed by a constitutional monarchy, a second republic, and a second empire. Even well-off families, blessed by inheritance or good fortune, found these epochal upheavals disorienting and difficult to navigate. The Morisots were no exception.

There were three Morisot sisters, Berthe, Edma, and Yves in ascending order of age. There was also a brother, Tiburce, who was seven years younger than Berthe, the youngest sister. Together the sisters had a startling effect on the painters who were welcomed into their circle in the 1860s—first Puvis de Chavannes, Alfred Stevens, and Fantin-Latour, and by the end of the decade, Manet and Degas. Their father, Tiburce, had been fortunate to marry into wealth. Having studied architecture at the École des Beaux-Arts, he co-founded an architectural journal, but the enterprise collapsed and his partners bailed on him, leaving him saddled with debt. Unable to pay, he fled France for Greece. Upon his return, he met Cornélie, whereupon both his legal and financial jeopardy evaporated: Cornélie (who was sixteen when they wed) was the daughter of a director in the Finance Ministry.

A moderate conservative, Tiburce was nonetheless modern in outlook, both principled and pragmatic. He had supported the constitutional monarchy of Louis-Philippe, the so-called Citizen King. During Louis-Philippe's reign, Tiburce rose in the ranks of the provincial civil service, eventually wielding considerable power as prefect of an entire regional department. But after the 1848 revolution forced the abdication of Louis-Philippe, he lost his job. Berthe was seven at the time, Edma nine, and Yves ten. An intervention by his father-in-law earned Tiburce a new posting—in Calvados. But he was fired again when Louis-Napoleon—soon to style himself Napoleon III—seized control in a coup at the end of 1851. Compromised by his association with the earlier regime, Tiburce's career never really recovered. He was recalled to Paris, where he was assigned a position devoid of power, as judicial adviser to the auditor's office.

That was in the summer of 1852. Thanks to Cornélie's family, the Morisots didn't have to worry unduly about money. Cornélie was little perturbed. She became a popular and exuberant hostess, known for her Tuesday-night salons at the family residence in Passy. Meals would be followed by musical performances or theatrical parlor games. Everyone who came to the house could see that the daughters' greatest enthusiasm was for painting. At the end of 1866, Yves, the eldest, married a tax inspector, Théodore Gobillard. He had served as an officer in the army and had lost an arm fighting in Napoleon III's recent campaign in Mexico. A year after the wedding, Yves gave birth to her first daughter, and when the infant was one, Gobillard was transferred from the Breton coast to Mirande, in the Southwest.

Yves's departure brought Berthe closer to Edma than ever. But now Edma had married, too, and Berthe was left alone in the house with her parents.

THE 1869 SALON MARKED the first time in six years that neither Morisot sister would be exhibiting her own work. Instead, Berthe was to feature as a model, in a painting by Manet. The potential for mortification was high. Manet's submissions were always controversial. It wasn't just that he painted in a manner that, to traditionalists,

appeared insultingly casual. It was that he played maddening games with the history of art, bypassing piety and deference in favor of sly winks and saucy insinuations. *The Balcony*, his homage to Goya's *Majas on a Balcony*, with dark-eyed Berthe in the lead role, could easily be read in the same way as *Olympia*, which had been clearly understood as an image of a modern courtesan. Goya's *majas* were, after all, prostitutes. If Berthe hadn't grasped this when she agreed to pose for Édouard, the allusion was clear to her now. There was nothing overtly louche about the painting itself—and it was really just a nod to Goya. But you could never tell how the public was going to react.

In 1849 the exhibition had been moved from the Salon Carré to the Palais de Tuileries. It was now held in the Palais de l'Industrie, in the eighth arrondissement, a half-hour walk along the right bank of the Seine from the Morisots' house in the sixteenth. Originally constructed for the 1855 Exposition Universelle, or World's Fair, the Palais de l'Industrie was Napoleon III's attempt to rival and surpass London's Crystal Palace. Its masonry exterior sheathed a metal skeleton, and its almost preposterously huge interior was illuminated by natural light pouring in through a vaulted glass and cast-iron roof. Almost everyone complained about how unsuitable the spaces were for the display of art. The ventilation was poor, the lighting in the run of galleries on either side of the nave electric and harsh. Attempts had been made to improve things by changing the layout, but compared to the stateliness of the old venue, the Louvre, this space was compromised by an air of commercialism and vulgarity.

Visitors to the Salon lined up in the early morning so that, by nine o'clock, crowds were already pressing against the ticket windows. Inside, after negotiating the giant staircase, one looked down and saw an array of sculptures on pedestals and plinths and a café where—according to the writer, artist, and collector Jacques-Émile Blanche—"future enemies would fraternize over a sandwich and a glass of beer." Ham, cheese, and pâté were on sale. People smoked cigars and ate sherbet. "The merchants," wrote the art historian Henri Loyrette, "were in the temple."

The galleries were organized alphabetically, by artist's last name.

So Berthe, whose eye trouble had eased in time for the opening, tried to make a beeline for Room M—not for Morisot this year but for Manet. But on the way, she and her mother, who was her chaperone, had to negotiate various social obstacles. "The first thing we beheld as we went up the big staircase," she wrote to Edma on May 2—the day of the opening—"was Puvis's painting."

Puvis was Pierre Puvis de Chavannes. He was forty-four years old, a celebrated painter who specialized in arcadian, neoclassical murals in muted colors. He had trained briefly under Delacroix and subsequently in the studio of Manet's teacher Couture. Plodding, politically conservative, something of a bore, but nonetheless an original and influential artist, Puvis was a regular at the Morisot home. He was actively courting Berthe. His personal situation, however, was odd. For more than a decade, he had been close to a Romanian princess, Marie Cantacuzène. She was officially married to her cousin, a minister in the Romanian government, but the two had separated. The princess had had a brief affair with the painter Théodore Chassériau, and it was in Chassériau's studio that she had met Puvis, who then persuaded her to model for him. No one knew the precise nature of their relationship; it appeared to be intimate without being sexual.

Berthe, climbing the steps at the Palais de l'Industrie, didn't see Puvis himself, but she did bump into another love interest, this one from her past. His name was Jacquemard. He was standing in front of Puvis's big painting and seemed to be admiring it. But as Berthe wrote wryly to Edma, "What he seemed to admire less was my person. There is nothing worse than a former admirer. Consequently, he forsook me very quickly." Her account was tailored to Edma and intended to entertain her. It reveals much about Berthe's character—above all, how spirited she was. She was conscious of her effect on others, confident in her own beauty, alive to every social nuance, and fearless in her judgments. She had neither a rampaging ego nor any real capacity for self-delusion.

The next person she ran into was Carolus-Duran, a painter in Manet's circle, with his wife. When he saw Berthe and Cornélie, he

"blushed violently," wrote Berthe, without saying why. "I shook hands with him, but he did not have a word to say to me. His wife is a tall and handsome woman. He is showing a portrait of her which, I think, is going to be a success, although it is quite vulgar. It isn't absolutely bad, but I find it mannered and flat."

When Berthe finally reached Room M—its flimsy-looking temporary walls naked beneath the high glass ceiling—Édouard was already there. He wore his top hat in the bright natural light and looked dazed. "He begged me to go and look at his painting, as he did not dare move a step," she wrote. She had spent weeks watching Édouard at work in his studio. She had seen him, too, every week at the salons that her parents hosted, as well as at Degas's father's on Mondays, at Alfred Stevens's home on Wednesdays, and at Édouard and his mother's home on Thursdays. But she was seeing him now in a new way, and she was, she admitted, beguiled. "I have never seen such an expressive face as his," she told Edma. He "was laughing, then had a worried look, assuring everybody that his picture was very bad, and adding in the same breath that it would be a great success. I think he has a decidedly charming temperament," she concluded. "I like it very much."

More beguiling still was his portrayal of Berthe in *The Balcony*. Here it was, on the walls of the Salon, available to everyone's eyes. She didn't know what to make of it. "I am more strange than ugly," she wrote. Meanwhile, the painting's sexualized associations were already threatening to burst into the open: "It seems that the epithet of *femme fatale* has been circulating among the curious." It would have been awkward for Berthe to stare too long, so she went looking for Fantin-Latour with the other assembled *F*s. His "insignificant sketch," she wrote that evening, "was hung incredibly high, and looked extremely forlorn. I finally found him, but he disappeared before I could say a word about his exhibit. I do not know whether he was avoiding me, or whether he was conscious of the worthlessness of his work. I cannot believe he is the person we admired so much last year."

This was brutal—but the fact was, Fantin-Latour had recently

gone down in the Morisot sisters' estimation. Eighteen months ear-
lier, at a dinner at the Manets', all the young men had been talking
about Edma, who was yet to be engaged at that point. Fantin told
the company that he had never seen a beauty as ravishing. When
Édouard told him he should propose to Edma, he answered that he
had always heard that she didn't *want* to marry. Now Edma *was* mar-
ried and no longer painting.

Fantin had then turned to another female painter, Victoria
Dubourg, whom he met at the Louvre. They soon became engaged,
although it would be almost a decade before they married. Degas had
recently spent several months working on a portrait of Dubourg. She
was not as beautiful as either of the Morisot sisters. Nor did Degas
try to enhance her looks, showing her in a shapeless brown smock,
seated in an uncomfortable upright chair, leaning forward with her
hands clasped in her lap. And yet her large-eyed gaze is intelligent and
appraising, and Degas's depiction of her reveals palpable respect. The
vase of lilacs on the mantlepiece beside her respectfully acknowledges
her profession—she was painter of floral still lifes (like Fantin)—and
her bare hands are conspicuously pink, even raw-looking—a clear
sign that she was accustomed to working with them and that she was,
so to speak, "in the trade."

For Berthe, Degas's straightforward validation of Dubourg as a
painter might have induced a mild wince: after all, Édouard had so
recently depicted her, Berthe, not as a painter but as a fashionable
beauty, a fantasy femme fatale out of Goya. It was certainly irritating
that Dubourg was making her debut at the Salon, while for the first
time in years, neither Morisot sister was showing. In her letter, Berthe
wanted to show Edma—who might have pictured herself with Fan-
tin as an alternative to her present life—that she was unimpressed.
"I certainly think that [Fantin's] excessive visits to the Louvre and to
Mademoiselle Dubourg bring him no luck," she wrote.

Suddenly Degas showed up in Room M. He greeted Berthe, only
to abandon her and go to speak with two women who had previously
posed together for one of his portraits. "I must admit I was a little
annoyed when a man whom I consider to be very intelligent deserted

me to pay compliments to two silly women," joked Berthe. So she turned back to Édouard, who went on, for an entire hour, to lead her, Suzanne, and his mother through the Salon's various galleries. Keeping up a constant patter of commentary, he was as charming as ever. But his attention was scattered, and Berthe had to negotiate not only Suzanne and Madame Manet but also the crowds, the social whirl, and the egos of many of her fellow artists, on a day when all of them, including Édouard, were anxious.

"I was beginning to find all this rather dull," she explained to Edma. But then she "bumped headlong" into Puvis, and her boredom was about to get worse. Puvis was over the moon to see Berthe. The prospect of running into her had been his primary motive for coming (or so he gallantly said). And here she was! How marvelous. He proposed that he chaperone her on a walk through the galleries. "I wanted to see the pictures," wrote Berthe, "but he implored me so eagerly: 'I beg of you, let us just talk. We have plenty of time for looking at paintings.'"

Berthe had lost track of Manet and Suzanne, and her mother, feeling a headache coming on, had abandoned her to take a seat on a sofa. In different circumstances, the prospect of a long chat with Puvis might have been pleasant, but Berthe was distracted by the many familiar faces strolling by. Some of them stopped to comment on her appearance (inevitably comparing her with Manet's painting) or to lament the absence this time of her own work.

Puvis appointed himself as her chaperone. He was his pedantic and patronizing self—the antithesis of Édouard—and Berthe could tolerate him only so long. The fact that he was courting her made it harder to brush him aside. She couldn't just casually excuse herself and wander away. So she brought him back to her mother, who was sitting with an acquaintance, and they all went off together until they found Édouard again. As soon as she had the chance, Berthe, in an indignant whisper, reproached him for leaving her stranded with Puvis. If she expected thereby to obtain an apology or gain some kind of emotional upper hand, her hope was in vain because this was not a notion Édouard cared to indulge. Berthe could count on all his devo-

tion, he coolly replied, but he "would never risk playing the part of a child's nurse."

TWO YOUNG WOMEN—they look so alike they can only be sisters—are seated on a sofa upholstered with floral fabric. They wear the same white dresses with the same blue polka dots, frilled collars and sleeves, and black chokers around their necks. They sport, too, the same upswept, massy hairdos with dark ringlets falling to their shoulders. Their bodies turn inward, one mirroring the other. And yet the artist, Berthe Morisot, has permitted a few asymmetries. The sister on the left, for instance, looks out at the viewer, while the one on the right looks across the trajectory of her companion's gaze at something out of the frame. There are two Japanese fans, one, open and framed, on the wall over the sofa (Berthe had recently received it from Degas, who had decorated it with Spanish dancers and musicians); the other, half open in Berthe's hand, concealing a sign of the intimacy that is the picture's true subject: Behind the fan, we are made to understand, their hands are touching.

Berthe painted *The Sisters* in 1869, most likely after seeing that year's Salon. Until this point, she had been primarily a painter of landscapes. But she had come away from the Salon feeling bored by the genre. A landscape by Charles Daubigny, for instance—a lauded Barbizon School painter who had done much to encourage Berthe's painting—struck her as "common and heavy." More pleasing, she thought, was a painting by a follower of Manet, Frédéric Bazille. Titled *View of the Village*, it had clearly been painted outside rather than in the studio. Berthe loved the way Bazille had captured the flooding, beneficent feeling of the natural light. The contrast with the gloom and artifice of landscapes worked up in the studio was impossible to miss. But she loved even more that the painting wasn't primarily a landscape. Its main subject, posing on a hilltop overlooking a Provençal village, was a sweet, fashionably dressed, slightly vulnerable-looking young woman, wearing a white dress with pink stripes, a flowing crimson sash, and a black choker. Against all the overworked and somberly colored studio productions hanging on the

walls at the Salon, the painting stood out. Yes, it looked a little naïve, a little awkward. But it was incredibly fresh. Better yet, it had a psychological charge—a palpable air of ambivalence and fragility. Berthe wanted to capture a similar quality in her own work when she painted herself with Edma.

CIRCUMSTANCES AND TEMPERAMENT had made the whole Morisot family close, but Berthe and Edma were especially tight. They were each other's confidantes and champions. Both were talented artists. When they were teenagers, their mother's idea had been to surprise her husband on his name day with an unexpected gift: drawings by his daughters. The private lessons she had enrolled them in entailed a long, weekly trudge across Paris. The teacher was pompous and a bore—or so the girls felt—but both Edma and Berthe took to art with unusual zeal, and over the next few years they fell under various good influences. None was more important than that of the great landscapist Camille Corot. By then in his seventies, "Papa Corot," as he was affectionately known, became a regular at Madame Morisot's Tuesday-night soirées, where he liked to watch the young people talk while smoking his pipette in the corner. An exquisitely sensitive observer of the effects of sunlight on landscape, Corot was also a model of humble, unflagging devotion to his calling.

The Morisots' house had a bold, bohemian energy that defied the expectations of their social class and their affluent, rather sedate neighborhood. Among their regular guests were the immensely famous opera composer Gioachino Rossini, a neighbor in Passy until he died, at seventy-six, near the end of 1868, and the influential republican journalist Jules Ferry. Ferry, who would go on to become France's prime minister, was intrigued by both unmarried sisters and tried to pay court to them. He was always "irreproachably correct," Cornélie was amused to observe, but in truth, he didn't stand a chance. Part of what made Berthe and Edma so alluring in these settings was precisely that they were not "irreproachably correct." They were charming and forthright. They discussed politics. And they were unmistakably serious about painting.

On the ground floor of the house, connected to a small but charming garden with large, shade-giving trees, was a spacious living room. Berthe and Edma had used this room, along with the "ladies' living room" directly above, as their painting studios until a separate building was constructed specifically for them. The building of this dedicated studio was momentous: It was an acknowledgment by Tiburce and Cornélie of the important role that painting had come to play in the lives of their two younger daughters. In 1864, Edma and Berthe submitted two paintings each to the Salon. All four were accepted.

PROFESSIONAL FEMALE ARTISTS were not uncommon in France. Figures fluctuated, but for much of the nineteenth century, around 10 percent of artists whose paintings appeared at the annual Salons were female, and many of them carved out professional careers, painting not just still lifes (which were low on the hierarchy of genres) but also prestigious narrative scenes and portraits. Still, the Salon itself was deeply hierarchical, and women faced many more obstacles than men. They tended to exhibit fewer works each, and unlike the many men who had previously been decorated or were members of the academy, they were never exempted from the process of selection by jury because the academy itself barred women. Between 1864, the year Edma and Berthe first showed at the Salon, and 1900, only 3 percent of artworks purchased by the French state were by women. So although women were not excluded, they were obstructed, diminished, and generally discouraged.

One exception was Adèle d'Affry, a leading sculptor, who became a friend, confidante, and role model to Berthe at a time when she was wrestling with whether to commit herself to art. D'Affry went by the pseudonym Marcello. Five years older than Berthe, she had already forged a formidable reputation as a sculptor. She was close to some of the most illustrious figures of Second Empire Paris, from Delacroix and George Sand to the architect Garnier, the young painter Henri Regnault (who was lighting up the art world with his bold and large-scale Orientalist works), the politician Adolphe Thiers, and Empress

Eugénie. Inevitably, Berthe's sense of what was possible for a female artist was deeply affected by Marcello's example. But their relationship mattered on other levels, too. Both women prioritized honesty, trust, and the truth of intimacy over social form. "We had everything to say to each other, and with her I dared to bare my soul," Berthe later recalled.

Descended from Swiss nobility, Marcello was gifted, striking, and fearless. But her life had also been tragic. She had taken up art only after the death—six months after their wedding—of her husband, Carlo Colonna, the Duke of Castiglione-Altibrandi. Colonna had contracted typhoid fever in Paris, and there was simply no saving him. Marcello's first work was a bust of her late husband; her next was a self-portrait, and from that point on her rise was rapid. Although her application to study at the École des Beaux-Arts was rejected because of her sex, she was not deterred. She studied animal drawing at the Natural History Museum under the direction of the great animal sculptor Antoine-Louis Barye and took anatomy classes in the basement of the School of Medicine. In 1863 she had three busts exhibited at the Paris Salon under her freshly minted pseudonym. Empress Eugénie was so taken with one of them that she drew her into the imperial social circle and within two years, Marcello had an official commission to execute Eugénie's portrait. The couturier Frederick Worth owned three of her sculptures, and Garnier acquired her striking *Pythia* to decorate the basin of the grand staircase of his new opera house.

So Marcello's success was social as well as artistic. But it came at a price. Having ingratiated herself with the imperial family, she was criticized with special force by those opposed to the regime. This she could handle. She was quick-witted and socially supple, and Berthe, watching her maintain her balance in such a fraught political environment, received lessons in conduct that she would soon have to draw on herself.

Marcello quickened Berthe's interest in sculpture, and so in 1863–64, she studied with the sculptor Aimé Millet. He not only taught Berthe but asked her to pose for him, using her face as the basis for an

architectural medallion. He also introduced Berthe to Rossini who, impressed by her musicality, picked out an upright piano for her and personally signed it. Since moving to Paris in 1859, Marcello had been a tenant in the house of the artist Léon Riesener, and in due course she introduced him to Berthe. A bond was soon established, and soon after Berthe's and Edma's momentous first showing in the Salon of 1864, the Morisots rented from Riesener an old mill on the Normandy coast. Riesener had left there a journal, filled with notes articulating his own thinking on art. Reading it gave Berthe an opportunity to imbibe his way of thinking. Its impact on her proved tremendous.

Riesener was a cousin and confidant, since childhood, of Delacroix, who painted a famous portrait of him in 1835. He was, like Delacroix, a passionate colorist, in love with the painters of the Venetian Renaissance and with Rubens rather than with the classical tradition that linked the Greeks to Ingres, via Raphael, Poussin, and David. If there was a difference between Delacroix and Riesener, it was that where Delacroix loved drama, poetry, and history and was constantly making allusions to all three in his art, Riesener's pictures were more stripped back, less literary. Modest and introspective, he was a sensualist, willing to relax into art's visual pleasures without always feeling obliged to impose deeper meanings on it. He was in this sense (like Corot) a key forerunner to the Impressionists. "Art must always remain young, even savage," Riesener had written in his journal. And: "What is beautiful is what is allowed—our senses know their laws without them needing to be explained to them. In this regard, they never trick themselves—they perfectly know beauty."

Berthe read Riesener's journal repeatedly over that summer idyll and the next. So intoxicated was she that she carefully copied more than a hundred pages from it into her own notebook. Back in Paris, she and Edma spent time with Riesener's daughter Rosalie, making copies at the Louvre. In 1866 Rosalie painted Marcello, prompting much talk in both the Morisot and Riesener households about this striking, aristocratic sculptor, tragically widowed, whose artistic rise seemed unstoppable. Berthe, Edma, and Rosalie all admired Marcello's resilience and fortitude, and Berthe in particular wanted to

emulate her air of independence. She couldn't help but notice that as a widow, Marcello was free from pressures to forsake her art to attract, or cater to, a husband.

WAS IT REALISTIC for Berthe to think she might follow in Marcello's footsteps and dedicate her life to art? The tutor who had preceded Corot, one Joseph Guichard, had sensed the looming problem. "With characters like your daughters," he wrote to Cornélie (with no small measure of masculine self-regard), "my teaching will make them painters, not minor amateur talents. Do you really understand what that means? In the world of the *grande bourgeoisie* in which you move, it would be a revolution, I would even say a catastrophe."

Guichard's letter set alarm bells ringing in the Morisot household. Cornélie was no revolutionary, but she knew her daughters and was sympathetic to their ambitions. How could she not be? She had always been surrounded by people with knowledge of painting, and it was she, their mother, who had encouraged them to take up art in the first place. But Cornélie also knew the mores of the *grande bourgeoisie*. She understood the expectations placed upon young women who, in keeping with their biological "destiny," were expected to fulfill the roles of wife, mother, and homemaker and who, under French laws governing marriage, were essentially their husband's chattels. So Guichard wasn't telling Cornélie anything she didn't already comprehend. But her daughters were headstrong, and the situation was running away from her.

If this troubled her—and clearly it did—she was not, perhaps, entirely displeased. She could take pride in the fact that Edma and Berthe were more than just talented. They had already tasted success—and at the Salon no less.

IN 1865, ENCOURAGED BY the previous year's success, Edma had painted a portrait of Berthe that reads as an unmistakable statement of intent. She showed Berthe standing at an easel, a red headband holding back her long dark hair. She wears elegant gold earrings and a brown smock over a red garment with white buttons done up to

the collar. Her right hand holds a thin paintbrush—not casually but with relaxed precision, like a surgeon holding a scalpel or a violinist her bow. The brush hovers over a rectangular palette that she supports with her left arm. Her left hand holds a white paint rag and a quiver of brushes. She has a strong, fine nose with a hint of color high on her youthful cheeks and (Berthe's most striking feature) dark eyes engulfed in shadow. She stares not out at the viewer (as she would later do in Édouard's *The Balcony*) but at the canvas she is working on. Her focused concentration is palpable. The painting has a smoldering quality, an intensity and resolve that convince us of what Edma saw in her sister, even if few others did. It is hard to see, if you were the painting's subject, how it would not affect your idea of yourself.

EDMA AND BERTHE CONTINUED to have their paintings accepted by the Salon jury through the second half of the 1860s. They sent work, too, to provincial exhibitions and showed in the shopfront at the Parisian galleries of Martinet and Cadart. In 1867 Jules Ferry (no doubt trying to endear himself to the Morisots) wrote to Cornélie to say that he had noticed people standing outside Cadart's expressing admiration for one of Edma's paintings. (Ferry's own star was rising that year: he had written a powerful indictment of Baron von Haussmann's financial corruption, relying on documents that may have been supplied to him by Berthe's father Tiburce. Within two years, his exposé would lead to Haussmann's disgrace and downfall.) Cornélie passed Ferry's note along to Edma but couldn't resist adding, matter-of-factly, that "the picture has not sold, and I am still wondering how artists who depend on selling their work manage to live."

Cornélie wrote with the wryness of a mother who felt confident, or at least hopeful, that her daughters would feel no such obligation. But a deeper question hovered: Who would fall in love with—let alone want to marry—a woman wearing a paint-smudged smock with a paintbrush always in hand? As women, Edma and Berthe were excluded from the official art schools—the usual path to professional success. But anyone could register to copy at the Louvre, and anyone could submit work to the Salon, so the Morisot sisters did both. When

they went to the Louvre, Cornélie usually trailed along as their chaperone, sitting and sewing while they worked. She observed that the sisters' camaraderie helped each to defend herself—and the other—against the slow-working acid of self-doubt.

But were Edma and Berthe good enough to entertain dreams of careers as artists? Cornélie doubted it, and it became gradually more important to her that they adjust their sights. "Never have I seen you choose what was within your reach," she warned Edma, intending the words equally for Berthe. "Whimsy is all very well, but not when it creates trouble. The real science of life, in small matters as in large," she went on, with intolerable (for offspring) moderation and reasonableness, "is always to smooth things out, to make them easier, to adjust to things rather than wanting them to adjust to you."

This sounded like a good foundation for a harmonious marriage, perhaps even a sound method for avoiding war. But it didn't comport with the pursuit of serious artistic ambition. Cornélie, however, persisted: if her daughters were to continue to paint, she argued, they should at least try to paint in a more pleasing style. The amusing thing was that, even as she wrote such things, she could predict, with a mother's special foresight, her daughters' feisty response. "I can see you're shrugging your shoulders," she wrote, "and I can see Berthe's sarcastic or glacial expression telling me: 'Take the brush yourself then.'"

IN 1869 EDMA WAS SUPPOSED to be happy. Ahead of her sister, she had married. The next part of her life would be children. But her imagination, inevitably, adhered to her previous life with Berthe. "In my thoughts," she wrote, "I follow you about in your studio and wish that I could escape, were it only for an hour, to breathe that air in which we lived for many long years. . . . I hope my husband is not aware of the void that I feel without you." This note received a bracing reply from Berthe: "Come now," she wrote, "the lot you have chosen is not the worst one. You have a serious attachment, and a man's heart utterly devoted to you. Do not revile your fate. Remember that it is sad to be alone; despite anything that may be said or done, a woman

has an immense need of affection. For her to withdraw into herself is to attempt the impossible."

Berthe and Edma had always lived together and for years worked side by side in the same studio. One of the hardest parts now was that they were having to write to each other. But the problem was not just that they were physically apart. It was that they were no longer on the same trajectory; their adventure was no longer *shared*. The change was wrenching. It had happened so suddenly that it left them in shock. For Edma, marriage felt like a capitulation. It ended her hopes for an artistic career. Perhaps in the bigger game of life, such a capitulation made sense. Edma had no way to know. But every letter the sisters exchanged now had a scuffed and melancholy tint, as if worn down by the abrasions of so many unanswerable questions.

"If we go on this way, my dear Edma, we shall no longer be good for anything," wrote Berthe in mid-March. "You cry on receiving my letters and I did just the same thing this morning." In April, less than a month before the opening of the 1869 Salon, Edma had made a brief visit to Paris, before returning to Lorient. Almost immediately after her departure, Berthe sent her a letter. What they had talked about during Edma's visit—the tension between marital affection and the need for an independent existence—still occupied her thoughts. "Men incline to believe that they fill all of one's life," she wrote, "but as for me I think that no matter how much affection a woman has for her husband, it is not easy for her to break with a life of work. Affection is a very fine thing, on condition that there is something besides with which to fill one's days."

The "something" for her, it was tacitly understood, was painting. But for Edma, Berthe insisted, it could be motherhood. "Do not grieve about painting," she urged. "I do not think it is worth a single regret."

When the Salon ended and she was reunited with Edma, Berthe set about commemorating their relationship. The result, *The Sisters*, was one of her subtlest and most beguiling pictures. It was a declaration of sisterly love, clearly—but it was more than that. It marked Berthe's turn away from landscape and toward portraits and interiors—and to some extent toward "inner life" (that is to say, psychology, emotion).

More specifically, *The Sisters* was a tribute to all that she and Edma had shared and an assertion that they would remain close and that their fates would never diverge too greatly.

IN A LETTER TO A FRIEND, Berthe's father once wrote that "Berthe always seems astonished; I don't know if it's by others or by herself." He was beguiled by her secretive nature and would occasionally ask her older sister Yves if she had any insight into Berthe's inner life. In another letter, he recounted an evening when he had tremendous difficulty getting Berthe—fourteen at the time—to come in from the garden. She wanted to spend the whole night outside, and it all ended in tears. (Berthe would often refer to that evening with her own daughter Julie.)

There was now something Berthe hesitated to share with Edma, most likely because she knew Edma had already succumbed to some version of it herself: a fascination—or really a kind of intoxication—with Édouard Manet. Berthe was unsure if she was in danger of losing her heart or if it was already too late, but she was undoubtedly under some kind of spell.

The problem, of course, was that Édouard had a wife. He and Suzanne had been married for five years, and they had been together as a couple for much longer than that. But at times Berthe thought their union had something unconvincing about it—a hastily cobbled-together quality not entirely snuffed out by its evident durability. Édouard was always solicitous around Suzanne, and there was real affection between them. But Suzanne was older than her husband and hardly of the same class. (She had originally been employed as a piano teacher by Édouard's parents.) Her French, what's more, was unpleasantly marked, thought Berthe, by the gutturals of her native Dutch.

And then there was young Léon, the shadowy figure who had posed in the background of *The Balcony* and in many other pictures by Édouard. A charming boy, but was he in fact Édouard's nephew, as he was presented in public? Or was he his son? The marriage was a fact. So was the presence of the boy. But the whole situation seemed cloaked in layers of unexplained secrecy.

In any case, the connection between Berthe and Édouard seemed to be deepening. He spoke ever more freely in her company and was responsive to her flirtatious sallies. It was all very diverting, to say the least. Berthe tried hard to channel her energy into less futile activities—above all, into her art. But after spending so much time in Édouard's studio, and especially after Edma's departure, she found herself assailed by insecurities. She was reaching a crisis point. Perhaps all artists were forever insecure, she thought, even those who had tasted success. Even Édouard, for all his audacity. And yet certain artists seemed so adamant, so sure of themselves, so inflexibly devoted to their craft. Ingres was a classic case. She wondered, too, about Édouard's brilliant but prickly friend, Degas. What an enigma! He had an almost acidic air of aloofness. When he did speak, he was prone to cruel put-downs, made crueler by their concision. Ripples of silence sometimes spread out around his words as their meaning settled in. But his otherwise faultless manners failed to conceal deep channels of emotion. Berthe had seen him on a recent Wednesday night at the home of Édouard's friend, the society painter Alfred Stevens, and she wrote to Edma to tell her that he, Degas, had been speaking about her.

"He finds you very strange," she reported. "From several things he said about you, I judge him to be very observing. . . . He came and sat beside me, pretending that he was going to court me, but this courting was confined to a long commentary on Solomon's proverb, 'Woman is the desolation of the righteous.' "

Confusing, perhaps—but to Berthe, not unamusing. Her own intelligence was ironic and mercurial. She liked Degas's quick-wittedness. She mulled over what Edma—powerfully nostalgic for her old life—had written in reply: "You are right, dear Berthe, in all that you say to me. It is disheartening that one cannot depend on artists. My infatuation with Manet is over; as for Monsieur Degas, that is a different matter. For one thing, I am curious to know what he could have to say about me, and what he finds strange in my person. The commentary on the proverb must have been pretty and piquant. You may call me crazy if you like, but when I think of any of these

artists, I tell myself that a quarter hour of their conversation is worth as much as many sterling qualities."

This was newlywed talk, fired by Edma's acute awareness of the erotic possibilities she had so recently renounced. She seemed to acknowledge this as she continued: "I know how you leave your letters lying about, so, once again, burn this one, and continue to write me your gossip, as you call it. I have nothing better to do than to decipher it. Life here is always the same. The fireside, and the rain pouring down."

Being out of Paris, Edma had lost touch not only with the world of art and gossip but with the wider political situation in the capital. Berthe, on the other hand, knew enough of recent developments to feel at once excited and anxious. Napoleon III had been in power for almost twenty years, but things seemed to be coming untethered. Scandals were erupting left and right. The republicans appeared to be gaining the upper hand. It seemed more than conceivable that the regime might finally collapse. The emperor had introduced many liberal reforms—inching toward parliamentarianism, allowing for strikes and limited trade unions, and increasing press freedoms. In some ways, France was now the most liberal country in Europe. But these and the emperor's other attempts to appease his critics had left them unsatisfied. The more he tried to reform his own government, the louder were the voices calling for his regime to end. You could feel something brewing. Manet and Degas were both saying it openly: France would once again become a republic. The Second Empire would one day be no more.

〰 〰 〰

CHAPTER 3

〰 〰 〰

The Execution of the Emperor Maximilian

FOR ALL HIS SOCIAL CHARM AND PAINTERLY FLAIR,
Édouard Manet was a political creature—a passionate republican.
Among his close friends were many journalists, fellow republicans
who had been agitating for change for years. Édouard, whose antip-
athy toward Napoleon III went back two decades, hoped he could
contribute something to their efforts.

Just as Berthe had two sisters, Édouard had two brothers. All
three had fine features and wore beards. Gustave's hair was a lit-
tle darker; Eugène's build was more slender. Both brothers shared
Édouard's antiestablishment leanings and republican convictions.
Of the three, Gustave, trained as a lawyer, was the most outspoken.
He frequented the Café Frontin, known as the "radicals' rendezvous"
(Édouard sometimes went with him) and attended lectures by radical
republicans on the Rue de la Paix. Eugène, although quieter, was also
politically engaged. Their father, the judge, had also been a republi-
can, but his profession and high-ranking position obliged him to be
discreet about it.

In 1848, when a stable republican government had last seemed
genuinely viable, Édouard had been sixteen and at loggerheads with
his father, who was urging him to go into the law. In late February

of that year, Louis-Philippe d'Orléans, France's increasingly unpopular constitutional monarch, was swept from power after two days of street demonstrations. Trees were felled and omnibuses overturned to create barricades in the streets. When shots were fired, the National Guard was called in to quell a crowd incensed at having been fired upon. Many guardsmen rebelled, as did some segments of the regular army. When Louis-Philippe came out to review his soldiers in front of the Tuileries Palace, they failed to cheer him. Many instead shouted "Long live reform!" And like the banks of a river in flood, the king's authority, his dominion, collapsed. He had already survived assassination attempts—including one in 1835 when a bullet from a homemade twenty-five-barrel volley gun grazed his forehead. The same gun killed eighteen people and injured twenty-two. Now fearing for his life, he fled the palace in disguise and, under an assumed pseudonym ("Mr. Smith"), found safe harbor in England.

It was a euphoric time for liberals and republicans. Within weeks, the revolutionary fervor in France spread to other European capitals—first to Vienna and Berlin, then to Baden, Dresden, Leipzig, and other German states. The Prussian Army withdrew from Berlin, Metternich fled Vienna, and power-sharing constitutions were issued in Naples, Piedmont-Sardinia, and Denmark. Venice declared itself a republic; the Milanese rose up against the Austrians, and the Poles against the Prussians. It all happened so quickly, and it seemed so easy. "For politically sentient Europeans," as the historian Christopher Clark has written, "1848 was an all-encompassing moment of shared experience. It turned everyone into contemporaries, branding them with memories that would last as long as life itself." This was true for Manet and for so many of his compatriots. He may have been only a teenager, but he was acutely alive to the potential significance of the unfolding events and permanently inspired by them.

What did Europe's insurgents want in 1848? Constitutions that would allow them representation. Civil liberties—especially freedom from censorship and political repression. Citizen militias—because they didn't trust regular armies. And greater economic opportunity. As for the first French Revolution, a lot of the impetus for the events

of 1848 was, in fact, economic: two bad harvests had led to price rises, a downturn in trade, business bankruptcies, and a credit crisis. As economic disparities widened, the lower classes were haunted by the possibility—which for many had become a brute reality—that one could be employed full time and still live in desperate poverty. But discontent with the Citizen King was also about political philosophy, and the uprising was led, in part, by professional revolutionaries who recalled the French Revolution with residual idealism. They were joined by liberal, middle-class journalists disenchanted with Louis-Philippe's constitutional monarchy. For them, republicanism was, at heart, a fight for democracy against autocracy.

After Louis-Philippe's ouster, a provisional government declared suffrage for all adult men over twenty-one years of age (thereby increasing the electorate from 240,000 to 9 million). Slavery was abolished in France's colonies, and the new government met the unemployment crisis by establishing National Workshops, where workers could perform menial jobs for regular pay, efforts led by Louis Blanc, with support from Armand Barbès. Many, but not all, welcomed reforms such as these. In the summer, elections led to the formation of a moderate government, liberal but orderly, suggesting that the appetite for radical change was not as great as many hoped.

Similar dynamics were at play elsewhere in Europe, as tensions arose between newly formed assemblies and radicals wanting more direct democratic action. Feeling their chance slipping away, the radicals in France, led by Blanc, organized demonstrations, which led to bloody conflicts with the National Guard, still loyal to the government. The radicals marched to the Palais Bourbon, where the new National Assembly was in session. Forcing their way in, they read out a declaration in support of Poland, then surrounded the Hôtel de Ville, proclaiming their own "insurrectionary government." Eventually they were dispersed.

But to guard against a repeat, a Party of Order was established. One of its first actions was to close the National Workshops, which released a million unemployed men back onto the streets of Paris. Mass protests ensued, and barricades were erected. There followed

three days—the so-called June Days—of bloody fighting between socialists and the military. The demonstrators were defeated, three thousand insurgents were killed, and fifteen thousand people were arrested. A new government was formed by the Party of Order, and Blanc, like Louis-Philippe, had to find refuge in England.

The pendulum swung back. As summer turned to fall, counter-revolutions took place in Berlin, Prague, Vienna, and Wallachia. Government troops returned to the big cities, parliaments were shut down, and insurgents were arrested. Radicals regrouped in cities in western and southern France, in some German states, and in Rome, where a Roman Republic was declared. But by the summer of 1849, the Prussian Army had extinguished the last of the popular revolts on its territory, and French troops had snuffed out the Roman Republic, restoring the papacy. Prussia's King Wilhelm steadily and ruthlessly tightened his grip on power, and in Vienna, Ferdinand was replaced by Franz Joseph, his bewhiskered and reactionary nephew, who would rule over his polyglot, far-flung empire until 1916. The revolutions were over.

Gustave Flaubert later made these events the subject of a novel, *Sentimental Education*, published in 1869, on the cusp of a new crisis. Flaubert was no fan of popular revolts. His contempt for human folly and barbarism matched Goya's: "everything traces back to stupidity and the immense human capacity for self-deception." He had put years of work into the novel, so he was bitterly disappointed by its tepid reception. Had its message been heeded, he told friends, the catastrophic events of 1870–71 could have been avoided.

In any event, at the end of 1848, the autocratically inclined Louis-Napoleon—a nephew of Napoleon Bonaparte and a man whom the Goncourt brothers once compared to "a lizard that looks asleep but isn't"—was elected president of France's Second Republic.

ALL THESE EVENTS coincided with a more personal crisis in the life of the teenaged Édouard Manet. He was pondering the problem of what to do with himself. He loved painting. When he was a boy, his mother's brother, Edmond Fournier, had taken him to gal-

leries and museums and paid for drawing lessons. But in his parents' eyes, "artist" was not an acceptable career choice. To placate them, Édouard proposed entering the naval academy, which would provide a viable path into law. He failed the entrance exams, but a loophole allowed him to try again if he went first on a training vessel bound for Rio de Janeiro. And so in December 1848, having watched as a king was overthrown, a republic established, elections held, a radical coup erupted and crushed by a conservative reaction—all within a mile or two of his home—he sailed far from tumultuous France.

The voyage to Rio, during the northern winter of 1848–49, altered Édouard's life. It gave him, most obviously, a taste for ships and the sea (fully a third of his career output would address maritime themes). But his moral imagination underwent perhaps a bigger transformation. Events back in Paris continued to unfold at high velocity, but at sea, time passed slowly. Édouard celebrated his seventeenth birthday on the voyage. In Rio, where he spent three months, he saw things that would affect both his politics and his feeling for justice for the rest of his life. He spent weeks on board the ship without leave to go ashore, but when he did, he witnessed many privations. "All the Negroes are slaves," he wrote to his mother from Rio; "they all look downtrodden; it's extraordinary what power the whites have over them." He saw a slave market, too—a "revolting spectacle." The experience deepened his concern over what was happening back in France.

"With your knowledge of politics, how do you feel about the election of L[ouis] Napoleon?" he wrote to his older cousin, Jules Jouy. "For goodness sake, don't go and make him an emperor; that would be too much of a good thing." "Try to preserve our good republic until my return," he wrote to his father, "for I well and truly fear that Louis Napoleon is not himself much of a republican."

When Édouard returned from Rio, he once again sat the naval entrance exam. It was a last, half-hearted attempt to please his parents and gain entry to the law. But again, he failed. His parents despaired. But Édouard felt as if he had finally been cut loose. On the voyage, he had impressed his shipmates with his artistic abilities. "I have to tell you that I developed a reputation during the crossing," he wrote to

his mother. "All the ships' officers and all the instructors asked me to make caricatures of them. Even the captain asked for one to give his family as a Christmas present." He now resolved to commit himself to painting. Rejecting the idea of studying at the École des Beaux-Arts, he enrolled instead in the studio of the more progressive and unconventional painter Thomas Couture. Couture, an avowed republican who believed strongly in the value of sketching from life, inculcated in Édouard a lifelong habit of sketching that became the equivalent of journalistic note-taking.

ON A COLD, GRAY DAY in December 1851, Édouard found himself sketching dead bodies in a cemetery in Montmartre. He was in the company of fellow art students, all from Couture's studio. His warning about Louis-Napoleon had proved prescient. Three days earlier, building on groundwork he had been laying for years, Louis-Napoleon had instigated a coup d'état that snuffed out, once and for all, the troubled, short-lived Second Republic. Going out into the streets on the day of the coup, Édouard and his friend Antonin Proust had found themselves walking along with protesters. Finding themselves suddenly in the direct path of a cavalry charge, they rushed into a side street where they were stopped, arrested, and detained overnight. They were released the next morning. But for Édouard, it was a wake-up call.

The cadence of events now accelerated again. Making no effort to disguise his authoritarian stripes, Louis-Napoleon cracked down violently on the rebellions that broke out across France. Scores of dissidents—including Victor Hugo, a republican, and Adolphe Thiers, the moderate constitutionalist who was a friend of the Morisots—were either imprisoned or forced to flee. The day after the coup, in a scene foreshadowing the events of 1871, Édouard watched protesters being lined up against a wall and shot. The next day gunshots directed at army troops in Paris triggered a retaliatory massacre of more than one hundred men, women, and children. For this alone, many never forgave Louis-Napoleon.

Couture's response to the upheaval was unexpected. Instead of

canceling classes or confining his students to the safety of the studio, he led his class up the hill to the cemetery in Montmartre. There the corpses of executed protesters and opponents had been laid out on the ground, awaiting burial. With sketchbooks in hand, the students took up positions in front of the bodies.

"Start working," Couture told them.

The students sketched quickly, fighting down feelings of fear and revulsion. Couture kept them at it for hours. Édouard worked especially quickly, his gaze continually drawn to the faces of the corpses. He always remembered, wrote his first biographer, Edmond Bazire, "their sinister look and cold ferocity."

ÉDOUARD HAD JUST TURNED twenty, but he was about to become a father. His own parents had hired Suzanne Leenhoff to teach him and his two brothers piano, a decision they would soon come to regret. Édouard was not especially musical, but he grew fond of his teacher and was soon making clandestine visits to her apartment in Belleville. He was nineteen and Suzanne twenty-two in the spring of 1851, when she fell pregnant. For Édouard's family, this was a major embarrassment—and potentially a scandal—since his father, in his capacity as a judge, routinely oversaw paternity cases. It was imperative that Édouard's "indiscretion" be kept under wraps. The baby was born at the end of January 1852, two months after the coup. Léon, as the infant was named, spent his early years living in Suzanne's apartment, to which Édouard made regular visits. He was closely involved with raising the boy, although Léon was passed off in public as Suzanne's little brother. Only after his own father died, in 1862, did he finally marry Suzanne. For reasons that remain unclear, Léon was never legitimated.

On December 2, 1852, a year after the coup (and on the anniversary of the coronation of the first Napoleon), Louis-Napoleon legitimated his violent seizure of power by crowning himself Emperor Napoleon III. After many setbacks, including a failed coup in 1840, for which he had endured six years in prison, eventually escaping by

disguising himself as a workman, he finally had achieved his heart's desire. But for Édouard, who had believed, with a teenager's authentic sincerity, that France could thrive as a republic, it was a tremendous setback. His dream had been summarily snuffed out.

ONE DAY IN 1867, while Paris was playing host to the exotic splendors and technological wonders of the Exposition Universelle, or World's Fair, Édouard had walked up the hill to the Trocadéro, very close to the Morisot home on the Rue Benjamin Franklin. The whole area beneath him was in the process of being leveled to create the Place du Roi-de-Rome, named for Napoleon I's son, who was Napoleon III's cousin and since birth the King of Rome. This was a case of Napoleon III taking up and adapting ambitious plans his uncle had been forced to abandon more than fifty years earlier. The emperor had recently visited the site with Eugénie to inspect the works.

It was early morning, a warm day in June, already beginning to get hot. Édouard, who was carrying paints and brushes with him, chose a position just above the terrace to set up his easel, to which he secured a large canvas, almost seven feet long and just over three feet high. A few people were holding up umbrellas to fend off the morning sun. There was a patch of lawn and a curving gravel path in the immediate foreground. A gardener was watering the grass, and several people were walking their dogs. Some tourists had risen early to enjoy the view of the exhibition sprawling below; it was the spot all the guidebooks recommended. Filling the vast expanse of the Champ de Mars, once a market garden, then a military parade ground (it is where the Eiffel Tower now stands), the exhibition was like a city within the city. It was laid out in "quarters," its curving streets lined with pavilions and reconstructions of famous sites. Lifting his gaze and looking out beyond the exhibition, Édouard could make out the distant spires and domes of various churches and, farther off, the Butte Montmartre. Much closer to hand, rising high over the Champs de Mars, was Nadar's balloon, tethered to a very long rope that intermittently caught the morning light and seemed almost to disappear.

———

JUST TEN DAYS BEFORE the April opening of the Exposition Universelle, the Champ de Mars had been a sea of mud. The situation was so bad that Napoleon III had been prevented from traveling in his coach to inspect the preparations. That week, with Edma by her side, Berthe had watched from the balcony as five hundred workmen cleared the area around the glass and filigreed ironwork dome—an enormous elliptical structure, fully sixteen hundred feet long—that was the fair's central edifice. An even bigger workforce had brought in equipment, building materials, and exhibits transported in crates from all over the world.

In little more than a week, an astonishing transformation was wrought. Then for several summer months, more than 11 million people thronged to the fair. They streamed around the exhibition grounds and paraded through the main glass structure, which was surrounded by stalls and kiosks as well as mock Incan palaces and Egyptian temples, with men and women from dozens of countries dressed in elaborate national costumes, all speaking different languages. Among the dignitaries and heads of state who visited Paris that summer were the Prince of Wales, the Pasha of Egypt, the Tsar and Tsarina of Russia and the brother of the Mikado of Japan. King Wilhelm of Prussia came with his chancellor, Otto von Bismarck. From his perch in exile, Victor Hugo had contributed an introduction to an exhibition guide, in which he wrote of his hopes for peace and fraternity in a unified Europe, with Paris as its natural capital. The city had never seemed more indispensable or more interpenetrated with the world beyond its walls.

The main exhibition hall had been divided into seven regions. A succession of industrial and military wonders was laid out— everything from a British locomotive to an American field service or "ambulance," developed during the recent Civil War, and a fifty-ton breech-loaded steel gun designed by a Prussian called Krupp. There was a fabulous display of jewelry and a presentation of various model workers' dwellings, one designed by Napoleon III. The emperor knew

that Haussmann's overhaul of the city, even as it improved hygiene and transport, had displaced thousands of workers from their neighborhoods in central Paris to slums on the outskirts; he wanted to be seen addressing the problem.

The presence of Nadar's balloon hovering over the festive scene was a reminder of the day, four years earlier, when a crowd of close to 200,000 had flocked to the same site to see the launch of *Le Géant* (The Giant), an enormous, double-decker balloon built to Nadar's specifications. Inflated with 200,000 cubic feet of gas, *Le Géant* rose to the same height as the towers of Notre-Dame. It supported a two-story wicker cabin divided into six compartments and an observation deck big enough for twenty people. The launch was a triumph—the crowd was astonished—but the initial flight lasted just three hours, so Nadar repeated it two weeks later. This time the public intoxication was enough to bring the emperor and his entourage to the launch site. That created an acute dilemma for Nadar: he was a committed republican who had publicly mocked the emperor in his political cartoons. Desperate to avoid an awkward meeting, he hid for as long as possible in the service hut next to the balloon. Eventually coaxed out by friends, he greeted the emperor with a polite *"Je suis M. Nadar."* After a brief chat about heavier-than-air flight, Nadar and his wife Ernestine, who was also on board, readied for the launch.

Le Géant was cast off and began to rise. *"Bon voyage, Monsieur Nadar!"* called out the emperor. Sixteen hours after its launch, the balloon came to a halt in Prussia. During its traumatic descent, the balloon bounced "like a crazed comet" along the ground for several miles, ripped up telegraph poles, narrowly avoided a collision with a train, and tore through a farm. Finally it plowed into a forest, in the process dramatically ejecting all its passengers, one after the other, ending with Ernestine and Nadar.

Since then Nadar's interest in ballooning had waned, but he was deeply in debt. So at the 1867 Exposition Universelle, he decided to charge visitors for the privilege of riding in a tethered balloon over the fair, a dozen at a time. Édouard was happy to see his friend back

in the public spotlight, where he belonged by temperament, and he made sure to paint the balloon into his canvas.

UP BY THE TROCADÉRO, Édouard set out his palette and paints and picked out a brush. Conscious of the changing light, the gathering heat, he worked quickly. His touch was loose but sure. After an hour, all the main elements were in place. He was trying to stay focused on what the canvas needed next, but there were so many distractions. Several passersby muttered unasked-for or inaudible comments. That didn't help. But in truth, Édouard's ability to concentrate had become a problem lately. He was uncharacteristically morose. His close friend, Baudelaire, was on his deathbed. He was haunted by the demise of such an influential companion and extraordinary mind. Édouard, meanwhile, was struggling with a sense that whatever he ventured forth was destined for failure. He continued to feel that he could justify his decision to pursue art (instead of the law, as his parents had urged) only by achieving a popular success at the Salon. Although he had made a gratifying splash six years earlier with *The Spanish Singer*, in the intervening years his best efforts had received more ridicule than praise.

One of the most ambitious components of the French section of the fair was a display of more than five hundred paintings and sculptures by the nation's most celebrated artists. This massive exhibition, like the annual Salon with which it coincided, included works by the academic painters Ernest Meissonier, William Bouguereau, and Jean-Léon Gérôme—but nothing by Manet. His exclusion from both exhibitions was demoralizing. When, back in the spring, news of his omission was confirmed, he'd been incensed. He decided that, if he couldn't count on any official support, and if, as a result, no one would be able to see his work, he would have to mount his own exhibition. In this, he was following a precedent set by the artist Gustave Courbet.

REGARDED IN HIS TIME as the father of Realism, Courbet had turned forty-eight in the summer of 1867, so he belonged to the generation ahead of Édouard, who was thirty-five. But among progressive-

minded painters agitating against entrenched institutional structures, Courbet had been the trailblazer. Early in his career, he had endured repeated rejections by the Salon jury. But these experiences only increased his contempt for officialdom and for the art bureaucracy, which he criticized with ever-increasing stridency. Courbet believed passionately in the liberating potential of art. His family was the foremost in Ornans, in the Franche-Comté region in eastern France, where his father owned huge tracts of land. Courbet had spent his privileged childhood traipsing through the countryside sluiced by waterways that, over the millennia, had gouged out caves and carved cliffs. Well educated, he was nonetheless proudly provincial, and he brought a crude and ruddy vigor to his dealings with the art world. He made it his mission to shake up Parisian assumptions of cultural superiority. Édouard, of course, had no such impulse. The scion of a respected Parisian family, he didn't just identify with the capital—he epitomized it. So although both painters were boldly innovative, Courbet's rustic Realism was the antithesis of Édouard's urbane style, which mingled journalistic factuality with varieties of irony, poetry, and play.

Once slim, Courbet had lately grown stout, but he was tall and had a distinctive beard that jutted out from his chin like the branch of a fir tree. He cultivated an aura of cloddish authenticity, but he was much savvier than he let on. A dedicated follower and friend of the anarcho-socialist Pierre-Joseph Proudhon, he cast himself as a man of the people. As an artist, he was genuinely bold. A run of spectacular, attention-grabbing self-portraits—as a wild-eyed desperado, as a wounded hero—suggested that he also had an unassailable sense of his own worth. His first artistic breakthroughs had occurred in the aftermath of 1848. That revolutionary year he had forged a sense of himself not just as an observer but as a political player, a participant. He painted everything—still lifes, portraits, and scenes of rural labor, all in the gritty, Realist style he had single-handedly pioneered. Almost two-thirds of his output was landscapes, and every Courbet landscape is a statement of pride, fierce and tender, in his native Franche-Comté region. Favoring dark, massy tones (the American painter Childe

Hassam once compared them to "molasses and bitumen"), he showed women with rolls of fat and dimpled flesh and painted laborers and country folk, like an honest bricklayer using the flat side of a palette knife to obtain layered effects that loosely approximated textures in nature—rough stone, for instance, or shimmering leaves.

On the one hand, rural themes and painterly *terroir* were precisely what Édouard wanted to get away from. He loved light—and even more, he loved the idea of painting with a light touch. Yet he was conscious of everything Courbet did and sympathetic to the older painter's republican politics. He watched with interest as Courbet demonstrated how to use publicity—and a pinch of controversy—to attract attention. Thwarted by the Salon, Courbet had set out to find new ways to build a market. ("If I am making art, he wrote to Théophile Gautier in 1846, "it is first of all to make a living from it.") He was as effective a self-promoter as Nadar, and he knew how to use abrasive and scandalous behavior to his advantage. "I will be so outrageous," he wrote to the critic Francis Wey, "that I'll give everyone the power to tell me the cruelest truths. You see I am up to it. Do not think this is a whim. . . . It is a serious duty, not only to give an example of freedom and character in art, but to publicize the art I undertake."

Courbet, in other words, was an agitator—a proud republican and provincial willing to speak truth to the calcified hierarchies of power in Paris's art world.

As the 1855 Exposition Universelle neared, Courbet submitted several of his paintings to the jury that was selecting the art. They accepted some of them but rejected his two most ambitious works, *A Burial at Ornans* and *The Atelier.* Courbet withdrew the paintings they had accepted and put a selection of them, along with the two enormous paintings they rejected, on display in a temporary pavilion that he had built at his own expense opposite the entrance to the fair on the Avenue Montaigne. He called the show, which amounted to a career survey, *Du Realisme.* He advertised with posters pasted all over Paris and charged an admission fee of one franc. (It was the same fee charged

by the fair itself, where five thousand works were on display, including retrospectives devoted to Delacroix and Ingres.) He also made photographic reproductions of his paintings—early versions of postcards.

Courbet's exhibition was not a success. Very few people saw it, and he lost a lot of money. But he had demonstrated that it was possible for artists to extricate themselves from official channels and market themselves as independent artists. It was a lesson Édouard didn't forget.

TWELVE YEARS LATER, with money borrowed from his mother, Édouard paid for the construction of a pavilion outside the entrance to the 1867 Exposition near Pont de l'Alma. It would display his own solo exhibition. He chose fifty original paintings, three painted copies of Old Masters, and three etchings. For the accompanying pamphlet, his new friend Émile Zola—who had just written his third novel, *Thérèse Raquin*, a spectacular and best-selling tale of adultery and murder—wrote a polemic on Édouard's behalf. The exhibition was Édouard's chance to show who he really was—to give those who had been prejudiced against him a true idea of his range and, above all, his sincerity. It was an opportunity to kill the public caricature, to present himself afresh.

Alas, the enterprise backfired. Although visitors arrived in decent numbers, it seemed they came primarily to laugh. Sales were pitiful. Despite charging admission, he found himself losing 150 francs a month. And the response in the press brought no comfort. One or two critics wrote nice things. Since more than half of the paintings were of Spanish-related subjects, one critic had thought to describe Manet as "a Velázquez of the boulevards," which pleased him greatly. But other critics compared him unfavorably and (he felt) erroneously to Courbet who, having been excluded from the current Exposition Universelle, had set up his own pavilion for the second time. Attracting bigger crowds and a more positive reception, Courbet's pavilion cast Manet's in its shadow. Édouard, meanwhile, was now deeply in debt to his mother, who was losing patience with her quixotic son.

———

AT TEN O'CLOCK on that June day in 1867, Édouard put his brushes down, packed up his paints and palette, and after letting the paint dry out a little, headed back to his studio, where he planned to work his sketch up into a finished painting. He never did. Instead, that day or the next, he got wind of an event in far-off Mexico that was so upsetting to him—so horrific, in fact—that he dropped everything to embark on the most ambitious campaign of his career.

The news coming out of Mexico in June 1867 appeared to Manet as the culmination of a disaster that had been unfolding in that country for the best part of a decade—a disaster for which Manet believed Napoleon III bore complete responsibility. Manet did not yet know the scale of the catastrophe; nor could he guess at how it would play into the bigger disaster to come. But without falling afoul of the censors, he wanted to paint something that would make Napoleon III's culpability, his moral rot, blatant.

Mexico had been lurching from crisis to crisis for much of the nineteenth century. The country had valuable natural resources, which made it alluring to the United States, a constant threat to its north, and by 1860 there was a feeling in France, matched in Britain and Spain, that Europe's great powers should move to intervene. Debt was a persistent problem for Mexico, so when the liberal, republican president Benito Juárez dared to declare a moratorium on payments to its European debtors (the interest alone amounted to more than two years of national income), Napoleon III had the pretext he sought. In 1862 his army led a coalition of ten thousand Spanish, British, and French troops to Mexico to force repayment. The timing of the move was opportunistic: America's Civil War had removed it from the geopolitical equation. But France had grander designs on Mexico than mere debt repayment: Napoleon III wanted to make of it a client state that would do his bidding.

When this became clear, the Spanish and British tactfully withdrew, while the French marched on to Mexico City. On May 5, 1862—marked today as Cinco de Mayo—they suffered a humiliating,

now storied defeat at Puebla, southeast of Mexico City. Eight hundred French troops were reported as killed, missing, or wounded. Back in Paris, government censors tried to contain the news but failed, and Napoleon III now had to appease a divided public. Some wanted the troops to return home; others were calling for reinforcements—and revenge. Napoleon III chose revenge. He sent more troops, and by March 1863, the French had Puebla under siege. Mexican resistance nonetheless continued.

The frustrated French emperor was getting in too deep. He was close to calling off the whole misconceived adventure when his forces finally achieved a breakthrough. Juárez was forced to flee to the north, and the French general François Achille Bazaine (later to play a villainous role in the 1870 war with Prussia) entered Mexico City, where he established a provisional government.

In Paris, there were festivities and celebrations. But Napoleon III knew that entering the Mexican capital did not mean his problems were over. Searching for a path to longer-term stability, he settled on what he hoped would be a viable solution. He offered the title of Mexican emperor to Archduke Maximilian, the liberal-leaning younger brother of Austria's Franz Joseph. Reluctant at first, Maximilian and his wife Charlotte, the daughter of Leopold I of Belgium, were given flimsy guarantees, but they decided to accept the new role, and in June 1864 they arrived in Veracruz.

That same month two American ships on opposite sides of the U.S. Civil War had crossed the Atlantic toward France, and on June 19 a dramatic naval battle took place off the coast at Cherbourg. A Confederate sloop of war, the CSS *Alabama*, had docked at the port of Cherbourg for repairs; as soon as it left French territorial waters, it was engaged in battle by the USS *Kearsage*, an ironclad steam sloop of war on the Union side. From the cliffs above Cherbourg, hundreds of excited onlookers watched the battle, which ended with the sinking of the *Alabama*. Manet was not among them, but he read the eyewitness reports, and with his distaste for slavery and love of republicanism, he was alive to the momentousness of what was going on across the Atlantic. Fired by memories of

his own earlier voyage to Rio, he decided to paint the battle, basing his composition on news reports.

Back in Mexico, Maximilian's reign began promisingly. He appointed a liberal ministry and—against expectations—continued many of the policies of the ousted Juárez. He and Charlotte (or Carlota, as she became known) adopted two children, the grandsons of a previous Mexican emperor. But Juárez had not gone away. In fact, he had established an opposition government in Chihuahua, in the north. And in the summer of 1865—the year of *Olympia*'s showing at the Salon—the Americans, whose Civil War had just ended, lent him support by establishing a blockade to prevent French reinforcements. As Maximilian's rule became increasingly wayward—draconian in some instances, permissive in others—Juárez's guerilla forces won a series of victories.

THE CONFLICT, WHICH HAD already turned into a quagmire, now threatened to become something much worse. Back home the campaign in Mexico was increasingly unpopular, so finally, on January 15, 1866, Napoleon III informed Maximilian that he was going to withdraw French troops—something he had been hinting at for over a year. The decision left Maximilian's government utterly vulnerable. In fact, for Maximilian and Carlota, it was effectively a death sentence, as Carlota surely knew. She rushed to Europe to plead for help on her husband's behalf. She began with Eugénie and Napoleon III, but they were both unyielding. With brutal frankness, Napoleon III told Carlota that he saw Mexico as a lost cause and urged her to persuade Maximilian to abdicate.

As she hurried on to her next high-level meeting, Carlota became increasingly frantic and paranoid. On her way to Rome to plead with Pope Pius IX, she was convinced that Napoleon III had sent assassins to murder her. During her audience with the pope, she broke down, reiterating her conviction that there was a plot to poison her. In response, the pope took the extremely rare step of allowing a woman to stay overnight in the Vatican. Day by day, Carlota's condition worsened. With her mind unraveling, she was taken to Miramare Cas-

tle, on the Adriatic coast near Trieste, and, on a psychiatrist's advice, placed under house arrest.

Meanwhile, in Mexico, her husband's situation came to a head. On February 5, 1867, French forces withdrew from Mexico City, and a month later they left the country entirely, departing from the port of Veracruz. Maximilian, along with his two top generals, Miramón and Mejía, went to Querétaro, northwest of Mexico City, to confront Juárez's forces, which now laid siege to the town. The siege of Querétaro lasted two months, ending when a betrayal allowed Juárez to enter the city and force the foreign emperor's surrender. Maximilian and his two generals were charged with treason.

In Europe, the public followed Maximilian's fate with dread and disbelief. Queen Victoria and Victor Hugo were among the many powerful voices who wrote to Juárez, trying to persuade him to spare Maximilian's life. But their efforts failed. As Europe gasped and Carlota lost her mind, the trio, on June 19, 1867, were put before a firing squad. The order to fire was given, but horrifically, when smoke from the fusillade dispersed, it became clear that two of the victims, including Maximilian, were still alive. One of the generals, still standing, arms flailing, was finished off by a shot in the ear. The NCO then took up position over Maximilian's fallen body in order to deliver the coup de grâce. But he somehow bungled the job, and flames from the misdirected shot ignited Maximilian's vest. Water was thrown on his torso to extinguish them. Two more attempts failed because the rifles misfired. The NCO, nervous and upset, finally ended the emperor's life.

Napoleon III's censors tried to suppress the news, but new morsels of information kept leaking out, and as they did, Édouard burned with ever greater indignation. He knew that to depict Maximilian's execution would be to court serious trouble, but he was not deterred. In fact, having set aside his depiction of the Exposition Universelle—a canvas that now almost felt like an endorsement of Napoleon III's cynical, spectacle-loving Paris—he embarked on what he intended as his most trenchant indictment of the regime.

Édouard spent more than a year on the Maximilian project. It

was a sustained, impassioned painting campaign, unlike anything he'd attempted. But the Maximilian paintings were not just a critique of Napoleon III; they were a continuation of Édouard's fascination with political violence and death—a fascination informed partly by Goya but also by what Édouard had witnessed as a young art student during the political convulsions of 1848–51. All the paintings in his Mexican series showed the execution. and all were inspired, as would be *The Balcony*, by Goya. Édouard imagined something on the scale of history painting—the highest on the hierarchy of categories acknowledged by the Salon (above portraiture, genre painting, landscape, and still life, in that order)—but updated to the very recent past, like journalism—and painted, of course, in his own distinctively modern style. He didn't want to editorialize. He didn't want to appeal to sentiment or pathos. But he was determined to show what had happened.

Édouard worked on the first two versions over the winter of 1867–68. He was nervous about it. As would happen with *The Balcony*, he kept changing his mind about the composition, partly in response to new information coming out of Mexico. He abandoned both early versions after about four months' work. He then made a lithograph, followed by an oil sketch and a final painted version in 1868–69. As he worked, he had Goya constantly in mind. His Spanish predecessor had witnessed extrajudicial killings, among other atrocities, during the Peninsular War.

Charles Yriarte's monograph on Goya, published the previous year, included a reproduction of the Spanish master's terrifying depiction of a nighttime execution, *The Third of May 1808*. Édouard had seen this painting two years earlier on his visit to the Prado. Seeing the reproduction in Yriarte's book (which also included the *Disasters of War* etchings) renewed his fascination. At least two in Goya's *Disasters of War* series depicted victims who were about to be summarily shot by firing squads. Inspired by Goya's composition in the etching "And there is no help!," Édouard tried to convey the horror not only of the moment just before Maximilian's death but the moments on either side. In two of his four versions, he was brazen enough to

give the Mexican soldiers French uniforms, and in another version, he gave one member of the firing squad a face closely resembling Napoleon III's—making absolutely clear his belief about who bore responsibility for the debacle.

This was too much for the imperial government. Napoleon III had lately been talking about relaxing censorship—within limits. ("To those who might regret that larger concessions have not been made to liberty," he said, "I would answer: Liberty has never helped to found a lasting political edifice, it can only crown that edifice when time has consolidated it.") Édouard's depictions of the Mexican fiasco clearly went beyond those limits and were duly censored. He was "unofficially informed," according to one report, that his painting "would have every likelihood of being rejected at the next Salon, if he insisted on presenting it." Meanwhile the lithograph he made from the same composition, hoping it would circulate more easily, was expressly banned. Zola responded to the censorship, in a piece published in *La Tribune*, noting sarcastically that if Manet wanted a success, he should have shown "Maximilian alive and well, with his happy, smiling wife at his side. Moreover, the artist would have to make it clear that Mexico has never suffered a bloodbath and that it is living and will continue to live under the blessed rule of Napoleon III's protégé."

Baudelaire, whom Édouard was mourning as he embarked on these paintings, had once called for criticism to be "partial, passionate, and political." Manet's paintings based on the events in Mexico were all three. But those events seemed far away, across the Atlantic Ocean. Édouard couldn't know that Paris itself would soon be besieged, then drenched in the blood of its own inhabitants.

W W W

CHAPTER 4

Ⓜ Ⓜ Ⓜ

Studio in the Rue de la Condamine

TOWARD THE END OF 1869, BERTHE'S ENERGY REACHED A low ebb. As the pillars holding up Napoleon III's Second Empire began to wobble, she admitted to Edma feeling profound lassitude and self-doubt. She was overcome, she wrote, by "an insurmountable laziness." Everybody reproached her, she complained, but she lacked "the strength to react." Her parents felt helpless. It pained her father to see Berthe's "poor little face bewildered and dissatisfied over a fate about which we can do nothing," wrote her mother. She was relieved when Berthe left Paris to visit Edma over the summer.

The various threads of Berthe's predicament seemed to be flexed against each other in a self-tightening knot. She missed her sister; yet she envied her sister. She felt pressure to marry; yet she wished not to marry, knowing it would likely derail her artistic ambitions. She was enthralled and inspired by her new acquaintances, Manet and Degas; yet she felt diminished in their company. Their talents were so glaringly evident, their audacity daunting, it was difficult not to feel a degree of inadequacy.

The problem was, she was in love with Édouard. His company was so intoxicating, she craved more time with him. She was fond, in fact, of his entire family. The brothers' political views intrigued her.

They seemed strangely in accord with Manet's painting: bold, clear-sighted, unabashed. Their attitude was such a contrast to her parents' reflexive caution.

Over the winter, Berthe had decided to move away from landscapes and concentrate instead on portraits and interiors. She was in awe of Degas's draftsmanship and wanted to emulate some of Manet's painterly brio. She was also still thinking about Frédéric Bazille's beautiful depiction of a woman in a pink-and-white-striped dress admiring the view over the town on the outskirts of Montpellier. Of course, it was one thing to register what she liked and wanted to do, quite another to carry it out on the canvas in front of her. There were days when she felt enfeebled. She was a woman, a daughter, a (she hated to say it) spinster—*une vielle fille*. If part of her identified with Shakespeare's heroines and was ready to do something wild and unexpected, she was also a realist. She had no desire to upset her family, whom she loved and whose hard-fought, grown-up, worldly wisdom she saw great sense in. In any case, if she loved Édouard, it was wasted emotion; she could do nothing about it. When they were together, they talked about painting. Édouard had praised her painting of the harbor at Lorient so effusively that she presented it to him as a gift. She also gave him a portrait she had made of Edma. He confused her by praising it and at the same time saying it could be improved with a bit of retouching, which he convinced her to do. She thought he was probably right.

MEANWHILE SHE HAD TO WATCH as Édouard grew closer and closer to Eva Gonzalès, a young painter who had recently become his student. Gonzalès had only just turned twenty. Her father was a novelist and journalist, her mother a musician. She was a dark beauty of Spanish descent, which, in the eyes of the hispanophile Manet, put her one step above Berthe, who merely *looked* a bit Spanish (or so Berthe mused). For months now, Édouard had been working on a large-scale portrait of Gonzalès. It showed her at the easel in the act of painting a still life. Gonzalès wears a flowing white dress. A white peony—peonies were Édouard's favorite flower—has been cast

on the floor at her feet. At the same time, Gonzalès was hard at work on her own painting, based on Édouard's *The Fifer*. Both paintings, Édouard's and Eva's, would be displayed at the 1870 Salon. Meanwhile Édouard was painting another, smaller picture of Gonzalès at the easel, this time with a young man in a Spanish costume seated at the edge of a table beside her.

Why, Berthe wondered, did Édouard present Gonzalès in the act of painting, while she, Berthe, a much more experienced artist who had shown several times at the Salon, merely posed for him, passively? Concerned by her lassitude, the people around Berthe tried to haul her out of her despondency. But the situation was awkward. Gonzalès had "all the virtues, all the charms," wrote Madame Morisot, displaying wry maternal fatalism on her tortured daughter's behalf. Édouard, meanwhile, appeared heedless. Digging in to Berthe's vulnerability, he held up Gonzalès as an example for her to follow. "She has poise, perseverance," he told her (in Berthe's account of the conversation to Edma). She was able "to carry an undertaking to a successful issue." Berthe, meanwhile, felt creatively barren.

Edma returned to the family home in Passy from Lorient, where she had been feeling alone and "at the end of the earth." She was huge with child by now, even as Berthe—exercising perverse control over at least one part of her life—had lost more and more weight. The sisters were revived by each other's company, and there was joy and relief in the house when Edma gave birth to a baby girl. But then, in the middle of winter, Edma returned with the baby to her husband in Lorient, and Berthe sank into a full-blown depression. "I do not think Berthe has eaten half a pound of bread since you left," Madame Morisot wrote to Edma. "It disgusts her to swallow anything. I have meat broth made for her every day."

BY THE BEGINNING OF 1870, Édouard's confidence was on the rise again after the frustration of his money-losing pavilion outside the 1867 Exposition Universelle, the anticlimax of his Maximilian campaign, and the poor reception given *The Balcony* the previous summer. (Describing the latter as "uncouth," Albert Wolff, the art critic

who seemed to enjoy his role as Édouard's nemesis, had lamented that Manet appeared to be lowering himself "to engaging in competition with house painters.") All this he had put behind him.

Still, the year got off to a bad start. After an unkind review by Edmond Duranty in *Paris-Journal*, he had felt obliged to challenge the writer to a duel. The cause was trifling, but Édouard was furious. He had only recently fallen out with Degas over Degas's double portrait of him and Suzanne—the canvas Manet had slashed with a knife. Since Duranty was very much Degas's man, his mouthpiece, there was some buried tension there. But it was also true that Édouard's republican blood was up, and he likely had at the back of his mind the recent public tumult around the death of Victor Noir at the hands of Prince Pierre-Napoleon Bonaparte. The prince, a nephew of the first Napoleon Bonaparte, was Napoleon III's cousin. He had once been an avowed (and unlikely) republican, who strongly disapproved of his cousin's 1851 coup, but the self-appointed emperor had since won him over.

On the penultimate day of 1869, a Corsican newspaper loyal to the regime published a letter from Pierre Bonaparte defending his uncle (the first Napoleon) from attacks in a radical republican paper, *La Revanche*. Pierre Bonaparte's letter called the staff of *La Revanche* cowards and traitors. In response, allies of the *Revanche* staff at *La Marseillaise*, a republican paper in Paris run by Paschal Grousset and Henri de Rochefort, demanded satisfaction. Grousset sent two seconds, one of them Victor Noir, to Pierre Bonaparte's home near the Bois de Boulogne, where they presented the prince with Grousset's letter and challenged him to a duel. The prince declined the duel, dismissing the two men as "menials." When Noir protested, a scuffle ensued, with one or the other (the facts were disputed) slapping his adversary with a glove, whereupon Pierre Bonaparte shot and killed Noir.

When news of the killing hit the press, it caused an enormous uproar. Rochefort, who had been the editor of the banned radical republican newspaper *La Lanterne* before establishing *La Marseillaise*, delivered an indignant speech, and the revolutionary socialist Louis-Auguste Blanqui led a protest that was all but obligatory for every

republican to attend. A crowd of 100,000 took part in the funeral procession in the most emphatic display yet of opposition to Napoleon III's regime. All this excited Édouard, the more so since his own recent attempts at protest had fizzled.

The events were still fresh when Édouard spotted Duranty at the Café Guerbois. The Guerbois consisted of two long rooms joined end to end. The walls in the first were white with gilt trimmings. The space was made to feel larger by scattered mirrors. The second room had low ceilings and was always dense with smoke. Long rows of columns obscured the sightlines of patrons, who ducked in and out of view as they played billiards at one of the five tables placed all in a row or lounged on banquettes.

Édouard walked up to Duranty and slapped him with his glove, whereupon the two men, following custom (though with scant conviction), settled on a duel. Having designated Zola as his second, Édouard spent the day before the duel scouring the city in search of an appropriate pair of shoes. "I can't tell you what trouble I went to to find a pair of really broad roomy shoes in which I would feel quite comfortable," he wrote to Antonin Proust. He finally found a pair in the Passage Jouffroy, but he worried, he joked, that the soles were so springy that his sword thrusts might pass over Duranty's head. The duel was fought—a bungled affair, all clumsiness and clattering metal—and honorably called off when Duranty was struck lightly in the chest. Édouard was driven by lighthearted remorse to offer his new shoes to Duranty. They didn't fit, and the two men were quickly laughing over the absurdity of it all.

Édouard was feeling optimistic, by now, about the wider political situation. Significant liberal reform, at the very least, was in the works. Before long, they might even see a regime change. In the fall of 1868, Proust had introduced Édouard to Léon Gambetta at the Café de Londres. The two men had hit it off. Gambetta was young but clearly brilliant. He was also, like Édouard, congenial company, and his enthusiasm for the republican cause was infectious.

Édouard was beginning to feel vindicated, too, in his artistic pursuits. Having a student had been good for his ego—he had been

teaching Gonzalès for almost a year. Zola had meanwhile dedicated his latest novel, *Madeleine Férat*, to him—a notable compliment. And Édouard knew that a group portrait by Fantin-Latour, intended as a tribute to his influence on the circle of progressive painters over the course of the 1860s, would be displayed at the upcoming Salon. Fantin's picture showed Manet seated before his easel—an esteemed master surrounded by admiring students. The acolytes, in this case, were Otto Scholderer (a German follower of Courbet who had lately turned his attention to Manet), Pierre-Auguste Renoir, Zacharie Astruc (the critic, artist, and poet), Émile Zola, Edmond Maître, Claude Monet, and Frédéric Bazille.

Sensing that his name was beginning to carry some weight, that his originality was finally being recognized, Édouard ramped up his efforts to change the composition of the Salon jury, hoping to make it less conservative, more amenable to the new painters. He fired off manifestos and sent letters to whomever he thought he might influence. He was no longer a lonely maverick; he was the unofficial head of a new school, a new way of thinking. People were coming around.

FRÉDÉRIC BAZILLE, ONE OF Manet's most exceptional protégés, was inordinately tall. You can see how almost freakishly he towered over his friends in a painting he made of his studio early in 1870. Mischievous, loose, and very much intended for an in-crowd, the picture was Bazille's answer to *A Studio in the Batignolles*, the homage to Manet that Fantin-Latour was simultaneously painting for the Salon. Bazille worked on his more private picture, in fact, between sittings for Fantin. But his group portrait is different. It's as much about the studio as its occupants. The large room's atmosphere is gorgeously informal, as of a convivial share house occupied by college students—students, in this case, who just happened to be writing a bright new chapter in the history of art. It includes a piano, a pink sofa, a red armchair, a stove, and an easel, all casually arrayed around a large room with a smooth gray floor. At the far end of the studio an enormous floor-to-ceiling window, almost half of it obscured by a semitranslucent black curtain, lets in gray Parisian light. More than

a dozen paintings, framed and unframed, many (poignantly) Salon rejects, hang on the wall or are stacked on the floor in a corner. The figure on the right, playing piano beneath an unframed still life by Manet, is Bazille's dear friend Edmond Maître. It's unclear who the figures at far left are, but they are probably Renoir (with whom Bazille shared the studio) and Monet (who was close to both). Standing at the easel at the back of the room are Astruc, whom Manet had painted in 1866, and Manet, the only one of the group wearing a hat. The implication is that he has just popped in, like a visiting professor deigning to share his wit and wisdom—but perhaps will not stay for too long.

The sixth figure, almost entirely obscuring the framed painting on the easel, is Bazille himself. Even leaning slightly against the canvas's frame, with one leg propped on the easel's base, he is more than a head taller than Astruc and Manet. The painting on the easel is his. But according to Bazille, it wasn't he who painted himself into the studio picture. It was Manet. He had simply picked up Bazille's brushes, in front of all the others, and—as a gesture that Bazille read not as condescension but as a sign of friendship and esteem—painted in the rangy figure, in effect painting Bazille into his circle of friendship.

BAZILLE'S STUDIO PAINTING was at once a low-key protest picture and a pledge of loyalty to Manet—a salute to the little band of striving painters who were inspired by his example. The studio, his fifth in as many years, was on the Rue de la Condamine in the Batignolles district, close to Édouard's home and studio and to the Café Guerbois. Bazille had recently begun showing up at the Guerbois, along with—more intermittently—his friends Monet, Cézanne, and Renoir. All were a little in awe of Manet.

At the beginning of 1870, Bazille had just turned twenty-eight, Renoir was about to turn twenty-nine, and Monet had turned twenty-nine the previous November. None of these future "impressionists," as they were to be labeled, were clear about where they were going or how best to proceed. They knew they didn't want to paint like Alexandre Cabanel or Jean-Léon Gérôme or Meissonier or Bouguereau or any of the other artists who won plaudits (and a healthy market)

at the Salon by painting flawless, fantasy nudes and finely detailed historical scenes, building up illusions of three-dimensionality with imperceptible shifts in tone and exquisitely modulated highlights. All this they found saccharine, artificial, and totally out of touch. Light, and the way it fell on bodies and things, was what interested them. Where artists who thrived at the Salon exerted total control in the carefully managed circumstances of their studios, Bazille and his friends wanted to take their easels outside and let natural light into their paintings, to show real people and landscapes as they looked to sincere, unbiased eyes.

Their two chief role models were Courbet and Manet. Both opposed the imperial regime's dead hand on the arts and provided, albeit in different ways, examples of how to forge ahead in the face of hostility. Like Manet, these younger painters also admired Delacroix, who had died in 1863. (A few years earlier, Fantin-Latour had painted *Homage to Delacroix*, a group portrait that included Manet, Duranty, Whistler, and Baudelaire.) But they also adored the landscapes of Camille Corot and Charles-François Daubigny. They paid heed to all these older painters' lessons about light, color, movement, and brushwork, but they wanted to push things further. So they painted with bright palettes and a light, efficient touch, keeping the subtle, intermediate tones required for conventional modeling to a minimum. That way the finished products looked vivid but comparatively flat, like a landscape seen with only one eye. For now, since they were aiming for inclusion in the Salon, they continued to work up their paintings in the studio, but they wanted to preserve and even emphasize the light and atmosphere they had recorded outside.

So a minor irony was implicit in Bazille's studio painting. He and his friends actually wanted to break out of such studios, to make their canvases convey a more truthful, unfiltered response to the world. Of course, it was not always clear to them when their efforts qualified as finished and fit for public display and when, on the other hand, they failed to rise above the level of sketches. And for as long as this remained an open question, Salon juries were unlikely to take their bolder efforts seriously. This was a problem: commercial galleries were

very few, so success at the Salon was still the only realistic way to build a reputation that could lead to sales and a sustainable career.

The art establishment's conservatism was not just an aesthetic matter. It bled into the wider political situation. The painters in Manet's circle were almost all republicans. And since their few champions in the press—people like Zola and Duranty—were also, for the most part, ardent republican journalists working for openly republican publications (many of them subjected to censorship), the art establishment inevitably associated these new painters with opposition to Napoleon III's regime.

IN THE SPRING OF 1865, as if to demonstrate his devotion both to Manet and to natural light, Claude Monet decided to produce an enormous "manifesto" painting that he would call *Luncheon on the Grass*. It was a deliberate nod to the scandalous Manet painting exhibited at the Salon des Refusés two years earlier. But where Édouard's painting, showing a naked Victorine Meurent seated between two clothed men, was patently fictional, Monet's *Luncheon on the Grass* was straightforwardly naturalistic. It showed fashionably dressed young men and women (the figure at the far left is Bazille) enjoying a picnic in a forest glade. But it was painted so roughly, and with such desultory attention to details of modeling and facial expression, that it left many doubting Monet's judgment. Courbet was also among the picnickers depicted by Monet. Keen, perhaps, to see the extent of his influence on the younger generation, he came to the studio to inspect it, and his response was positive. But Monet, at this point, was so broke that he was forced to abandon the painting. Unable to pay his rent, he offered the painting to his landlord as security. When he later redeemed it, it was in such poor condition that he cut it up, hoping to salvage at least the main section.

While visiting the shared studio, Courbet also found a moment to offer some words of encouragement to Bazille. Frédéric Bazille was from a well-off Protestant family in Montpellier, in southern France. His father was an agronomist and winegrower (in 1868, he had co-discovered phylloxera), his mother an amateur musician. The town-

house next to his parents' home was owned by Alfred Bruyas, the industrialist and collector who had been a longtime supporter of Courbet. When Bazille, still a teenager, saw Bruyas's collection in the salons of the Hôtel Plantade, the work that leaped out at him was Courbet's *The Meeting*. The painting—known also as *Bonjour, Monsieur Courbet*—depicts the chance encounter, at a turn on a country road, of Courbet, Bruyas, and Bruyas's servant, Calas. What's interesting about the encounter—and Courbet's decision to paint it—is that the artist clearly thinks himself socially on a par with the wealthy industrialist. Wearing a white shirt and light blue pants, Courbet carries on his back a folding easel and everything he needs to paint directly from nature. His confidence—his blustery ability to cast painting as a noble endeavor—was part of what drew Bazille to the painting. But he was also intoxicated by what he described as the painting's "charm of light" and "flame of exhilaration." When later he took up painting himself, the challenge of showing believable figures in outdoor light (as opposed to effects of light concocted back in the studio) became his overriding obsession.

Bazille's parents had wanted him to become a doctor, but his interest in medicine, never very strong, faded, and in 1862 he persuaded them to let him move to Paris to pursue art alongside his medical studies. Everything then happened with bewildering speed. He joined the studio of the painter Charles Gleyre, whose students already included Renoir and Alfred Sisley. When, the following year, Monet joined them, he and Bazille became close friends. They went together to Fontainebleau—famous as the territory of the Barbizon landscape painters—and the following spring they went to Normandy. At this stage, Bazille was still equivocating about his medical studies, despite Monet pestering him to get serious about painting. But by the end of 1864—which was also the year he met Manet—Bazille and Monet were sharing a studio. Bazille painted the studio's interior almost as soon as he moved in, making sure to include loosely sketched renditions of Monet's latest paintings on the walls.

Bazille returned regularly to his family's property at Méric, just outside Montpellier. He was as deeply attached to the landscape

around it as Courbet was to the Franche-Comté region. And so gradually the bright Provençal sunlight found its way into his canvases. Bazille's patient, loving parents continued to fund their son, awaiting any news of success. He knew the Salon jury had the power to vindicate his decision to pursue art and open up a viable career path, and he knew his parents understood this. The problem was that year after year, he and Renoir and Monet found their best efforts rejected.

The frustration built. By 1867, when the Salon jury rejected almost all the future Impressionists, and Manet and Courbet set up their independent solo exhibitions, Bazille had had enough. The whole selection-by-jury process felt arbitrary and humiliating to him. He was fed up not only on his own behalf (his continued dependence on his parents was a source of deepening embarrassment) but also on behalf of his friends: Monet was desperate for money, and Renoir wasn't much better off. Manet, too, surely deserved better by now than to be subjected to continuous insult and rejection.

So Bazille took to calling openly for an overhaul of the system. He argued that, at the very least, there should be a reprise of the 1863 Salon des Refusés. This would give the public a chance to judge the quality of the rejected work for themselves. Alternatively, as Bazille wrote to his mother, he and his friends could mount their own exhibition, completely independent of the Salon.

Fired by a sense that things were coming to a head, Bazille decided that summer to follow Monet's lead and embark on a painting that would function as his own "manifesto." The resulting canvas showed eleven members of his family gathered under a spreading tree on the terrace at Méric. Provençal daylight pervades the picture, which seems to emit an invisible rosemary- and lavender-scented steam. Some of the eleven figures are a little stiff, but they are solid and vivid. Bazille was unquestionably making strides in his ambition to build on what he had loved about Courbet's *The Meeting*. When he returned to Paris with his friend, Edmond Maître, in the fall of 1867, the two moved into the studio in the Rue de la Condamine. This brought Bazille closer to Manet and to the influence of the Café Guerbois circle. But "Mama musn't worry," as he wrote to his sister. "The Batignolles

is a quiet neighborhood where the cost of living is cheaper than in central Paris."

Then came the 1868 Salon. To Bazille's great surprise, *The Family Gathering* was accepted, along with another of his paintings—a still life of potted flowers. He was quick to share the news with his parents. But his friend Monet, who had had one work accepted and another rejected, remained mired in difficulties. Hemorrhaging money, he seemed unable to find a buyer for anything. His partner Camille had just given birth to a son, Jean. At his christening, Bazille was named godfather.

The new painters battled on. As if keen to record their camaraderie for posterity, they regularly painted each other. Bazille painted intimate, informal portraits of Monet, Renoir, and Maître. Renoir, in return, painted Bazille seated casually before a canvas and then Maître's girlfriend, while Bazille painted Renoir's lover, Lise Trehot, dressed in North African costume, tying a sash around her waist. In 1869, the year Manet's *The Balcony* made its public debut at the Salon, Bazille once again submitted several works. He was bitterly disappointed when only one—*View of the Village*—was accepted. It was poorly placed and hung up high. But Berthe Morisot noticed it as she navigated the social shoals of that year's vernissage. "Big Bazile [sic] has done something that I find really good," she wrote to Edma. "It is a young girl in a very light-colored dress sitting in the shade of a tree and you can see a village behind it; there is a lot of bright sunlight. He is trying to do something we have tried so often to do: portray a figure in the open air; and this time, I do believe he has pulled it off."

BY THE END OF THE DECADE, Bazille had become a regular at the Café Guerbois. Aflame with enthusiasm and more productive than ever, he had fallen more heavily under the spell of Édouard, embarking on several paintings that were outright homages to his new friend and mentor. First came *Studio on the Rue de la Condamine*, to which Édouard had made his mischievous yet welcome contribution. At the same time, over the winter of 1870, Bazille worked up a lushly sensuous Orientalist canvas titled *La Toilette*. (A sketchy ver-

sion of it appears, unfinished and unframed, on the wall in *Studio on the Rue de la Condamine*.) At first glance, *La Toilette* looked like an Orientalist fantasy painted in the manner of such Salon favorites as Gérôme. But Bazille had tempered Gérôme's photographic slickness with a relaxed, eroticized naturalism borrowed directly from Manet's *Olympia*. He followed it with two paintings portraying the same Black model who appears in *La Toilette*, this time arranging flowers in a vase. This painting, too, was an explicit salute to Manet: peonies, as Bazille knew, were Édouard's favorite flower.

Even as his infatuation with Édouard grew, Bazille's relationship with Monet had been showing signs of strain. Throughout their friendship, Bazille had helped Monet financially, lending him money, buying his paintings, paying the studio rent. But now Monet had an infant son and was destitute. He was trying to do things on the canvas that marked him out from Manet and Courbet—and by extension from Bazille. Where Bazille, for all his love of natural light, was most concerned with showing stable, solidly drawn human figures in the landscape, Monet was edging toward something different. He had become preoccupied with finding ways to capture light's fugitive nature. The poses and expressions of human figures, when they even appeared, carried less and less importance for him. In the summer of 1869, he had taken Camille and their little boy Jean to Bougival so that he could work outdoors alongside Renoir. The two took their easels to a bathing spot called La Grenouillère (the Frog Pond), a floating island on a section of the Seine, just west of Paris, between Bougival and Chatou.

The Île de la Grenouillère had a restaurant and a boat rental. It was linked by gangplanks to an even smaller, perfectly round island, dubbed "the Camembert" and planted with a single tree. La Grenouillère was popular with the younger crowd. A decade later Guy de Maupassant would write about it in his story "Femme Fatale." In the summer, he wrote, the heat could be suffocating in this "dead branch" of the Seine where the current moved slowly. In the adjacent park, "busty women with peroxided hair and nipped-in waists could be seen, made up to the nines with blood red lips and black-kohled

eyes." The restaurant's patrons could watch couples cruise by in small rented boats. There was an ambient odor of spilled drinks, cheap perfume, and talc. The place "reeked," wrote Maupassant, "of vice and corruption and the dregs of Parisian society." Those who congregated there were "cheats, con-men and cheap hacks" who "mingled with other small-time crooks and speculators, dabblers in dubious ventures, frauds, pimps and racketeers." Maupassant surely exaggerated for literary effect, but La Grenouillère was not the elegant, decorous setting it has been mistaken for by Impressionism's more sentimental fans.

Monet and Renoir were intoxicated both by the combination of lovely riverside setting and by the louche atmosphere. Sitting side by side facing "the Camembert" from the riverbank, they were mesmerized by the way the water seemed to break up the light. To convey the effect of ripples reflecting light at different angles, they applied paint in short, staccato strokes, one contrasting color beside the other, and they painted the figures on the circular, cheese-shaped platform with just a few casual-looking strokes. Afterward, unsure of what he had done, Monet described his picture as a bad *pochade*—a hastily executed, unresolved sketch. (Around the same time, he painted a bigger, more resolved painting of the same subject, but it went missing during World War II.) But in rendering the physical world as colored light broken into discrete units, rather than meticulously modeled space, the two artists together had effectively invented Impressionism.

〰 〰 〰

CHAPTER 5

🕮 🕮 🕮

The Salon of 1870

BY 1870, A TREMENDOUS ROILING ENERGY, AS OF WATER
coming to the boil, seemed to enliven and accelerate the activities of
all the future Impressionists. A new way of painting was coming into
being. Monet and Renoir continued to paint along the Seine, west
of Paris. Bazille, meanwhile, had lost all patience with the Salon and
swore never again to submit work to the jury. Instead, he resolved to
revive the plan he had been dreaming about for two years: to establish
a breakaway exhibition. A dozen talented artists, he reported, were
with him. They had decided to rent a space, where they would hold a
nonjuried exhibition.

Bazille's plan could easily have turned into the first Impressionist
exhibition, but circumstances intervened. He changed his mind and
did, in fact, submit work one last time to the Salon. In the event,
the breakaway exhibition he proposed didn't take place until 1874, by
which time he had been dead for more than three years.

AS ÉDOUARD GADDED about town and tinkered with his portrait
of Eva Gonzalès, Berthe, sorry at heart, touched up the paintings
she planned to submit to the 1870 Salon. One of them was a double
portrait of Edma seated beside their mother. It was a strong paint-

ing, but as the deadline for submissions approached, she was thrown into a state of confusion: Puvis de Chavannes told her that Madame Morisot's head was all wrong. She took up his suggestion to redo it. But when she invited him to return to see the results, he claimed to be too busy and instead offered bland compliments and gratuitous, generalized advice ("put some accents on the head"). Berthe was not especially vulnerable to Puvis's opinion. ("So far, no great misfortune," she wrote to Edma.) But then, "tired, unnerved," she paid a visit to Édouard's studio. It was a Saturday, shortly before the deadline for submissions. Édouard asked her how she was getting on. "Seeing that I felt dubious," she reported, "he said to me enthusiastically, 'Tomorrow, after I have sent off my pictures, I shall come to see yours, and you may put yourself in my hands. I shall tell you what needs to be done.'"

Berthe's complicated feelings for Édouard were layered over insecurities about her painting. This painting in particular had given her lots of trouble, and her anxiety was heightened somewhat by vague feelings of jealousy over Édouard's developing relationship with Eva Gonzalès. But he seemed to grasp none of this. And what he did next was so painful to Berthe that it stayed with her for years.

He came by the Morisot home at about one o'clock, as he had promised, full of confidence and good cheer. The two painters went out to Berthe's studio at the back and stood together in front of the painting on the easel. Initially, Édouard was positive. He found the painting "very good," he said. But the lower part of the dress wasn't quite working, he opined. Before she could say anything, he picked up her brushes and put in "a few accents." When Manet had taken a brush to Bazille's *Studio on the Rue de la Condamine*, Bazille had taken it as a sign of friendship. But Berthe was in a different place and wasn't expecting what came next. The brushstrokes looked "very well," she reported to Edma, but then her misfortunes began.

"Once started, nothing could stop him; from the skirt he went to the bust, from the bust to the head, from the head to the background. He cracked a thousand jokes, laughed like a madman, handed me the palette, took it back; finally, by five o'clock in the afternoon we had

made the prettiest caricature that was ever seen." The carter, who had the job of taking the finished painting from the studio to the Salon jury, was waiting, so Édouard made Berthe put it on the handcart, and off it went. "And now I am left confounded," Berthe wrote. "My only hope is that I shall be rejected." Their mother, she added, was "in ecstasies," finding it all very amusing, "but I find it agonizing."

By the time Cornélie wrote her own account of the scene to Edma, she had realized the gravity of what had taken place: "Yesterday [Berthe] looked like a person about to faint; she grieves and worries me; her despair and discontent were so great that they could be ascribed only to a morbid condition; moreover she tells me every minute that she is going to fall ill. She overworked herself to such a point on the last day that she really could not see anymore, and it seems that I made matters worse by telling her that the improvements Manet had made on my head seem to me atrocious. When I saw her in this state, and when she kept telling me that she would rather be at the bottom of the river than learn that her picture had been accepted, I thought I was doing the right thing to ask for its return. I have got it back, but now we are in a new predicament: won't Manet be offended? He spent all Sunday afternoon making this pretty mess, and took charge himself of consigning it to the carter. It is impossible to tell him that the entry did not get there in time, since the little sketch of Lorient went with it." (Berthe had also submitted a second painting, a portrait of Edma done at Lorient.) "It would be puerile," Cornélie continued, "to tell this to anyone except you; but you know how the smallest thing here takes on the proportions of a tragedy because of our nervous and febrile dispositions, and God knows I have endured the consequences. It is these constant ups and downs that make it impossible to compose oneself."

THE 1870 SALON—the last of the Second Empire—duly opened, and after Berthe's late change of heart, it included both of her paintings. The exhibition was enormous. Artists were limited to two submissions, as they had been since 1863. Among the new painters, not only Morisot but Degas, Manet, Renoir, and Sisley all had their sub-

missions accepted. Bazille's *La Toilette* was rejected, but to his delight, *Summer Scene* was accepted. It was a huge, square work, just over five feet on all sides. Scholars think it was most likely inspired by a description of young men bathing in bright sunlight in *Manette Salomon*, an 1867 novel by the Goncourt brothers. But Bazille, as Degas had done earlier in his career, borrowed the young men's poses from Renaissance paintings by Andrea Mantegna and Sebastiano del Piombo. The results are mixed: the bathers' bodies are awkward. But the light! The light was drenching. Nothing quite like it had been seen at the Salon before.

The jury awarded the main prize that year to Tony Robert-Fleury for his *Last Day of Corinth*, an exquisitely finished, frieze-like arrangement of desperate, semiclad women in the ancient Greek city, which had been captured and destroyed by the Roman army in 146 BC. A plume of black smoke (soon to be a familiar sight in central Paris) dominates the background. But the star attraction, the painting that captured everyone's imagination, was a very different kind of portrait. It was painted by Henri Regnault, a handsome, twenty-six-year-old artist, with a long, pointed beard and hair that coiled in tight, glossy waves from his head. Regnault had won the Grand Prix de Rome, a prestigious, highly competitive award that sponsored several years' study at the French Academy in Rome, in 1866. (Manet and Degas had both tried and failed to win the award.) But instead of traveling exclusively to Italy, as tradition dictated, he obtained permission to use the prize funds to travel to Spain and North Africa as well. Regnault was close to Berthe's friend, the sculptor Marcello. Both were in the circle of Napoleon III's wife, Princess Eugénie, and regular guests at the home of the statesman Adolphe Thiers. The two artists both recently depicted a Black Abyssinian chief—Marcello as a sculpted bust, Regnault as a painting. Marcello's version made it into the 1870 Salon. But it was Regnault's painting of another model, this one female, that caught everyone's attention that year.

Working in Rome, at the Villa Medici, Regnault had set out to make a simple portrait study from another model he shared with Mar-

cello, Maria-Veronica-Concetta Latini. At first, Regnault set the smiling, slightly disheveled-looking Latini, who had jet-black hair, against a red background. Following the Orientalist vogue, he draped her in jewelry and dressed her in a translucent skirt embroidered with gold. As the painting progressed, he twice decided to enlarge it. And in a final twist, he changed the background from red to a sumptuous gold, creating an overwhelming effect of saturated yellow. Playing up the Orientalism with a leopard skin rug laid over a tribal carpet, he also amplified the eroticism by offering a glimpse of the model's thighs through her translucent skirt. And in a touch reminiscent of *Olympia*, he showed Latini's naked left foot coming loose from its black slipper.

Almost as an afterthought, Regnault called the picture *Salomé*. And even though at least five other painters (including Puvis de Chavannes) exhibited interpretations of the biblical Salomé story at the same Salon, there was general astonishment at Regnault's painting. "This fantastic *Salomé*," wrote the critic Paul de Saint-Victor, "bewitched all of Paris." Another critic, Gautier (famous for coining the term "art for art's sake"), described it as "magical"—a "symphony in yellow major." "*Salomé*," he wrote, "sparkles, it glistens, it melts in the light, it dazzles." Regnault's *Salomé* was more conventionally modeled than the figures in Manet's work, but the picture has the same air of knowing make-believe. Latini's sly, intimate grin is not an attempt at biblical veracity: it is a knowing fiction, like Manet's 1860s renderings of Victorine Meurent in different costumes. The viewer is not just permitted but encouraged to register that Latini, an artist's model, has simply dressed up in the artist's studio. The erotic charge—the question of her relationship with the real artist (as opposed to an imagined King Herod)—is less implicit, more tantalizing as a result.

Regnault himself was much whispered about. He was, they said, "as beautiful as Apollo, as strong as Hercules," as well as a "musician, singer of Venetian arias, expert in athletics [and] adored by all the women." "The public is agog for this hero covered in glory who paints flesh and cloth with the mastery of Velázquez," wrote Jacques-Émile Blanche. Rumors spread that his *Salomé* had "already been acquired by a millionaire collector for a fantastic sum. Twenty thousand francs,

perhaps? It's unimaginable." Regnault had in fact recently become engaged. But that didn't stop the excited speculation. His fiancée, Geneviève Breton, wrote in her diary about standing in front of *Salomé* at the Salon and being addressed by a stranger. "And you haven't heard about what they are saying?" he asked her. "He wants to marry that ugly and vulgar Salomé, a painter's infatuation. He's known her since he arrived in Rome and is mad about her."

THE NEW PAINTERS spent the unusually hot summer of 1870 painting, fraternizing, and wrangling with officialdom. Bazille returned to his family home in Méric. Monet wed Camille Doncieux in early June, with Courbet serving as a witness. Zola had married earlier in the spring. Berthe remained unmarried, but she had shaken off enough of her heartsick torpor to paint *The Pink Dress*, on the face of it, a simple-looking portrait of an acquaintance, Marguerite Carré. But *The Pink Dress* was deceptively radical and constitutes a decisive tilt toward what would become known as Impressionism. Berthe's touch was extremely light—the weave of the canvas is still visible in places—and she had almost entirely eliminated half-tones and shadows, as if taking to heart Manet's insistence that for him, as John Rewald put it, "light appeared with such unity that a single tone was sufficient to convey it and that it was preferable, even though apparently crude, to move abruptly from light to shadow than to accumulate things which the eye doesn't see and which . . . weaken the strength of the light."

Taking his own advice, and inspired by the recent arrival of a Chardin still life featuring a brioche in the galleries of the Louvre, Édouard painted two ravishing brioches. In paintings like these, he seemed to be at his best, his touch preternaturally assured and his sensuous, pleasure-loving nature given full rein. He saw a great deal of Berthe over the summer, and eighteen months after the drawn-out sittings for *The Balcony*, he convinced her to sit for him again, this time posing alone and unchaperoned. The result was one of his greatest portraits. *Repose*, as he named it, shows Berthe relaxing on a deep, upholstered sofa, with a large Japanese print by Utagawa Kuniyoshi

on the wall behind her. Berthe leans slightly to the left, propped up by her elbow. Her arms, tapering to slender fingers, are spread out on either side of her, the right hand holding a closed fan. Wearing a white dress, she looks physically relaxed, and yet the pose seems somehow unsustainable, so that the painting feels tremendously volatile, fired by an erotic energy that borders on the inappropriate.

Unfortunately, however, Berthe's vexing relationship with Édouard had taken on yet another handicap. On a walk around the Salon, which had opened in May, she had made the mistake of introducing him to Marguerite Carré's pretty sister, Valentine. Manet was instantly infatuated and didn't try to conceal it. "He's been after me ever since to come and have her pose for something in his studio," Berthe wrote to Edma. "I don't more than half like the idea, but when he gets an idea in his head . . . it must happen immediately."

Carré eventually agreed. A beautiful, ample woman with fine facial features, she posed in the garden at the Rue Franklin wearing a cascading white dress, a black ribbon tied around her neck, and a black bow at her bust. In the painting, Berthe's brother Tiburce reclines on the grass immediately behind her. However, before the painting was finished, Carré's mother called a halt to the sittings. She had heard more than she cared to about Manet. So the painter had to replace Valentine with Edma, who had returned to Passy over the summer. He painted in Edma's new baby in a carriage. But Carré's features (though somewhat fudged) prevailed, and the picture as a whole has a fresh, unsullied look that, in its treatment of outdoor light, its poster-like flatness, and its apparently arbitrary cropping, makes it another early Impressionist picture.

From looking at it, it would be impossible to guess that in the streets beyond the Morisot garden, as the hot days gave way to nights of unrest, tempers were fraying, and whatever wider accord had existed was rapidly coming undone.

PART II

The Siege of Paris

〰 〰 〰

CHAPTER 6

⋔ ⋔ ⋔

War Is Declared

ON THE SECOND DAY OF 1870—THE YEAR THE EMPIRE
collapsed—Napoleon III surprised everyone by appointing one of his
more vocal opponents, Émile Ollivier, as minister of justice and de
facto prime minister. Ollivier had been a regular guest at the Manet
family's weekly salon during the 1860s. His friendship with Manet
dated back to 1857, when Manet, his brother Eugène, and Ollivier had
found themselves in Italy together. The Manet brothers had shown
the republican parliamentary deputy around Venice, and the friend-
ship was consolidated when the three men met up again in Florence.
In Venice, they paid a visit to Carlo Cattaneo, the activist and phi-
losopher who played a role in the Italian insurrection against the
Austro-Hungarian government, part of the revolutions of 1848. The
first artwork Manet ever presented under his own name was a friendly
caricature of Ollivier, published in a liberal, anticlerical journal.

When Napoleon III called him in, Ollivier needed persuading. But
he was a moderate rather than a radical. And just as Manet believed
he could reform the Salon from within, Ollivier thought he might be
effective from a position of influence inside the imperial regime. So
he took the job. For Napoleon III, ushering Ollivier into the fold was
part of a larger plan. The emperor wanted to appease his increasingly

agitated republican opponents by accelerating his campaign of liberalization from the previous year. Ollivier took office at the start of 1870 with—ironically—a pacifist agenda. Disarmament across Europe was his goal. That was naïve, sniffed the politician Thiers. No warmonger, Thiers nonetheless understood the importance of deterrence. "To talk of disarmament in the present state of Europe one needs to be both foolish and ignorant," he said. Yet at the end of June, Ollivier was sanguine, saying, "At no period has the maintenance of peace seemed better assured."

Within weeks, however, the two politicians' rhetoric was reversed. Ollivier, like a mouthpiece of fate, was loudly proclaiming the inevitability of war against Prussia. War, Thiers was convinced, would be an invitation to disaster.

TENSIONS BETWEEN FRANCE and Prussia had been building for years. Prussia bristled at the permanent threats from France to its west and Russia to its east. For the entire nineteenth century, despite all its internal political convulsions, France had been the dominant military power on the continent. But by 1870 that power was diminished. The means of warfare were changing, and the French military had failed to keep up. The Prussians understood earlier than the French the transformative importance of railways for the mobilization and concentration of forces. The Prussians also had developed superior artillery. Although the French had some advantages, including the powerful new breech-loading chassepot rifle, which was more effective than its Prussian equivalent, in general they were behind.

France's deeper problem was the equivalent of an infection in an open wound. It was a divide between the military and the civilian edifice it was supposed to defend. The first Napoleon had shown the power of mass armies. But after the upheavals of the Napoleonic era engendered a populist drive toward liberty, Europe's national militaries found themselves having to put as much energy into snuffing out internal rebellions as into dealing with foreign threats. The more autocratic the regime, the more pronounced the threat of revolution.

The risk was that republican sympathies would not only pit a nation's military against its own civilians but infect the military itself. In this context, an army's loyalty to the dynasty in power took on special value. And because it was easier to guarantee the loyalty of a small professional army than that of a mass army, some countries, including France, were inclined to let their armies shrink and even languish, underfunded, insufficiently modernized, and isolated from the civilian population.

Prussia made no such mistake. King Wilhelm adored his Prussian army with special ardor because, in 1848, it had quashed a homegrown liberal revolt. He did his utmost to ensure that his policy of universal military service would not introduce seditious elements but would instead effect a more intimate union between army and nation. Prussia allowed no exceptions to its requirement for universal service, but in France, Napoleon III implemented a system of conscription by lottery, which allowed eligible men whose numbers came up to pay for their place to be taken by others. The system favored the well-off and resulted in working-class men routinely filling in for the more affluent and better educated. Republicans loathed the system. They saw it as a "blood tax" on the poor. But when reforms were proposed, Thiers successfully opposed them. It was natural, he claimed, for lower-class men to be attracted to the military. "The society where everyone is a soldier is a barbarous society," he said.

But where the Prussians knew they could maintain order within their own military, Thiers knew France could not be so confident. French military successes in Crimea, in Italy, and in the Far East had enhanced the prestige of Napoleon III's army. But French soldiers, who were poor and often illiterate, knew they could be called on at any moment to protect the regime against its own people. It was a prospect many of them resented.

In their complacency, the French didn't think of the Prussians as a particularly serious threat. But they had been shocked by Prussia's victory over Austria at Sadowa in 1866, and they were concerned about its implications for the balance of power in Europe. That victory had cemented the authority of the Prussian general Helmuth von

Moltke, a strict disciplinarian with a philosophical temperament who commanded extraordinary loyalty. Under Moltke's command, Prussia had been ready for war with France since 1867. By 1870 its army was in peak shape.

The French were generally aware of the Prussian Army's advances. Napoleon III had intuited that success abroad could do much to ameliorate his problems at home, so he, too, wanted to improve his army. But he also understood the urgency of liberal reform, and the two imperatives were incompatible. The liberals he was trying to win over were deeply suspicious of any attempts to enhance the military, for fear that it be employed—again—to crush them. And many who saw the need to rehabilitate France's military were nonetheless wary lest it be infected by the radical left.

In 1866, Marshal Adolphe Niel, Napoleon III's minister of war, had persuaded the emperor to revive the National Guard, a reserve army for home defense formed during the French Revolution and dissolved by Napoleon III after his 1851 coup. Now it was reconstituted and split in two; the larger part was the Mobile National Guard, a mass reserve army that could be deployed nationwide. Napoleon III's supporters thought it was a bad idea to arm so many men, given that among them would likely be republicans who would try to incite the army against the government. Republicans like Favre, too, cautioned against turning France "into a barracks." But Marshal Niel had his eye on foreign threats, and his response was bracing: "Take care that you don't turn [France] into a cemetery."

Still, the imperialists' fear of internal revolt was genuine. It was one reason that, even as the government supplied the professional army with the chassepot rifles, it kept the National Guard—whose members would soon include Manet and Degas—in a shambolic, untrained, and poorly armed state.

A NEAT DIVISION BETWEEN two parties—republicans and Bonapartists—might have made France's situation, if not workable, then at least legible. But five different constituencies were vying for

ascendency in France, with many shades in between. The result was an inexorable slide toward anarchy.

The first group were the Bonapartists. In power since 1851, they wanted to preserve the illustrious Corsican's family dynasty. Great things had been achieved under Napoleon III's rule—above all the modernization of the economy and the rebuilding of Paris—but his political support was disintegrating in lockstep with his physical condition. Struggling with a painful bladder stone, as well as gout, arthritis, hemorrhoids, and neuralgia, he looked more mortal by the day.

Vying to supplant the emperor were not one but two monarchist groups. The Catholic Legitimists wanted to reinstall the Bourbon line, ousted in 1830. The Orléanists, meanwhile, saw Louis-Philippe's July Monarchy (1830–48) as a blueprint for France's best hope: a stable, constitutional monarchy along the lines of Britain's. Thiers was the Orléanists' great champion. The constant cautions, criticisms, and corrections made by this small, speechifying elder statesman, with his thin, grating voice, worked on the emperor's authority, wrote his biographers, like "water eroding stone."

The fourth group, the moderate republicans, saw Louis-Philippe's July Monarchy as a failed experiment and instead gathered around the lawyer Léon Gambetta, who was popular with the young, especially students. A friend, like Ollivier, of Manet, Gambetta had shot to fame during a public trial late in 1868. Charles Delescluze, a radical journalist, was charged with attempting to erect a monument to an opponent of Napoleon III's 1851 coup. Gambetta, pleading on his behalf, let loose an impassioned attack on Napoleon III's legitimacy.

The fifth and final group was also republican, but of a more radical bent. High on the fumes of the revolutions of 1789 and 1848, the radical republicans had updated the call for *liberté, égalité,* and *fraternité* with the class-conscious critiques of thinkers like Proudhon, Bakunin, and lately Karl Marx. (*Das Kapital* was published in 1867, although not in French until 1872–75, when it was published in serialized format.) Prominent among their leaders was Louis Blanqui. They found their strongest support in Paris's outer arrondissements, espe-

cially Belleville and Montmartre, and were suppressed with special ruthlessness by Napoleon III.

By 1870, republicans, both moderate and radical, were in control of local governments not only in Paris but in most other major French cities. And yet 70 percent of France remained rural, and among this population, support for Napoleon III and a desire to defend the Catholic Church remained high.

A WAR APPEARED TO BE just what Napoleon III needed. A conflict with, say, Prussia might arouse enough patriotic fervor to bind together all five political constituencies. A quick victory, if it came, would consolidate the emperor's prestige, stirring memories of his uncle's triumphs, and erasing the disgrace of the recent debacle in Mexico.

So a logic was at work, even if its rationale was cynical. In fact, Napoleon III remained unpersuaded by such thinking. But his wife, Eugénie, was for war—the more so because the obscure incident that occasioned the war that did come involved her native Spain. The Spanish throne had fallen vacant, and a certain Prince Leopold was proposed to fill it. That alarmed France because Leopold was a member of the Hohenzollern-Sigmaringens, the royal family of Prussia. France saw the vacancy as a chance to extend her influence in Spain. Having a Prussian on the throne would not only prevent this ambition, it would destabilize Europe's precarious balance of power. So France protested—with such vigor that, with an almost audible sigh, Prussia withdrew the Hohenzollern candidacy.

To Napoleon III and Ollivier, this was a win—and quite sufficient. The emperor was not confident that a war with Prussia would end in a French victory. But the Prussian withdrawal of the Hohenzollern candidate satisfied neither Eugénie nor the belligerents in the French government, even though their view had prevailed. France and Prussia now commenced a dangerous game of statecraft. Wanting to turn Prussia's mildly awkward correction into a humiliating backdown, France adopted a posture of high indignation, demanding that Prussia guarantee that it would never again propose such a candidacy.

Otto von Bismarck, Prussia's minister-president, saw an open-ing. For years, he had been working toward the formation of a greater German Empire—one that might challenge France's dominance in Europe. He saw that a war might solidify bonds between the indepen-dent German-speaking states, tipping the scales toward unification. So like a jujitsu combatant turning an opponent's thrust against him, he used France's overreach to harness a fateful momentum—a momentum that would continue, catastrophically, far into the twentieth century.

Past seventy, Prussia's King Wilhelm didn't want to go to war with France. He had willingly agreed to the withdrawal of the messy and potentially embarrassing Hohenzollern candidacy. But he refused to give the French the guarantee they demanded because he saw it for what it was: a deliberate provocation. France already had what it sought. Enough was enough.

The French, inevitably, framed Wilhelm's refusal differently. Wil-helm, they said, had been involved in a blatant attempt to extend his family's influence; for him to feign aloofness now was disingenu-ous. Bismarck and General Moltke, meanwhile, looked for a way to exploit this minor diplomatic kerfuffle. They edited Wilhelm's polite but firm refusal, sharpening it, transforming Wilhelm's respectful ret-icence into a pointed refusal, a snub. This version—the infamous Ems telegram—was released to the French public. Its effect was incendi-ary. It was, in Bismarck's famous phrase, a "red rag to the Gallic bull."

Bismarck's ploy wouldn't have worked if France, too, hadn't wanted war. But it did. The streets of Paris exploded with patriotic indignation. The entire fractious nation was inflamed, both by its anger at Prussia and by a nostalgic yearning for military glory. The tentative hypothesis—that a war might unify the country—appeared instantly confirmed.

ÉDOUARD MANET, TOO, was in favor of war. His friend Antonin Proust, who would soon be appointed Gambetta's secretary, recalled Manet's attitude on the eve of war at the Café de Londres, where Gam-betta was also present. Manet "became more and more silent . . . som-ber, taciturn," wrote Proust. "Breaking his silence, he had an argument

one evening . . . that almost turned nasty. He would not allow any criticism of the army. . . . If the bad policies of the Empire had caused harm, then the Empire must be got rid of, but the army should not be insulted. Gambetta agreed."

Thiers and Gambetta had been almost the only holdouts against war. Thiers publicly denounced the charade that had led to it. But he was a patriot and a pragmatist, and he privately assured Napoleon III that if war was declared, he would support it. Thiers knew the casus belli was weak and that this would isolate France. "Do you want all Europe to say that although the substance of the quarrel was settled, you have decided to pour out torrents of blood over a mere matter of form?" he asked. Gambetta agreed with the statesman, more than forty years his senior.

But no one else was listening. It seemed unthinkable to the French that their proud and wealthy nation could lose a war with upstart Prussia. Replying to Thiers, the recently pacifist Ollivier said he accepted war with a "light heart." And although he was quick to elaborate ("I mean a heart not weighed down with remorse, a confident heart"), it was a statement he would profoundly regret.

France declared war on July 19, shortly after the 1870 Salon closed. In Paris, people were ecstatic. "Crowds swept down the boulevards and bands of people brandished torches crying 'To Berlin, to Berlin!,'" Zola later wrote in his novel *La Débâcle*.

But the French imperial army never reached Berlin. After a bungled mobilization, it gathered along the border in Alsace and Lorraine. Almost half a million soldiers from Prussia and allied German-speaking states were already there, with another nearly 1.2 million in barracks, just a train trip away. They were better organized and better supplied, vastly superior not only in numbers but in heavy artillery.

Half the reservists France called up failed even to reach their assigned regiments, and poor planning caused terrible shortages of food, uniforms, and basic equipment. The French soldiers were exhausted, frustrated, and demoralized before the battle had even been joined. Forced to march huge distances back and forth for no apparent purpose and to scrounge for their own food, French troops

quickly lost faith in their leaders. Drunkenness, insubordination, and looting became rife. Notoriously, the only maps available to officers were maps of Germany. They became entirely redundant when, after a series of defeats, it became clear that the war would be fought entirely on French territory.

Eugénie urged her husband to take full command of the army, leaving her in control of the government in Paris. So in late July, a week after the declaration of war, the ailing emperor left for Metz, two hundred miles east of Paris. Unfortunately, as a military strategist, Napoleon III was no match for his uncle. What's more, his judgment was clouded by constant, mind-deranging pain from his bladder stone; it was agony for him just to mount his horse.

On August 2, heedless of Prussian concentrations elsewhere, the French advanced across the border into the town of Saarbrücken. They easily overwhelmed the town's defenses, but the victory was meaningless. Over the next few days, the French engaged in a succession of battles. At Wissembourg, six thousand troops were caught in a death trap by fifty thousand Prussians. At Froeschwiller, French forces under the command of Marshal Patrice de MacMahon might have won, but they were crushed by sheer weight of numbers, and the encounter turned into a bloody rout. It took a week to bury the dead. The border confrontations now moved westward as French forces, split in two by the Prussian advance and "lashed," as Zola wrote, "by the mad winds of panic," retreated. Cut off from supplies, they were undone as much by haphazard decision-making and misdirected marches as by lost battles. Many troops never even saw action. By mid-August, the French Army commanded by Marshal François Achille Bazaine, a veteran of the war in Mexico, was in Metz, surrounded by Prussians, while most of the rest of the army, led by Marshal MacMahon and Napoleon III, was being forced into a trap eighty miles to the northwest, at Sedan.

In Paris, a dispatch arrived bearing false news of glorious victories. It started at the Bourse, or stock exchange, and the news spread haphazardly, like a forest fire in a gusting wind. Thousands poured into the streets. "General MacMahon has shattered the Prussians

and taken 25,000 prisoners, among them the Crown Prince!" heard Ludovic Halévy, an opera librettist who was a close friend of Degas. A prima donna, Madame Sass, stood up in her carriage and sang "La Marseillaise," and flag-waving crowds joined in for the chorus. But then, just as quickly, word spread that the report was false.

The bitter truth eventually emerged. The army had been defeated at the border and was in shambolic retreat. "What a collapse! What a fall! What wretchedness!" wrote Gustave Flaubert in an anguished letter to George Sand. "How I wish I were dead, not to have to think about all this." The French situation was dire. "Without a miracle," wrote Halévy, "we are lost. This is the end of the Empire. One may not mind much about that, but supposing this also means the end of France?"

W W W

CHAPTER 7

𝔐 𝔐 𝔐

Corot's Dream

THE DAY AFTER THE FRENCH DEFEAT AT FROESCHWILLER,
Ollivier declared martial law. Napoleon III, who had by now yielded
his supreme command to Bazaine, was retreating from Metz to the
army base at Châlons, one hundred miles east of Paris. Knowing that
his presence in Paris might trigger an uprising, Eugénie urged him
not to return to the city. Yet even in his absence, rumors of an insur-
rection set off tremors in the capital. Most of Paris's inhabitants were
patriots, with no desire to see Prussia defeat France; they assumed,
like their compatriots, that the military setbacks would prove tempo-
rary, that France would ultimately prevail. But many Parisians also
hoped that, in the course of the struggle, Napoleon III's misadventure
would catalyze what had long seemed inevitable: the rebirth of the
republic that his 1851 coup had strangled.

A week after Froeschwiller, in the working-class Parisian suburb
of La Villette, one hundred armed agitators—suspected followers of
Blanqui—staged a riot. The government response was firm: forty-
three men were arrested, and four were executed. Meanwhile Ollivier,
just over half a year into his job as minister of justice, saw that he had
to resign. Eugénie replaced him with die-hard imperialists, led by the
general and statesman Comte de Palikao.

Strasbourg, to the east of Metz, was under Prussian siege, and Paris now had to prepare for a similar fate. General Louis-Jules Trochu was appointed governor of Paris and charged with organizing the city's defense. The work began immediately. Trees in the parks were cut down, and hundreds of thousands of sheep and cattle were moved from the surrounding countryside into the Bois de Boulogne. In an open session in the Legislative Assembly, Thiers warned of the coming battle beneath the walls of Paris.

BERTHE MORISOT'S PARENTS, Tiburce and Cornélie, now faced a dilemma: Would they stay in their Passy home or seek safety in the countryside? Berthe, as an unmarried woman living with her parents in an affluent outer suburb, had a vision of events that was distant, smudged. She had to rely on whatever news her parents saw fit to relay to her. The household seemed suffused with a strange new atmosphere: shocked sobriety; adrenalized purposefulness; underlying bewilderment. Berthe was concerned for her studio. She needed to know what would happen to her canvases, easels, brushes, and paints if she had to leave Passy. Beyond that, she felt strangely redundant, almost infantilized, like a teenage girl sitting on the steps, eavesdropping on an adult argument.

Empress Eugénie, too, was concerned for a collection of artworks over which she had come to feel a personal proprietorship—in her case, that of the Louvre. Holed up in the Tuileries Palace, which was connected to the Louvre, she issued orders to panicked curators to take down the museum's greatest masterpieces and send them to Brest for safekeeping. Two trainloads of paintings had already left when Edmond de Goncourt ran into a man who said his job was to escort the third trainload the following morning. His colleague, he said, was "crying like a baby" over Raphael's *La Belle Jardinière* "as if over a loved one about to be nailed into her coffin." The painting, idolized by such canonical French artists as Poussin, David, and Ingres, had been removed from its frame, rolled up, and placed in a crate. That night after dinner, Goncourt went to the railway station at Montparnasse, where he observed crates that were holding Titian's *Pardo Venus* and

scores of other masterpieces—"pictures that one had imagined fixed to the walls of the Louvre for all eternity and which were now nothing but parcels, protected against the hazards of removal by the word 'FRAGILE.'"

MEANWHILE 110,000 FRENCH TROOPS were engaged in ferocious battle with 190,000 Prussians at Saint-Privat, northwest of Metz. After sustaining huge losses, the French were forced to retreat, leaving Bazaine and his army trapped in Metz and eliminated from the war. Less than two weeks later the Prussians encircled Sedan, 150 miles northeast of Paris. Napoleon III's fourteen-year-old son, the heir apparent, had accompanied his father to the battlefield, but he was now hurried away to safety in Belgium and thence to England. In Paris, frantic attempts to lay a submerged telegraph line along the Seine from Paris to Rouen ended in failure when Prussians, tipped off by a French collaborator, discovered them. A mood of paranoia swept through the invaded country. Mobs set upon scapegoats and suspected spies. In mid-August, a young nobleman-farmer in a remote part of the Dordogne was arrested, suspected of being both a republican and a Prussian collaborator. Local villagers tore him to pieces and set him on fire.

Sedan, which would spawn a nostalgic mythology of patriotic valor, was really a site of national humiliation. It was the war's nadir, a bloody, brutal, all-day battle that saw 250,000 Prussians launch a decisive assault on 100,000 Frenchmen. The hottest fighting centered on the village of Bazeilles, two miles from Sedan, where a band of French infantryman held out in a small inn as the village around them was battered and burned. From a hilltop, King Wilhelm watched the French cavalry perform heroic—and futile—charges in a nearby stretch of open land. "Ah, *les brave gens!*" he is said to have murmured—"The brave fellows!"—as the Prussians systematically slaughtered them.

Napoleon III, his cheeks rouged to hide his deathly pallor, spent much of that day riding back and forth on his horse, hoping to conjure the spirit of his uncle—or perhaps simply manifesting a death wish.

By day's end, no bullet had found his chest, but he knew the battle was lost. He had a letter delivered to King Wilhelm, which began: "Sire and brother, having failed to die among my men, it remains only for me to surrender my sword unto the hands of Your Majesty. I remain, Your Majesty, your Brother, Napoleon."

THE FRENCH DEFEAT at Sedan marked the end of the Second Empire. When news of the defeat arrived in Paris, on September 3, it hit like "a second thunderbolt," Zola would later recall. At first, the morning telegram announcing the capitulation was not believed. But at four-thirty p.m., the empress had received confirmation from her husband. Incensed, she railed against his haplessness, vomiting forth a bilious stream of invective. "Pale and terrible," as one observer wrote, "her eyes were hard and brilliant with anger, her face distorted with emotion."

On the streets, rumor contended with counter-rumor. But the truth eventually took hold. Goncourt recorded in his journal the general dismay, "the consternation written on every face, . . . the siege of the newspaper kiosks, the triple line of readers gathering around every gas lamp." Consternation soon turned to anger. Imperial emblems were smashed and torn down all over the capital. Crowds swarming the streets looked suddenly, ominously, purposeful.

Eugénie sat with the sorry truth of defeat through the night. By morning, she knew she was in mortal danger. A delegation came to her at the Tuileries Palace, urging her to abdicate. She refused. But refusal was by now a meaningless gesture—events had overtaken her. Half a million people poured into the Place de la Concorde, surrounding the Vendôme Column as if defying this symbol of Napoleonic triumphalism.

At the same time, the Legislative Assembly met to declare the end of the empire. A crowd invaded the chamber, and shortly afterward, in bright sunshine, Léon Gambetta and Jules Favre—a lawyer and politician who had tried to resist the coup of 1851—proclaimed a republic at the Hôtel de Ville. It all happened so quickly. General Trochu, who had only recently sworn fidelity to the empress,

left his office in the Louvre, rode out to join the festive parade, and was shortly thereafter named president of the new Government of National Defense. Favre was appointed vice president and minister for foreign affairs; Gambetta, minister of the interior. Political prisoners were promptly released.

Trochu went to inform General Palikao that France was once again a republic, the empire over. But the general barely heard him. Groggy with grief, he had just received word that his son was killed at Sedan.

The Louvre curators packing up paintings for removal to Brest had turned to masterpieces by Claude and Poussin, but at some point in the day, their work was halted. The crowds outside were too unruly to risk it.

Eugénie, meanwhile, had been made to realize that her time was up. Metternich, the Austrian ambassador, and Costantino Nigra, his Italian equivalent, hustled her out of the palace through the galleries of the Louvre. The only painting still on the walls—it was simply too big to move—was *The Raft of the Medusa*, Théodore Géricault's darkly dramatic rendering of shipwrecked desperation. Eugénie paused in front of it—startled, as if by sudden recognition—before scampering on.

Once outside, she was pushed into a cab with a companion, Madame Le Breton. The two women, having nowhere to go, tacked and twisted their way through the volatilized streets of Paris, hoping a good plan would occur to them. After several hours, Eugénie remembered her dentist, an American called Thomas Evans. At his home, they at last found safe harbor. Early the following morning, Evans smuggled them out of Paris. To pass through the city gates, where guards were now on high alert, the empress impersonated a mentally ill woman being taken to relatives in the countryside. The party made haste to Deauville, where Evans convinced the owner of a sixty-foot yacht, the *Gazelle*, to take Eugénie across the Channel. Still in denial, she wept bitterly as she boarded the yacht, which sailed through rough seas to the Isle of Wight and thence, eventually, to Hastings, where the former empress was reunited with her son.

The imperial palace at the Tuileries was liberated at four p.m. on the day of Eugénie's escape. "Property of the People" was chalked

on its walls. Every visible *N* was destroyed, and the Avenue de l'Empereur was renamed Avenue Victor Noir, after the journalist shot by Napoleon III's cousin, Prince Pierre-Napoleon Bonaparte, at the beginning of the year.

THE PRUSSIANS HAD BEGUN their advance on Paris immediately after Sedan, and they were fast approaching. They planned to lay siege to the city. Adolphe Thiers was meanwhile trying to hold France together. On the day the republic was declared, he presided over a meeting of the rump of the Legislative Assembly, advising them to resist any temptation to oppose the new government. With the enemy marching on Paris, resistance would be "unpatriotic," he said.

The following day he met with fellow Orléanists, telling them to keep their princes away from Paris. France could ill afford a civil war when it was in existential danger. But what worried Thiers as much as the Prussian advance, Orléanist interference, Bourbon plotting, and Bonapartist revenge was something he could do little about: it was that Paris, in the name of its own defense, was about to arm hundreds of thousands of its inhabitants, many of them radicalized and impatient with broken promises. A war between two armies might very easily tip over into a people's war, in which a whole citizenry—men, women, and children—had a stake.

The torrent of events was now in full flow. It was hard to keep up with the hourly developments. On September 5, Victor Hugo returned to Paris after nineteen years in exile. Gambetta suspended the imperial order to send the Louvre's artworks to Brest. And Georges Clemenceau was elected mayor of Montmartre. The following day Thiers met with the British ambassador, Lord Lyons, in the hope of obtaining British intervention and securing an armistice. The request came to nothing—one in a long series of diplomatic disappointments.

Posters went up all over Paris: "The enemy is advancing. The defense of the capital is assured." Paris was about to be—but was not yet—cut off. Its inhabitants were like a population about to be quarantined in response to an outbreak of plague. Some rushed to leave—the train stations were mobbed as Parisians with means tried

to depart and foreign citizens scrambled to get home. Others decided to stay. The majority, being too poor to abandon their responsibilities or having nowhere else to go, had no choice but to stay. But farmers and other residents of the regions around Paris poured into the city to escape the hostile advancing army. They staggered around the streets looking anxious and lost. The old and infirm were pushed in makeshift wheelchairs. On rickety handcarts, market gardeners lugged cabbages, leeks, and pumpkins. Public hunts were organized in the surrounding forests to prevent the Prussians getting their hands on game.

Roads leading out of the city were impeded by herds of cattle being driven in, the more recalcitrant farm animals tugged by lengths of rope. The Bois de Boulogne, where Manet and Degas had liked to watch horse racing, was soon filled with 250,000 sheep and 40,000 oxen. "Over every open space, down the long avenue all the way to Longchamp itself, nothing but sheep sheep sheep!" wrote the Paris correspondent for *The Manchester Guardian*.

About ten thousand troops who had escaped from the battlefield at Sedan limped into the city, exhausted and bedraggled. Their arrival, wrote one Parisian, was like "the floating in of a wreck upon the beach." They were to join the fifty thousand trained troops already in the city. They set up camp on the Champs de Mars, the site of the 1867 Exposition Universelle. Berthe could see their tents from the terrace behind her home.

The influx of soldiers and regional inhabitants seeking safety inside the defensive walls meant that, within just a few weeks, Paris's population swelled from 1.5 million to 2 million. But the new government knew neither how many mouths it had to feed, nor for how long they would need to be fed. The best guess was a month. To be on the safe side, it tried to guarantee enough grain, flour, and fuel for eighty days. Blanqui urged the government to expropriate all the city's food and distribute it equitably, but it failed to establish rationing or a centralized distribution system that would be fair to everyone.

In addition to the professional soldiers, there were also about 100,000 poorly trained members of the recently formed Mobile

Guard in Paris, and another 90,000 men who were part of the Parisian branch of the National Guard. Most of them had joined only after the initial declaration of war. Now, as the Prussian Army approached, the Government of National Defense put out a call for yet more recruits. The response took everyone by surprise: in short order, the National Guard swelled to 350,000. The numbers alone—of combined regular troops, Mobile Guard, and National Guard—were impressive: more than half a million men. The sharp report of guns employed for rifle practice soon echoed around the city, an ominous sound for those, like Thiers, who remained concerned about an insurrection by radicals.

Enthusiasm ran high. Still, few people with military experience placed much faith in this impromptu force's ability to ward off the Prussians. "We have many men," said General Trochu, "but few soldiers." Recruits to the National Guard were paid 1.5 francs a day. Among them were Édouard Manet and Edgar Degas. Both artists were patriotic. Both felt duty-bound to defend the freshly hatched republic. That the circumstances were alarming did not deter them—it only increased their sense of righteousness.

Renoir was drafted into the cavalry and sent to Bordeaux. Bazille, from his family home in Montpellier, enlisted voluntarily. Both men eventually served in regiments outside Paris. Other artists chose, as Manet and Degas had done, to stay in the capital, among them Courbet, Puvis, Corot, James Tissot, Fantin-Latour, Meissonier, Gustave Moreau, and Rouart. In ways both immediate and obscure, they all had to rethink their lives at this point. What was an artist's duty at such a time? The sculptor Carpeaux, who was forty-three, spent his days drawing the daily lives of troops from his residence at the Luxembourg Palace.

Other artists did their best to avoid the coming disaster. They could no longer feel safe in Paris. One trade magazine for artists even put out a warning to artists interested in painting out of doors: "It is dangerous to make any drawings, sketches or studies after nature. The local people fancy they see Prussian spies everywhere." Cézanne went into hiding in L'Estaque, near Marseille, where he was suspected of being a conscientious objector. "When the military police arrived,"

according to Maurice Denis, "his mother would tip him off, and he escaped through a backdoor into the scrubland with a basket of provisions." Pissarro, who carried a Danish passport, had wanted to enlist, but his mother pleaded with him not to. He escaped from Louveciennes, on the road between Paris and Versailles, just ahead of advancing Prussian troops, who ransacked his home, removing a painting of fir trees from its stretcher and using it as a kitchen apron, then dumping it on a manure heap. He and his heavily pregnant partner, Julie Vellay, went to stay with friends, the painter Ludovic Piette and his wife Adèle, in Montfoucault, where Vellay gave birth to their third child, Adèle Emma, in October. Alas, the baby died just days later. The couple eventually made it to London, where at the start of December Pissarro met up with his mother, who had fled there ahead of them, and Monet.

Monet's family had purchased for him an exemption from military service. Over the autumn, he had been with Camille and their young son Jean at Trouville on the Normandy coast, enjoying a honeymoon, of sorts—although Monet was also on the run from creditors. He left for Le Havre alone, then crossed the channel to England, where he was joined in October by Camille and Jean.

SOMETIME DURING THE NIGHT of September 9, Camille Corot—Berthe's former teacher and a regular guest at her home— had a dream. It was that the enemy had entered Paris and set it alight. Plumes of smoke billowed upward, dispersed by strong winds into a dreadful soup of gray and white. The city was razed. As soon as the seventy-four-year-old awoke, he tried to paint the vision. The scene that emerged from his frenzied brushstrokes was inchoate, apocalyptic. "Paris was on fire, as if submerged by an ocean of flames," wrote his friend Alfred Robaut, paraphrasing what Corot had told him. Off to the right, you could make out the cupola of the Church of Saint-Geneviève, named for the city's patron saint. A figure farther to the right flies through the sky—it is the Exterminating Angel departing the scene, his work accomplished. At the center of the picture, a giant figure emerges to tower over the horizon, her raised right arm bran-

dishing a torch. To Papa Corot, whose home town of Ville d'Avray, on the road from Paris to Versailles, would be destroyed and pillaged during the siege, she represented France "standing at the heart of the destroyed city, promising to repair everything." Corot, a beloved and charismatic figure, worked hard over the coming months to help the poor and needy in Paris survive the siege. He kept his painting, *Le Rêve*, hidden away in a corner of his studio until the end of his life. By then, he had long since been persuaded that the dream was a premonition.

TO ENFORCE ITS SIEGE of Paris, the Prussian Army had to seal a fifty-mile circumference, which would require almost all of Moltke's men. The fortifications around Paris had been built between 1841 and 1846 according to a plan laid out by Thiers himself. They were still known as the Enceinte de Thiers, the Thiers Wall. The city was surrounded by ninety-three projecting bastions joined by a masonry wall thirty feet high. Beyond the wall was a moat, and on the outer side of the moat were sixteen forts, separated by one to three miles each. The forts were somewhat out of date—cannon range had doubled in the thirty years since they were built. But they were placed in commanding positions—none more so than the forbidding Fort Mont-Valérien, on the summit of the hill at Suresnes, west of the Bois de Boulogne. And each fort was armed with fifty to seventy heavy guns. To improve the defenses now, Trochu employed ten thousand laborers to dig trenches in the weaker areas. Electrically charged landmines were laid, the network of catacombs was sealed off, and barges were tied across the Seine to impede enemy access by water. Across the entire city, trees were cut down, the wood to be used for fuel and barricades.

Confidence among the suddenly militarized population was high. On September 13, less than a week before the siege began, the troops that were mustered together in Paris turned out for morale-boosting review by Trochu. Even Goncourt, who tended toward mordant cynicism, was moved by "this amalgam of working men and tradesmen turned soldiers who were ready to die together." He saw "gray beards

mingled with beardless chins" and "frock coats side by side with smocks." Noticing soldiers holding hands with little daughters who had "slipped into the ranks," he was moved to wonder "whether one of those miracles might not occur which come to the help of nations who have faith."

ON FRIDAY, SEPTEMBER 16, 1870, Édouard Manet had a difficult task to perform. Due to report for military duty the next day, he had decided to shut up his studio on the Rue Guyot. It was a melancholy assignment. He would have his best paintings delivered by cart to his friend Théodore Duret for safekeeping. He had dispatched a note to Duret the previous day, listing those he would deliver. It included paintings that today are some of Manet's most celebrated. Wrapping them up was especially dispiriting, as he enjoyed the paintings' company. But he had to wonder (hardly for the first time), why hadn't they found buyers?

Duret's home was no museum, but he had room to spare. His family owned a cognac business, and Duret himself had co-founded a republican newspaper, *La Tribune*. He and Manet had become friends in Madrid when Édouard had traveled there in 1865. In 1868 Manet had painted a full-length portrait of Duret in the style of Velázquez. And in May 1870, a mere four months earlier, Duret had written a laudatory review of Manet's work. Of course, all this already belonged to a different era, when foreign travel, make-believe, costumes, and the game of art still felt possible—still *permissible*.

Édouard's note now to Duret was brisk. "My dear Duret," it began. "I am sending you the pictures you have kindly offered to shelter during the siege." First on the list was *Olympia*, the painting Paul Valéry would later describe as "supreme, obscene and brutally factual." More than six feet wide, it was bound to be conspicuous on the street. Fourth on the list was a painting almost as big (but vertical where *Olympia* is horizontal), *The Balcony*, Édouard's first painting of Berthe. *Repose*, his second portrayal of her, was last on the list, where it was described as "Mlle B." Like the other eleven, it had failed to find a buyer.

And so now Édouard was shutting up shop, wrapping his paintings to be carted across Paris, where he hoped they would be safer. "In the event of my death," he scrawled in the blank space beside the list, Duret should take his pick of *Moonlight* or *The Reader*. Alternatively, if he preferred *Boy with the Soap Bubbles*, he should ask to take that. The next day these dozen Manet paintings were smuggled through the streets of Paris. The siege had not yet begun, but the city was already profoundly changed. When Édouard returned late to the apartment on the Rue de Saint-Pétersbourg, off the Place de Clichy, just up the hill from the Gare Saint-Lazare, he wrote to Suzanne. Along with Léon and Édouard's mother, she had left Paris eight days earlier. After a long journey, they had reached the town of Oloron-Sainte-Marie, at the foot of the Pyrenees, close to the Spanish border. Édouard was full of news about the happenings in Paris since their departure. The women, he reported, were furious and, in Montmartre, were whipping the men into action, demanding that they get out of the home. They were not going to have to harangue him, he hastened to add. He was fully committed to his soldier's destiny. He would be reporting for duty tomorrow.

"Tell Léon to behave like a man," he signed off.

A WEEK LATER ÉDOUARD and his brother Eugène, accompanied by Degas, paid a visit to the Folies Bergère, where Manet would later paint one of his best-known paintings. The recently opened cabaret hall, initially known as the Folies Trévise, had been converted into a site for patriotic rallies where the poems of Victor Hugo were read aloud. On that particular night, the three men went to hear a certain General Gustave Cluseret speak. Édouard was fascinated by Cluseret. He had fought in Crimea, raised a foreign legion for Giuseppe Garibaldi in Italy, then fought on the Union side in the American Civil War, where he miraculously rose to the rank of brigadier-general but was eventually forced to relinquish his command after losing support. Back in France, Cluseret had worked with the Russian Mikhail Bakunin, who was leading the anarchists in a tussle for dominance with Karl Marx within the International.

The talk that night was all of "guns and revolvers," wrote Édouard, but it became clear to him that those in attendance neither loved nor trusted the republican government. Those he described as "true republicans" were intent on overthrowing the government after the war, he said. He left the question of what constituted a "true republican" ominously unanswered.

The next morning he walked north from the Batignolles with his other brother, Gustave. There was a lot to take in. Soldiers not yet assigned billets were camping out on the squares and along Haussmann's roomy boulevards. The brothers rounded the Butte Montmartre, where Nadar had set up camp and was busy preparing the Place Saint-Pierre for the launch of the *Neptune*, a tethered observation balloon intended to observe Prussian movements. They crossed the Seine at Pont d'Asnières before arriving at Gennevilliers, where the Manet brothers jointly owned several properties. Gustave was convinced the enemy would never reach Paris, that a peace would be negotiated before they could. But Édouard was no longer so sure. The city struck him as sad. So many people had departed. The trees had been cut down. Everything was being burned. Even the grain stacks were on fire in the fields.

That night Édouard went with Eugène to another meeting, this one in Belleville, a center of republican radicalism. The organizers read out the names of regular attendees who had left Paris ahead of the coming attack. Someone proposed to publish their names on posters around the city and to confiscate their property and assets "for the benefit of the nation." Édouard made no comment on this in his letter to Suzanne, merely confessing that he was lonely. Coming home to an empty house every day was deflating. Seeing the two pianos only made it worse. He knew Suzanne would be missing them—the touch of the keys; the calm, focused state to which they gave her special access; the music itself. Playing had been part of Suzanne's daily routine. Their intimacy had first developed at a piano, and Suzanne almost always performed at the weekly salons. These recent memories were suddenly like spectral tableaux from a past as distant as Japan. Édouard promised that if the apartment were threatened by Prus-

sian shelling, he would move the pianos to a safer place, the home of their friend Jules de Jouy—though he was quick to add that he didn't think any shells would reach so far. He knew how hard it had been for Suzanne to abandon her home, so he tried to reassure her that it had been the right decision. "For one thing," he wrote, "women would only get in the men's way . . . and in any case, very few women have stayed behind."

But this wasn't entirely true. Most Parisian women had neither the means to leave nor anywhere to go. Among those who did, some still found it hard to decide whether to stay or leave. Berthe was one of them. Édouard and his brother Eugène had paid a visit to the Morisot home a few days after Suzanne's departure. It was a Saturday. After the Morisots welcomed them, the conversation turned almost immediately to the wider situation. They had heard about the scenes at the railway stations. They all put on brave faces, but everyone was clearly shaken. Every piece of news, every rumor they exchanged only compounded their anxiety. When they said goodbye, it was with no clear sense of how things would be when they next saw one another.

On the same day, Édouard wrote to Eva Gonzalès, who had already left, predicting that Paris was on the verge of being sucked into a nightmare scenario: "death and destruction, looting and carnage" would be inevitable, he wrote, if Europe failed to intervene.

Two days later Cornélie wrote to Edma and Yves, who were with their families in southwestern France. She said she wished that Berthe were with her sisters instead of with her in Paris. Édouard and Eugène had scared her with their talk: "You know how they see everything in the blackest possible light." For her part, she couldn't believe the worst. "The fact is, things never turn out as well or as badly as one anticipates." But when she said the same thing to Berthe, Berthe scolded her for her complacency. To her, Édouard's pessimism seemed entirely credible.

By Thursday, September 15, Moltke had established headquarters on the Marne at Château-Thierry, less than forty miles east of Paris. By the following Sunday, mail had stopped arriving in the French capital. Édouard was sleeping on straw at the fortifications. Thiers was

in London pleading for foreign assistance. Victor Hugo was firing off pamphlets and delivering rousing speeches addressed to the French nation. Up on the Butte Montmartre, Hugo's and Édouard's friend Nadar was getting ready to transition from tethered observation balloons to balloons that could float over the Prussian lines.

On the eighteenth, Berthe wrote to Edma, not knowing if the letter would reach her: "I have made up my mind to stay." Her reason was that "neither father nor mother told me firmly to leave." According to Berthe, her parents wanted her to leave "in the way anyone here wants anything—weakly, and by fits and starts."

So she made the decision with her eyes open. Being unmarried, without responsibilities to a husband or children, Berthe believed her place was with her parents. "If by ill luck anything did happen, I should have eternal remorse," she wrote. But because she was writing to Edma, she could also be honest. It was all excruciatingly difficult, she confessed. She felt sad, isolated, encased in a weird silence. And she was having nightmares. In a sense, she had already been invaded: her studio had been converted into makeshift lodgings for members of the newly formed militia. "I have no way of using it," she reported, knowing Edma would understand what this meant for her. She was worried, meanwhile, about their brother Tiburce, who was in the army fighting who knew where; they had had no news from him. As the Prussians swept through the countryside, she was hearing distressing rumors of atrocities. Yet Berthe insisted her underlying state was calm, philosophical. In her letter, she even tried half-heartedly to channel some of Cornélie's wisdom: "I have the firm conviction that everything will come out better than expected."

The next day, September 19, 1870, the French lost a battle at Villejuif, just south of the city walls, which forced them to evacuate the plateau of Châtillon. The Prussians cut the last telegraph line to Paris. The Siege of Paris had begun.

〰️ 〰️ 〰️

CHAPTER 8

〰️ 〰️ 〰️

The Siege Begins

PARIS BESIEGED! IT WAS UNTHINKABLE. STARVED OF RELI-able information, separated from loved ones and friends, those who remained in the capital had no inkling of how much waiting, wondering, and worrying lay ahead of them. Most imagined the French Army, which needed only time to get organized after the chaos of the previous month, would soon launch a liberating offensive. Many gave it about three weeks. But neither Trochu nor Jules Favre felt optimistic. They wanted to try to negotiate a way out. So as Paris was sealed, Favre secretly slipped out of the city to meet with Bismarck and Moltke. The Prussian high command had established temporary headquarters at the Rothschilds' château at Ferrières, to the east of the city. Bismarck was unyielding. His demands of Favre—that the French surrender the fort at Strasbourg, where at just that moment the French Army was heroically resisting, as well as all of Alsace and part of Lorraine—were so extreme that they reduced the foreign minister to tears of frustration. The talks were broken off.

So be it. The inhabitants of Paris—proud capital of a freshly hatched republic, inflamed by patriotic fervor, and now defended by more than half a million men—were in no mood to compromise with an upstart Teutonic army. Victor Hugo was exhorting all of France

to come to Paris's aid. The city was electrified by defiance. And yet Bismarck held all the cards. His army had achieved what no one had thought possible. Certainly, he worried about the endgame: Thiers's fortifications were formidable. And if foreign powers intervened, things could get difficult. But why should he offer concessions?

ON SEPTEMBER 20, Versailles surrendered without a shot being fired. But skirmishes broke out elsewhere around the city's periphery. "The enemy caused fairly heavy losses yesterday," wrote Édouard, who spent the first three days of the siege on guard duty at the fortifications. "The militia faced their fire with courage enough, but unfortunately the troops of the line gave way." Collapse and defeat seemed imminent.

Two days later Édouard was still at the ramparts. "It's very tiring and very hard," he wrote to Suzanne. "One sleeps on straw, and there's not even enough of that to go around." News of Bismarck's intransigent position in negotiations with Favre had leaked. Édouard, whose patriotic blood was now at a rolling boil, decried the Prussian's "outrageous pretensions." He was no longer an artist—he was a soldier. Paris, he said, was "determined to defend itself to the last." He sounded unflappable. ("We heard the guns going all night long," he wrote. "We're all getting quite used to the noise.") But he was tormented by the thought that Suzanne and Léon and his mother would have no idea of his fate and that his letters might never reach them.

In this, he was by no means alone. Of all the issues Paris faced, the problem of how to communicate with the outside world had become the most pressing. The City of Light had been plunged into an extended epistemological darkness. Developing a reliable means of two-way communication—between Paris and the remnants of the French Army, and between the new republican government and its potential foreign allies—would be crucial if they were to slice through Bismarck's taut net.

SEALING THE CITY's fifty-mile circumference had required almost the entire Prussian Army, so most of the rest of France remained

unoccupied. A provisional government was therefore hastily established in unoccupied Tours, 150 miles to the southeast. Trochu's Paris government—the so-called Government of National Defense—needed to communicate with it to coordinate strategy. Sending out postal runners was futile—and sometimes fatal. Of the twenty-eight postal runners sent out of Paris in the first week of the siege, all but one was captured or shot.

Only one viable solution presented itself: hot-air balloons.

Back in the first week of the war, Nadar—perceiving a potential military role for balloons—had formed the No. 1 Compagnie des Aérostiers. The director of postal services, Rampont-Lechin, had realized how useful balloons could be for military observation. Since September 16, a badly battered balloon, the *Neptune*, had been ascending every day from a launching pad at the Place Saint-Pierre in Montmartre. The *Neptune*'s varnish was old and brittle, its seams were splitting, and its numerous punctures leaked coal gas. But tethered to ropes, it hovered four hundred feet above the Butte Montmartre, affording its pilots views of where the Prussians were digging trenches and placing their Krupp guns.

The mayor of Montmartre, Georges Clemenceau, had initially rebuked Nadar for commandeering the square without asking permission. But Clemenceau (the future subject of a Manet portrait and two-time prime minister of France) had misread the patriotic feeling that now adhered to these old balloons. He quickly made amends, providing a cartful of hay for the pilots to sleep on and sending half a dozen large dogs to guard the area. The dogs lent canine warmth at night to the three bell tents where Nadar's pilots, or *aérostiers*, slept and ate. Meals and wine were provided by a nearby café owner, Monsieur Charles.

By late September, Nadar was agitating for approval to launch flights that might float mail out of Paris. The urgency was palpable, so on September 22, he was instructed to prepare the *Neptune* for a launch. All night long a team of volunteers patched the holes with cotton and painted the degraded seams with rubber cement. At seven a.m. Rampont-Lechin arrived at the site in a fiacre loaded with canvas sacks. They contained 275 pounds of mail.

An hour later the *Neptune* began its ascent. Its pilot, Jules Duruof, alone in the basket with his precious cargo, looked down at the crowd, which cheered and waved as he shouted farewells. He cut the trailing ropes and emptied a bag of ballast. The balloon shot skyward, rapidly rising to five thousand feet. A slower ascent might have been advisable, since the balloon was unusually fragile. But the mail was heavy, and height was paramount: Duruof's chief concern was to get out of range of the Prussian guns. The *Neptune* drifted southwest. It soon passed beyond the hilltop fort at Mont-Valérien, hovering over the Prussian positions, which appeared to Duruof's eyes like a "black ant heap." The Prussians opened fire.

No one at that point knew the range of the Prussian rifles; only later was it established, as Richard Holmes pointed out in his history of ballooning, *Falling Upwards*, that their bullets were harmless beyond about 3,500 feet. So Duruof's calculation about altitude had been right. Nevertheless, he could feel the vibrations as cannon shells hurtled through the air below him. He returned their expressions of interest with his own sallies, sprinkling Nadar's business cards—each one printed with "Nadar Photographe" and personally marked by the great man with "Compliments to Kaiser Wilhelm and Monsieur Von Bismarck"—from the basket, watching as the cards fluttered down to earth and in some cases into the river, which the *Neptune* seemed to be following of its own accord. For a while Uhlans—the dreaded Prussian cavalry—pursued the balloon, but they eventually gave up, obstructed by turns in the meandering Seine.

After about three hours and sixty miles, the *Neptune* came down near Évreux, on the grounds of the Château of Craconville. It was eleven a.m. Duruof's orders were to hand over his cargo to a general or a prefect. But since he was close to a railway station, he decided to take a train straight to Tours. There his heroic aerial voyage was announced in an official bulletin, which presented both a synopsis of the news out of Paris and a personal message from Gambetta to M. Cremieux, the head of the provisional delegation in Tours. The message, published in newspapers throughout France, declared that Paris was prepared for a heroic resistance and could hold out all win-

ter. Any Prussian reports of discord inside Paris, he added, should not be believed.

A second balloon was successfully sent out of Paris two days later, when Berthe wrote to Edma. She was getting used to the cannons, she reported. But it was unnerving to be in Passy, so close to the fortifications. Were they in danger from the Krupp guns? No one knew, but for now, Berthe noted, morale was up. Paris seemed well defended. The first balloon flights had succeeded. The distressing thing was to have no idea when or how she would hear from Edma again.

Édouard wrote to Suzanne that same day, expressing a similar alloy of optimism and anxiety. It tormented him that she was without news from him. A balloon, he had heard, was due to go out the next day. He'd been assured that his letter would be on it, so he prayed it would reach her. He and his two brothers were all in good health. It was impossible to make predictions, he said, but Paris was well-fortified, and he was confident that, with the help of the remnant provincial forces, they could defeat the Prussians.

From this point on, there was a balloon flight every two or three days. Many carried letters from Édouard, Berthe, and Cornélie. Duruof's package of mail on the first balloon had included some pages written by Nadar in his bell tent on the Place Saint-Pierre. One was an open letter to *The Times* of London. After it was transcribed by clerks in Tours, it was sent by train to Le Havre, carried by steamboat to Dover, then put on an overnight Royal Mail express train to London. On September 28 it was published in a special issue of *The Times* dedicated to the Siege of Paris. (Unhelpfully, from France's standpoint, it included detailed maps of Paris's defenses, which Moltke studied closely.) Nadar knew that the English were generally unsympathetic to France in its current predicament. After all, France had declared war on Prussia, not the other way around. Besides, many British observers saw Paris as a haven for decadence and depravity. So Nadar was trying to win back some sympathy. He painted the Prussians as unreasonable, cruel, and guilty of overreach. Having defeated France's military, they were now intent, he wrote, on punishing her civilians. What's more, in its new, straitened circumstances, Paris was

showing itself worthy of the respect it had been previously denied: "I could only wish, sir, that you could bear witness to the sudden, unexpected sight of Paris transformed and regenerated, and now standing utterly alone in the face of supreme danger. The city of pleasure and frivolity has become silent, grave and serious-minded."

WHEN ÉDOUARD WASN'T on duty at the ramparts, he was allowed to return to the house on the Rue de Saint-Pétersbourg. In letters to Suzanne and his mother, and to Eva Gonzalès, he complained that he couldn't have milk with his coffee and that the butchers were open only three days a week. He described shortages at cafés and queues forming from as early as four a.m, adding that they and all other Parisians—as far as he knew—ate meat just once a day. And yet somehow it was all weirdly stimulating. What was more, he was feeling optimistic. He thought the Prussians must be regretting their decision to besiege Paris.

Édouard had always loved walking in Paris. He was a sharp noticer, almost preternaturally alive to class distinctions, women's fashions, and the subtle minutiae of city interactions. He liked to be noticed in turn. Before the war, he used to go about in a top hat, carrying a cane and wearing blond leather gloves. At the same time, he liked to disarm people with his informality. As a guest in others' homes, he'd think nothing of sitting cross-legged on the floor like a child.

Now, as he walked from his home in the ninth arrondissement, traversing the eighth and crossing into the seventeenth to pay a visit to Berthe and her parents, the city astounded him. He was used to this walk. It usually took about an hour. But the familiar streets and their activities were utterly changed. Their meanings had been scrambled and were no longer legible. "Paris nowadays is a huge camp," he wrote. His fellow soldiers seemed to be doing drills from five a.m. until evening, he reported. Life was otherwise tedious, especially in the evenings, since cafés and restaurants closed after ten o'clock, leaving bed the only option.

When he arrived at the Rue Benjamin Franklin, the Morisots greeted him warmly. But there was a pained and fretful melancholy

in the house. Édouard realized why when they told him they had decided to leave Passy and move into central Paris. The reason was the Krupp guns, they confessed. It just didn't seem safe to be so close to the city walls. Édouard was surprised: he still thought a bombardment unlikely. But he could see the sense in what they were saying. They would rent a home in the Rue d'Argenson, off the Boulevard Haussmann in the eighth arrondissement. The good news was that it was just a short walk from Manet's home.

Over the next few days, however, something must have changed the Morisots' minds. They never did move. Perhaps Édouard's optimism allayed their anxieties. Or perhaps Berthe's parents were unenthused about moving her closer to the artists of the Batignolles—and to Manet in particular.

PARIS WAS NO LONGER recognizable as the city of pleasure—the Ville Lumière, capital of the nineteenth century. "If you saw Paris today, you would be astonished," wrote one resident, Louis Péguret, to his mother in the provinces. "It's no longer a city, it's a fortress, and its squares are nothing more than parade-grounds." But the changes were not just physical: they were also psychological. Everyday life had turned uncanny. An enormous civilian population had been militarized virtually overnight. But these freshly hatched soldiers were not out on a battlefield or gathering in mess tents far from home. They remained in their own neighborhoods, mingling with their neighbors. Most ate food prepared in their own kitchens and slept in their own beds; they shared living quarters with wives and daughters, grandfathers and nephews; they occupied public spaces with children and shopkeepers. None of this matched anyone's idea of being a soldier.

Goncourt took to riding on the ring railway around Paris. The theaters and café concerts had closed, so visiting the fortifications became a favorite Sunday-afternoon entertainment. The train carriages were crowded with new recruits dressed in red military trousers, stripes, epaulets, and caps. But the militarization of the city was not confined to the fortifications. The Tuileries stables and gardens had been turned into a vast artillery park. The still-unfinished Opéra

Garnier was made into a military depot. National Guard officers were billeted in the Bourse. High points around the city—the Butte Montmartre and the top of the Arc de Triomphe—were made into semaphore stations. Known sex workers were moved off the streets and into workshops where they were employed sewing uniforms. The Gare du Nord became a flour mill. Other buildings—the Palais-Royal, the Palais de l'Industrie, the Grand Hôtel du Louvre, and several theaters—were transformed into hospitals. Factories were converted to arsenals. Cannons were forged from melted scavenged iron. And a huge common grave was dug in an area of wasteland in Montmartre—an anticipatory measure intended to prevent the spread of disease in case of mass deaths.

All these preparations for war unfolded as the new republican government was trying, in extreme circumstances, to redress the flaws of the imperial regime and establish new systems of administration. The parallels with the first French Revolution were obvious. A fight to the death with an invading army could break out at any moment.

ARTISTS WHO HAD SIGNED UP for the National Guard banded together in military companies. Bastion 84, for example, was composed entirely of artists. Henri Regnault joined with friends to form another company. Degas served in Bastion 12 alongside his boyhood pal Henri Rouart. Gustave Courbet, now in his fifties, did not enlist. He was an avowed pacifist but no coward—he had declined his chance to escape Paris and return to his family in Ornans. His reward was to be elected president of a committee established to safeguard artworks in museums in and around Paris. That made him responsible for the Louvre, the ceramics museum at Sèvres, the palace at Versailles (which had fallen into Prussian hands), the Cluny and Luxembourg museums, the Gobelins tapestry works, and the Vendôme Column. Preeminent among these sites was, of course, the Louvre. Its history linked it intimately to the first French Revolution and to the ideals of liberty, equality, and brotherhood that republicans believed successive regimes had betrayed—but could now be restored. Protecting its collection was a hallowed task, and Courbet now threw himself into it.

As an administrator, he was out of his depth, but he believed earnestly in what he was doing. For years he had striven to loosen the state's suffocating stranglehold on art and its institutions. He finally had an opportunity to effect change.

Courbet's motivations were always sincere, but he was a compulsive grandstander. He wanted desperately to remain relevant despite the emergence of a new generation of artists, led by Manet. When— shortly before the outbreak of war—he was offered a knighthood cross in the French Legion of Honor, he turned it down. This had the instant and intended effect of getting all the French papers talking about him. He explained to the minister of fine arts that his political beliefs made it impossible for him to accept a title deriving from "the monarchic order." When the state presumes to give out awards, he declared, "it is usurping the public's taste. Its intervention is . . . fatal to the artist, who it misleads as to his worth, [and] fatal to art, . . . which it condemns to the most sterile mediocrity." Manet's young followers couldn't have put it better.

Courbet is remembered as a socialist, but he was also a kind of libertarian. He wanted to belong to no school, church, institution, academy, or regime other than "the regime of freedom." A born agitator, he knew he could play off widespread resentment of the privileges claimed—and abused—by the deposed imperial regime. So he drafted a letter to the Government of National Defense that contained a proposal for the removal of the Vendôme Column. The column had long been unpopular, and pulling it down would be in line with mainstream Parisian sentiment. Erected on the orders of Napoleon I, its design was based on Trajan's great victory column in Rome. In 1863 Napoleon III had placed atop it a statue of his uncle wearing a toga and a laurel wreath, so like the unfinished Opéra Garnier, it was heavily associated with Bonapartist power. The column, wrote Courbet, is "a monument devoid of any artistic value, tending by its character to perpetuate the ideas of wars and conquests that were part of the imperial dynasty but that are frowned on by a republican nation." As a symbol, it was "antipathetic to . . . the harmony of universal brotherhood that henceforth must prevail among nations."

Its presence made "France ridiculous and odious in the eyes of European democracy." He was requesting authorization, he concluded, "to unbolt that column."

In the event, his request was refused. Other priorities had intervened as Courbet's vision of the "harmony of universal brotherhood" rapidly receded. But Courbet carried on with his work, bringing artworks from the Élysée Palace and other locations to the Louvre for safekeeping. The *Venus de Milo* was moved to the basement of the Prefecture of Police on the Île de la Cité. At the Louvre itself, windows were reinforced and sandbags piled up around the perimeter. For Courbet and his fellow republicans, seeing this "cardinal emblem of French patrimony," as the art historian Hollis Clayson aptly described the Louvre, released from the yoke of imperial control was marvelous. For art lovers of all political persuasions, seeing it surrounded by sandbags was deeply alarming.

BY THE END OF SEPTEMBER, the inhabitants of Paris were still poking doubtfully at what they knew was true but had to take largely on trust: there was no way out. It was hardest, perhaps, on those, like Berthe, who had been given an opportunity to leave but had refused. She was hardly alone in her predicament. But as she reflected on her circumstances—confined to her parents' house, her dear sister away on the Normandy coast, and soldiers occupying her studio—she felt pangs of dismay.

The balloon flights offered hope. On September 29 the *États-Unis*, a triple balloon constructed from two old balloons held apart by a rod with a small balloon roped between them, had been sent up out of the city. Its three baskets carried 120 pounds of letters, along with newspapers and government dispatches. The next day's departure was the *Celeste*, a balloon customized for scientific purposes by the young adventurer Gaston Tissandier. This flight, too, was a success, although the landing near Dreux, seventy miles west of Paris, was rough: Tissandier broke his arm. Nonetheless, he made it to Tours, where he was tasked with setting up a communications center.

What had begun as Nadar's fanciful dream was now the Paris

Balloon Post. "One would have to be a pinhead not to recognize the huge significance of what has been achieved," wrote Hugo in a letter to Nadar. "Paris is surrounded, blockaded, blotted out from the rest of the world!—and yet by means of a simple balloon, a mere bubble of air, Paris is back in communication with the rest of the world."

THE SINGLE MOST IMPORTANT figure to have left the city ahead of the Prussians' arrival was Thiers. He may have been an Orléanist with a preference for constitutional monarchy, but the new republican government needed him. More than any of his colleagues, he was a credible statesman—pragmatic, patriotic, wizened by age and experience. He wasn't always tactful, but he was shrewd. So Trochu and Favre asked him to drum up foreign support, in the form of diplomatic pressure or even the threat of military intervention. They knew—as did he—that the longer the war went on, the worse the peace terms would be. Prussia had already won a near-complete victory. Only outside pressure would induce Bismarck to compromise.

Thiers was willing to try. On September 12, he left Paris for London, now crowded with French refugees. (Their number would soon include Monet and Pissarro). Meeting with William Gladstone, the British prime minister, Thiers received little encouragement—only a promise that Britain would urge Bismarck to meet with Favre. Undeterred, on September 18 he left for Vienna, via Tours, Turin, and Venice, arriving in the Austrian capital on the twenty-third. Five days later—the same day the French troops who had been holding out at Strasbourg finally capitulated—he arrived in St. Petersburg, having passed through Warsaw.

THIERS WAS A SHORT, unprepossessing man with a distinctive, pear-shaped head that was catnip to political cartoonists, and he spoke with a Provençal accent. His jowls drooped around his chin. He had thick, closely cropped hair and wore wire-rimmed spectacles, behind which his eyes twinkled with an amused but unflagging intelligence. Berthe's parents, who shared his politics, had known and admired him for years. He was thought to be the model for Eugène de Ras-

tignac, an important character in a number of Balzac's *La Comédie humaine* novels.

When Thiers married, in 1833, his bride was the sixteen-year-old daughter of his longtime confidante, Eurydice Dosne. Eurydice, who was three years older than Thiers, was almost certainly his mistress. But she was already married to a much older and very wealthy stockbroker, Alexis Dosne, who had been persuaded to support Thiers's political career financially. The purpose of the 1833 wedding to Eurydice's daughter, then, was to give cover to the more authentic relationship between Thiers and the woman who was now his mother-in-law. In 1869, soon after Edma's wedding, Eurydice died—leaving Thiers devastated.

Even after his political ascent, Thiers would always be regarded—especially by the upper classes—as a parvenu. He was an intimate confidant of Berthe's friend and role model, the sculptor Marcello. He surrounded himself with female company and loved, too, to have precious objects about him. The support of Eurydice's husband had allowed him to pay off his debts, with enough left over to acquire a grand house on the Place Saint-Georges, which he proceeded to fill with pictures, busts, statuettes, bronzes, and china. Visitors described his study as "a little museum." In the afternoons, he routinely visited Paris's more official museums. As a young journalist and lawyer, he had even dabbled in art criticism.

An admirer of the British system of constitutional monarchy, Thiers loathed both would-be despots and what he referred to as "*la vile multitude.*" He believed fervently in the freedom of the press, asserting that "if you deprive the nation of the freedom of the press you render it deaf and blind." He had warned of the "immense danger" represented by Bonaparte's nephew. This warning cost him. During the latter's 1851 coup, Thiers was yanked from his bed and taken to Mazas Prison. He was released, only to be sent into exile, along with Victor Hugo and thousands of others deemed a threat by the self-proclaimed emperor. When, after eight months, he was permitted to return to France, he was expelled from political life.

So Thiers had ample reason to mistrust Napoleon III, but he was

just as wary of the radical republicans. He thought them deluded and profoundly doubted their ability to govern. "We must have two oppositions," he said, "one for the fools, the other for reasonable people." In the 1860s, as Napoleon III was introducing liberal reforms, Thiers was allowed to reenter politics. Astonishingly industrious (he was powered by cold coffee, imbibed day and night), he was an irrepressible speechifier: between 1863 and 1870, he delivered no fewer than fortyfour speeches in the Legislative Assembly, many of them open attacks on the emperor. He cautioned repeatedly about the risks of Napoleon III's foreign adventures, but his warnings went unheeded, prompting spasms of frustration. "I tell you," he said, "there is not a single blunder left to commit."

FOR TEN DAYS AFTER the siege began, as the Prussians consolidated their occupation of every village within thirty miles of Paris, there were no serious engagements between the two armies. But on the last day of September, the Parisian forces attempted a breakout. Under the command of General Joseph Vinoy, they attacked the Prussian lines at several points to the south. Their initial successes were soon reversed by Prussian reinforcements, however, and by midafternoon the French had retreated, having lost two thousand men, including a general, Pierre-Victor Guilhem.

In October, the Prussians began to unleash their artillery on the ring of French forts. The exploding shells could be heard throughout the city—an unnerving, intermittent booming. The cannons often fired at night, disrupting the sleep of besieged Parisians. The day after Guilhem's funeral, Édouard explained to Suzanne that there were things he couldn't write down because letters sent by balloon could fall into enemy hands. Separately, he wrote to his mother that he had been trying to use his friendship with Léon Gambetta to secure for Eugène a post in the Ministry of the Interior. But Gambetta was preoccupied. His dramatic balloon mission was slated for the following day.

TO THE FRENCH PUBLIC, Léon Gambetta represented energy, ability, and resistance. Along with Thiers, he had been one of the

only voices cautioning against war back in the summer. But now that his country was in peril, he was determined to defeat the Prussians militarily—more determined, in fact, than either Trochu and Favre, who were secretly inclined to favor negotiations.

The crowd that came up the hill on the morning of October 7, 1870, to see the *Armand Barbès* and the *George Sand* take to the skies had invested all its hopes in Gambetta's success. If he were captured or killed, it would be a disaster—and a massive propaganda coup for the Prussians. As Victor Hugo scanned the scene and one-eyed Gambetta gazed down from above, Nadar looked through the parallel barrels of his binoculars as two dozen sailors released both balloons from their moorings. Gambetta rose over the houses of Montmartre, taking in first the cheering crowds, then the stupendous city below, and finally the Prussian encampments. He carried 220 pounds of mail at his feet and sixteen carrier pigeons in a cage lashed to the rigging. His instructions were to get to Tours, where he was to take command of the Ministry of War. He would then rally France's provinces to organize an army to come to the aid of Paris and drive out the Prussians.

The *Armand Barbès* and the *George Sand* (carrying the two American arms dealers) slowly cleared the neighboring buildings, rising to about five hundred feet. Unfortunately, the wind shifted, and they drifted north toward Saint-Denis and Le Bourget—not the direction in which Nadar hoped they would go. Both places were crawling with Prussians. And now further trouble arose. As the *George Sand* floated serenely toward Amiens, Gambetta in the *Armand Barbès* failed to gain the desired lift and in fact began to descend. The timing was terrible. Two defensive forts, Fort de l'Est and Fort d'Aubervilliers, were just beneath him, but they were powerless to help the foundering balloon, which floated haplessly over the perimeter line and met with a fusillade of musket fire. Gambetta, the first statesman ever to ascend in a balloon, was utterly defenseless. He heard a tear and snap as several bullets struck the wicker basket. His pilot, Trichet, threw out more ballast. Finally, the balloon began to rise again, not by much—but it was just enough. The shooting eased, and the *Armand Barbès* continued its northward drift.

Gambetta now had time to register aspects of the experience that he later wrote about. Even with his monocular vision, the horizon seemed vast in ways it never did from the earth. Even more amazing—stupefying, in fact—was the flatness of the land below. "The earth had the appearance of a badly designed carpet," he wrote (almost as if describing a painting by Monet or Renoir), "or rather of a carpet in which different colored wools had been woven entirely by chance. Light and vastness were deprived of the values which shade and proportion give them." Some painters, most prominently Victor Navlet, who specialized in perspective views and architectural interiors, had tried to imagine what Paris would look like seen from a balloon. But even his vast aerial view of Paris from the south, which debuted at the Exposition Universelle of 1855, seemed fussy and artificial compared to what Gambetta was seeing now.

Late morning turned to early afternoon. The two balloons had drifted thirty miles to the north. They were now near Creil, at times so close that the occupants of the baskets could call out to each other. But then the *Armand Barbès* began to descend again. The situation was dire: it had not yet cleared Prussian territory. Suddenly, Gambetta heard more shooting. Moments later he was stunned when a musket ball grazed his hand. Dazed, he fell back into the mail sacks as more bullets zipped past. Several pierced the fabric of the balloon. Clutching his wounded hand, Gambetta waited, expecting a conflagration at any moment—and if not that, then a disastrous final loss of altitude caused by escaping gas. In fact, the puncture was so small as to be almost negligible. But the balloon continued to lose altitude, and Trichet had no choice but to let it descend toward a field near Chantilly. The field had been occupied only moments earlier by a Prussian squadron of uhlan cavalry, and they were still in the vicinity. Only warning shouts from some workers in the field alerted the balloonists to the danger. More ballast was desperately tossed out. The *Armand Barbès* pitched upward again and once more stuttered northward, galloping uhlans in hot pursuit.

By now the two balloons had lost sight of each other. The pilot of the *George Sand* had sensed safety and descended, making a smooth

landing at Crémery, just north of Roye. The *Armand Barbès* had not made it as far and was now skimming the heavily forested region of Compiègne, near Épineuse. By this point, even though Gambetta and his companions had been suspended precariously in the air for four and a half hours, they were not yet forty miles from Paris. Since they could no longer see their pursuers, Trichet decided to attempt again an emergency landing. Unfortunately, he overshot the open ground he was aiming for, and the balloon's basket crashed into an oak tree.

In the ensuing chaos, Gambetta found himself hanging by a rope, upside down, high above the ground. Local villagers arrived on the scene, suspicious and hostile. Only after Gambetta frantically waved a tricolor and shouted *"Vive la République!"* was he able to convince them that he and his fellow balloonists were not Prussians. They were quickly disentangled, bundled (along with the mail) into a haycart, and led to the nearest village. In constant fear that the Prussians were on their tail, they proceeded to Épineuse, where Gambetta was recognized and welcomed by the mayor, then hustled on to Amiens. Gambetta's hand was bandaged en route, but he appeared pale and weak, and his eyes flickered out. He was successfully revived, and when he felt sufficiently lucid, he released a carrier pigeon so that news of his safe arrival might make it to Paris.

After spending the night in Amiens, the balloonists were put on a train to Rouen, where they eased into a station filled with crowds whooping in the rain and a splendid parade of National Guard recruits. Here at the station, Gambetta gave one of those rare speeches that transcend mere rhetoric, because everyone present comprehends the gravity of what is at stake. Paris, he declared, was counting on the provinces. "If we cannot make a pact with victory," he declared, "let us make a pact with death."

A train then took him to Tours.

〰 〰 〰

CHAPTER 9

𝔐 𝔐 𝔐

Line in Front of the Butcher Shop

PARISIANS MAY HAVE BEEN UNITED IN RESISTANCE TO
the Prussian invaders, but in other ways they were divided. One seg-
ment of the population was well-off. They endured great anxiety, but
for the most part they endured it with household servants, money in
the bank, and supportive families. They were the ones who kept dia-
ries and wrote letters, and it is largely their collective account of the
Siege of Paris that has come down to us. The other segment of Paris
was poor, anxious, hungry, and cold. They lived in crowded, often
unsanitary conditions. Their stories remain obscure because they
didn't keep diaries or write eloquent letters that were posthumously
published. They knew the Prussians were trying to defeat and humili-
ate them, but they were less sure that the new republican government
was equipped to do anything about it.

Paris, meanwhile, had lost its luster. For such a vivid, spectacle-
loving city, it felt like an abrupt reversal. The theaters and cabarets
had closed. The railway stations were poignantly empty. Women
spent hours every day standing in line for food. Men attended meet-
ings in the evenings, where the talk turned from the war to rents,
food scarcity, sick children, and disappearing jobs. The city's confin-
ing walls struck Théophile Gautier as "a belt too tightly drawn." As

the autumn deepened and temperatures fell, the worrying intensi-
fied. To allay their anxieties, many took to alcohol. In early October,
meat was rationed. The hunger was bad, but in many ways waiting
around for something to happen was harder. Nathan Sheppard, an
Englishman who lived through the siege, wrote of "the intolerable
tension of expectation." "There is an all-pervading sense," he wrote,
"of something that is going to happen, and which may come at any
moment. This gives a sense of unreality to one's whole life. . . . The
solid earth seems turned to smoke, and to be going away from under
our feet. . . . Such is the inner life of the siege."

FRANCE HAD WAGED A WAR and lost. It had a new government.
A great city had been drastically transformed. Yet to Berthe Morisot,
many things felt strangely the same. She was still *une vieille fille*, a spin-
ster. She was still living with her parents. She was almost thirty years
old. What did her life so far amount to? A shapeless painter's smock
hanging in a dusty cupboard. She was more limited, more confined
than ever. All the feeling of potential in her life—that her painting
might make meaningful advances, that she might earn money from it;
and all the intoxications of her social life, her friendships with Manet
and Degas, her relationships with the Rieseners, with Marcello, with
Puvis, and others—all this had dispersed like so much smoke.

Meanwhile she was ill and losing weight. Cornélie had become
concerned about her diet: it wasn't the first time Berthe's psychologi-
cal state had affected her this way. She was high-spirited, intelligent,
and excitable, but she was also prone to depression. Now, as the day-
light hours grew shorter and temperatures dropped, a sense of futility
had taken hold.

If the siege had isolated Berthe, it stimulated a new solidarity
among many other women. They were angry that the conflict was
threatening their homes, their children's schools, the very fabric of
their daily lives, so they banded together on committees, serving as
ambulancières (nurses in mobile hospitals) and *cantinières* (carriers of
soldiers' mess kits). The schoolteacher Louise Michel, who led the
Women's Vigilance Committee in Montmartre, was a regular, tren-

chant speaker at Club Rouge (Red Club) meetings. At the other end of the social spectrum, Juliette Adam, a prolific diarist, established a field hospital in the Conservatory of Music. It was staffed by twenty women from up and down the social ladder: workers, shopkeepers, artists, and *bourgeoises*. "Instead of staying home mulling over their troubles, devouring their spirit," wrote Adam, these women "come together to work for the wounded; the most courageous fortify the weak ones; we talk about the war, the siege, the government, the newspapers; their imaginations find nourishment. They all thank me for the moral good I have done them by pulling them out of their isolation. . . . One needs work and distraction."

Berthe, unfortunately, lacked company, distraction, and sense of purpose. She was an artist, not a social organizer. Paralyzed by self-doubt, in faltering health, and still stunned by the rapid turn of events, she pined for her sister's company. And for her studio.

BEYOND THE MORISOT HOME, Parisians were losing faith in the Government of National Defense. On October 9, a crowd from working-class Belleville—the city's most radical neighborhood—marched on the Hôtel de Ville, demanding municipal elections. They wanted the chance to make decisions for themselves. For that to happen, power needed to devolve from the center to the local precincts, known as *communes*. So they chanted *"Vive la Commune."* Forces loyal to Trochu organized a counterprotest, and that day the two sets of protesters pitched insults at each other. Nothing was resolved, but calm was restored by evening.

The rest of October resounded with the thunder of cannon fire. People were preparing for the worst. But for now, the Prussians were reluctant to attack the city. Instead, their Krupp guns bombarded the twelve surrounding French forts. On October 13, French gunners tried to return fire from Mont-Valérien, the biggest fort, just west of the Bois de Boulogne. The fort enjoyed a view of Napoleon III's château at Malmaison to the southwest (the site of Josephine Bonaparte's garden) and, farther out, of La Grenouillère, where Monet and Renoir had painted the first Impressionist pictures.

But while aiming to the south at a Prussian encampment, the Mont-Valérien gunners hit instead the château at Saint-Cloud, on the banks of the Seine. Erected in the sixteenth century, the château had been renovated on the eve of the French Revolution by Marie Antoinette. It was where Napoleon Bonaparte had been declared Emperor of the French in 1804 and where Napoleon III had invested himself as emperor in 1852. He and Eugénie had held court at Saint-Cloud, where they frequently hosted foreign royalty, including Queen Victoria when she came for the 1855 Exposition Universelle. It was now destroyed.

"Each day we hear the cannonading—and a great deal of it," wrote Cornélie that same day. She knew she and her family were vulnerable. The nearest forts were Issy and Vanves. Her family's friends the Delaroches had two sons stationed at Vanves, the target of concentrated Prussian aggression. Their two daughters, who had sat for a painting by Berthe the previous year, were beside themselves with worry. "The poor little Delaroches are no longer able to speak without bursting into tears," reported Cornélie in a letter to Yves and Edma. If the forts at Issy and Vanves fell into Prussian hands, she added, the Morisots would vacate the house at Passy and move somewhere out of range of the Prussian artillery. Meanwhile, not knowing what was going on drove Cornélie into varieties of curiosity that came close to recklessness. "It is impossible to keep still," she wrote after walking with Berthe through drenching rain "to see where the fighting was taking place."

ON OCTOBER 21, TROCHU ordered three columns—a total of eight thousand men—to attack the forward Prussian lines at Malmaison. The three-pronged offensive was designed both to test the soundness of the Prussian lines and to raise French morale. Among the soldiers involved were Degas's good friends, the painter James Tissot and the sculptor Joseph Cuvelier. The Parisian forces pushed through the park at Malmaison, taking Buzenval, but as the head of the advancing columns came up against Prussian barricades, artillery pounded the rear. As evening fell, the French commanders ordered a retreat, having lost

five hundred wounded or dead, with 150 taken prisoner. Among the dead was Cuvelier. The news was broken to Degas by Tissot, his friend and onetime protégé. Tissot mentioned that he had made drawings of his fallen comrade on the battlefield. If he was hoping Degas would be impressed, he was wrong. "You would have done better if you had brought back his body" came the stinging reply.

Degas was upset not only by the senseless loss of Cuvelier; he was also furious at art, at its impotence—and by extension, his own. The backstage dreamworld at the Opéra where, over the previous year, he had indulged his imagination, suspecting it might hold the key to unlocking a greatness he felt within, had been closed in September. Since then it had reopened—but neither for ballet nor opera. Instead, it was reserved for political lectures, recitations of Victor Hugo's poetry, and the singing of republican hymns. The conversion epitomized Degas's bitter new reality. The relationship between art and life had been turned upside-down. Theater, make-believe, and imagination had been co-opted and traduced, switched out for propaganda. And for death: Cuvelier would not be coming back.

Nor was Degas the only one feeling frustrated and enfeebled. Édouard had painted virtually nothing since the summer. All his usual springiness and charm, his *interest* in life, seemed expunged. And the same was true of Berthe. Hoping to rouse her, her parents attempted a low-key reprise of their old soirées, inviting Manet, Degas, and Alfred Stevens (who was unwell and couldn't come), along with a young doctor—a bachelor who they hoped might provide a diversion for Berthe.

When Manet and Degas arrived that night at the Rue Benjamin Franklin—the scene, pre-siege, of so much music, levity, intrigue, and wit—a storm seemed imminent as fronts collided overhead, and the behavior of the company was similarly unsettled. The bachelor doctor "played the languishing lover," according to Cornélie, but Berthe was unimpressed. Degas seemed pleased to be back in the Morisot home, but his bitterness about Cuvelier's death lingered, and he behaved sourly. "He was impossible," wrote Cornélie. "He and Manet almost got to pulling each other's hair in an argument over our defensive

efforts and the employment of the National Guard." Both artists, were "willing to die," she added, evidently amused by the notion, "in order to save the country."

Back in the Batignolles, Manet continued to write to Suzanne, not knowing if she would receive his letters and still not receiving any reply. He tried gallantly to joke about the stylishness of his new military greatcoat and complained that he had injured his foot, making it difficult to leave the house. The weather, he said, was terrible. A smallpox outbreak seemed to be spreading, and food shortages were beginning to hurt. Édouard wrote that they were down to seventy-five grams of meat per person and that milk was being reserved for children and the sick. He had asked to be attached to General Vinoy's command, but the request had come to nothing. He didn't mention that he had been to the Morisots'. Instead, he emphasized his solitude. He had struggled to find a photograph of Suzanne, he wrote, eventually finding the relevant album in the drawing room. He could now take great solace from being able to look at her face. "I woke up last night thinking I heard you calling me."

ON THE EVENING OF OCTOBER 27, Carey de Bellemare, an ambitious brigadier posted at Saint-Denis, north of the city, launched an attack on the Prussians at Le Bourget. A veteran of the war in Mexico and, more recently, Sedan, he had neither asked for nor received authorization from Trochu, but on the twenty-ninth he came to the general to report that his force of 250 *francs-tireurs* (irregular formations of light infantry or sharpshooters) had taken the village and he wanted a promotion. The town, alas, was of no discernible strategic value. During the meeting, news came through that the Prussians had launched a counteroffensive. The French successfully repelled it, but their position degenerated when the Prussians called in reinforcements, bombarded the town, and finally launched a full-blown assault. By then, however, the Parisian press had already proclaimed a French victory. The public response was predictably ecstatic; it was the first such "victory" they could point to. However, the euphoria proved short-lived. After many hours of house-to-house fighting, the

remnant French troops found themselves holed up in a church, where their commanding officer shot himself, preferring that fate to surrender. By lunchtime on October 30, the Prussians had secured the town and killed or captured twelve hundred men, having lost fewer than five hundred of their own. Many of the captured were from Batignolles, leaving Manet's neighbors, as he wrote to Suzanne, "in a state of desolation."

The day before Bellemare launched his unauthorized action, Trochu had been informed that General Bazaine and his Army of the Rhine, besieged at Metz since August 21, were negotiating a surrender. This was shocking: Bazaine's army was considered key to Paris's hopes. Many were convinced that the general had enough firepower to break out of Metz. But Bazaine's troops and the residents of Metz had all been on bread rations for two weeks. So short of food were they that they had already butchered and eaten many of the cavalry horses and most of the transport mules. When word of the negotiations leaked and FALL OF METZ was blasted on the front page of *Le Combat* on October 27, Trochu denied the story. He rebuked *Le Combat*, copies of which were then set alight on the streets.

But Bazaine *had* surrendered—he was later court-martialed for it—and by October 30, the government in Paris was forced to admit it. Four thousand French officers and 150,000 troops were now out of commission. The surrender released Prussian troops to reinforce the Siege of Paris and to pour west and south to combat the French forces that Gambetta was trying to build from his base in Tours.

The two crushing disappointments, Metz and Le Bourget, merged in the minds of the population. Disappointment turned to fury, and the following day radicals attempted a coup, having heard rumors that Thiers was not only seeking an armistice but willing to give up Alsace. They were not wrong: Thiers knew that Moltke and Bismarck had been worried about Gambetta's forces—the so-called Army of the Loire—but after the fall of Metz, the threat they posed had been neutralized and could no longer be used as a bargaining chip in negotiations. Thiers was therefore convinced that France should seek an armistice without delay and that the whole country

should hold elections to the National Assembly as soon as possible. Elections would help secure foreign support (Britain, for instance, had not yet recognized the provisional government), which would in turn strengthen France's otherwise dismal bargaining position. Trochu and Favre were in broad agreement with Thiers; they had balked only at the harshness of Prussia's demands. Whether Bismarck and Wilhelm would consider softening those demands depended largely on outside pressure. But it was clear to Thiers, as to Trochu and Favre, that the French position could only worsen the longer the stalemate continued.

Gambetta, however, disagreed. He couldn't abide the thought of France suing for peace. Believing the Prussians would become more vulnerable the longer the siege went on, he was optimistic they could still be beaten. But after difficult negotiations that pitted Thiers and himself against each other, Gambetta reluctantly agreed to seek an armistice, so long as it could be made to favor France militarily.

Thiers then prepared to travel to Paris via Prussian headquarters at Versailles, his movements safeguarded by an agreement negotiated by Russia. He arrived in Versailles, met briefly with Bismarck, and was then escorted to a German outpost at Sèvres, where he was put in a boat and carried down the Seine for a meeting that night at the Quai d'Orsay. He arrived just hours after the French surrender at Le Bourget. Confirming the bad tidings from Metz, he informed Trochu and Favre that Britain and Russia supported an armistice proposal and elections. With Trochu's support, Thiers would take the proposal—which included a ceasefire lasting at least twenty-five days, free movement for Parisian residents, and an opportunity for the besieged city to boost its provisions—back to Bismarck. Trochu and Favre and the other ministers took all this in and, after a long meeting, gave Thiers the green light.

But word of Thiers's contact with the Prussian leadership had gotten out and quickly spread among the radicals of Belleville and Montmartre. The backroom maneuvering incensed them. Georges Clemenceau, the young, mustachioed mayor of Montmartre, posted an announcement describing any armistice proposal as "treason."

On the evening of October 30, Edmond Adam, the husband of Juliette Adam and Trochu's chief of police, went to Trochu to warn of a possible insurrection. He tried again at eight a.m. the next morning, but both times he was dismissed. Nonetheless, on his own initiative, he ordered ten loyal battalions of the National Guard to prepare to protect the Hôtel de Ville. Crowds gathered outside. Later in the day, as the fever climbed, Adam called ten more battalions to the ready. Rain fell intermittently from a pigeon-gray sky. Brandishing umbrellas like swords, people shouted antigovernment and anti-Thiers slogans, and many chanted *"Vive la Commune!"*

Adam's National Guardsmen began to waver. Some carried their rifles with the butt pointing upward to signal that they were on the side of the crowd. In Belleville, the "red" leaders sent their local National Guardsmen to the Hôtel de Ville, with the intention of overthrowing Trochu's government and installing a new leadership team made up of Blanqui, Delescluze (the radical journalist whom Gambetta had defended), Félix Pyat, Gustave Flourens, and Victor Hugo.

Flourens, the son of a distinguished physiologist, led a smallish band of radicals toward the Seine, where the swelling crowd was beginning to encroach on the Hôtel de Ville. Somewhere amid the melee a shot was fired. Everyone dispersed. Summoned from the Louvre, Trochu rode through a jeering crowd but managed to enter the building unharmed. Favre—breaking off a lunchtime discussion of the armistice proposal with Thiers—soon followed. Urging calm, Trochu gave orders that no one should open fire. His government convened in a conference room upstairs. But their presence at the Hôtel de Ville, instead of projecting authority, only galvanized the crowd, and soon several hundred had pushed through the gates and into the courtyard.

Inside, Trochu and his ministers were trying to decide what they could offer the crowd by way of appeasement. They sent out the radical republican and editor Henri Rochefort in the hope that he could be more persuasive, but he was booed and threatened. The stalemate dragged on, as the mob outside shouted for blood and the cabinet inside discussed the potential timing of elections. Prodded upstairs

by the surging crowd, it was Flourens, finally, who broke into the conference room, followed by Blanqui, Delescluze, and Pyat. (Hugo, wisely balking at the prospect of leading a coup, stayed away.) Marching back and forth on the conference table while waving a Turkish scimitar, Flourens declared the government overthrown and began issuing orders. But his announcement devolved into a drawn-out dispute over who should take charge. As the crowd downstairs grew more inebriated, they seemed to forget the purpose of their protest and instead began looting and smashing furniture, even tearing up a plan of Paris drawn by Baron Haussmann. They stumbled upstairs, broke into the conference room, and—not recognizing Blanqui—jostled and harassed the sixty-five-year-old socialist, leaving him cowering in a corner.

Trochu was now a captive, yet he seemed unfazed. Puffing all the while on a cigar, he refused to concede his government's authority. But nor did he threaten the insurrectionists, and by nighttime, with heavy rain pouring outside, the "coup" had degenerated into farce. In the chaos, one minister, Ernest Picard, was able to slip out unnoticed. He went to the Place Vendôme, where he issued orders to the National Guard battalions loyal to the government. By eight-thirty p.m., they had retaken the Hôtel de Ville, and the coup was over.

But the events of October 31 had been more than a fever dream. They were a precursor of what was to come. In the immediate term, the effect was tangible. When Thiers returned to Versailles the next day to put the armistice proposal to Bismarck, the Prussian would not negotiate. After Bazaine's capitulation, he knew his army was utterly dominant. What was more, there was no point in negotiating (he told Thiers) because he could not be confident that the negotiators would remain in power. The previous night's insurrection had made that all too clear.

Thiers was furious, but he knew it was true; it was exactly what he had been desperate to avoid. On November 5, he crossed back into Paris for secret talks, urging Trochu and Favre to accept Bismarck's harsh terms. It was folly, he said, to hold out for Gambetta's Army of the Loire to come to the rescue. If Gambetta failed, which he likely would, France would be forced to accept even more punitive terms. In

the meantime, who knew what further trouble the radicals might stir up? As it was, the government in Paris was hanging by the slenderest of threads. But by now, Thiers's efforts at persuasion were moot: on November 6, Bismarck broke off negotiations altogether.

THE WAR WOULD continue, only worse, wrote Édouard on November 7, having informed Suzanne of the collapsed armistice talks. He said he'd often regretted sending her out of Paris, but was now glad he had.

Much of November passed as if in a strange, floating dream. The marvelous, loathsome, glamorous racket that was Second Empire Paris had seemed a real thing just three months earlier; it was now a distant fiction. Life grew bleaker by the day. With temperatures plummeting, wood and coke were running perilously low. Attempts to organize any form of equitable food distribution had fallen shamefully short. Hoarding became commonplace. In front of the Hôtel de Ville, there was a rat market. The bigger, fleshier rodents sold for 60 centimes, while standard-size denizens of the sewers sold for 30 or 40.

Manet's etching *Line in Front of the Butcher Shop* shows a meandering, improvised line of women standing under umbrellas, waiting to gain entry to the establishment referred to in the title. A bayonet just visible beyond the umbrellas, to the left of the door, suggests that the shop is under guard. The print has an economy that, even for Manet, feels drastic: the doors are only slightly ajar, revealing a thick, black vertical stripe meant to evoke the darkened interior, which may or may not contain the provisions the huddled women hope to purchase. The masses of their bodies are cast in shadow by their big umbrellas, whose wet surfaces reflect bright, bleaching light. The image, described by art historian Léon Rosenthal as "the crowning achievement of [Manet's] art as an etcher," has an abstract, Japanese-style simplicity, as if not only life but art had, by necessity, been reduced to essentials.

Édouard commuted from the family apartment to the fortifications, occasionally spending the nights there. His younger brothers would convene at the apartment on the Rue de Saint-Pétersbourg to

eat their frugal meals and share news. The family's housemaid, Marie, shopped for food, cooking whatever she succeeded in bringing back. Two fellow soldiers were sleeping in Léon's room. Degas, meanwhile, had discovered during target practice that he couldn't see the target properly with his right eye. A doctor diagnosed retinal disease, a slowly deteriorating condition that would plague him for the rest of his life. It meant he couldn't be trusted with a rifle, so he was transferred from the infantry to the artillery.

In a letter addressed to Eva Gonzalès, Édouard described his new life, trying to maintain the fiction that he was still a painter, worthy of being her mentor. He claimed he was carrying around his paintbox and a portable easel, both squeezed into his kitbag. He was determined, he said, not to waste his time and to make use of whatever facilities were available. But this, it turned out, was wishful thinking. He mentioned his diet (horsemeat and donkey on good days—both were expensive), noting the existence of butchers' shops for dogs, cats and rats. The city had become terribly sad. Of all the privations, what pained him the most, he said, was not seeing Gonzalès anymore.

Dipping his pen into the same ink, he complained to Suzanne about not having heard any news from her for so long. Smallpox, he wrote, was spreading quickly, especially among the refugees who had come in from the countryside. But he and his brothers were in good condition: staying active had been good for them. He said he was on maneuvers for two hours every day. "I wish you could see me in my huge gunner's greatcoat." He told Suzanne, too, about keeping his paintbox and easel in his kitbag. "I'll soon be starting to make studies out of doors—they'll be worth a few francs as souvenirs."

NOT FAR FROM BATIGNOLLES, in Montmartre and Belleville, nightly political meetings at the Red Clubs offered radicals the chance to vent and conspire. As the temperatures fell, these crepuscular, unheated halls would fill with the bluish smoke of burning pipes and the frosty plumes of exhaled air as speakers took turns to share rumors, denounce the government, float plans for defeating the Prussians, and propose food distribution measures. Attendees were mostly

working class, but siege conditions had played havoc with social distinctions. People of diverse backgrounds often simply wanted the solace of company, warmth, and laughter. City life was no longer functioning as it should. The mortality rate was rising alarmingly: by mid-November, it was already more than double the pre-siege average. The sewage system was beginning to collapse, and public laundries had had to close because of a soap shortage. The public talk was patriotic, but the stench of disgrace that had started with the routing of the army at Froeschwiller and Sedan had spread after Metz and could not be ignored.

Victor Hugo hosted Goncourt for dinner a week after the failed coup. Grateful to have extracted himself from the chaos of Pyat's misadventure, the garrulous class warrior and die-hard Romantic was still giddy about being back in Paris after his decades in exile. "I like Paris as it is now," he declared. "I wouldn't have liked to see the Bois de Boulogne in the days when it was crowded with carriages, barrouches, and landaus. But now that it's a quagmire, a ruin, it appeals to me. . . It's beautiful, it's grandiose!" They discussed the changes Baron Haussmann had wrought over the previous decade, and soon the conversation turned to the city's defenses. The question on which it was difficult to agree was: Defenses against whom? "The government did nothing to provide a defense against foreigners," declared Hugo; "everything it did was designed to provide a defense against the population."

GOOD NEWS FINALLY ARRIVED midway through November. Eighty miles south of Paris, Gambetta's Army of the Loire had retaken Orléans, the city Joan of Arc had saved from the English siege in 1429. In Paris, the news triggered a rare outbreak of optimism. The hope was that forces within the city might break through Prussian lines to meet up with the Army of the Loire driving north.

By now, two or three balloons were being launched from Paris every week. The postal service had commandeered the Gare d'Orléans (now Gare d'Austerlitz) and the Gare du Nord, converting them into balloon factories. Silk—the preferred fabric because it was lighter—

was in short supply, so calico was used instead. The material was spread out on enormous trestle tables, then cut and sewn by teams of volunteer dressmakers. Workers at the Gare du Nord factory used industrial sewing machines, whereas those at the Gare d'Orléans did it all by hand. Teams of landlocked sailors, accustomed to working with sailcloth and ropes, varnished the calico with linseed oil and lead oxide to make it airtight and twisted the cables. The bags themselves—plain white at the Gare du Nord, striped red and white at the Gare d'Orléans—were suspended from iron girders, inflated with air pumps, and allowed to dry before being moved to the launch sites. There, before takeoff, they were filled with coal gas. Hydrogen was lighter, but it, too, was in short supply, and coal gas had the advantage of not requiring a flame to reheat it during flights, potentially attracting enemy fire.

News of the retaking of Orléans by Gambetta had been delivered by a blood-spattered pigeon on November 14, five days after the decisive battle at Coulmiers, just west of Orléans. From the time of the first successful balloon flight out of Paris, Nadar and his No. 1 Compagnie des Aérostiers had been trying to solve the problem of how to get reply mail back into the city. Balloon pilots could control the altitude of their craft, within limits, but they lacked steering mechanisms, so the balloons' direction was determined exclusively by the wind. On November 7 the Tissandier brothers, Gaston and Albert, having flown out of Paris separately, attempted a return flight in the *Jean-Bart*. With the prevailing winds in their favor, they took off from the gasworks at Rouen, their center of operations, sixty-eight miles northwest of Paris. Their basket was loaded with 550 pounds of return mail, brought to Rouen by train from all over France.

The *Jean-Bart* floated for twenty miles over the Seine toward Paris. But the wind dropped as the sun set, and it came down at Les Andelys, still fifty miles from the city. They decided to try again in the morning. But by then, the wind had changed direction. Uncomfortably close to the Prussian lines, they launched anyway, hoping that at a higher altitude the wind would favor them. In freezing mists, they drifted all day in temperatures that hovered just above zero degrees

Fahrenheit. They could see nothing, but they still hoped that they and their cargo of letters would be in Paris by nightfall. Eventually, they landed in the waters of the Seine. Alas, they were not in the besieged city. They had gone backward and were in a forested gorge near Heurteauville, west of Rouen, farther from Paris than when they started. Villagers in rowboats had to come to their rescue.

The failure of the Tissandiers' attempt caused the postal service to switch to homing pigeons. Letters are heavy relative to birds, and for pigeons to pull off what balloons had been unable to accomplish, the French needed to innovate—and quickly. On November 12, four days after the *Jean-Bart* plunged into the Seine, the commercial photographer René Dagron drifted out of Paris on *Le Niépce*, a balloon named for Nicéphore Niépce, one of the inventors of photography. Dagron had his own invention—and a plan that Nadar and the director of the postal service were determined to help him carry out. *Le Niépce*, carrying thirteen hundred pounds of camera equipment, landed sooner than expected and dangerously close to the Prussians; Dagron only just managed to scramble to safety. But he eventually made it to Tours, where he proceeded to set up a microphotography operation unprecedented in its ambition.

In Tours, thousands of letters intended for recipients in Paris were brought directly to Dagron. Employing a method he had been experimenting with for years, he arranged hundreds of letters at a time onto a large, flat board, securing them in place with a plate of glass. He then photographed them. The resulting exposure was reduced to a tiny negative on a roll of ultrathin collodion film. Each roll could hold more than one thousand letters. A roll of film—or sometimes four or five, tucked inside each other—was then inserted into a small goose quill, two inches long, which was fastened by silk threads to the strongest tail feather of a pigeon that had already been carried out of Paris by balloon.

Back in Paris, pigeon trainers operating as post office agents kept watch twenty-four hours a day. Stationed on small pavilions in a handful of locations, one of them near Édouard in the Batignolles, they looked out at the sky. If the weather was clear, they could often

see birds making their way toward them from a considerable distance. Entering their dovecotes exhausted and sometimes wounded, the pigeons would be gently soothed, their goose quills detached, and the rolls of negatives sent to the postal service. The rolls were cleaned in an ammonium solution, cut up into separate strips, and projected onto large screens by a magic lantern. Sitting in the darkened room, a team of clerks transcribed the letters back onto paper.

Over the course of the siege, 363 pigeons were carried out of Paris by balloon, in the hope that they would ultimately find their way back to the city. Only fifty-seven did. The Prussians had learned of the program and did their utmost to disrupt it, sending out pigeon-hunting patrols armed with buckshot and releasing falcons and hawks. Few pigeons were shot down, though many were incapacitated by cold or exhaustion, and some were killed by birds of prey. But even though only a small fraction of the birds made it back, most of the letters did, thanks to duplication: Dagron made copies of every roll, then inserted the same photographically miniaturized letters into quills attached to different pigeons, thereby increasing their chances of being delivered. The pigeons were also stamped on their tail feathers with numbers that helped the postal service keep track of them. Altogether, about 60,000 of the 95,000 letters sent to Paris were successfully delivered.

THE LETTERS ÉDOUARD eventually received from Suzanne were all delivered by this unlikely method, which depended on balloons, birds, microphotography, and magic lanterns. But by November 23, he had not yet received a single reply, and his disappointment was palpable. "So you didn't follow my instructions for sending your news," he complained. Ten thousand letters had been carried by pigeon into Paris, but none of them was addressed to him. Missing her acutely, he had filled their bedroom with portraits of her and was "reveling," he wrote, in the woolen socks she had knitted him, especially because torrential rains meant that the earth on the fortifications had turned to mud. In the meantime, his housekeeper Marie was distraught because her cat had been killed, almost certainly for food. In

fact, they suspected their two billets. What was to be done? Édouard signed off with a loving embrace, swearing that he "would give Alsace and Lorraine" to be with Suzanne.

Three days later, on November 24, Édouard had just tucked himself into bed when the doorbell rang. It was a delivery: a telegram from Oloron! He felt a rush of emotions as he opened it. It was the first news of any kind he'd received from Suzanne in more than two months. In his response, he wrote that finally hearing from her had given him courage—something that had lately been in short supply.

The Prussians had captured three mail-laden balloons in November, prompting Nadar and the postal service to switch to nighttime launches. On the night of November 24—the day Manet received Suzanne's letter—a balloon named *La Ville d'Orléans* hit violent weather. Its two pilots, Rolier and Bézier, soon found themselves flying at sixty miles an hour in a direction they could no longer discern. For fifteen hours they huddled in their basket, in temperatures as low as minus 32 degrees Fahrenheit. Finally, basket and earth reconnected. The two balloonists were on the side of a mountain—that much was clear—but they had no idea where. Surrounded by snow, they plodded downhill for two days before finally encountering a forester. They couldn't understand his speech or discern his language. Only when they were shown a box of matches with a picture of Christiania on it did they realize they were in Norway. They had flown 840 miles—farther than any other siege balloon.

When Rolier and Bézier explained their situation, some farmers hiked back to the crash site to recover their precious cargo. The tattered remains of the balloon itself had been blown into the next valley, but the farmers recovered three of the four mailbags along with the balloonists' two telescopes, a cooked goose, two baguettes, and a bottle of brandy. Rolier and Bézier were then sent on their way to Tours, via London and Saint-Malo. They arrived on December 8.

Lights Extinguished

FRÉDÉRIC BAZILLE HAD FIRST LEARNED OF THE OUTBREAK of war while staying at Méric, his family's estate just outside Montpellier. It had been a hot Provençal summer, the days dry, the evenings vibrant with the descant of cicadas. Painting outdoors, he was growing daily in confidence, loosening up his brushwork and letting in sunlight—the kind of bright light that irradiates foliage, blocks out stark shadows, and leaves bare skin soapy with sweat. One of his paintings was of a young male nude reclining on a grassy meadow. Another showed an old ruin on the banks of the river Lez; it was like an Italian landscape by Corot but with extra wattage. Bazille planned to return to Paris, and to the congenial company of Manet, Monet, Morisot, and Renoir, late in the summer. At the start of that year, he had taken a new studio on the Left Bank, near the École des Beaux-Arts.

But in mid-August, after the outbreak of war, he set aside his dreams of artistic success. He enlisted in the army as a quartermaster in the Third Zouave Regiment. The Zouaves were a highly decorated unit founded under Louis-Philippe. Originally drawn from an Algerian tribe, the Zwawas, they were, by 1870, mostly from mainland France, but they kept their distinctive uniform of voluminous trousers, short, open, embroidered jacket, and soft red cap, or *chechia*.

To this day, no one is quite sure what motivated Bazille. His well-off parents had earlier purchased a replacement, or stand-in, which excused him from national service. He was no warmonger. "I will definitely never be shouting long live any war," he wrote to his dear friend Edmond Maître at the beginning of August. Maître was dismayed, therefore, when he heard the news. "You are mad, stark-raving mad," he wrote. "Why not talk it over with a friend? You have no right to make this commitment." Maître nevertheless offered his "heartfelt hugs" and, prior to sealing the letter in an envelope, handed it to Renoir, who scrawled: "Break a leg. Arch-brute."

Just a few days before Sedan, Bazille was sent for training to Philippeville, in northeastern Algeria. When his regiment returned to mainland France on September 27, Paris was besieged, and the French Army was in utter disarray. Bazille was stationed near Besançon, close to the Swiss border, conducting complex maneuvers that never quite led to engagements with the enemy. He was impatient for action but in good spirits: "Being so tall, I am the best-known man in my regiment," he wrote to his parents. "The officers are charming with me. I take a lot of meals at their table." By November, however, he was disenchanted with military life. A letter from Maître brought news of Manet and Degas, holed up in Paris, serving in the National Guard. They sounded no better off—but at least they were in Paris!

On November 28, Bazille was promoted to the rank of sergeant-major, declaring, in response to a congratulatory toast, "I know for myself I won't get killed; I have too many things to do in life." The next day his regiment, which had marched into territory just sixty miles south of Paris, engaged the Prussians in a futile attempt to cut off access to Orléans, the city so recently retaken by Gambetta. The battle went disastrously. In midafternoon, hoping to turn the tide, the French general Crouzat attacked the Prussians from the west of the village of Beaune-la-Rolande. Bazille was one of his officers. They met with heavy gunfire from the village itself. There were civilians still in the town, and when Bazille saw them attempting to flee, he realized they were coming dangerously close to the firing line. He charged to the head of his company to warn them of the danger. And

then—suddenly—bullets ripped into his arm and stomach. His tall frame buckled, and he fell to the earth.

Days later, when his father was informed, he was told only that his son had been wounded. So he immediately set off from Méric and journeyed more than four hundred miles. At Beaune-la-Rolande, his desperate questions received no answers, until finally someone led him to the battleground and pointed to a snow-covered grave. His son's. A witness saw him fall to his knees, and for several minutes, he wept. Returning to his feet, he took a cutting from a nearby juniper bush, dug up the body, and carried its great but inert length back to Montpellier on a peasant's cart. In the bright November sunlight, he reburied his son, then planted the juniper cutting on the terrace at Méric. One of the originators of French Impressionism had been cut down in his prime.

ÉDOUARD KNEW HE WOULD see action sooner or later and wondered how he would fare. The days of strolling the freshly hewn boulevards with Baudelaire, discussing art with Degas at the Café Guerbois, or playing the master in Bazille's studio felt far in the past. Like everyone else, he was aware that Trochu and his generals had been planning a large-scale breakout, a *grand sortie*, since the siege's first days. The Prussians knew it, too. It was obvious—and not just because it was the only logical way out of the impasse, short of surrender. It was also a political necessity: you couldn't recruit a force of several hundred thousand men and transform an entire city into a military camp without offering those men the satisfaction of at least trying to beat the enemy.

Ordinary Parisians were growing impatient. Food was running out, temperatures plummeting. Trochu was skeptical about his chances of success, but his grip on power was weakening, and he knew it was time to act. He had planned for an assault on the Prussian lines to the city's northwest, hoping that Gambetta would be able to wheel his forces up so they could attack in a pincer movement. But Gambetta preferred simply to advance northward from Orléans toward the capital's southern suburbs. So on November 19 Trochu's

general, Ducrot, gave orders to his officers to move his prepared force of 80,000 men, 400 heavy guns, fifty-four pontoon bridges, and huge quantities of supplies back along the boulevards of Paris to the opposite side of the city, a position not directly to the south—where Ducrot knew the Prussians had insurmountable strength—but somewhat to the east. His plan was to be as fleet as possible. There was to be no baggage train. Soldiers would shoulder their own rations (for six days) but carry no blankets. Any wagons following behind the troops would carry only ammunition.

To the public, Ducrot appeared full of resolve. "I swear before you and before the entire nation: I shall only re-enter Paris dead or victorious," he announced. "You may see me fall but you will not see me yield ground."

But the Germans became aware of the plan and sent reinforcements. Ducrot's main attack was delayed by a day because of heavy rain. Pontoons were laid, and in the wet dawn French forces crossed the Marne at two separate points. They enjoyed some success in their first hours. Their thundering artillery temporarily subdued the German forces before French troops overpowered them in brief battles at Champigny and Brie. But Ducrot's forces came under heavy fire from well-entrenched positions, and the fields were soon littered with French dead. The Germans counterattacked and by nightfall drove the French back to the same positions at Champigny and Brie that they had taken in the morning. The Prussian lines had held, but they were rattled. The following day a truce enabled both sides to regroup, entrench their positions, and bury their dead.

Édouard saw action during this *grand sortie*, but it's not clear in what capacity. All we know is that on December 2 he was back at his desk, writing to Suzanne; by then, the truce was over and the Germans had launched a massive counterattack. He told her that he had been at the battle the previous day. The noise had been deafening, but he was surprised by how quickly he'd adjusted to the shells flying overhead. He'd been close enough to witness the wounded retrieved from the battlefield under enemy fire and to see captured enemy. With a combination of pride and curiosity, he noted that the Prus-

sian prisoners, most of whom seemed very young, were well-treated. They didn't seem particularly upset about being taken into captivity. For them, he observed, "it means the end of the war. But when will it end for us?"

As he wrote, some of the fiercest fighting had taken place around Champigny and Brie. The French infantry had successfully kept the counterattacking Germans at bay, and when the mists cleared, the guns from the fort at Mont Avron forced the Germans to retreat in disarray. On the night of December 2, the Prussian high command was worried. They thought the French might actually break through on the third.

But they needn't have feared. The French could not sustain their attack. Ducrot had been told that the Army of the Loire, a force of 120,000 men, had commenced its northward march, but he doubted their chances of making it to Paris in time. He couldn't wait: his infantry, the Garde Mobile, had spent three nights out in the open, in temperatures below freezing, without even blankets. On his morning inspection of the troops on December 4, Ducrot saw men "crouched on the frozen ground, exhausted and shivering" and desperately hungry. He knew it was time to pull them back into Paris. Mists concealed their morning movements across the Marne. They camped in the Bois de Vincennes, twelve thousand fewer than when they had set out.

The failed sortie marked the beginning of a forlorn new stage in the siege. The following day Bismarck sent Trochu a note announcing that the Army of the Loire had been defeated and that waves of Germans advancing south had retaken Orléans. This in turn forced Gambetta's provisional government to withdraw from Tours and reestablish itself in Bordeaux. Having broken his promise to succeed or be left on the battlefield, Ducrot now implored Favre to sue for peace.

IF, ON THE NIGHT of November 30, a balloon had happened to float over Paris, the scene below might have appeared to twinkle faintly until all but a sprinkling of yellowish smudges and some roving searchlights dissolved into the surrounding darkness. Supplies of gas had been summarily cut off. The light that had illuminated Sec-

ond Empire Paris, transforming social life in the process, had been in short supply for over a month. Earlier in the siege, Thomas Gibson Bowles, the founding editor of *Vanity Fair*, had noticed the "astonishing" effect that halving the supply of gas to the streetlamps had had on the atmosphere. "It has changed the aspect of the town," he wrote, "and no less striking is the influence it exerts in driving people home at an early hour." In place of the gas lamps, twenty thousand oil lamps were installed on the streets, and the difference was immediately noticeable. Where gas light has a blue tonality, the light from the petrol used in the oil lamps was yellowish, like the aging varnish over the Louvre's Old Masters. Optically, the effect seemed to many not just "lugubrious" but "utterly passé," and the smell was acrid. Haussmann's long boulevards were transformed back into the dark and dangerous streets of old. The only remaining signs of modernity were the military's electric searchlights crisscrossing the sky at night. As winter deepened, the gloom emphasized the city's lost prestige, its "tarnished luster"—an indicator not only of material decline but faltering morale. Temperatures were now consistently below freezing. After two heavy snowfalls, the city was blanketed in snow from December 12 until early January.

With Christmas approaching, Paris was still resisting, but the optimism of autumn had guttered out. Hungry, sapped of its glamour and pride, the city was bracing for a winter that would prove the coldest in living memory. One night after December's first big snowfall, Edmond de Goncourt walked from Passy to nearby Auteuil. The road had not yet been cleared, and the snow muffled the city's usual din. As he trod a path between the Bois de Boulogne and the Seine, his every footfall produced the soft crunch and gentle squeak of compacting snow. He found himself succumbing, in this strangely altered atmosphere, to morbid imaginings. "The sky melts into a damp fog, pierced only by the diffuse clarity of moonlight," he wrote in his journal. "The idea of death, in this landscape of moon and snow, comes almost sweetly upon you. You could fall asleep without regret in such poetic coldness."

Goncourt's brother, Jules, had died earlier that summer after a stroke brought on by syphilis. He had been just thirty-nine. Jules

had been Edmond's fellow diarist and co-conspirator. Ever since their mother's death in 1848, the two brothers had done everything together. They dined together in restaurants, went to museums and looked at art as if through each other's eyes, and they slept in adjacent rooms. In twenty-two years, they had been separated only twice, in both cases for no more than twenty-four hours. Jules's final days had been excruciating. He suffered violent convulsions, fever, and delirium. "To think that it is finished," wrote Edmond, on the eve of Jules's death. "I shall no longer have him walking beside me when I go out. I shall no longer have him facing me when I eat. . . . I shall no longer have his twin mind to say before me what I was going to say or to repeat what I have just been saying."

Six months later—and it had been a stunning six months—Edmond was still grieving the loss. But he was no longer quite as dazed. His old powers of perception appeared intact on the December night when he paid a visit to Victor Hugo. Some "rebellious streaks of white" in Hugo's hair, he wrote in his journal, reminded him of one of Michelangelo's prophets, and on his face was an expression of "strange, almost ecstatic tranquility." Yet every now and then, noted Goncourt, the master's "dark bright eyes, or so it seemed to me, lit up with an indefinable expression of evil cunning."

AFTER HIS RETURN FROM EXILE, Hugo had taken up residence at the apartment of his old friend Paul Meurice on the Avenue Frochot, just down the hill from Nadar's balloon launch site at the Place Saint-Pierre. There an unending stream of politicians and writers had come to pay their respects. Hugo was happy to be back in Paris, where he was almost frantically loved. His renown—as poet, playwright, and novelist but also as a champion of the poor and proselytizer for a city he saw as a beacon for a universal civilization that he hoped one day to see realized—was unrivaled. Even as the Prussian noose tightened, bureaucrats in the fragile new republic named boulevards, orphanages, and hot-air balloons after him. Politicians who came to ask his advice would promptly introduce legislation for whatever initiatives he recommended. Women, too, lined up at his door. His diary

entries during the siege were peppered with coded references to the lovers he took, sometimes more than one a night. "Every night at about ten o'clock," according to Goncourt (who was supplied with the details by Madame Meurice), Hugo would leave the Hôtel Rohan on the Rue de Rivoli, where his long-term mistress Juliette was quartered. "He would then return to the Meurice home where one, two or three women would be waiting for him, frightening the other tenants who bumped into them on the stairs—all sorts of women, from the most distinguished to the dirtiest of drabs." On December 16, Hugo's diary suggests he slept with no fewer than five women.

But two nights earlier he had taken into his arms just one—an unmarried woman called Marguerite Héricourt, to whom Hugo had given a Spanish nickname, "Doña Sol." His time was limited that night, because he also received a visit from the art critic Philippe Burty, a keen connoisseur of prints and a friend of Édouard Manet. Burty had carried a set of Francisco Goya's *Disasters of War* etchings through the streets of Paris and up to the Avenue Frochot. It was a bitterly cold night. The streets were piled high with snow.

There was no fuel left for a fire so the two men sat in their coats, passing the prints back and forth. Hugo let his mischievous eyes linger over each of Goya's etchings, scanning the captions appended in Spanish beneath. The things Goya had been willing to show almost defied belief. He had been dead forty years, but it was uncanny: he could have made these images yesterday. It was all terrifyingly raw. Wild-eyed men cut down at close range by soldiers with rifles. Women yanked from their babies and raped. Goya's etched lines had an unadorned, improvised quality complemented in his captions by a tone so sardonic, it slid into an almost sensuous contempt. Beneath a depiction of a man retching over a pile of corpses, he had written, "This is what you were born for." In the etching labeled "Charity," naked corpses are thrown in a hole in the ground. In "Rabble," a male body, naked from the waist down, is about to have a long stick shoved up his anus. Other etchings of lynchings, dismemberments, and impalings have titles like "This is too much!,"

"Nobody knows why," "What more can one do?", "This is worse," and simply, "Why?"

Once in a while, to let his eyes rest, Hugo looked up from the etchings and gazed out the window, remembering. He had gone to Spain as an army brat on the cusp of puberty. His father, Joseph Léopold, had been a general in the army of Napoleon Bonaparte. The Spanish rebellion had left Napoleon's forces effectively besieged in the cities and towns, making Hugo's three-month journey from Paris to Madrid with his mother and brothers extremely perilous. A French convoy that had passed over the Pyrénées immediately ahead of his was ambushed and massacred, the women raped, the children dismembered, the men roasted on spits. Hugo's father was meanwhile engaged in a running battle with a local leader of the rebellion. Goya depicted some of the brigand's atrocious terror tactics in *Disasters of War*. But as he well knew, French tactics were scarcely less horrific. The anticlerical General Hugo, for instance, became known for hanging garlands of severed heads over church doors.

Hugo's time in Spain was fraught—and not just because of the rebellion. Soon after he and his two brothers and their mother Sophie arrived in Madrid, his father learned that Sophie had had an affair with Victor's godfather, who had recently been arrested in Paris for plotting against the emperor. When the scandal broke, Hugo was separated from his mother. But when Arthur Wellesley, the future Duke of Wellington, began marching on Madrid, they were reunited and, along with thousands of their compatriots, swiftly ushered out of the country. At the cathedral town of Burgos, the young Hugo saw a Goyaesque scene: a man seated backward on an ass on his way to the public square, where he was to be garroted. Farther on, at Vitoria, he saw the severed limbs and head of a bandit's nephew nailed to a cross. Many in this hasty French exodus perished crossing the hot dry plains north of Madrid, where the wells were poisoned with the festering carcasses of dead animals. Hugo made it safely back to Paris. His godfather, however, was taken to a vegetable garden on the outskirts of Paris, placed in front of a firing squad, and summarily shot.

At the center of the fifteenth of Goya's *Disasters of War* etchings—the execution scene—a blindfolded man is about to be executed by three French soldiers. With his unmatched flair for tonal contrasts, Goya used the white of the paper, haloed with thick horizontal hatching, for the man's illuminated clothes. This etching and Goya's painting *The Third of May 1808 in Madrid* had been among the inspirations for Manet's *Execution of the Emperor Maximilian* three years earlier. In the etching, the executioners' musket barrels protrude into the frame at right. Terrifyingly, the man can't see them—his blindfold prevents it—but we can. With typical terseness, Goya captioned it "Y no hai remedio": "And there is no help."

"Beautiful and hideous" was Hugo's verdict in his diary that night.

WHEN ÉDOUARD LEARNED of the defeat of his friend Gambetta's Army of the Loire, he despaired, convinced it represented the end of the city's last hope. He was constantly hungry. In one letter to Suzanne he lamented the fact that his mother had chosen not to lay in provisions; there was nothing left to eat. And the lack of information grew more oppressive. On December 7, not a single pigeon had homed for three days. Two days later rumors spread that the long-feared Prussian bombardment was about to begin: huge numbers of Krupp cannons were being carted from Versailles and placed around Paris's perimeter. Édouard had survived his brief experience of the battlefield, but his general health was compromised, and he was plagued by a mysterious injury to his foot. Within a few days of the failed sortie, he requested a transfer out of the artillery and onto the general staff. "The work in the artillery was too demanding," he wrote to Suzanne. "So don't worry, I shall be safe as well as in a position to see everything."

Meanwhile, by mid-December, Berthe had withdrawn into herself. Her health had deteriorated badly as the winter deepened and food became scarcer. Her parents were gravely concerned, regretting more than ever their acquiescence in her decision to stay in Paris. "We are very much on edge, very sad," Cornélie wrote to Edma and Yves on December 15. "Berthe worries me a great deal. She seems to be

getting consumption [tuberculosis]. She fainted last week. For almost two months she ate enough and looked fairly well; now, all that is wiped out."

The worst was not being able to see ahead. "We see no reason why this should end," wrote Cornélie. "Paris will not yield as long as it is possible to hold out. The people are beginning to suffer, but are so courageous, and those who advocate capitulation are but a small minority. The general opinion is that we could indeed go on in this way for another two months. Obviously, if the defense is maintained for that length of time, we shall all suffer."

ALTHOUGH THE MODERATES around Trochu were urging him to sue for peace, he knew the Prussians would refuse to offer acceptable terms and that any sign of caving in to Prussian demands would inflame the radical elements within Paris. So for now, he had to hold out. Paris, after all, had not yet been conquered. Around the world, people were heaping praise on the city for its tenacity and resolve.

Still, a dispassionate look at the supply situation suggested that bread for civilians would not last beyond January 15 and, for the army, January 31. So Trochu prepared for another sortie to the northeast. On the morning of December 21, with the landscape shrouded in mist, a combined force of regular troops, *francs-tireurs,* and marines pushed east from Saint-Denis toward Le Bourget. The temperature was 7 degrees Fahrenheit (minus 14 Celsius). The French were initially held at bay by intense Prussian shelling, but they gradually advanced and soon succeeded in taking Le Bourget.

However, a second, tightly packed column was not faring so well. These troops, under the command of General Ducrot, were coming from a different direction. They never saw the enemy—only distant puffs of smoke that dispersed into the lingering mist—yet they were torn asunder by enemy fire. It was butchery. By midafternoon, with the sun already near the horizon, Ducrot ordered his soldiers to pull back. Loath to admit defeat, he made them dig trenches through the night, intending to revive the attack in the morning. But the ground was frozen solid. The soldiers had no wood for fires and no possibility of erecting

tents—the ground was too hard even for pegs. Blasted by a brutal north wind, they passed the night and the next day out in the open. There were a thousand cases of frostbite. Two thousand men had been killed.

Favre saw the state of the troops on a visit to Trochu's headquarters the following day and decided it was time to bring the military more firmly under the government's control. He would have demanded Trochu's resignation, but no replacement was palatable to Paris's weary citizens. (Ducrot was ready to surrender; Vinoy was not even a republican.) So Trochu was persuaded to stay on and think up yet another plan.

THREE DAYS BEFORE CHRISTMAS, Édouard wrote again to Suzanne, explaining that both Eugène and Gustave were with their battalions, but he, Édouard, was too sore even to ride. All they had left to eat was some unrefined bread and occasional scraps of meat. He hoped that his letters were reaching her, unsure about whether the wind "is in the right quarter for balloons at the moment."

Christmas Day was the one-hundredth day of the siege. The next day a group of radical republicans met at the Club de la Reine Blanche. One man, referring to himself as "Citizen Joly," got up to express his dismay at the total lack of military success. Trochu and his government, he concluded, were "dragging us gently toward capitulation," so it was time to "take matters into our own hands."

In some ways, his proposal paralleled what breakaway young artists like Bazille, Monet, and Renoir had been propounding before the war: a new, more democratic way of doing things; a leveling of hierarchies; a shrugging-off of calcified, inherited models of decision-making. But Joly was not proposing an art exhibition. He was proposing the formation of a new governing assembly of three hundred members. Although he thought it unwise to call it a Commune—he worried the word had associations with Robespierre's Terror and might deter "the faint-hearted"—another man, Citizen Gase, stood up to say he deplored euphemisms and dishonesty and that the Commune should be called the Commune. "At the end of the meeting," according to the minutes, "there were cries of 'Vive La Commune!'"

HAVING BEEN TRANSFERRED from active duty to the general staff, Édouard found himself under the command of an artist rival—the painter Ernest Meissonier. Meissonier was seventeen years older than Édouard and had attained the rank of colonel. A star at the annual Salons, he was celebrated for his detailed military paintings of Napoleon I and for piquant scenes imagining daily life in the seventeenth and eighteenth centuries. John Ruskin, the great English critic, was in awe of his "manual dexterity" and "eye for fascinating minutiae." This was exactly the kind of eclectic, historicist, show-offy painting Édouard most loathed, so he was less than thrilled at having to serve under him. After meetings, according to Beth Archer Brombert, a Manet biographer, Meissonier left idle sketches on the table that toadying subordinates eagerly snatched up—though not, conspicuously, Édouard, whom the colonel never acknowledged as a fellow artist, despite being perfectly aware of who he was.

Édouard's contact with Meissonier did prompt him to turn to thoughts of painting. He had told Suzanne that his knapsack held "everything necessary for painting" and that he thought he could produce some things that would later have value as "souvenirs" of the siege. So on December 28, his first day working on the general staff, he made two small, sketchy and exceedingly bleak-looking paintings. The first showed the small railway station at Sceaux, just south of the Montparnasse Cemetery in the fourteenth arrondissement. Édouard gave it to a friend and fellow artist, Eugène Lambert, but it has been missing since 1944. The other, called *Effect of Snow at Petit-Montrouge*, showed the tall and boxy spire of the Church of Saint-Pierre (erected during Haussmann's redesign of the city) at nearby Petit-Montrouge, seen from across an expanse of snow and brown earth. The painting is inscribed "to my friend H. Charlet" (likely a fellow National Guardsman) "28 Dec. 1870." It is virtually monochrome. Manet's handling of the foreground is extremely loose, and the distant church spire and other buildings are conveyed with the barest notations. If he had in mind a souvenir, the

memory invoked by *Effect of Snow at Petit-Montrouge* was of desolation and gloom. Manet painted nothing else during the siege.

SHELLS WERE NOW REGULARLY falling to the east of Paris. "Cannon all night long," wrote Hugo in his diary. The writer had spent the siege writing stirring broadsides, agitating on behalf of the indigent, and enjoying his celebrity as the republic's benevolent patriarch. Everyone, it seemed, wanted a piece of him. Back in October, three days before Gambetta's departure on the *Armand Barbès*, Hugo had marveled that a "popular photograph of myself is being sold in the streets." A few days later five delegates from the ninth arrondissement came to him "to forbid me from getting myself killed, seeing as how anyone can get himself killed but only Victor Hugo can do what he does." Now, four days after Christmas, Hugo received a heartbreaking letter from his writer friend Théophile Gautier.

Gautier had a horse he loved, but Paris's equine population was thinning dramatically. People were hungry, and the time had come for Gautier to sacrifice. The prospect made him distraught. "Loving and adoring only you in all this life," he wrote to Hugo, "I come with tears in my eyes to beg you to use one of your mighty words to save the life of a poor and cherished beast which they wish to take to the abattoir." Appealing to Hugo's "universal goodness," which "has pitied beasts as well as men," and thanking Hugo for not laughing at his suffering ("I am ashamed of disturbing Olympus for such a trifle"), he begged him to "spare this poor innocent being." "We must act quickly," he concluded, "I have only a 24-hour period of respite."

"Th. Gautier has a horse," noted Hugo in his diary. "The horse has been arrested. It is to be eaten. Gautier has written asking me to obtain its pardon. I have appealed to the Minister." Meanwhile that same day, something more awful than the killing of a poet's horse took place. For weeks, the city's more privileged inhabitants had been eating animals from the zoos in the Jardin d'Acclimatation and the Jardin des Plantes—some of them at the restaurant Voisin, where the chef, Alexandre Choron, prepared such dishes as antelope terrine with truffles and haunch of wolf with deer sauce. Hugo himself had been

presented with antelope on November 29; two days later (the same day an orphanage named for him was opened on the Boulevard Victor Hugo) he had been served bear and the next day stag. By late December, running low on such relatively palatable fare, the zookeepers had turned to the city's two beloved elephant twins, Castor and Pollux. For seven years the pachyderms had entertained and awed both residents and visitors to the city. "As lively and playful as kittens" is how one correspondent for the *Times* described them. They would "gallop and strike each other with their trunks," then "lie down beside each other." Small children would be placed on their backs as they were taken for walks through the Jardin d'Acclimatation.

But now all that was over. Just keeping two elephants fed consumed enormous resources. And for what? The twins could be put to better use. So now a Monsieur Deboos from the Boucherie Anglais, which catered to wealthy clients, purchased Castor and Pollux wholesale for 27,000 francs. On the appointed day, a carbine gun was used to shoot Castor. The wound gushed blood, but the elephant seemed largely unaffected. "He seemed convinced that the wound was due to an accident, and did everything his butchers told him with the greatest docility," wrote one observer. Two steel-tipped dumdum bullets, designed to expand on impact, from a chassepot rifle proved more effective. The lead lodged beneath Castor's thick hide, and the enormous creature slumped screaming to the ground. Pollux met the same fate the next day, December 30. Their bodies were dismembered, skinned, sold to restaurants, and eaten—generally, it seems, without pleasure: the meat, according to Henry Labouchere, was "tough, coarse and oily, and I do not recommend English families to eat elephant as long as they can get beef or mutton."

As Prussian shells rained down on the Fort de Rosny, east of the city, Hugo noted in his diary that "we are not even eating horse now. It *may* be dog, or *perhaps* rat. I am beginning to have stomach pains. We are eating the unknown."

ON NEW YEAR'S DAY, Édouard and his brother Eugène crossed the cold, denuded city to pay another visit to the Morisots. Gangs armed

with hatchets were sweeping Paris, cutting down everything in sight, from the old limes and plane trees in the parks to the young saplings lining Haussmann's boulevards.

Both families had been rent asunder. Those who had remained in the city were hungry, cold, and ill. Fruit and vegetables were no longer available. Candle tallow or horse fat were being used in place of butter. Milk had long since run out. People were devising strange concoctions as viable substitutes, especially for children, but they carried only a fraction of the necessary nutrients. Typhoid, cholera, and smallpox were spreading among the poor. The mean mortality rate for the month of January in Paris over the previous five years was 838. It now swelled to 3,680.

When he arrived at the Rue Franklin, Édouard immediately worried. The Morisots were visibly unwell and struggling to cope with "the hardships of the siege," he reported to Suzanne. Berthe appeared particularly gaunt and anxious. He wished he could do something for her. The two families felt unaccountably bound to each other, drawn tight by an invisible thread. But as they sat to talk, they avoided politics. The one thing both families had long wanted—the removal of Napoleon III—had come to pass. But Trochu's provisional government was in an invidious position, and rumblings of a takeover by radicals were getting louder. Berthe's parents dreaded such an eventuality, but they knew that Édouard and his well-born brothers had expressed support for the radicals' agenda.

Édouard was careful in what he wrote to Suzanne—he didn't want to worry her—but he, too, was struggling. His position on the general staff required him to spend hours each day outside in the cold on horseback. Unaccustomed to spending so much time in the saddle, he developed boils and soon was confined to his room for two days.

BY NOW, TROCHU'S GOVERNMENT of National Defense was in disarray. A meeting of delegates from all the radical clubs was held on the Rue d'Arras, in the Latin Quarter. It was announced that a committee representing all twenty arrondissements would be formed with "a view to establishing the Paris Commune."

The Prussians, meanwhile, were losing patience. Laying siege to a well-fortified city was draining and—for the besiegers as much as the besieged—demoralizing. So Moltke finally resorted to a measure he'd been loath to pursue, for fear of arousing the indignation and intervention of foreign nations: he began to bombard Paris itself.

It was the first time a modern nation had indiscriminately bombed a civilian population. For the first four days of 1871, the shelling was directed at the forts to the south and to the east. But on the evening of January 5, a Wednesday, one cannon began lobbing screaming shells into the city itself. Once this moral Rubicon was crossed, 300 to 400 shells were fired into the city every day. Most were directed from the south, and so the Left Bank, dominated by some of the coldest and hungriest working-class inhabitants, absorbed the worst of it. The Panthéon and the Sorbonne both sustained damage. "The enemy is not content to shoot on our forts," declared Trochu, in a statement posted throughout the city. "Now it fires its projectiles on our buildings, it threatens our homes and families. This violence redoubles the resolution of the city to fight and to conquer . . . *Vive la France! Vive la République!*"

The power of the Krupp cannons astounded everyone. Their normal range was over two miles, but extra-heavy charges meant that shells fired from the Châtillon Heights could reach as far as the Île Saint-Louis. Those charges had to be used sparingly because they could damage the guns. But for Parisians, simply knowing that it was possible—that no matter where you were in the city, you could never feel entirely safe—was to feel subject to continuous intimidation. The bombardment was conducted mainly at night, to accentuate the terror. Surprisingly, however, most of the shells exploded in open spaces, and those that hit buildings were less destructive than might be imagined. "There was no wailing," wrote the English journalist Albert Vandam, "no wringing of hands, no heartrending frenzied look of despair. . . . There was merely a kind of undemonstrative contempt."

Paris may have been on its knees, its leaders all but ready to concede, but the bombardment aroused a renewal of purpose and unity that almost certainly prolonged the siege. When hospitals and

churches were hit—persuading Parisians that these buildings were being deliberately targeted—French bellicosity flared like embers coated with the ash of exhaustion. Trochu sent an official complaint to Moltke, who replied that the evening fog had made accuracy difficult. It would become easier, he said ominously, when they got closer.

The city's residents finally had something specific to respond to: a spectacle. "Parisians go out of curiosity to see the bombarded neighborhoods," wrote Hugo. "One goes 'to the bombs' like one would go to watch the fireworks." But of course, those who lived on the outskirts of the city, nearer to the Prussian artillery, like the Morisots, were less eager to gawk at craters or walls blasted to rubble. They were frightened. The bombardment attained a lashing intensity on the night of January 8 when nine hundred shells were fired into the area around Odéon at a rate of one every two minutes. More than twenty people were killed, and thirty-seven were badly injured. Residents cowered in basements, listening out for the whistle and scream of falling projectiles. And yet only sixty people were killed by exploding shells during the entire January bombardment.

But other things were killing them. As January progressed, thousands of Parisians were dying of disease and starvation. Women were generally worse off, as most of the men were enlisted in the National Guard, among whom provisions were more evenly spread. For those not eligible, the price of whatever food was available had risen beyond most people's means.

DEGAS, LIKE ÉDOUARD and Berthe, did very little painting during the siege. He was busy in the artillery, art supplies were hard to obtain, and he was worried about his recent diagnosis of retinal disease. But deep into the siege, he did hire a model and got her to pose, fully clothed, in a chair by the window in the shadowy interior of his apartment. Light from outside cast her face in shadow, transforming her into a wistful silhouette. Degas loved to experiment, and the unusual contre-jour effect created by the figure against the window excited him. He brushed some color—predominantly burnt orange—onto paper, using paint drained of its oil and thinned with turpentine, so

that the effect was more like watercolor or gouache than glossy oil paint. He indicated an empty chair with cursory black outlines and curtains with streaky vertical lines in white. The woman is turning away from us and into the light. She looks pensive. One cannot tell if she is calm, anxious, or perhaps obscurely ashamed. When the session was over, according to the artist Walter Sickert, who became close to Degas later in life, Degas gave the model a hunk of meat as payment, "which she fell upon, so hungry was she, and devoured it raw."

ON JANUARY 8, a week after the Manet brothers' visit, Cornélie wrote to Edma and Yves to say that Berthe's health had taken a disturbing turn. She had sent for a doctor, who gave her "the impression that her frail health will improve under his care," but she was clearly anxious. The Prussian bombardment, she continued, "never stops. . . . It is a sound that reverberates in your head night and day; it would make you feverish if you were not already in that state." Some bombs had landed nearby. "You might assume that we are afraid, but we are not at all frightened; it is curious how much of its force an evil loses when it is faced at close quarters." "Paris does not lose courage," she concluded. "I find it superb, and yet what suffering, what dire need. It is heartrending."

Édouard, meanwhile, was once again bedridden—a bout of flu to go with the boils on his backside. Paris, he wrote, was unimaginably sad. The horses had all been eaten. The only remaining bread was barely edible. Gas had run out. And all day, all night, the cannons boomed. He was glad his mother had been spared such conditions, and that Léon had avoided conscription and possible death.

The next day—the day Paris ran out of coal—the Morisots received news that Berthe's brother, Tiburce, had been captured by the Prussians. He was being held captive in Mainz, near Frankfurt, more than three hundred miles from Paris. Manet heard about it from Cornélie. "The poor things needed some good news," he wrote to Suzanne.

ÉDOUARD DID NOT yet know it, but this last letter was written on a momentous day in modern European history. In a lavish ceremony

held in the Hall of Mirrors at Versailles, a unified German kingdom was declared. Bismarck had been working toward this goal for years and had goaded France into war precisely in order to realize it. All through the winter, he had been hard at work negotiating with princes and parliamentarians in the southern German states and with party leaders in Prussia. He did all this while navigating a path between King Wilhelm, who was old, unwell, and anxious about unintended consequences, and the crown prince, who was passionately in favor.

Europe now had a formidable new power—a unified state with a strong sense of destiny, a state that would change the course of history. The ceremony was witnessed by nobility from all the German-speaking states. The French never forgave the fact that it took place not in Berlin but in Versailles.

Meanwhile the world was beginning to think that Paris had suffered enough. The bombing campaign had stimulated international outrage, and Bismarck was increasingly worried that other European powers would feel obliged to intervene. At the same time, he was trying to make sense of the political dynamic inside Paris, since it would have repercussions for any peace treaty. Were Trochu and Favre in control? How close were the radicals to mounting a full-blown insurrection? What was Thiers playing at? What role would Gambetta play? And could Empress Eugénie, who was in England proposing peace terms that would return her to power (with or without her ailing husband), impose stability where others had failed?

Even as the besieged city's resistance was beginning to crumble, Moltke's ability to maintain the siege was coming under strain. It was challenging to supply 800,000 troops in a foreign territory with food, arms, and equipment, to maintain communications across vast distances, and to keep up morale through a punishingly cold winter. Fatigue was setting in, even in this most disciplined of armies. The scattered French forces organized by Gambetta (which now included soldiers under the command of Giuseppe Garibaldi, fighting for the new French republic in the final military campaign of his career) were making life difficult for German soldiers. For months, French *francs-tireurs* had been launching night attacks on small, vulnerable German

contingents, disrupting lines of communication and supply, so that the soldiers now lived in fear of these unpredictable attacks. The German troops surrounding Paris, meanwhile, were homesick, as bored and tired of waiting as were the residents trapped inside Paris. Moltke, blind to the political implications ("I am concerned only with military matters," he snapped), wanted Paris crushed and its defenders imprisoned so his army could march south to destroy Gambetta's forces. "We must fight this nation of liars to the very end," he said. "Then we can dictate whatever peace we like."

CHAPTER II

The Siege Ends

BY THE TIME THE GERMAN EMPIRE WAS DECLARED AT
Versailles on January 18, Moltke and Bismarck were openly at log-
gerheads, and the king—now to be referred to as the Kaiser—was
forced to act as referee. His intervention humiliated Moltke at
exactly the moment when the government in Paris was preparing
a third and final *grand sortie*. The exercise took place on January
18 and 19—and was all but designed for failure. The Red Clubs
in Belleville and Montmartre had been demanding the chance to
mount a full-throttle attack for so long that Trochu finally let it
proceed, almost to prove a point, hoping thereby to pave the way for
an acceptable peace.

At dawn on January 19, ninety thousand men were to pour out
of Mont-Valérien in the direction of Versailles. This happened to be
exactly where the German lines were strongest, their positions rein-
forced by a maze of trenches, redoubts, and other obstructions that
led through a forest back to Versailles. About half the French attack-
ers were from the National Guard, and many thousands of them had
never seen a day's fighting. They were to advance in three lines spread
across four miles toward German forces at Bougival, to the west, and
toward Saint-Cloud, to the south. This was the same territory that

had seen so much mayhem back in October at the Battle of Buzenval, where Degas's friend the sculptor Cuvelier had been killed.

That tragedy was to replay itself. Henri Regnault, the young Orientalist painter and Prix de Rome winner whose *Salomé* had made him the star of the 1870 Salon, had returned to Paris from Rome shortly ahead of the German advance. Holders of the Prix de Rome were automatically excused from military service, but Regnault, against the exasperated warnings of his father Victor, was determined to enlist. He was desperate—like many of his fellow National Guardsmen—to join the battle. In October he had proposed to Geneviève Breton, who had agreed to marry him. He saw out the year 1870 manning the fortifications at Colombes and Asnières on the Seine.

Just days before the call to battle, Regnault had been offered an officer's commission, but he refused it. "You have made me a good soldier," he explained; "don't make me a mediocre officer." He received his marching orders on January 17. That night, as Marc Gotlieb writes in his book about Regnault, his fiancée presented him with some bread, a packet of letters, and a silver charm. The next morning his regiment, the Sixty-Ninth Battalion, mustered on the Boulevard Malesherbes, where they were assigned their packs. From there they walked to the Champs-Élysées, where they converged with ninety thousand other troops, and all marched on to Pont de Neuilly.

They sang; they were cheered by children and elderly men; and as the sun set, their wives, mothers, and girlfriends strode alongside them, arm in arm, in some cases carrying their rifles. Having crossed the Seine, most of the troops hunkered down in a field and went to sleep in the open air. But rain poured all night, and Regnault and his fellow artist Georges Clairin managed to find refuge in a wine shop. To stay warm, Regnault squeezed his legs into the sleeves of a fur coat. Awakened after midnight, he marched with his battalion up the steep slope to Mont-Valérien, where they waited in the bone-chilling cold at the base of the fortifications until dawn, vulnerable to German shelling but concealed by fog and rain.

At dawn they were still there, dangerously exposed as the sun rose and the fog cleared. They were waiting for a column led by Ducrot,

but it was still more than an hour away, delayed by obstacles that the French themselves had put in place and forgotten to dismantle. Eventually, on the orders of the commandant at Mont-Valérien, three guns were fired—the signal to start the attack. Regnault's Sixty-Ninth was made to wait at the fort for an uncomfortably long time, but finally, as the German guns boomed away, it was allowed to advance. On either side of Regnault and Clairin, their fellow soldiers were picked off by sniper fire and "collapsed and fell like drunks," according to Clairin. Nonetheless, the two men reached the ridge, where Regnault jettisoned his pack and scrambled up the steep slope toward a château.

At the same time, the left column swept up the hills of Montretout and Saint-Cloud, outflanking the first lines of the German defense. The soldiers forced the Germans to retreat but were soon bogged down. The heavy guns they had wanted to drag up behind the advancing troops were delayed. Then they were thwarted by the slippery slopes.

Meanwhile Regnault had made it to the château, where he ran into another friend, Emmanuel de Plaza. Briefly breaking ranks, the two men hugged and kissed each other's cheeks, bringing tears to Regnault's eyes. Seconds later he rejoined his company as they surged into the forest beyond the château.

Behind the château was a huge wall that curved across the park. Here the Germans positioned themselves, able to fire on the advancing troops with impunity. The French needed explosives to breach the wall, but their supplies of dynamite had frozen overnight, rendering them useless. By late afternoon, the hopelessness of their position had become plain. "Only the wall, always the wall," wrote Clairin, "that neither with our bayonets or our own nails could we tear down." Long-simmering tensions between the professional soldiers and the raw recruits boiled over into angry accusations and insults. Some tried to desert but were shot, and in the chaos friendly fire compounded the damage.

Watching wistfully from Fort Mont-Valérien, Trochu finally gave the order to retreat at five p.m. The withdrawal degenerated into panic, then outright mayhem when retreating troops, tripping over dead

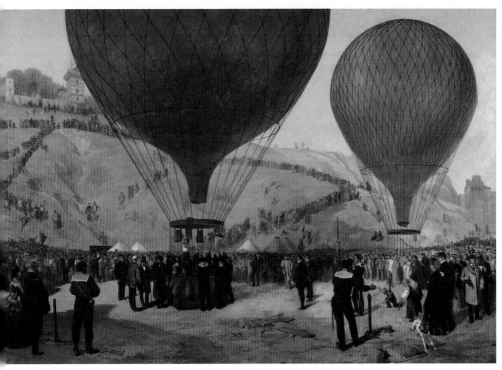

1. Jules Didier's painting of Léon Gambetta departing Paris by balloon.

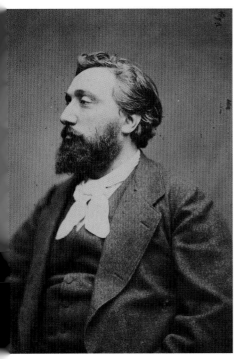

2. Léon Gambetta, republican politician.

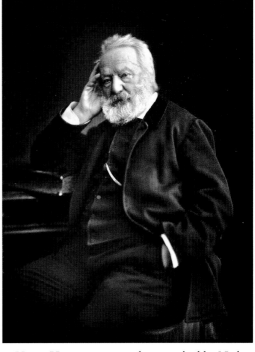

3. Victor Hugo, writer, as photographed by Nadar.

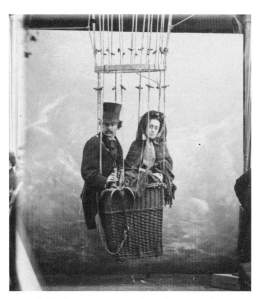

4. Nadar, the pioneering photographer and balloonist, posing with his wife Ernestine in a balloon gondola.

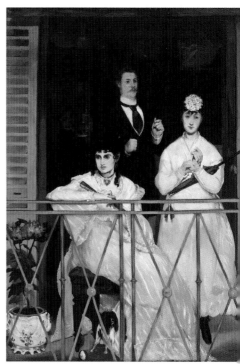

5. Édouard Manet's *The Balcony* (1868–69) was his first depiction of Berthe Morisot.

6. Berthe Morisot's *The Sisters* (1869) is thought to depict Berthe (*left*) and her sister and fellow painter Edma shortly after Edma married and left the family home.

8. Manet's 1868–69 lithograph showing the execution of the Emperor Maximilian was censored by the French government, which understood it as a damning critique of Napoleon III's foreign policy.

7. Edgar Degas's portrait in graphite of his friend and rival, Édouard Manet, c. 1865–70.

9. Frédéric Bazille's *Studio in Rue de la Condamine* (1870) includes his fellow painters Renoir and Monet and, standing at the easel beside Bazille's tall figure, his friend and mentor, Édouard Manet.

10. Manet's etching *Line in Front of the Butcher Shop* (1870–71) shows people waiting for food in the rain during the Siege of Paris.

11. Pigeons carrying letters into Paris tempered the isolation of Paris's residents and its political leaders toward the end of the siege.

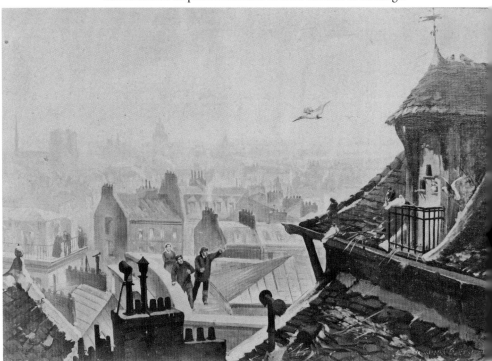

12. Adolphe Thiers, statesman.

13. Gustave Courbet, Realist painter and left-wing radical who influenced the Impressionists.

14. Thiers ordered the cannons taken by disaffected National Guardsmen to the Butte Montmartre to be retrieved, thereby provoking the declaration of the Commune and forcing Thiers's army to retreat to Versailles.

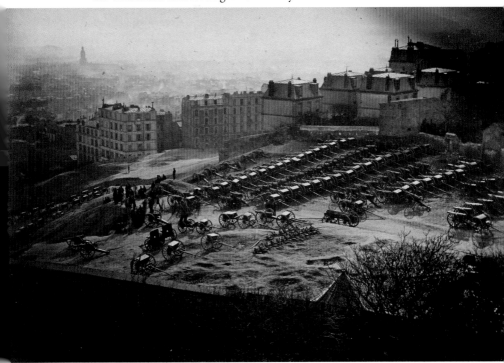

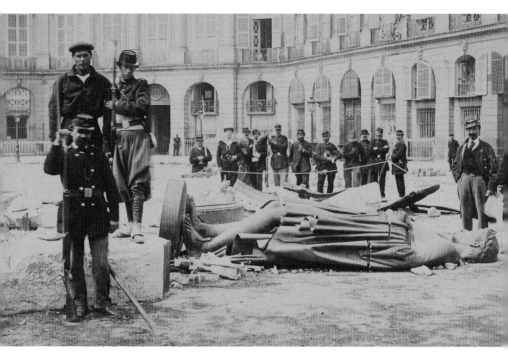

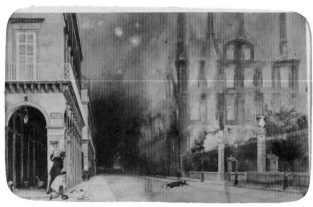

15. The Vendôme Column, a symbol of Bonapartism, after it was pulled down during the Commune.

16. Terrible fighting took place along the Rue de Rivoli during Bloody Week.

17. Barricades near Père Lachaise Cemetery near the end of Bloody Week.

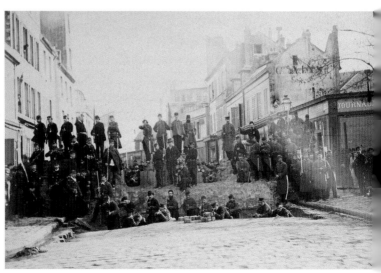

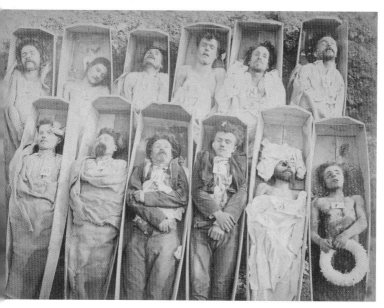

18. André Disdéri's photograph of dead Communards in open coffins at the end of Bloody Week.

19. Édouard Manet used his earlier images of the Mexican emperor Maximilian's execution as the basis of this lithograph showing summary executions by a barricade during Bloody Week.

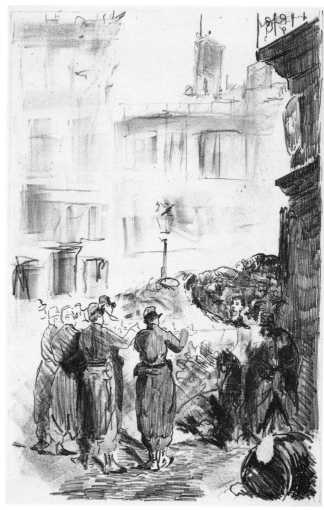

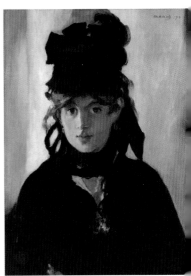

20. Berthe Morisot painted her husband (Manet's brother) Eugène during their honeymoon on the Isle of Wight in 1875.

21. Édouard Manet's *Berthe Morisot with a Bouquet of Violets* was painted in 1872, before she married his brother.

22. Édouard Manet's *The Rue Mosnier with Flags* (1878) shows a crippled man, possibly a war veteran, walking along the street opposite the artist's studio on a national holiday celebrating the Fête de la Paix.

bodies in the failing light, ran up against the ammunition trains, supply wagons, and ambulances that had been brought up from behind in expectation of an advance. It was difficult to maneuver in the darkness and the cold. Mud caused wheels to get bogged. It took all night for many soldiers to get back to Mont-Valérien and from there into the cold and starving city. They left behind a shambles of abandoned weapons and dead or wounded warriors. In all, about 1,500 were killed and 3,500 wounded—many times the number of German casualties.

After the order to retreat, Regnault made it back through the forest to the château, where he briefly took cover. "So many bullets had been flying around us for hours and hours that we no longer paid them much attention," claimed Clairin. Feeling in his pockets, Regnault realized he still had some cartridges left. He wanted to use them, but Clairin warned him not to. "It's over," he said. But Regnault ignored him and took off. Clairin never saw him alive again. No one knows how Regnault died—whether it was by a German bullet or by friendly fire (which, according to Trochu's own estimates, may have accounted for five hundred French deaths that day). But diarists all over the city made note of it, and the story of Regnault's last day quickly took on an aura of legend.

When news of this last, most demoralizing defeat reached Paris, people were stunned. Carts piled high with the dead were driven back into the city along the same routes that the troops had marched out on. Bodies washed up on the banks of the Seine. An armistice was declared on January 20 to allow the battlefield to be cleared. But many dead and wounded remained with the Germans, who had simply retaken their earlier positions after the French retreat.

Every Parisian knew it was the end.

MANET'S NEXT LETTER to Suzanne acknowledged what now appeared inevitable. Daily bread rations had been cut down to three hundred grams. (These discouraging morsels scarcely deserved the name "bread." He said Marie would keep a sample to prove it.) He had recovered from his flu and would be back on duty the next day. Urging Suzanne to stock up on provisions for when they returned to

Paris, he noted that many people were in genuine danger of dying from starvation. He told her to gather together preserves and any other food she could get her hands on. Everything in Paris was bound to remain outlandishly expensive.

Cornélie, meanwhile, was positively beaming, even as the battlefield was being cleared of corpses. "We are very happy today my dear, Edma," she wrote. "At last we have news!" The household on the Rue Franklin had received a long letter, via the pigeon post, reassuring them that Edma, Yves, and their several infants were all in good health; that Edma's husband Adolphe, the naval officer, was at sea; and that Berthe's brother Tiburce had escaped from captivity in Mainz by hiding in the hold of a ship carrying coal to Hamburg. He was back in the French Army, now a lieutenant.

"That is an unexpected joy," Cornélie wrote to Edma. "Your father wept upon hearing that all of you are well; he has been less concerned about his son than about you."

THE FRENCH ARMY of the Loire, meanwhile, had been defeated in battle near Le Mans. For Trochu, it meant the end. His colleagues persuaded him to resign and replaced him with General Joseph Vinoy, a stout man in his late sixties. The radicals seized on Trochu's resignation, and the following day, January 22, a group marched on Mazas Prison demanding the release of Gustave Flourens and other leaders of the chaotic insurrection back in October. The prisoners were freed. The next day, not unexpectedly, Flourens marched on the Hôtel de Ville. A gunfight ensued; five people were killed and eighteen wounded. "Civil war was a few yards away, famine a few hours," remembered Favre. The government shut down two of the radicals' newspapers, Le Reveil and Le Combat, and at the same time, accelerated talks with Bismarck.

On January 23, Jules Favre traveled with an escort to the German military headquarters at Versailles. By now, the besieged city had a full-scale smallpox epidemic on its hands. Typhus and typhoid were also endemic, but the two biggest causes of death were bronchitis and pneumonia. The unusually cold winter and chronic hunger had left

even better-off families like the Manets and Morisots acutely vulnerable. At Versailles, Favre had little leverage. Despite their differences, Moltke and Bismarck were united in wanting to impose the harshest terms possible. The parties eventually agreed to an armistice that was something short of a complete surrender. Bismarck was aware of the instability within Paris and the threat it posed to any agreement, so the terms required the French, as quickly as possible, to settle on a legitimate national government. Only then could she meaningfully negotiate the actual terms of the peace.

The armistice provoked disgust and despair among many of Paris's suffering residents. They needed relief. They had put so much into the war effort, both physically and psychologically; so many had lost their lives or seen their livelihoods destroyed; yet they had never had the satisfaction of fighting an "honorable" war. Rather, they had spent a long, brutal winter trapped in a city that grew dimmer and dingier by the day, receiving no reward for their sacrifices. And now the whole harrowing experience was ending in humiliation.

Humiliation—and yet relief. Édouard longed to see his family again. "It's all over," he wrote to Suzanne. He told her that any hope of holding out for longer had died. People were literally starving to death, and the distress and anxiety had not yet ended. "We are all as thin as rakes," he wrote, adding that for several days he himself had suffered from diet-related exhaustion and illness. No one who hadn't been through the siege could know what it had truly been like, he wrote. He promised to leave Paris and reunite with them as soon as he could, but for now he had to wait as higher authorities met to determine the city's future.

Berthe, too, had to wait before reuniting with Edma and Yves and their families and with her brother Tiburce. By February 4, food and other supplies were coming back into the city, but the distribution was fitful and insufficient. "We have been living on biscuits for about twelve days," wrote Cornélie to Edma and Yves, "for the bread is impossible and makes us all sick." Berthe had "hollows in her cheeks, [and] this morning she is in bed with stomach cramps." Her mother was desperate for the whole horrific chapter to be over: "We

have a great wish to escape from this confinement, and I have a great need to hold you in my arms."

OVER THE NEXT FEW DAYS, enormous quantities of food poured into Paris, much of it the result of relief efforts organized out of Britain and the United States. But there was still only one way out of the city, across the Seine at Neuilly, just north of the Bois de Boulogne. All the other roadways were impassable, having been bombed or shelled. People lined up for hours at locations that had been converted into warehouses for provisions sent from Britain. At Bon Marché alone, seven hundred packages of rations were handed out every hour. Thousands of forlorn and emaciated faces waited to receive them.

By February 6, Gambetta had resigned, battered by defeats. Two days later, as per the armistice agreement, elections were held for a new National Assembly, a body that could legitimately represent all of France, not just Paris, and could therefore negotiate peace. The prospect of elections filled most Parisians with dread. They had hoped for so much and endured such prolonged misery, only for their dreams of a vibrant and victorious republic to dissolve. Many believed that Trochu and Favre were guilty of treachery. They had been so eager to avoid the reforms wanted by the left that they had been willing to cave into the enemy and hand control of Paris back to reactionary forces.

Gambetta's old rival Adolphe Thiers was the clear favorite to win control of the government. Experienced, steeped in realism, and committed to order, he had been vindicated by his original vocal opposition to the war; he would now lead France through the painful weeks to come. "All eyes are turned toward you," an old rival, Montalivet, said to him ahead of the election. "There is not one sensible man who does not see with confidence the government of the country in your hands, in whatever form it may be." Predictions of a reactionary turn proved correct. Paris and several of the other big cities returned left-wing republican delegates (among them Gambetta and Victor Hugo). But across the country, out of 768 seats, more than 400 were won by candidates who favored a restoration of the monarchy, be it Bourbon or Orléanist.

The newly elected National Assembly met for the first time on February 13 in Bordeaux. Its members wanted to rid France of the German presence at the earliest opportunity and were determined not to let Parisian "histrionics" get in the way of restoring stability. Hugo promptly resigned, convinced that he and his fellow Parisian delegates were being deliberately sidelined. The delegates from Alsace, who saw the writing on the wall, did likewise. Gambetta, who was simply exhausted, went into self-exile in San Sebastián, where he walked daily along the beach, writing letters to Antonin Proust (Manet's future biographer). On February 17, Thiers was returned as *chef de l'executif,* a post that combined head of government and head of state. The last time he had been prime minister was under Louis-Philippe.

BY FEBRUARY 9, nutritious food had arrived at the Morisot residence on the Rue Franklin, and Berthe's health was slowly improving. She had been demoralized as well as sick, she admitted in a letter to Edma. Her mother had also grown very thin. It would be good for them all to see a fresh face or two. "The thought of spending a couple of weeks away from Paris, and with you, revives us. . . . It seems to me that we have so much to tell one another, so much to grieve about together."

Berthe wanted Edma to understand the enduring lesson that she had taken from the war. It was neither pretty nor uplifting. "I have come out of this siege absolutely disgusted with my fellow man, even with my best friends," she wrote. "Selfishness, indifference, prejudice—that is what one finds in nearly everyone."

Édouard, meanwhile, had only just learned of Bazille's death at Beaune-la-Rolande. He was crushed. Less than a year had passed since he had stood at Bazille's easel adding flourishes to the young man's painting of the Rue de la Condamine studio. The pity of his death was beyond words.

Édouard left Paris on February 12. Two days later he was reunited with Suzanne, his son Léon, and his mother, Eugénie-Désirée. He took them to Bordeaux, where the newly elected National Assembly was meeting and where Édouard found Zola. The writer was struck

by his old acquaintance's demeanor. Events in Paris had shaken him, there was no question.

The end of the war prompted a wistful, retrospective mood and an accompanying tenderness, even softness. The Morisots thought it best to stay in Passy—at least for now—and so the correspondence among the women in the family continued. "When I left you," wrote Edma to Berthe, "neither of us anticipated such a long separation. I remember you packing my trunk and saying to me each time I handed you something: 'So you intend to spend the winter there.'" The implication—that Berthe had sensed that Edma was abandoning her—had taken on a terrible weight in hindsight. Edma was acknowledging this, though with a delicacy that required no response. Instead, she switched to politics. The Morisots were not entirely of one mind, but they shared a wariness of extreme positions and a suspicion of tribalism. Cornélie had Orléanist sympathies, like Thiers, but she and Edma also felt for Manet's friend Gambetta, whose resignation and self-exile had made him a scapegoat. "We feel just as indignant as Mother does when Gambetta is unjustly attacked," wrote Edma. "It was he who did most for the defense, and it is he who is most thoroughly denounced today . . . and held responsible for our defeat."

Meanwhile there was talk in the newspapers of the German Army entering Paris. "Perhaps," wrote Edma, "you are now witnessing that sad spectacle. Nothing is to be spared us."

THIERS HAD BEEN NEGOTIATING with the Germans. An announcement of the dreaded peace terms was imminent. The rumor was that Thiers would use the occasion to try to disarm the National Guard. So on February 24 angry crowds—including many Guardsmen—occupied the Place de la Bastille. They flew a red flag from the July Column, which commemorated the *trois glorieuses*— the three days in 1830 that had brought about the fall of King Charles X and the beginning of Louis-Philippe's July Monarchy. The radical left now claimed the column as an antiauthoritarian symbol. Two days later the peace terms were announced. They were as punitive as feared. France would give up two of its most cherished and produc-

tive provinces, Alsace and Lorraine, including the bastion cities of Strasbourg and Metz. The French government would have to pay 5 billion francs in reparations by September 1875. And although Thiers had managed to save the vital town of Belfort, near the border south of Strasbourg, Paris would have to pay in the coin of humiliation: the German Army would be permitted to make a triumphal march into Paris.

It all seemed drastic beyond imagining. "The peace terms seem to me so ponderous, so crushing," wrote Goncourt, "that I am terrified the war will only break out again, before we are ready for it." Berthe was similarly dismayed. The terms, she wrote, "are so severe that one cannot bear to think about them."

In the eyes of the leftists in Paris, the treaty amounted to nothing less than treason. The Government of National Defense had never really wanted to battle the Prussians, they said; now, wary of radicals, the National Assembly was in a hurry to cave into their demands. The reason in both cases, they believed, was class-based self-interest. Those with money would sacrifice anything to prevent Paris's radicals from taking power and redistributing their wealth. A cartoon by Gaillard *fils* captured the sentiment: it depicted a corpulent Thiers—designated "king of the capitulators"—standing atop a platform groaning with game, conserves, and bottles of sherry. Arms benevolently outstretched, he smiles as legislators prostrate themselves before his edible throne.

The narrative of betrayal had spread like forking roots beneath the crumbly topsoil of the new republic. It now burst into the open. Furious crowds poured into the streets, their outrage matched by bitterness. An estimated 300,000 Parisians marched past the July Column in a second protest that lasted all day. The city's suffering had been in vain, and now the whole sorry saga would be capped by Germans marching into Paris. Bile gushed in the protesters' mouths. It was intolerable, disgusting—and at some deeper level, inexplicable. Some in the crowd were almost crazed with indignation. When a speech was interrupted by cries of "Spy! Spy!" the crowd hauled forward a man called Vincenzoni and accused him of taking down the

names of National Guardsmen. The baying crowd kicked and beat him and—in a scene worthy of Goya's *Disasters of War*—dragged him to the banks of the Seine, where they tied his hands and feet and threw him into the river. He had begged to be allowed to shoot himself but was refused. Over the course of two hours, whenever his head bobbed to the surface, they pushed it back under until he drowned.

POWER APPEARED TO BE sliding inexorably from Thiers's hands. A crowd invaded the prison of Sainte-Pélagie and released political prisoners, among them Paul-Antoine Brunel, a lieutenant who, just days before the capitulation, had been arrested by General Vinoy, accused of ordering National Guardsmen under his control to seize ammunition. Now, in a coordinated effort that inaugurated a whole new phase of Paris's troubles, National Guardsmen from more than 200 of the 275 battalions seized hundreds of cannons from army depots and artillery parks around the city and transported 227 of them up the hill to Montmartre. In taking this fateful action, the Guardsmen were acting on instructions from their own Central Committee, an authority newly established to rival General Louis d'Aurelle de Paladines, the reactionary whom Thiers had recently—and provocatively—appointed chief of the National Guard. The Guardsmen felt possessive of the cannons since most of them had been paid for during the siege by public subscription. They were determined to prevent them falling into enemy hands—a distinct possibility, it suddenly seemed, now that the Germans were being allowed to enter Paris.

The Central Committee then went a step further. Refusing to accept the capitulation to the Germans, it established, by fiat, a Republican Federation outside the control of the national government. Its justification was that the government had betrayed Paris and failed to defend her and thus had forfeited its right to govern. From now on it would be up to Parisians to govern themselves.

DIVISIONS WERE DEEPENING not only at the governmental level but inside the Morisot home on the Rue Franklin. The prospect of Germans parading through Paris sent alarm bells through their

neighborhood, since Passy was on the route from Versailles to Paris. People came out on the streets to protest the treaty. "Our Passy, usually so quiet, was animated," wrote Berthe. "The Place de la Mairie and the main street were filled with noisy crowds." No one knew when the Germans would come—only that they would—and the uncertainty drove everyone to distraction.

The siege was over, but the Morisots were once again going to bed thinking about occupation, civic breakdown, and the possibilities of violence and death. "Each day brings us a new sorrow, a new humiliation," wrote Berthe in dismay. "The French people are so frivolous that they will promptly forget these sad events, but I am brokenhearted." Describing the local uproar in a letter to Edma, Cornélie also gave a vivid account of the lynching of Vincenzoni, an act she described as "odious and revolting in the last degree.

> *They drowned an officer of the peace or policeman, after subjecting him to two hours of torture, and not a soul among the millions who were there did anything to save the unfortunate man, who only begged for the mercy of having his brains blown out. What infamy! What a nation! When I hear accounts of such misdeeds, I begin to hate the Prussians less. No doubt we shall have to billet some of them. God knows what senile or childish idea has got hold of [your] father; he says he will have his door broken in rather than open it, and that if they use force, he will sacrifice his life rather than yield.*

Cornélie dismissed her husband's furious vow of self-sacrifice as melodramatic, but she was conscious of her audience (a concerned daughter) and may in reality have been just as worried, just as enraged. Certainly the presence of Berthe, their attractive, unmarried daughter, in a house that might soon be occupied by German soldiers in a mood to exact revenge or to "reward" themselves after a long winter siege can only have enhanced their fears. There was no telling what might happen.

Writing to Edma, Berthe seemed unusually upbeat and chatty,

offering a rare glimpse into her political views by expressing sympathy for the leftists. "But if by chance I timidly advance that opinion," she noted, "Father throws his arms in the air and treats me as a madwoman." "Do you know," she continued, "that all our acquaintances have come out of the war without a scratch, except for that poor Bazille, who was killed at Orléans, I think. The brilliant painter Regnault was killed at Buzenval. The others," she went on, in a wry vein, "made a great fuss about nothing. Manet spent his time during the siege changing his uniform. His brother writes us today that in Bordeaux he recounted a number of imaginary exploits." Degas, she noted, "is always the same, a little mad, but his wit is delightful."

Berthe had not yet finished writing her letter when she learned of the "great commotion" in Paris the previous day. The word was that the National Guardsmen at Belleville had declared their intention to fire at the Germans when they entered the city for their victory procession. "I think," she signed off, "we are at the beginning of an emotional period."

AT EIGHT A.M. ON MARCH 1, a young lieutenant and six troopers of the Fourteenth Prussian Hussars leaped over chains and other impediments that resentful Parisians had placed in their way and continued under the Arc de Triomphe. Behind them marched thirty thousand German veterans of the siege. Wilhelm, now emperor of Germany, had wanted his triumphal march to match the splendor of the parade held after the first Napoleon's defeat in 1814. It would be a lesson to France, the aggressor, that all the world could witness, and so he planned to lead his troops in a large-scale, three-day victory parade. Parisians were given to understand that it might take even longer—that the Germans could occupy the city for as long as it took to ratify the treaty.

At every public meeting, accusations of treachery were leveled against Thiers who, it was claimed, "hadn't wanted to spare the great, heroic city this final shame." Openly insurrectionary talk became more widespread as, for two days, the Germans occupied the Champs-Élysées district. Some locals came out to watch or jeer at them. But

for the most part, wrote Zola, Paris "didn't stir, lugubrious, its streets deserted, houses shuttered, the entire city dead, veiled in the immense crape of its mourning." Some German soldiers were permitted to walk through the galleries of the Louvre—a low point for the museum's staff, who had been working throughout the siege under the direction of Courbet.

Cognizant of the volatility inside Paris, the National Assembly in faraway Bordeaux rushed to ratify the treaty. The vote was 546 to 107. The ratified documents were rushed to Favre in Paris, who hurried them on to Bismarck. Although Bismarck had wanted the victory parade to last longer, under the terms of the treaty his troops now had to withdraw. Having won far more than he expected (an "incredible result," Emperor Wilhelm had said of the treaty), he ordered his troops to withdraw to the Bois de Boulogne, where they were again inspected by the emperor at Longchamp, where Manet and Degas used to fraternize with the horse-racing crowd. Wilhelm understood the precariousness of the wider situation, but he still complained that his troops were "as good as being chased out of Paris."

THROUGHOUT THIS COMBUSTIBLE post-siege period, the artists in Manet's circle—the future Impressionists—were scattered. Monet remained in London. Renoir, recuperating from illness, found himself stationed nearer the Spanish border, riding horses and teaching a young girl to paint. Sisley settled at Louveciennes, near Pissarro's home, which had recently been occupied by Prussians. And Degas went to stay with his friends the Valpinçons at Ménil-Hubert in Normandy.

After meeting up with Zola in Bordeaux, Édouard, along with Suzanne and Léon, left for Arcachon, a seaside town west of Bordeaux. They stayed for a month. Édouard resumed painting, but only tentatively. He had been on the road for several weeks and was still recovering both his health and his bearings. The one painting he spent time on was a picture of Suzanne and Léon sitting at a round table in the rather desolate interior of the seaside home they rented at Arcachon. It could have been a celebratory painting—an avowal of love for the

wife and son from whom he had been so cruelly separated for so many dark months. But as always with Manet, the picture is more muted and difficult to read than that. Suzanne is shown from behind and at an angle, in lost profile (a way to avoid depicting her face, which always seemed to present difficulties). She appears to be taking in the view through the window out to the Atlantic. Léon, who had just turned nineteen, perches sideways on his chair. Looking up from the book on his lap, he smokes a cigarette. He looks suddenly very grown up—no longer the innocent blond, the pliable model from Manet's earlier paintings. He had escaped conscription by a whisker.

The window to the turquoise sea suggests a beneficence—a kind of emotional exhalation after the fear and claustrophobia of the siege. But there's also something guarded about the picture. You can feel the little family still getting used to one another's company, struggling—at different rates, perhaps—to fuse their separate experiences over the previous five months, as if painter, wife, and son were each trying to reassemble the pieces to a scrambled puzzle. While he was alive, Manet never exhibited *Interior at Arcachon*. It likely felt too raw.

THE MORISOTS LINGERED in Paris, just as they had after Sedan. But with each passing day their decision—or indecision—began to look more foolhardy. Order was breaking down. The German victory parade had crystallized disappointment into righteous anger. Demonstrations continued almost every day at the Place de la Bastille.

Back in September, most Parisians had been happy to see the ouster of Napoleon III and the declaration of a republic. Now the moderate republicans who had assumed power appeared to have been thoroughly discredited. Voters across the country had elected a reactionary government. Mostly Catholic and to a large extent royalist, they wanted peace and a return to order, which meant muzzling the godless agitators in Paris. Thiers was a known Orléanist, but he was savvy. He had said as far back as 1850 that "the Republic is the regime that divides us the least." Seeing the turbulence in Paris, he now warned representatives of both the Orléanist and Bourbon families to stay away from the city. This was not enough for many

Parisians, who remained suspicious. They feared that in time—and likely under Thiers's devious guidance—France would revert to a monarchy. Increasingly, they felt their concerns diverging from those of the rest of the country. They had bled and suffered, then lost elections they saw as rigged. Now all they had stood and fought for was in danger of being reversed.

Along with the National Guard, tens of thousands of French soldiers were still in Paris, awaiting orders. Their presence was stretching the city's still-fragile resources. One observer saw "soldiers wandering about . . . their uniforms sullied, disheveled, without weapons, some of them stopping passers-by asking for some money." Their loyalty to Thiers's new national government could not be guaranteed. They were only one provocation away from rebellion.

CORNÉLIE HAD ONLY JUST heard about the National Guard's seizure of the cannons when, with the Germans still withdrawing from Paris, she wrote an extraordinary letter to Yves. Her take on the seizure was trenchant: "Paris is far from peaceful." She was convinced that the National Guard fully intended to use the cannons if they thought it necessary. She praised Thiers, who all along had been "the spokesman for all people of common sense." Since there had been no way for France to win the war, it would have been better to negotiate—as Thiers had tried to do at the outset—and "to be swallowed whole" rather than to allow France to be fractured while clinging to absurd illusions. The radical left, she opined, "would not have acted any better or differently from the others, fighting against impossible odds as we were. But now it will be easy for them to pose as heroes, to manipulate the passions they have aroused, and to incite the populace to bold deeds by flattering words to further their personal ambitions." Her fear was that they would "take advantage of the state of things to plunge us into chaos."

Parisians who favored continued resistance against the German Army, she went on, ignored the fact that people in the provinces were tired of fighting a war they had already lost. Having lived through so many failed breakouts during the siege, she was sick of belligerent

talk that never led to successful actions. "All those fire eaters . . . who clamor so loudly for a war to the death took to their heels during our sorties. Nothing is more shameful than the conduct of the men of Belleville and Ménilmontant, who have the courage only to fight their own countrymen, hoping thus to find an opportunity for plunder and for gratifying all their passions."

Cornélie's commentary was not just scathing, it was in some ways prescient. She welcomed reports that Edma was planning to visit them in Paris. She expected the journey from Mirande to be "long and difficult," and she prayed that Edma would not arrive while the Germans remained in the city. In fact, Edma had already departed, and after arriving in Passy, she spent several days in her old home, tending to Berthe, going for walks, and sharing stories of all they had separately endured. She then traveled to Cherbourg to be reunited with her husband. On the day she departed, the two sisters went for a long walk along the boulevard. This time the pain of yet another departure felt almost unbearable. (In a subsequent letter, Berthe made a poignant reference to "that sad walk . . . that upset us so greatly.")

Around the same time, Berthe's brother, Tiburce, returned to Passy. He was in good health—a great relief. Dark clouds, however, were gathering, and Tiburce was about to be drawn into the heart of a new conflagration. Since he was still in the army, his family could do little to keep him out of harm's way. They could try only to protect themselves. So around March 6, they finally decided to leave Passy for the relative safety of Saint-Germain-en-Laye, just beyond the city's western reaches.

In leaving Paris, the Morisots were by no means alone. The city's more affluent residents were departing in droves. Many descended on Versailles, where the National Assembly, temporarily in Bordeaux, was preparing to establish itself rather than in the capital, where Thiers admitted he couldn't ensure its safety. But Versailles, with its rich royalist history, only stoked the fires of resentment in Paris. All of a sudden, the town was overflowing with bourgeois refugees, many of them unable to find suitable lodgings. Over the next few weeks, the population jumped from 40,000 to 250,000. Puvis de Chavannes,

who was utterly opposed to the radicals, was among the transplants. Not knowing that the Morisots had already decided to leave Passy, he wrote to Berthe expressing concern for her well-being. He was delighted, he wrote, to have left behind "my awful quarter [in Paris], where informing against one's neighbor was becoming a daily occurrence and where one may at any moment be forced to join the rabble under penalty of being shot by the first escaped convict who wants the fun of doing it." In Versailles, he concluded dreamily, he felt reassured and "bathed in a feeling of grandeur . . . since it recalls a beautiful and noble France."

PART III

The Commune

"Work Is the Sole Purpose of My Existence"

SHUTTLING BETWEEN BORDEAUX AND VERSAILLES IN early 1871, a distracted Adolphe Thiers was consumed by multiplying responsibilities. He had an entire nation to run. Jules Favre, however, could smell the coming storm. Unlike Thiers, Favre had spent the entire siege in Paris trying simultaneously to defend the city from the outside and to head off internal revolts. "You reproach me with thinking of nothing but Paris," he said to Thiers. "I reproach you with neglecting it."

In fact, Thiers was guilty of something worse than neglect. With potentially suicidal indifference, his new government had begun passing callous ordinances, each of which precipitously worsened the economic circumstances of Paris's poor. On March 7 the government ended the siege-period moratorium on debts; all debts were to be repaid within forty-eight hours. Another law ended the moratorium on rents; families who couldn't pay up were to be evicted. The government also ended a moratorium applying to items deposited at pawnshops, which had offered a lifeline to many; such goods could now be sold if they weren't reclaimed. Thousands of items—including 2,300 mattresses and 1,700 pairs of scissors—were now lost to their former owners. Most provocatively of all, the Assembly cut off the daily sti-

pend of 1.5 francs for National Guardsmen. This left tens of thousands of families without enough money to buy food. Thiers needed to raise money from the banks to make the first payment of war reparations, and the banks demanded proof of financial stability and order. But the upshot of these decisions was disastrous. Within three days, 150,000 people were thrown into bankruptcy.

Of course, everyone was short of money, including landlords. Manet, for instance, who owned, with his brothers, properties to the northwest of the city, was out of cash. On March 6 he wrote to Duret from Arcachon, begging for help: "I thought I would have some coming in about now and would not have to ask before you offered it—but there are a few commitments I must meet and I'm very short!" Other Parisians, however, were in much worse predicaments. They had no lifelines.

And now, their outrage was palpable. At a moment when the government needed to create and maintain hope after a prolonged disaster, it had instead ignited panic. Blind to the damage it had wrought, the National Assembly, still convening in Bordeaux, continued to go about its business. On March 8, it voted to annul the election to the Legislative Assembly of Garibaldi. There was logic behind the decision: Garibaldi was not, after all, a French citizen. But he was a committed republican who had fought valiantly for the French against the Germans. What's more, he had broad appeal across the various leftist factions. (Louis Blanc called him "a soldier of revolutionary cosmopolitanism.") His dismissal provoked Victor Hugo to resign. "I am bound to say," he told the Assembly, "that Garibaldi is the only general who fought for France and the only general who was not defeated."

Hugo was still in Bordeaux five days later, intending to leave the next day, when Charles, his forty-four-year-old son, died suddenly while in a cab on his way to meet his father at a café. Charles, a journalist and photographer, was obese, and his health had been undermined during the siege by long, cold nights on the ramparts. His distraught father decided that the funeral should be held in Paris, and he arranged to have his body transported back to the city.

On March 17, the day before the funeral, Thiers made two fateful decisions. Tipped off that Louis Blanqui would be visiting a doctor in Lot, in the South of France, he had the revolutionary socialist arrested and imprisoned. Taking Blanqui out, he reasoned, would deprive the radicals of their natural leader. Thiers then turned his eye on Paris. He knew that the cannons confiscated by the National Guard had become a powerful symbol for disaffected Parisians, especially those agitating for revolution. Almost two hundred of them were arrayed in serried ranks on the hill at Montmartre, their very presence feeding the radicals' appetite to continue the fight against Prussia and to revolt against the National Assembly. All this turbulence needed to be calmed, and the government had to reclaim control of the capital. Thiers convinced himself that reclaiming the cannons was key to doing so.

It was the gravest mistake of his career. His plan was to launch raids at dawn to recover the cannons for the regular army. At the same time, in a citywide operation, he would arrest opposition figures, occupy railway stations and bridges, and take over the Place de la Bastille, where demonstrators continued to gather daily. These actions, he hoped, would discredit the radicals, rally moderates, and pacify Paris.

AT THREE A.M., on an unusually icy and blustery night, soldiers under the command of General Vinoy fanned out across the city. Another general, Claude Lecomte, led a contingent up into Montmartre, close to Nadar's balloon launching site. Encountering no opposition, Lecomte seized the field holding 171 of the cannons. But what appeared to have been a quick and easy success soon began to unravel. The army had failed to supply enough horses to drag the cannons away, so the soldiers were forced to stand around them in freezing winds. The wait dragged on, and as dawn approached, many wandered off into the sloping streets to find coffee or bakeries. When residents awoke, they saw the soldiers and assumed a royalist coup was underway. Drawing back their curtains, they spilled out into the streets, trying to make sense of what was going on. Word spread that something was awry and that the cannons were about to be taken.

Soon Lecomte's stranded soldiers found themselves harangued by shopkeepers and National Guardsmen berating and shaming them for doing Thiers's bidding. "Where are you taking the cannons? Berlin?" they taunted. Louise Michel, the schoolteacher and radical activist (and one of Victor Hugo's many lovers), ran down the hill shouting about treason. The crowd near the cannons swelled. The soldiers looked hesitant, pliable. Their exchanges with the locals, who now surrounded the cannons, became more inflamed. Unable to get the crowd to disperse, Lecomte ordered his soldiers to load their rifles, fix bayonets, and finally to fire on the crowd. He yelled the command three times. But the soldiers refused. Many lifted the butts of their rifles in the air, signaling their allegiance to the National Guard rather than to the government. Others dropped their guns and proceeded to remove layers of their uniform. Lecomte's authority had evaporated. Suddenly some National Guardsmen grabbed Lecomte and several of his officers and bundled them into a nearby dance hall.

General Vinoy had been informed of the deteriorating situation and now arrived on the scene, only to vanish again, taking the remainder of his loyal soldiers with him. He knew they were outnumbered and that reinforcements were required.

But he had left Lecomte and his officers behind. Under armed guard in the dance hall, they could only wait and hope for help to arrive. The wait went on. No one came. After a while, they were frogmarched to the local headquarters of the National Guard. As they proceeded, they were hounded by a Goyaesque rabble baying abuse and kicking them from behind. The building in which they were deposited was left undefended, which made the crowd bolder. The windows were smashed and doors kicked open. Still no reinforcements arrived.

Meanwhile a retired general arrived at the Place Pigalle, curious to see what was happening. Tall and august-looking, General Jacques Léon Clément-Thomas, a moderate republican, had participated in the failed January breakout at Buzenval. He had resigned his command of the National Guard of the Seine on February 13. Although he was wearing civilian clothes, he was soon recognized. Once his name was announced, some remembered him for his role in the deaths of

revolting workers during the June days of 1848. When word of his presence spread, Clément-Thomas was seized, sprayed with invective, and thrown into detention along with Lecomte and his officers.

Morning turned to afternoon. Then, in a more chaotic version of the executions in Mexico that Manet had depicted four years earlier, first Clément-Thomas and then Lecomte were taken out into a garden with winding trellises at the back of the National Guard headquarters on the Rue des Rosiers (just behind where Sacré-Coeur is today). A shambolic group of Guardsmen and army deserters—the same soldiers who had earlier refused to fire on the crowd—had by now worked themselves up into a kind of delirium and were ready this time to use their rifles. They shot Clément-Thomas, then turned to Lecomte and murdered him, too.

Georges Clemenceau, still the mayor of Montmartre, heard about what was happening and tried desperately to avert it, knowing that the murder of two army generals was guaranteed to trigger violent reprisals. But he arrived on the scene too late. When he saw what had happened—what was indeed still happening, since the generals' bodies had been dragged out into the street where men and women were now urinating on them—he wept.

THAT VERY MORNING Victor Hugo had arrived in Paris by train for the funeral of his son. The writer had no idea what was taking place in Montmartre. He waited for two hours in the stationmaster's office at the Gare d'Orléans—right by the poignantly empty zoo—as people gathered for the procession to the Père Lachaise Cemetery. The funeral was expected to attract an enormous crowd. Goncourt was among those who came to pay their respects while Hugo waited. Finally the procession set off across the Seine in the direction of the Place de la Bastille.

Only then did it become clear that something dramatic was taking place in the city. The procession was forced to make several detours to skirt freshly erected barricades. A red flag was flying at the Place de la Bastille. Upon seeing Hugo, the commander of a National Guard battalion ordered his troops to present arms. There was a drum roll

and a short silence. A cry of *"Vive la République!"* went up. The procession moved on. Charles's prodigious size made the coffin unusually heavy, and when it arrived at the cemetery, it was too big to be carried through the narrow entrance to the burial vault. Workers set to filing down the stone—it was the only solution anyone could think of. For several hours they toiled, turning stone to dust. Worthies filled the unscheduled hiatus with somber speeches as, elsewhere in the city, a revolution was underway.

Alerted to that morning's turning of the tables in Montmartre, the Central Committee of the National Guard discerned its chance. On its orders, National Guardsmen in Montmartre and Batignolles swept down into central Paris and took over key locations, including the Prefecture of Police, the Place Vendôme, and by evening, the Hôtel de Ville. They met no meaningful resistance, and that night at the Hôtel de Ville the Central Committee gathered for the very first time as a de facto government. It would be known as the Commune.

Thiers's grand plan—to disarm and neutralize the agitators and restore order to Paris—had backfired spectacularly. He was left with no option but to order Vinoy to withdraw, at first to the Left Bank, then all the way to Versailles. He was working from the same playbook he had used in 1834, when confronted by the second weavers' revolt: withdraw, contain, debilitate, crush.

ON THE DAY THIERS withdrew his troops from Paris, Édouard was in Arcachon writing to friends. He wrote to the printmaker and painter Félix Bracquemond, admitting that he was desperate to raise some cash. "This dreadful war," he wrote, had left his finances in shambles. As yet unaware of the extraordinary events unfolding back in Paris, he was eager to return to his professional life as an artist. He wanted to submit *The Balcony*, his tribute to Goya and his first picture of Berthe, to the International Exhibition in London and was trying to make the necessary arrangements. The previous week, while still in Bordeaux, he had been ushered into the house where the National Assembly was gathering ahead of its move to Versailles. He had never imagined, he told Bracquemond, that France could be ruled by "such

doddering old fools." He made it clear that he meant his description to include "that little twit Thiers." He hoped Thiers would drop dead one day, midspeech, thereby ridding France of "his wizened little person."

Édouard's opinion of Thiers was widely shared. Karl Marx called him a "monstrous gnome." Flaubert was similarly contemptuous. "Can one find a more triumphant imbecile, a more abject pustule, a more turdlike bourgeois!" he had written to George Sand back in 1867 after Thiers's speech against Italian unification. "No! nothing can give you the idea of the vomiting that this old diplomatic melon inspires in me. . . . He strikes me as eternal like Mediocrity itself! He crushes me."

When he did learn of the events of March 18, Édouard was deeply troubled. Writing again to Bracquemond, he expressed himself with a political clarity matched nowhere else in his correspondence. It was a clarity born of bitter experience and profound disillusionment. "We're living in an unhappy country," he wrote, before proceeding to express his contempt for the contemptible murderers of Lecomte and Clément-Thomas. The radicals' bloodthirsty actions, he feared, had all but killed off an idea that had been making such headway in the public mind: namely, that the only appropriate system of government for "honest, peaceful, intelligent people" was a republic.

Only a republic, Édouard maintained, would allow France to regain its pride and its primacy among the nations of Europe, and to rise again "from the appalling depths to which we have fallen."

Édouard was Parisian to the core. But since the end of the siege, he had been out of the city long enough to appreciate the perspective of the rest of his countrymen. In the provinces, he explained to Bracquemond, you learned quickly that they hated Paris. Moreover, Thiers and the Assembly had erred grievously by choosing not to return to the capital in the immediate wake of the siege. Failing to control the city at that crucial juncture had encouraged the riots and upheavals that had, wrote Édouard, done so much damage, inspiring disgust and despair in "the hearts of all true Frenchmen."

Shedding the ill-fitting military costume he had donned with such pride in the early days of the siege, Édouard appeared keen to

distance himself from party politics and return to his earlier conception of himself as an artist. So much bloodshed and carnage was hardly an encouragement for the arts, he wrote wryly, but if, among so many misfortunes, there was a consolation, it was that they didn't have to be politicians and win elections.

GUSTAVE COURBET, his old rival, felt differently. The sudden, unforeseen establishment of the Commune filled him with excitement. He had been waiting for this moment all his life. He sensed an opportunity to fulfill his heart's desire—transforming the arts!—and wanted to make the most of it. On the very day when two generals were executed in Montmartre and government forces were ejected from Paris, several papers, including *Le Rappel* (which had been founded in 1869 by Victor Hugo's sons Charles and François-Victor along with Paul Meurice), published an open letter by Courbet. Addressed to his fellow artists, the letter proposed exactly what Bazille and his fellow Impressionists had been agitating for before the war: the establishment of a new, radically overhauled Salon run by artists. "Let them [the artists] determine how they shall exhibit; let them appoint the committees; let them obtain a building for the next Exhibition. It could be fixed for this May 15," he wrote, "for it is urgent that every Frenchman immediately start to help save the country from this immense cataclysm."

Earlier regimes, his open letter continued, had "nearly destroyed art by protecting it and taking away its spontaneity." That "feudal approach" had lasted so long, he claimed, only because it was sustained by a "despotic government." It had failed. The result had been "nothing but aristocratic and theocratic art, just the opposite of the modern tendencies of our needs." What were those needs? They were expressed, wrote Courbet, in a philosophy that revealed "man manifesting his individuality and his moral and physical independence." Government was the enemy: "It is beyond a doubt that the government must not take the lead in public affairs." Meanwhile, Courbet insisted, art shouldn't "lag behind the revolution that is taking place in France at this moment."

But was France, in fact, going to remain a republic, one that valued the "moral and physical independence" of its citizens and artists? To realists, it must have seemed unlikely. But Courbet—although he was the father of Realism in art—was not known for realism in his politics. He seemed blind to the fact that the Communards were far from unified and that their opponents in Versailles were intent on regaining control of Paris.

REACTION WAS SETTING IN. In Versailles, Thiers's government issued proclamations from which the word *republic* was pointedly missing. A majority of the Parisian National Guard had just effected a coup, but Thiers, refusing to cede control of the city, now appointed a conservative, Jean-Marie Saisset, to take charge of the Guard—or at least, that part of it not involved in the insurrection. The appointment was deliberately provocative. And yet Saisset remained in the city, mustering Bonapartists, royalists, and all those who wanted the coup to fail. Young Tiburce Morisot was on his staff.

On March 21, Saisset convened as many conservatives and moderates as he could to stage counterdemonstrations in central Paris. The following day they marched from Garnier's Opéra down the Rue de la Paix toward the Place Vendôme, where Saisset, his small force, and various supporters—about eight hundred people in total—gathered outside the National Guard headquarters, possibly with the intention of seizing it. They held up banners describing themselves as "The Friends of Order" or "Battalions of Order" and shouting "Down with the Committee!," "Down with the Assassins!," and "Long live the National Assembly!" But a group supporting the Commune, including a battalion of National Guardsmen, had also gathered. And just as Saisset was about to speak, shots were fired in his direction. It was unclear who fired them, or who was responsible for the return volley of gunfire. Everything about the incident would later be contested. But in the ensuing stampede, a dozen people were killed, including two National Guardsmen, a director of the Bank of France, the editor of *Paris-Journal*, a young American, and a viscount. The murder of the two generals, Lecomte

and Clément-Thomas, had been egregious enough. The Commune now had more blood on its hands.

Paris appeared to be descending into open civil war. The residents of the city's more affluent neighborhoods, including Passy, could no longer feel confident that the "low-life" and "rabble," as they called the Communards, would be defanged and marginalized by stronger, more moderate forces. Even Victor Hugo was disturbed by the carnage at the Place Vendôme and what it betokened. He left the city for Brussels that day. For all his sympathy with the Communards, he knew the coup was illegal and didn't want to get involved. (He later described the Commune as "an admirable thing, stupidly compromised by five or six deplorable ringleaders.")

Over the next few days, Saisset, with the scant forces at his disposal, holed himself up in the Grand Hôtel—a conservative redoubt in the heart of a radicalized city. Tiburce withdraw there, too, but not before making his way through the deserted streets of central Paris—lined with closed businesses and anxious faces peering out from behind curtained windows—to a rendezvous with his parents. He told them he had been in the front ranks during the previous day's confrontation at the Place Vendôme. "He could not have done more to make himself a target," marveled Madame Morisot; "he must think he is invulnerable by this time." Cornélie and her husband felt it best to return to Saint-Germain-en-Laye, where they had installed Berthe, but they wanted to stay within reach of Tiburce: "How can one leave one's son in the thick of this fighting?" For all her maternal concern, Cornélie was proud of her son. In a time of pervasive, generalized shame, when men everywhere—including, in her mind, Édouard and his brothers—had performed feebly and sometimes disgracefully, Tiburce had shown backbone. "This is my idea of how men should behave in a time of peril," she wrote to his sisters.

Meanwhile, at the Grand Hôtel, Saisset's forces padded the windows with mattresses and set up barricades and cannons outside. They were isolated and vulnerable, their position seemingly untenable.

On the evening of the twenty-second, the Morisots' family doctor, a M. Dally, came to dinner in Saint-Germain-en-Laye, having recov-

ered dead bodies and tended to the wounded at the Place Vendôme. He was visibly shaken. Berthe, too, was alarmed—and specifically anxious about Tiburce. These latest events had plunged the whole family back into a state of fear and uncertainty. Berthe confessed as much to Edma. Listening to M. Dally, she wrote, "brought back the siege to me as if I had never come out of it. Life has been a terrible nightmare for six months, and I am surprised that I am strong enough to be able to bear it."

PEOPLE EMERGING FROM TRAUMA, or from prolonged periods of crisis—of "stuckness"—are often ready to make great changes. Their experiences have given them a profoundly altered idea of what is at stake in their lives. Depending on how much damage they have sustained, and on what their circumstances were before, they may be moved to rewrite the narratives by which they had previously lived. So it was with Berthe Morisot. After living through a four-month siege, an artillery bombardment, a brutal winter, serious illness, and the very real threat of starvation, she was ready to reexamine everything. It wasn't necessarily that she was suddenly clearheaded. Her health was poor, her worries had deepened, her predicament was still full of unknowns. But her correspondence from this time is impressively cool and self-contained. She was ready to make a new declaration of purpose.

That she did so in a March 23 letter to Edma, her one true confidante, is as unsurprising as it is poignant. This first part of Berthe's letter was focused on present circumstances. It offered no hint of the conclusion to which she had come. Topographically, Saint-Germain-en-Laye is elevated, and the Morisots' temporary refuge there had a terrace, allowing them to see across a stretch of the Seine that doubles back on itself, snaking toward the fort at Mont-Valérien. Thiers and his Versaillais forces controlled the fort. They were trying to intimidate the Communards, so cannons boomed "around the clock," wrote Berthe, giving off smoke they could see from the terrace.

The contending forces were nominally different, but how little had actually changed since January, when the Germans had com-

menced their bombardment! News from Paris was reaching the Mori-
sots intermittently, but it was like those wisps of smoke: evanescent,
possibly significant, but in the end impossible to decipher. Some
of the people coming from Paris reported that its inhabitants were
starving. Others said the city was surprisingly peaceful. If "everyone
is fleeing," Berthe surmised, it suggested that "life there is not pleas-
ant." But she could not know anything for sure. She had learned
that Passy, their old neighborhood, remained intact. She was hopeful
about the fate of the Rue Franklin house. But she had also just heard
that Thiers's Army of Versailles was planning to bomb the Trocadéro
from Mont-Valérien. That couldn't be done, she reported, without
causing damage to Passy. So "we are philosophically awaiting the
outcome of all this."

There was more, however, that Berthe wanted to say. To Edma,
she could be truthful; their special rapport permitted forthrightness.
And yet Berthe's love for Edma also required her to exercise tact. She
wanted to write about nothing less than her dreams for herself, but
she could not do it without tacitly registering that, until very recently,
Edma had shared those dreams. Now, instead of being an artist,
Edma was a wife and mother whose painting days appeared to be
over. Even so, Berthe had to say what she had to say, knowing that
perhaps only Edma would truly hear it. Reading the letter, you can
almost hear her taking a deep breath.

Striking a brisk, even urgent tone, Berthe first asked if the condi-
tions at Cherbourg were conducive to work. The query, she admitted,
was self-interested: she wanted to go and stay with Edma, and she
wanted to paint. "This may seem an unfeeling question," she wrote,
"but I hope that you can put yourself in my position, and understand
that work is the sole purpose of my existence."

For a woman painter in the late nineteenth century, just to write
such a sentence took extraordinary courage. To write it while seriously
ill, after a siege, and as a civil war that had forced her family to flee
their home was breaking out, was nothing less than astounding.

Berthe elaborated. The countryside around Saint-Germain-en-
Laye was lovely, she noted, but she was not interested in painting with

amateurish intent, as she perhaps had in the past. Nor did she want "to work just for the sake of working. I do not know whether I am indulging in illusions, but it seems to me that a painting like the one I gave Manet could perhaps sell, and that is all I care about."

The message—although it was buried in a newsy, somewhat melancholy letter to a beloved sister—was clear: Berthe planned to pursue painting as a profession. It was a statement of frank and unapologetic ambition by a young woman who would go on to be regarded as the most groundbreaking female artist of the nineteenth century. Neither the intimacy of the correspondence nor the coolness of the utterance, nor its humility and self-awareness ("I do not know whether I am indulging in illusions"), can disguise the sense of a new, armor-plated resolve.

TIBURCE HAD SENT WORD from the Grand Hôtel that Saisset's supporters were awaiting reinforcements. The Morisots' servant delivered some civilian clothes and linen to him and reported back to Cornélie and her husband that they "were a large contingent and well-armed." In fact, however, no reinforcements arrived. Instead, the sides negotiated, and Tiburce was assigned to carry the communications back and forth between the various parties. ("He seems to have won considerable respect," wrote Madame Morisot: "his fellow officers come to take orders from him.") In the end, Saisset's small force was allowed to depart for Versailles, and a decision was made to hold citywide elections on March 26. The vote, when it was counted, left no doubt that Paris had rejected Thiers and his conservative National Assembly.

Thiers had effectively guaranteed this outcome, not only by his unpopular actions in Paris but also by his open discouragement of voting. He was adamant that what had happened was an insurrection on which no election could confer legitimacy. In any case, more than half a million mostly middle- and upper-class residents had left the city after the siege, so it was no surprise that the results skewed toward candidates supported by the working class. A wide spectrum of left-wing radicals and reformers won clear majorities. And so on

March 28, to the accompaniment of bugles and drums, the Paris Commune was officially proclaimed. A large crowd gathered to witness the announcement, and a contingent of National Guardsmen marched by the platform, in front of the Hôtel de Ville, where the ceremony took place.

Goncourt, writing in his journal that day, declared that government was "passing from the hands of the haves to those of the have-nots." He did not intend this remark as an endorsement. Authority was passing, he continued, "from those who have a material interest in the preservation of society to those who have no interest whatever in order, stability, or preservation." His verdict was scathing. And yet large numbers of Parisians drew tremendous moral satisfaction and genuine hope from the Commune's establishment. They had endured a winter of fear, frustration, and terrible scarcity. Suddenly they had a sense of renewed potential.

Courbet in His Element

IT IS NOT EASY TO SAY WHAT THE COMMUNE WAS. LIKE an Impressionist painting seen too close, it never really coalesced. In essence, it was a hastily improvised urban government, hamstrung from the beginning by limited resources and highly precarious security, but with vast ambitions. It was radical, in the sense that what it wanted, if enacted, would amount to drastic change. But in other ways it was surprisingly prosaic. Rather than global revolution, its supporters wanted municipal autonomy.

The Commune's older leaders and supporters carried over a sense of unfinished business from the revolutionary year of 1848. Others still looked back to the unmet promise of 1789. But in essence, the Communards wanted their city back—as much from Haussmann's rational and merchant-friendly overhaul (which had displaced so many of the working poor) as from Napoleon III, the Government of National Defense, and the Prussians. The Commune's leaders hoped that localized autonomy would evolve and catch on more widely, that it would form the basis of a democratic republic. And this in turn would have economic implications: it would provide people with "a system of communal insurance against all social risks"—including bankruptcy and unemployment. Already exacerbated by the siege, these last two

problems had been turned into a crisis by Thiers's decision to end the moratorium on the collection of rents and debts.

Supporters of the Commune, in other words, wanted more than just a share of power. They wanted their lives to be improved. They wanted the alleviation of crippling poverty and a better and fairer system of education, including for girls. And many of them—none more than Courbet—wanted to loosen the death grip of conservatism on the arts.

In some aspects, the Commune's new emphasis on municipal autonomy worked admirably. "I have never seen the streets of Paris so well swept," marveled Reverend William Gibson of the Methodist Mission. Yet from the beginning, the Commune struggled to bring substance or even a sense of appropriate priority to its wish list, which became longer by the day. Sixty-four representatives had been elected to its governing body. Some were political novices with odd backgrounds and unusual beliefs. But in fact, the majority were not wild-eyed, zealous revolutionaries. They were, as Rupert Christiansen has written, "respectable, earnest, public-spirited citizens, who worked for their bread and lived by traditional bourgeois values." The average age was thirty-eight. Half of the elected representatives were artisans—masons, carpenters, and so on. A quarter were from middle-class backgrounds. And as many as three-quarters were not actually born in Paris. A third had been on the committee of the National Guard.

What the Communards lacked was a charismatic leader—someone invested with the authority to act, who could resolve, either through mandate or through negotiated compromise, the inevitable and innumerable conflicts that arose. The followers of Proudhon, the man who coined the phrase "property is theft" and was the first person to declare himself an anarchist, outnumbered the followers of Blanqui, a socialist who was more concerned with overthrowing the given order than in establishing a new society. But both these rival camps were in fact minorities. Although Blanqui was elected leader, the gesture was purely symbolic: he remained in detention in Versailles, having been condemned to death for his role in the attempted

coup of October 31. Thiers simply ignored demands for his release. In Blanqui's absence, no one else was prepared—or able—to take charge.

So the Commune's authority was split between the Central Committee of the National Guard, which had been formed on March 20 and cast itself as the "guardian of the revolution," and the Commune proper, elected on March 26. The principle of local authority meant that the members of the Commune's council, all men, were also leaders of their local arrondissements. They relayed decisions made locally to the main council. But tensions between the main ideological factions were felt from the beginning. The Proudhonists (of whom Courbet was one) were opposed to states of any kind. They wanted the local arrondissements to retain their independence and function as conduits for a popular democracy. The Jacobins on the council believed chaos would ensue from so much local authority— particularly while the Commune was under extreme duress from the outside—and wanted to impose a more centralized structure.

ALL THE COMMUNE'S reforms were introduced against a backdrop of imminent attack. In Versailles, Thiers was rallying forces. His aim was to snuff out what was cast both as an insurrection and as an attempt by Paris to secede from the rest of France. He knew his German counterpart would find the Commune as intolerable as he did. Bismarck was in no hurry to let the French Army reconstitute itself, but he knew that the Commune would refuse to honor the terms of the treaty. So in early April, under pressure from Thiers, he agreed to release 100,000 French prisoners of war. The soldiers were slow to return from Germany, and for several weeks Thiers's forces remained in disarray. He knew better than anyone that retaking Paris would be difficult; it was he, after all, who had overseen the building of the fortifications. So before he attacked, he had to be sure of victory. Any action would have to be decisive. And to prevent a repeat, it had to be punitive.

Thiers had appointed Patrice de MacMahon—who had been wounded while leading the French forces at Sedan—as his commander in chief. As generals, he appointed two other Legitimists, two

Bonapartists, and one conservative republican. In the meantime, he did all he could to improve his forces' morale, to enhance their equipment and living conditions, and to saturate them in anti-Commune propaganda. The most widely read newspapers depicted the Parisian radicals as, according to John Merriman, "the dregs of society, ex-convicts, drunks, vagabonds and thieves, foreigners turned loose by virtue of fiendish plots organized by the International, perhaps in cahoots with Germany." The two sides skirmished from the beginning of April.

INCREDIBLY, PARIS WAS besieged again. Its remaining residents faced the very same reality they had so recently escaped: Supplies of food were cut off. Egress was denied. The threat of attack was constant. The result was an atmosphere of suffocation and paranoia, which certain Communard leaders—most prominently Raoul Rigault, the new chief of police—were ready to exploit. In the course of just ten days, between March 18 and 28, Rigault—an avid reader of books about the Terror and an aficionado of modern police tactics—had more than four hundred people arrested. MacMahon, in Versailles, was almost as ruthless, hunting down anyone suspected of treachery. Executions became commonplace on both sides. Each one escalated the levels of loathing, constituting one more point of no return for the other side.

Pierre-Auguste Renoir, according to his son the filmmaker Jean, wanted to escape Paris after the Commune's establishment. He might easily have been shot had he not secured help from Rigault. Before the war, Renoir had one day been painting outdoors at Fontainebleau when, out of the blue, he had encountered Rigault, who was on the run from Napoleon III's police. Having worked at Rochefort's weekly newspaper *La Marseillaise*, Rigault was a republican. Renoir gave him a disguise and helped him hide in the city. He then spoke to Pissarro, who contacted Rigault's friends, and they helped organize his escape from Paris. Now it was Rigault who wielded power and Renoir who wanted to make a getaway. Rigault was more than happy to oblige. He organized papers to secure Renoir's passage out of the city and even ordered a band to strike up "La Marseillaise" in his honor.

Anticipating an attempt to retake Paris by force, the Communards erected barricades all over the city. Strongholds bristling with cannons were established on the crest of Montmartre, at the Panthéon, and at the Trocadéro. This western part of Paris was home to some of its wealthiest residents, most of them Thiers supporters. So when, in the first week of April, Thiers began to bombard the city from the west, they were dismayed to find their arrondissements bearing the brunt of the shelling.

So inspired was Courbet by the Commune's establishment that he seemed blind to the wider predicament. For decades he had been championing the very ideas now being enacted. "This revolution is all the more just," he wrote, "as it originates with the people. Its apostles are workers, its Christ was Proudhon." In Courbet's eyes, Paris was free while the rest of the country remained "in bondage." But of course, the reverse was true, and no amount of ideological fervor could alter the fact that the residents of Paris were once again imprisoned and under bombardment.

Manet, Degas, and Morisot all remained sympathetic to the Commune and concerned about its fate. But they were also skeptical. Politically, Berthe had moved away from the convictions of her parents. She was anxious about the coming conflict but felt genuine sympathy for the radicals. Manet, meanwhile, was split. Born, like Berthe, into relative wealth, he was, like his brothers, alienated from his own privileged background and felt the justice of the radicals' cause. Despising tyranny, he felt a compassionate rapport with the destitute and downtrodden and had painted the poor of Paris with real feeling and originality. As a teenager, he had been inspired by the revolutions of 1848. Like Courbet, he wanted art liberated from conservative dullness, stifling bureaucracy, and censorship. But he was not one for joining clubs or movements.

At the beginning of April, curious about the Commune, he had decided to return to Paris, only to be told that all entry and egress had been cut off. So he took to the road instead, traveling from Arcachon north along the coast through Royan (where he spent two days), then Rochefort (two days), La Rochelle (one day), Nantes (two days), Saint-

Nazaire (two days), and finally Le Pouliguen, on the coast, where he stayed a month.

During that month, Paris fell apart.

WHEN, ON MARCH 30, Thiers's Versaillais forces made a tentative advance toward the city at Neuilly, the Commune decided it was time to retaliate. Thiers discovered their plans. He still had only about sixty thousand troops at his disposal, but on April 2 he launched an attack at Courbevoie, across the Seine from Neuilly. The Communards met the onslaught with vigor, and at midnight, a Communard sortie pushed back across the river. Board fences in Montmartre and Belleville were plastered with announcements that "royalist conspirators" had "ATTACKED," despite "the moderation of our attitude." The Commune's council anticipated that the Versaillais forces would either crumble or switch sides, induced by the same "fraternization" that had turned to their advantage in Montmartre two weeks earlier.

But nothing of the sort happened. From the upper windows of his home, Ambassador Washburne was astonished to find himself observing "a regular battle under the walls of Paris." "Thank God!" wrote Goncourt. "Civil War has broken out. When things have reached this pass, civil war is preferable to hypocritical skullduggery." Wandering away from the battlefield, Gustave Flourens, one of the Commune's more colorful leaders, entered a hostel. He had led the October revolt against Trochu during the siege. Like Blanqui, he had been condemned to death for his troubles, but Thiers's forces had been unable to arrest him. Now, as he entered the hostel, a Versaillais army officer immediately recognized him and was so infuriated that he dragged him outside, took out his sword, and split Flourens's skull in two.

The Communards' initial successes that April night were quickly reversed. Shells fired from Mont-Valérien tore through their forces, which soon fell back across the river in disarray. There were relatively few casualties, but the Versaillais took hundreds of Communards prisoner, and the victory boosted their morale.

After the fighting ended, a terrible thing happened: under a flag of truce, shots fired by the Communards killed General Vinoy's

beloved chief surgeon, Dr. Pasquier. The Communards claimed it was an error, but Thiers was in no mood to forgive and compared Pasquier's killing to the murders of Lecomte and Clément-Thomas.

The next day hundreds of Parisian women staged a rally in the city. They had heard that the prisoners taken by Thiers's forces were being summarily executed, and they planned to march peacefully all the way to Versailles. But the rebel National Guard held them back. Meanwhile the Commune's council was so incensed by the stories of reprisals and summary executions that it passed a "Hostages Bill." The idea was to intimidate Thiers into moderating his treatment of captured Communards. "Any person suspected of complicity with the government of Versailles," declared the bill, "will be immediately charged and incarcerated." Those found guilty (a jury would decide within forty-eight hours) would be held as hostages of the people of Paris. Linked to this declaration was a chilling threat: "any execution of a prisoner of war or a partisan of the legal government of the Commune of Paris will be immediately followed by the execution of a triple number of hostages."

And so the cycle of reprisals began.

FUELED ON BOTH SIDES by cravings for vengeance, the story of the Paris Commune tumbled and tripped toward its atrocious denouement. "We are caught between two bands of madmen; those who sit at Versailles and those who are at the Hôtel de Ville," Clemenceau said. Sincere attempts were made to de-escalate the conflict. At the beginning of April, moderates and supporters of Gambetta formed a group that tried to broker a compromise. But every attempt by leaders in Paris and Versailles to make concessions to the other side was denied.

So on April 4, a group of discontented Paris mayors founded the League of the Republican Union for the Rights of Paris, its manifesto signed by Édouard's brother Gustave, by Clemenceau, and by various other politicians, businessmen, doctors, lawyers, and journalists. All were republicans who were nonetheless worried by the extremism of the Commune. Trying to thread the needle, the league's mani-

festo blamed "the obstinacy of the Assembly of Versailles in not recognizing the legitimate rights of Paris." It made three proposals to the Assembly: that it recognize the republic, recognize the rights of Paris to govern itself by a freely elected council, and entrust the defense of Paris to the National Guard. On April 10, the league put out a second, distressed statement, calling for an end to "this fratricidal struggle." It sent a series of delegations to Thiers. Thiers met with them, but he was intent only on buying time and would not yield.

Goncourt grew agitated—and more flagrantly sarcastic. "If Versailles does not hurry up," he wrote, "we shall see the rage of defeat turn itself into massacres, shootings, and other niceties by these tender friends of humanity." But Thiers had no choice but to go slowly. Civilians had fled Paris by the thousands. Meanwhile, a worrying number of army troops had defected to the Communards. Bismarck had released French prisoners of war, but the treaty still imposed limits on the size of the French Army. So Thiers deputized Favre to negotiate with Bismarck to allow for the increase deemed necessary for the army to retake Paris. Defeating the Commune, Favre stressed, was in Germany's interests, since it was the only way the terms of the treaty would be met. Bismarck, who worried about the potential for the Commune to prove contagious and create problems back in Germany, agreed to let the Versaillais army grow by stages to 170,000. Meanwhile Rigault, the chief of police who had assisted Renoir, added a new name to the long list of "suspects" he'd been rounding up. On April 4, he arrested Monseigneur Georges Darboy, the archbishop of Paris, and threw him in solitary confinement in Mazas Prison.

As much as arguments over class or what form governments should take, attitudes toward the Catholic Church shaped the political upheavals of 1870–71. Where provincial France was steadfastly Catholic, most Communards saw the Church as power-hungry, corrupt, and avaricious. One of their first actions had been to mandate the separation of church and state. The arrest of Darboy, which was soon followed by the roundup of scores of priests, reflected an anticlericalism that now became increasingly fervent. The archbishop's arrest was especially incendiary. Rigault had ordered it with a partic-

ular goal in mind: convinced that the Commune needed Blanqui's leadership, he thought he could secure his release by using Darboy as a bargaining chip. But Thiers was having none of it.

As news of Darboy's incarceration spread beyond Paris, it was met with ever-increasing dismay. It quickly came to seem so outrageous that even Victor Hugo wrote a poem, "Pas de représailles" (No Reprisals), in protest. Far from forcing an exchange, the episode only confirmed Thiers in his determination to refuse to negotiate. More than any other single action, it galvanized antipathy to the Communards' cause.

Over the coming days, the Versaillais enjoyed a succession of victories against the Commune along the Seine, north of the Bois de Boulogne. And on April 8, having erected a bridge over the river, they took control of Neuilly.

MEANWHILE THE COMMUNE spat out edicts like a croupier dealing cards. One reintroduced the moratorium on rents. Another abolished military conscription and the police force, replacing both with a restructured National Guard. But it wasn't until April 19 that the Commune published an actual manifesto. It was posted all over the city in the form of giant placards. No doubt because the word *Commune* sounds like *Communist* and because Karl Marx was one of the first to write about the events of 1871, some have seen the Commune as a progenitor of the Communist revolutions of the twentieth century. In some ways it was. But in more salient ways, it was different. The April 19 manifesto declared an agenda that was fiercely republican but as much libertarian as socialist. It focused on decentralization, local government autonomy, individual liberty, freedom of conscience, and freedom of labor. The Communards wanted to dismantle any structures of power—governmental, religious, financial, military—that held people back. "The Communal Revolution," declared the manifesto, "inaugurates a new political era, experimental, positive, scientific. It is the end of the old governmental and clerical world, of militarism, [of] monopolism [and] of privileges to which the proletariat owes its servitude, the Nation its miseries and disasters."

This rhetoric spoke powerfully to Gustave Courbet. Even as the Commune's military predicament worsened, the painter-turned-administrator had never felt more optimistic. "Oh Paris! Paris, the great city has just shaken off the dust of all feudality," he wrote on April 6. Instead of worrying about attacks from the direction of Versailles, he redoubled his efforts to establish an art infrastructure controlled not by government cronies but by artists. He wanted to initiate a new order in which "aristocratic" and "theocratic" art could no longer impede either freedom of expression or the operations of democracy. Accordingly, he offered up a long wish list. He proposed taking over the entire museum system (which he had been running during the siege), abolishing the system of medals of honor, and dismantling government-run art schools such as the École des Beaux-Arts and the French School in Rome. The rooms of the École des Beaux-Arts, he asserted, would be made available to art students who, instead of being brainwashed by members of a government-sanctioned establishment, could cultivate their own idea of art, having "totally free choice among their professors."

Having set out his agenda, Courbet could now begin to enact it. He invited all artists in Paris to attend a meeting scheduled for April 10. Few made it, but unperturbed, Courbet rescheduled for two days later, and this time, more than four hundred artists attended. The result was the formation of the Federation of the Artists of Paris. Its manifesto, published in the Commune's official journal, called for the establishment of a committee of forty-seven elected artists: sixteen painters, ten sculptors, ten industrial artists, six printmakers, and five architects. The committee would be in charge of Paris's entire museum and art school infrastructure, and its mission would be threefold: conserving the art of the past, promoting the art of the present, and through education, cultivating the art of the future. Elections to the committee were held two days later at the Louvre.

Courbet's program sounds radical, but hundreds of artists who had been excluded from official, government-sanctioned structures were impatient for exactly the kinds of reforms he was proposing. Manet, who had been agitating for change for years, was among

them. His efforts had been coming to a head when the war with Prus-
sia broke out, so Courbet assumed Manet and his posse of admir-
ers, the future Impressionists, would back him. But he assumed too
much. Manet, who was no longer even in Paris, was stunned to learn
of his nomination to Courbet's committee. On April 17—again in
his absence and against his will—he was elected as a delegate to the
new federation of artists. So were, among others, Corot, Daumier,
and Millet, all in absentia. Six other elected artists who were in Paris,
including Manet's friend Bracquemond, promptly resigned.

Manet had enough problems with the establishment. Being
openly associated with the Commune was not going to help him. Nor
was he thrilled, on a more personal level, about being roped into the
schemes of Courbet, an artist he admired but who was undoubtedly
a rival and a general irritant. All the artists who wanted reform—
Manet included—recognized Courbet's role in liberating art from
inherited orthodoxies. They may have laughed at his bluster, but they
admired his courage and effrontery and recognized his tremendous
impact, as the founder of Realism, on the art of the past few decades.
But even those, like Manet, who were passionately republican didn't
necessarily subscribe to Courbet's broader anarcho-socialist poli-
tics. And Courbet's tendency to hog the limelight exasperated them.
Manet had experienced this during the 1867 Exposition Universelle,
when the two men, both excluded from the official exhibition, had
set up their separate solo pavilions outside the fair: Courbet's pavilion
had been mobbed. Then, during the siege, while Manet had dutifully
packed up his studio, enlisted in the National Guard, and sent forlorn
private letters to Suzanne via balloon, the pacifist Courbet had used
his notoriety to take control of Paris's art institutions and issue dra-
matic public statements. Now he was a high-ranking functionary in a
bona fide revolution, and he rejoiced.

For Courbet, political extremity represented opportunity. For
Manet, it represented jeopardy. Like Berthe, he longed for a return
to normality. Having made it through the hell of the siege, both
were desperate to return to making art—a messy, lumbering business
requiring time, focus, reliable supplies, and peace. They wanted social

and political change, but by now they had seen enough of chaos and dysfunction. For Manet, this latest coup wasn't something to cheer. The precariousness of the Commune—its illegality, its lack of clear leadership, its philosophical confusion—alarmed him as much as it worried Berthe, whose brother was in the army seeking to crush it. They balked at the Communards' overreach and saw, with dread, the coming backlash.

UNPERTURBED—AND SEEMINGLY oblivious to the existence of divergent opinions—Courbet plowed ahead. Asked by the editor of *Le Rappel* to justify himself, he wrote a lengthy response. "Dear Citizen" (the term of address had become de rigueur),

> I have been asked for a profession of faith. That must mean that, after thirty years of a publicly revolutionary and socialist life, I have not been able to get my ideas across. No matter, I will comply with this request. . . . I have been unswervingly occupied with the social question and the philosophies connected with it, choosing my own path, parallel to that of my comrade Proudhon. Renouncing the ideal as false and conventional, in 1848 I hoisted the flag of Realism, which alone places art at the service of man. . . . I have struggled against all forms of government that are authoritarian by divine right, for I want man to govern himself—according to his needs, for his direct benefit, and in accordance with his own ideas.

Courbet hoped that other governing bodies would follow the lead taken by his federation of artists. The more people could govern themselves according to their own interests, he wrote, "the more they will ease the task of the Commune." Defining himself as an individualist, he advocated for decentralization wherever possible.

Courbet was now finally in a position to carry out what he had proposed at the beginning of the siege: the pulling down of the Vendôme Column. To veteran soldiers and to anyone with Bona-

partist sympathies, the column was a sacred memorial, but anti-imperialists, revolutionaries, and pacifists hated it. In calling for its removal, Courbet had the Commune's full support. But he was not out for pure destruction. He wanted to save the base and remove the bas-reliefs that wound their way up the column. These reliefs, which were made from melted-down and recast enemy cannons, should be carted, he proposed, to Les Invalides, Napoleon I's final resting place and a hospital and retirement home for former army officers.

Such was the plan. But pulling down a structure that was 840 feet high was not easy to accomplish. The preparations took weeks. On April 18—the day Karl Marx was commissioned by the General Council of the International to write a pamphlet about the Paris Commune—Goncourt went to the Place Vendôme, where he saw scaffolding around the column in readiness for its destruction. The square, he wrote, had become "the center of a fantastic tumult and a medley of amazing [National Guard] uniforms."

Goncourt, who was as conservative as Courbet was radical, found himself musing about an incipient outbreak of iconoclasm. This was not a good time, he suggested, to be an artist—or someone who cares about art. "From all I hear," he wrote, "the employees of the Louvre are extremely worried." The *Venus de Milo*, he continued, had been hidden "deep down" at the Prefecture of Police beneath piles of police dossiers, because Courbet was "on her track," and the Louvre curators "fear the worst if the fanatical modernist lays his hands on the classical masterpiece." This was a little too much. Courbet may have had a streak of fanaticism, but he was not out to destroy art. Nor is it clear that he was personally responsible for the decision to tear down the Vendôme Column. Certainly he had called for its removal the previous year. But the Commune issued its official decree, proposed by Félix Pyat, four days before Courbet even joined the Commune committee. Pyat had called the column "a symbol of brute force and false glory, an affirmation of militarism, a negation of international law, a permanent insult to the conquered by the conquerors [and] a perpetual insult to one of the three great principles of

the French Republic, Fraternity." Courbet couldn't have put it better himself, but he still wanted to preserve the parts of it that could be said to constitute art.

Courbet's was a classic case of the artist's naïveté in the face of unfolding political realities that were deeper and more violent than he was willing to recognize. Goncourt, who was perhaps guilty of other forms of naïveté (that the injustices faced by France's underclass, for instance, might not lead to social convulsions), could scarcely believe the cognitive dissonance. "The newspapers see nothing in what is going on but a question of decentralization," he wrote on March 28, "as if it had anything to do with decentralization! What is happening is nothing less than the conquest of France by the worker and the reduction to slavery under his rule of the noble, the bourgeois, and the peasant."

Courbet had always been opposed to Jacobinism and its willfully cruel determination that the ends justify the means. But over the coming weeks, as the planned destruction of the Vendôme Column was several times delayed and Thiers's Versaillais army got the upper hand in the military conflict, it was the Jacobins among the Communards who began to thrive.

IT WAS CLEAR BY NOW that Paris was under attack, and with Thiers unwilling to yield anything, the Commune had to defend itself. Gustave Cluseret—the U.S. Civil War veteran whom Manet and Degas had gone to hear at the Folies Bergère at the beginning of the siege—was appointed to lead them militarily. Cluseret had "a coarsely handsome face" and a "curt, uncivil manner," according to his fellow Communard Louis Rossel. He was an experienced soldier but a chaotic leader. He created an atmosphere of "perpetual improvisation" and "fundamental incoherence," according to a secretary who worked under him. The result was "a mob-scene where everyone commands and no one obeys."

Cluseret realized that the same ring of forts that had previously kept the Prussians at bay would be key to defending the Commune. If he could use these forts—indispensable features of the Thiers

Wall—to keep the Versaillais army at bay, the Commune could force a negotiated settlement. But Thiers, trying to smash any such hopes, continued to bombard the city from the west. In response, Cluseret placed outward-facing batteries by the Trocadéro and at Château de la Muette. Both sites were close to the Morisot home, and many of their Passy neighbors believed Cluseret put them there precisely to draw fire upon them.

The Communard soldiers under Cluseret's command resented his attempts to impose centralized authority. This, after all, was the very thing from which they wanted to free themselves. But their principled opposition created problems on the battlefield. "Never," said Cluseret upon taking command, "have I seen anything comparable to the anarchy of the National Guard." They were indeed a motley, undisciplined crew. Each battalion had its own distinctive, ad hoc uniform. Most of the units were sodden with alcohol. And yet they could be surprisingly effective. When Goncourt woke up on the morning of April 12—a Wednesday—he was surprised to see Fort d'Issy still flying the Commune's red flag. He thought the Versaillais troops had already taken it. "Why this stubborn resistance which the Prussians did not encounter?" he asked. Because they were motivated, was his answer. For the Communard fighters, class loyalties had risen above patriotism. "The common people are waging their own war and are not under the Army's orders," he wrote. "This keeps the men amused and interested, with the result that nothing tires or discourages or dispirits them. One can get anything out of them, even heroism."

THIERS FOCUSED HIS bombardment on Neuilly, where artillery fire was followed intermittently by infantry attacks and street-to-street fighting, with terrible effects on a suburb that had largely been spared by the Prussians. The ground was littered with broken shells and crushed bullets. All the trees had been cut down. Beautiful houses were reduced to ruins, corpses left unburied. The bombardment ranged more widely, too. The Arc de Triomphe was hit multiple times. Even the U.S. legation, occupied by the minister to France, Elihu Washburne, was strafed with shrapnel. In Auteuil, just south of

Passy, Goncourt had to run down into his cellar when he heard the nearby "whistling of several shells." Edwin Child, a young Londoner living in Paris, saw a seventy-year-old woman having both her legs ripped off by an exploding shell. "It is becoming absolutely sickening," he wrote. "During the siege at least people knew why they were suffering and for what end, but now it would be difficult to say which is the most preferable, the Commune or the Government. Both give such proofs of their incapacity." On April 25 the two warring sides agreed upon an eight-hour truce to permit the evacuation of civilians trapped inside their ravaged homes in Neuilly. The medics who came in uncovered appalling scenes of starvation and suffering. The ghost of Goya had returned.

Thiers now settled on a plan that seemed more likely to succeed than the tactic of simply lobbing bombs into the city's bourgeois suburbs. He decided to focus on capturing Fort d'Issy. From there, his forces would enter the city at Point du Jour, south of the Bois de Boulogne, where the Seine intersects the city's perimeter. More than fifty powerful cannons were now aimed at Fort d'Issy as MacMahon's Versaillais forces left Neuilly and swept southward.

On April 26 a meeting in Paris of Freemasons, desperate to avoid more bloodshed, voted to march from the city center right to the front lines. Five days earlier they had managed to send a delegation to meet with Thiers in Versailles, but the old statesman remained resolute. "A few buildings will be damaged, a few people killed," he said of the coming onslaught, "but the law will prevail." So the Freemasons' march went ahead on April 29: its participants somberly strode down the Rue de Rivoli and up the Champs-Élysées to Porte Maillot, at the northeastern corner of the Bois de Boulogne, where the cannons were still active. They held up banners calling for peace and enjoining all sides to "Love one another." The sounds of explosions died down—but only after two Freemasons were killed.

The threat to Fort d'Issy prompted the creation in Paris of a Committee of Public Safety, a body in which emergency powers were to be concentrated. Courbet opposed it, fearing a return to the mistakes of the past. (He was thinking of the Terror.) But the proposal passed

narrowly, with the support of Blanquists like Rigault and Jacobins like Delescluze and Pyat. Fort d'Issy was meanwhile being battered to a pulp by MacMahon's cannons. On April 30 it was evacuated by its Communard commander who could wait no longer for Cluseret to send reinforcements. But just when it seemed too late, Cluseret mustered two hundred National Guardsmen and marched back to the vacant fort, yet to be occupied by the Versaillais. Inside they found a single boy, around sixteen or seventeen, weeping over a barrel of gunpowder. His plan had been to wait for the enemy to enter, then set light to the barrel, blowing up both himself and the fort. Cluseret dismissed him and regarrisoned the fort.

By now, paranoia had spread through the ranks of the Commune. Everyone was on the lookout for spies. So when Cluseret returned to the city from Fort d'Issy, he was arrested, accused of treason, and relieved of his duties. His replacement was Louis Rossel, a twenty-six-year-old soldier. Motivated more by patriotism than by class ideology, Rossel remained outraged by the city's surrender to the Germans. After receiving a message from Versailles calling on him to surrender Fort d'Issy, he said he would shoot the next messenger carrying any similar demand.

On May 3, MacMahon's Versaillais launched a stealth attack on a Communard camp near Fort d'Issy. Eight hundred Communards were set upon in their sleep. Fifty were killed, and a quarter taken prisoner. The National Guardsmen manning the fort itself were down to their last provisions as the guns pounded away and the Versaillais troops inched closer. The Guardsmen's commander slipped away, leaving his subordinates to face the relentless onslaught. Hoping to save the fort, Rossel planned a counteroffensive but could not muster the twelve thousand troops deemed necessary for the task, so he abandoned the notion the next day. After a spate of defections, he chose to humiliate his officers by cutting off their sleeves, a tactic that only lowered their morale. Having squandered an authority that—given the extremity of the predicament—relied on goodwill, he resigned in disgust on May 9. Fort d'Issy fell the same day.

Bismarck was meanwhile losing patience. On May 7 he threat-

ened to reoccupy Paris if the French government couldn't guarantee that it would abide by the terms of the peace treaty. Civil war was making that all but impossible. But three days later, after the fall of Fort d'Issy, he was willing to take Thiers's side in the conflict. Thiers, however, refused Bismarck's offer to use his army to reimpose order. He knew he would never be forgiven if German troops reentered Paris. But he did agree to a formal declaration of the Treaty of Frankfurt, bringing an official end to the Franco-Prussian War.

Saint-Germain-en-Laye, which is just twelve miles from the Louvre, had begun to feel too close to the chaos consuming Paris, so Berthe was sent to join Edma in Cherbourg on the Normandy coast. Spending all her time with Edma and the baby, she also began thinking about suitable subjects for paintings. It was hard to focus. She was dazed and, like all of France, in an extended state of shock. As she traveled to the coast, Cornélie sent a letter ahead to Edma, noting that "sadness has become like a second nature to [Berthe]." Édouard, too, was an exile from his own city. Unable—and by now likely unwilling—to return to his home and studio, he continued his aimless wanderings. He arrived in Tours, which, during the siege, had been the seat of France's provisional government. News of the Commune's fate was unreliable, but of course it was all anyone was talking about. The more Manet heard, the more dismayed he became. Stunning, that it had come to this.

〰 〰 〰

CHAPTER 14

𝔐 𝔐 𝔐

Music in the Tuileries

IN 1862, AT THE HEIGHT OF HIS SPANISH INFATUATION,
Édouard had painted *Music in the Tuileries*, a crowd painting that
doubled as a kind of manifesto. Although much smaller (and this was
surely intentional), it was Manet's answer to Courbet's *The Painter's
Studio*, a twenty-foot-wide painting that, with his usual orotundity,
Courbet had subtitled "A real allegory summing up seven years of
my artistic and moral life." *The Painter's Studio* attempted to present
a kind of synopsis of French society, conveying Courbet's aims as a
painter and paying tribute to his friends and supporters. Courbet had
painted it in 1855 for the great Exposition Universelle. Alas, the jury
for the Beaux-Arts portion of the exhibition, seen by almost a million
people, had excluded the painting.

Seven years later Édouard had wanted to do something similar—
but in his own style and with less bombast. *Music in the Tuileries*
was his first major depiction of contemporary life in Napoleon III's
Paris. In a style that, for its time, was startlingly brisk and unpol-
ished, it shows a well-to-do crowd, arrayed almost like royal cour-
tiers, gathered under the chestnut trees in the Tuileries Garden, an
extension of Napoleon III and Eugénie's palace, where concerts were
staged twice weekly. Édouard loved the setting. He used to go there

with Baudelaire, sketching children and their nannies, before retiring together to the cafés on the boulevards. When he set out to paint *Music in the Tuileries*, Édouard had in mind a painting then thought to be by Velázquez: *The Little Cavaliers*, which imagines a meeting of seventeenth-century Spanish artists, including Velázquez and Murillo. It inspired Manet to transpose the conceit to his own milieu.

In the same way that Velázquez, in his great masterpiece *Las Meninas*, had put the viewer in the position of the scene's central characters—Spain's king and queen—Manet deliberately omitted the orchestra that the crowd had come to hear. So there are no musicians and no instruments and no way of knowing if the concert has finished or is about to begin. Instead, *Music in the Tuileries* is a group portrait of the gathered audience—which is to say, of Manet and his friends. Among the group identifiable in the foreground are Bazille and Baudelaire, both of whom Manet had first met at the salon of Commandant and Madame Lesjosne. (Courbet's earlier manifesto painting had also included Baudelaire.) The Lesjosne salon had connected Manet to Paris's burgeoning creative avant-garde, including Zola and Nadar. Madame Lesjosne is one of the two seated women in the foreground, Manet's sly hint at the maids of honor in Velázquez's masterpiece. The other is the wife of the composer Jacques Offenbach.

Manet also included Offenbach himself; his brother Eugène; Théophile Gautier and Baron Taylor, both passionate promoters of Spanish art; Fantin-Latour; the poet and sculptor Zacharie Astruc; the novelist Champfleury (a great champion of Courbet); and Aurélien Scholl, a republican dubbed the "journalist of the boulevards." These friends and associates were almost all passionate republicans, opposed to Napoleon III. So for Manet to set his "manifesto painting" not in his studio, as Courbet had done, but in a festive, open-air setting right beside Napoleon III's seat of power was a subtle statement of political opposition. If Manet was a modern court painter—a "Velázquez of the Boulevards," as he would later be dubbed—he wanted it known that these people, not the entourage of sycophants around Napoleon III, constituted his court.

At the painting's far left, behind Comte Albert de Balleroy, the

animal painter with whom Manet had once shared a studio, stands
Édouard himself, partially cropped by the frame and holding a cane.
The pairing of Manet and de Balleroy evokes the pairing of Velázquez
and Murillo in *The Little Cavaliers*. Manet's cane, flicked up to rest on
his invisible shoulder but cut off by the frame, may also be intended
to suggest a painter's brush—as if he were standing in the same pose
as Velázquez in *Las Meninas*. Manet wanted to suggest that, like
Velázquez in the Spanish court, he was both a participant in the scene
and a proudly detached observer. This was also the characteristic atti-
tude of the *flâneur*—the modern figure Baudelaire had so brilliantly
evoked in his essay "The Painter of Modern Life." For Baudelaire, the
flâneur was "an ego in search of a non-ego." He was "independent,
intense and impartial," a "prince enjoying his incognito wherever he
goes." Modern life, believed Baudelaire, was grand and heroic but also
melancholy and fragmented. The task of the poet or artist, he wrote,
was to "distill the eternal from the transitory." And this was the task
Manet had set about.

Baudelaire had also argued that beauty was made up of two parts:
one eternal and unchanging; the other circumstantial and variable.
The best way to paint this second aspect of beauty, he wrote, was
quickly—with "a speed of movement that imposes upon the artist an
equal speed of execution." In *Music in the Tuileries*, Manet had done
just this, brushing on colored paint in dabs and patches with virtually
no modeling or chiaroscuro, conjuring a vision of staccato glimpses
and stabbing glances in place of focused or synthesized seeing. He had
used visiting card photographs as cues for his quickly sketched por-
traits, and he distributed the figures democratically across the paint-
ing's horizontal expanse.

Nine years after Manet painted *Music in the Tuileries*, Baudelaire
was dead; Napoleon III was no longer in power; Édouard had served
briefly, desultorily, as a soldier; and Paris was controlled by radical
republicans from whom he felt increasingly alienated. His vision of
himself as a modern Velázquez, a *flâneur* who was "independent,
intense and impartial," as Baudelaire had put it, had crumbled in
his hands. And now the Tuileries, where he had set his great, break-

through painting, was about to stage not just a travesty of Baudelaire's early vision of modern art but a full-scale tragedy.

EARLIER IN MAY, the Commune's ruling committee had decided to open the Tuileries Palace to the public. Enough musicians remained in the city to form several ensembles. And so a certain Dr. Rousselle, the Commune's director-general of ambulatory hospitals, now planned to use the palace's Salle des Maréchaux—a lavish ballroom—and the adjacent Galerie de Diane for a series of musical concerts. Dr. Rousselle hoped to raise funds for the wounded, but he also wanted to provide a little communal uplift at a time when morale was flagging. For by this time, the Commune's supporters were under tremendous strain. Conscious, at some level, of the coming catastrophe, they clung to whatever illusions weren't already in tatters.

By choosing the Tuileries as the concert venue, Rousselle and the committee wanted the public to be appalled by the lavishness of Napoleon III's and Eugénie's living quarters. "People! The gold that streams down these walls, it is your sweat!" read a proclamation posted throughout the palace. "Now that the revolution has liberated you, you reenter into possession of your own welfare; here, you are at home."

Tickets to the concerts sold briskly. The standard of playing was excellent (much better, everyone agreed, than anything they might be trying to stage in Versailles). Performances were accompanied by recitations from Hugo's *Les Châtiments*—his scathing 1853 condemnation of Napoleon III as usurper, dictator, and traitor. Despite the egalitarian rhetoric, class distinctions remained in play. The seats closest to the orchestra in the Salle des Maréchaux were more expensive and thus taken by wealthier patrons, while the rest of the audience crowded into the Galerie de Diane, where the music was harder to hear. At one point, competing cries of "*Vive la République!*" and "*Vive la Commune!*" crisscrossed the two rooms, snuffing out the music. Nonetheless, the music stimulated a sense of solidarity and elevation. And it was a way to push back against the idea, heavily publicized around Versailles, that the Communards were barbarous brutes. The

Communard Prosper Lissagaray observed his fellow citizens "making a collection for the widows and orphans of the Commune" at the entrance to the hall, before sitting down to enjoy the music of "Mozart, Meyerbeer, Rossini" driving "away the musical obscenities of the Empire."

At the second Tuileries concert, on May 11, Rousselle arranged for three different orchestras to perform in three different halls. The third concert was planned for the following Sunday, May 18. Thiers's forces were massing on the city's edge, ready to swarm through the Commune's increasingly shaky defenses. Guns were pounding away to the west and south. But Rousselle was undeterred.

VIOLENT CRIME AND VANDALISM were rare under the Commune, in part because Rigault's police were so ruthless. But as the fear of treason and spying grew more hysterical, more newspapers were suppressed and even vaguely suspicious behavior prompted arrests. Pyat's journal, *Le Vengeur*, however, had been allowed to continue. It now reported that 45,000 regular army troops were massed in the Bois de Boulogne and preparing to attack.

On May 10 the Committee of Public Safety decided that, in retaliation for the bombardment Thiers had ordered, his mansion on the Place Saint-Georges—his residence for over half a century and the home he had been given by his mother-in-law, Madame Dosne, on the occasion of his marriage to Elise—should be seized, its contents confiscated, and the building itself demolished. When the decree was proposed, Courbet worried aloud about the fate of Thiers's art collection, so he was appointed to oversee its removal and distribution among museums, libraries, and public institutions.

But when the dismantling began the next day, it degenerated into a free-for-all. Opportunists made off with Thiers's expensively acquired prints, mementos, and objets d'art. The house itself was then razed. Edwin Child, who watched the looting, called it "as striking an instance of futile spite" as any revolution had ever furnished. Informed of what had taken place, Thiers used the attack to earn sympathy from critics on the right who couldn't understand why it was

taking him so long to retake Paris. "I no longer have hearth or home," he lamented, "and that house where I received you all for 40 years is destroyed to the foundations. My collections dispersed! Add a few slanders and you have all that one gains from serving the country." What Thiers didn't reveal was that he had been given prior warning of the ransacking and managed to arrange for supporters to move his most treasured belongings to safety. "M. Thiers has taken the assassination of his house nobly," wrote Jules Ferry. "He has lamented his bronzes and his souvenirs, but, after all, it is not something that happens to everybody, and it is one form of glory."

More destruction followed three days after the Versaillais troops took Vanves, on the southern edge of the city, when Pyat and Courbet got their heart's desire. The Vendôme Column, after several postponements, was finally torn down. This symbolically charged action was planned as a ceremony, scheduled to take place at two p.m. The authorities were vigilant about security, so the square was cleared of all who had not purchased tickets, and the abutting alleys and side streets were jammed with onlookers. Dignitaries spilled onto balconies draped with flags. Communards wearing red belts and red scarves arrived in the square, which an enthusiastic committee had renamed Place Internationale. National Guardsmen readied cannons to be fired. A band played revolutionary songs as a wedge was cut out near the base of the column, and ropes were tied to the top, to be pulled on in the direction of the wedge.

But by five p.m., the obstinate column was still standing. Finally, at 5:35 p.m., a signal was given, and the band began playing "La Marseillaise." Two teams of men began pulling on the ropes—a strange reprise and inversion of the launch of Gambetta's balloon the previous October. Cries went up. A party of Americans, watching from the first floor of the adjacent Hôtel Mirabeau, began singing "Hail Columbia" to a rollicking piano accompaniment. There were loud cheers. The side streets swelled with emotion. But the column proved sturdier than anyone thought. It was another half hour before it finally came down. When it did, instead of a satisfying din, the crowd heard an

anticlimactic creaking as the column bowed before history like a wistful clown exiting the ring.

The Paris Commune was beginning to crumble from within. Later that same night, about one a.m., a gang of three hundred armed Communards broke into the Grand Hôtel du Louvre. They claimed to be trying to capture traitors who, they said, were being protected by enemies of the Commune. Insisting that there must be a secret passage leading out of the city all the way to Versailles, they poured into the basement. But it was all a ploy. By dawn, they had emptied the vast hotel of all its supplies of food, alcohol, tobacco, tableware, and other valuables. Twelve hours later an arms depot on the Avenue Rapp, near the Champ de Mars, exploded with a mighty boom. It was heard all over Paris. Millions of cartridges were lost. "A pyramid of flame, of molten lead, human remains, burning timber and bullets showered down," wrote Lissagaray. As if to parody the balloon flights that had provided so much hope during the siege, the explosion sent up a pall of black smoke that was "exactly in the shape of a mighty balloon."

Thiers continued his relentless bombardment. The Commune, displaying near-comical levels of denial, continued to pass futile legislation and issue arbitrary edicts. On the seventeenth, it passed a law removing legal discrimination between legitimate and illegitimate offspring. The next day it abolished all titles, privileges, liveries, armorial bearings, and honorific distinctions. And on the nineteenth, it voted to end theater subsidies and to place all theaters under the control of the Commission of Education.

Confused by reports about the arms depot explosion—or perhaps simply by the escalating artillery fire—Cornélie reported in a letter to Berthe in Cherbourg that the Trocadéro had been blown up. "Everything has surely been pulverized," she wrote. The news was false—the Trocadéro remained intact, as did the nearby Morisot home. But the thought that Berthe and Edma's paintings might have been destroyed appalled Cornélie. Her reaction was a rare acknowledgment, fired by emotion, of the centrality of art to her daughters' shared lives. "I

should have liked to preserve all the memories of your youth and of your common hopes," she wrote. "Now I am deprived of all those things that were realized, and that might someday have had value in eyes other than mine.

"You had better set to work!" she concluded.

Berthe didn't need to be told.

Cornélie had also heard reports—in this case true—of the destruction of the Vendôme Column. "To think that people could be found who would do such a thing, and others who would stand by and see it being done," she wrote. Her words could have been a caption to a print by Goya.

IT HAD BEEN A MONTH and a half since Rigault arrested Archbishop Darboy. The Commune's chief of police was still trying to use his most eminent hostage to secure the release of Blanqui. Washburne, of the American legation, visited the clergyman and came away believing Darboy in "the most imminent danger." He urged Thiers to reconsider his refusal to negotiate. But Thiers, who was about to give the order for his Versaillais army to retake Paris, would not relent. His recalcitrance provoked outrage in Paris, amplifying calls for Darboy to be shot. The revolutionary journal *La Montagne* declared— erroneously, as it turned out—that "not one voice would be heard to damn us on the day when we shoot Archbishop Darboy . . . and if they do not return Blanqui to us, [Darboy] will indeed die."

Washburne made a second visit to Darboy and found him confined to a small, gloomy cell, "without appetite" and "very much reduced in strength." The American was right to be concerned. Rigault's anticlerical bloodlust was up. On the day of Washburne's visit, he divided his collection of hostages into two categories: priests (including Darboy) and policemen. The latter were put on trial, then sent back to prison, ignorant as to whether they would live or die. The clerics' fate was to be decided the following week.

The next day, as more than fifteen hundred musicians convened for the fourth concert at the Tuileries, Thiers's Versaillais army prepared to invade Paris in earnest. A crowd of between 15,000 and 20,000

gathered at the Tuileries Palace, many of them workers and shopkeepers who had brought their families, all of them astonished, given the circumstances, to be in such splendid surroundings and listening to music. At the conclusion of the program, a military band began playing outside the palace. But their music was suddenly accompanied by the shriek and thunderclap of an incoming shell.

Very soon more shells began falling among the chestnut trees where Manet had set *Music in the Tuileries.* Incredibly, as if under some strange, waking spell, the crowd continued their celebrations, even as people were being injured and killed around them. "They were singing, two steps away from the dead, all of whom were French," wrote Jules Claretie, unable to conceal his abhorrence. The concert ended at around four-thirty p.m. when a lieutenant colonel, announcing a fifth concert for the following Sunday, declared: "Citizens, Monsieur Thiers promised to enter Paris yesterday. But he is not here."

BUT HIS TROOPS were getting close. At around three p.m., as eighty thousand troops awaited orders in the Bois de Boulogne, Jules Ducatel, a civil engineer on the side of the Versaillais, was strolling by the ramparts at Point du Jour, on the Seine south of the Bois de Boulogne. The Versaillais army's cannons had been pounding the fortifications there for several days. As Ducatel passed Bastions 65 and 66, he noticed that no one was guarding them. He notified a Versaillais naval officer, who approached the bastions on high alert in case a trap had been set. But it hadn't. Minutes later, while the officer telegraphed the generals, Ducatel climbed the ramparts and began waving a flag, signaling to the army that they could enter.

General Félix Douay was soon leading his troops into Paris—just as the fourth Tuileries concert was concluding. The troops secured two of the gates and swept into Passy. At a munitions depot on the Rue Beethoven, just down the slope from the Morisot residence, they surprised a large group of Communards, taking a hundred prisoners.

That night, as troops poured into the city and wheeled north toward Montmartre, Thiers, dining with family and friends in Versailles, received regular updates. In Paris, his Communard counter-

part, Delescluze, had been informed that the city's defenses had been breached. At first he refused to acknowledge it. He later issued a call to the barricades: "Enough of militarism! No more General Staffs with badges of rank and gold braid at every seam! Make way for the people, for the fighters with bare arms! The hour of revolutionary warfare has struck!"

Earlier in the day, Goncourt, hoping fervently for news of the Versaillais's success, had "wandered around for a long time in search of information." He found "nothing, nothing at all. The people who were still in the streets were like the people I saw yesterday. They were just as calm, just as dazed." So he returned home and went to bed "in despair." But he was awoken in the middle of the night by murmuring sounds. He went to the window but again saw nothing, his ears recognizing only the usual minor commotion as one company was relieved by another. Telling himself he had been imagining things, he returned to bed. But it wasn't long before he heard the unmistakable sounds of bugles and drums. He rushed back to the window. "The call to arms was sounding all over Paris," he wrote, "and soon, drowning the noise of the drums and the bugles and the shouting and the cries of 'To Arms!' came the great, tragic booming notes of the tocsin being rung in all the churches." The church bells' "sinister sound," he wrote, filled him with joy because it "sounded the death-knell of the odious tyranny oppressing Paris."

The initial gains of the Versaillais army were impressive. They quickly liberated Passy and took the Communard positions at the Trocadéro. They also captured the heavily sandbagged Arc de Triomphe before sweeping down the Champs-Élysées. But already in Passy and neighboring Auteuil, there were dark signs of what was to come. Both suburbs had been taken with virtually no resistance, but the Versaillais—stirred into a hysteria by weeks of anti-Communard propaganda—were in a ravening mood. A journalist for *Le Gaulois* later discovered thirty bodies in a ditch—all victims of summary executions. They had been lined up and gunned down by a mitrailleuse, a mounted volley gun capable of firing twenty-five rounds in quick succession.

Within twenty-four hours of the first breach of the ramparts, more than 130,000 Versaillais troops had entered Paris. Haussmann's wide boulevards, designed to facilitate government responses to guerilla-style insurrections, facilitated their progress. But the Communard fighters were determined and resourceful. As church bells sounded, drums rolled, and trumpets blasted, they rushed to consolidate barricades built around overturned trolleys or carts. Sandbags, paving stones, and bricks plugged the gaps. On the wider boulevards, the barricades were expanded into small fortresses, replete with cannons poking through holes. It was at the sight of the previous afternoon's concert that the Versaillais troops had met their first serious resistance. Fired upon from the terraces of the Tuileries Garden by Communard cannons and rifles, they sustained heavy losses and were forced to withdraw.

That day, a Monday, Goncourt could not bring himself to stay indoors: "I simply had to see and know." Others, too, had left their apartments, gathering in carriage gateways, fearful, angry, and excited. Goncourt saw a National Guardsman with a shattered thigh being carried along. He overheard rumors that the Versaillais army had taken the Palais de l'Industrie—the venue of the annual Salon—and turned it into a prison. He saw Communard National Guardsmen returning from the city's western quarters "in small bands, . . . looking tired and shamefaced." He soon realized that anyone found walking the streets was at risk of being press-ganged into service on the barricades, so he took refuge in the apartment of the art critic Philippe Burty, near the Bibliothèque Nationale.

IT WAS SPRINGTIME IN PARIS. The lilacs were in flower. Only days earlier, National Guardsmen had been coming home at night with bunches of flowers on the ends of their rifles. But now reality itself seemed altered, as when the panoramic view from a train window is suddenly impeded by a roar of displaced air and the racket of carriages hurtling past in the opposite direction. The Commune's leadership was crumbling. People who saw a way out took it. The passionate republican Henri Rochefort was among them. Prior to the war,

Rochefort had used his journals, *La Lanterne* and then *La Marseil-laise*, to undermine Napoleon III's authority. During the siege, he had joined the Government of National Defense and then the Commune. But even he could see that the situation was hopeless. Attempting to flee, he was captured by Thiers's troops and escorted to Versailles, a disgraced and disheveled trophy trailed by a jeering crowd. Cornélie, still in Saint-Germain-en-Laye, was at lunch when (she wrote) "we heard a terrible hubbub, a rumbling of carriages, at full speed, people running, cavalry squadrons galloping, and cries in the midst of it all. We flung down our napkins and in no time we were in the street, and learned that it was Rochefort being escorted to Versailles."

The feeling in the Morisot household at Saint-Germain-en-Laye was cautiously optimistic. Berthe's brother Tiburce was with the Versaillais forces serving under Admiral Saisset, although he was not on a tight leash and in the evenings had been staying with his parents at Saint-Germain-en-Laye. Not wanting "to miss any part of the affair," he headed once more into Paris on the morning of the twenty-second, as the army swept up into Montmartre. His plan was to get to the Morisot house on the Rue Franklin and stay there, but if he couldn't, he would return to Saint-Germain-en-Laye and share whatever news he had gathered. Relaying this to his sisters, Cornélie expressed the hope that they might all be back in Passy in a few days—although she noted in a letter to Edma that her husband, "who is always afraid to be happy, did not believe it."

Her husband was rightly fearful. The house on the Rue Franklin was far from safe. The Morisots heard from their servant, Louis, who had remained in Passy and was sleeping in the cellar, how bad things had become. An immense explosion—likely another arms depot—had convinced Louis that the house was collapsing. The rumbling vibrations abated, and the building appeared to have held together, but all the windowpanes were broken, and stones and dust were showered over the whole neighborhood. Worse still, for Berthe, was that only three windowpanes remained intact in the studio, and all the pictures had been dislodged from the walls.

At Saint-Germain-en-Laye, Cornélie could hear the "odious Prus-

sians" night and day. The troops were under orders from Bismarck to stay at the ready. Thiers had successfully pleaded with Bismarck to hold off, beseeching him "in the name of the cause of order to let us carry out this repression of banditry ourselves." But he knew Bismarck would order an intervention if the Versaillais forces failed to retake Paris quickly. Cornélie was confident that Thiers would succeed—it was now surely just a matter of time—and that, with the treaty restored, the Germans would finally go home. But in the meantime, she explained, "they are deployed and concentrated nearer to Paris. They regale the terrace with their music every day. Their arrogance is extreme. I don't like them any better since it has been decided they are no longer our enemies."

Chaos and violence were engulfing Paris. But Cornélie was already speculating on what would become of Thiers and the whole political scene after it was over. "I tremble to think," she wrote. "It is said that Thiers . . . will resign, and without him there will be nothing to restrain the reactionaries." This prospect frightened her. For all that she detested the radicals of the Commune, Cornélie was essentially a moderate and, like her husband, had no desire to see a conservative crackdown. "We shall advance," she gloomily predicted, "to a full-fledged monarchy, new struggles, open or hidden, with no respite." Thiers himself was alive to these possibilities. He knew that a reinstated monarchy had little chance of succeeding and that in the long term a republic remained more viable than any other form of government. Drawing the ire of conservatives, he had reassured republicans, who came to him in deputations in the weeks leading up to the retaking of Paris, that he was committed to a republic. The mayor of Lyon, a veteran republican, was one who came away cautious but convinced. "My friends and I trust you," he wrote to Thiers, "but we mistrust the Right. . . . Count on us . . . as you direct, we shall act."

After meeting resistance in central Paris, MacMahon had pulled the bulk of his Versaillais forces back to Passy. They had set up headquarters on the Rue Franklin, just down from the Morisot home. MacMahon himself was established in the house of their neighbors, the Guillemets. The commander of the second Versaillais army, Vinoy

(whose failed attempt to reclaim the National Guard's cannons at Montmartre had triggered the Communard uprising), occupied the home of the Cosnards, while the *intendant général*—a logistics specialist in charge of supplies—was in the Morisots' home. The Communards were made aware of their presence, and from behind the barricades at the Place de la Concorde and from a gunboat on the river, they began to lob shells along the line of the Seine. They "rained all about our house," Cornélie reported to Berthe on the twenty-third. A shell had hit an apartment on the second floor of Cornélie's father's nearby home, "smashing everything to atoms." Other neighbors' houses were badly damaged.

Incoming shells were not the only concern: Passy was not yet cleared of Communards who were willing to fight. In the house of a friend, Charles, "only the big pieces of furniture are said to be left," wrote Cornélie, "and the Communards scrawled disgusting arabesques on his embroidered coat." Tiburce was going in and out of Paris, bringing messages to and from General Vinoy and his officers. Moving around was extremely perilous. At one point, Tiburce tried to cross the Pont de l'Alma, but "bullets were whistling," reported Cornélie, "and the soldiers are in such a violent mood they don't give you time to explain yourself. . . . It is impossible to venture anywhere." She knew that her son's proximity to the generals was putting his life in jeopardy. Standing on the terrace at the Cosnards', Vinoy had been startled when a bullet fired from an unseen point struck the nearby summerhouse. But Cornélie was also proud of her son and of the Morisots' ability to be of service to their friend Thiers. Vinoy, wrote Cornélie, "was very amiable to Tiburce, who was received cordially by everyone." Later, returning from the city, Tiburce had run into Jules Ferry—who not so long ago (it seemed another life!) had courted his sisters, Berthe and Edma. He hitched a ride in his cab all the way to Versailles and from there returned to Passy without difficulty.

In the midst of the chaos, Tiburce invited Vinoy, MacMahon, and their senior staff to dinner at the Morisots' Rue Franklin home. He tried to be as obliging as possible. "He has put the cellar at their disposal,

as well as the linen, the china, etc.," wrote Cornélie. But even for such high-ranking generals, it was difficult to secure provisions. They had to send to Sèvres for meat because the neighborhood butcher shops were closed. That night they slept on mattresses on the floor—almost in the open, since all the windowpanes lay shattered on the floor. Tiburce's hospitality was reciprocated when the generals invited him to lunch on the twenty-second. "During the luncheon the shells did not stop whizzing, and fragments fell in the garden," wrote Cornélie.

This was not the situation Thiers and his generals had hoped for. According to Tiburce, there was talk among the general staff of pulling back and lifting the siege. "They did not feel inclined to let themselves be killed for no reason," wrote Cornélie. To add to the drama, halfway through writing the letter (dated May 23), she was interrupted. "I had got this far," Cornélie informed Berthe, resuming, "when there was a new excitement—a fire alarm—everyone ran to the terrace. Paris was burning they said."

Thiers had put out a call to all available firefighters in all the suburbs—including those in Saint-Germain-en-Laye. The reason? Apparently the insurrectionists were "trying to avenge their defeat by setting fire to everything," wrote Cornélie. "Rumors of all kinds are circulating—that the Louvre is burning, or the police headquarters, where all the hostages are being held. . . . In truth we know nothing."

———

ONE PERSON WHO *was* witnessing much of it at close quarters was Goncourt. He was still holed up in Burty's apartment with Burty, his wife Euphrosine, and their two daughters, Madeleine, ten, and Renée, who was not yet three. Shells had fallen on the buildings around them the previous evening, and the porch of the building on the other side of the street had been destroyed. The Burtys had made up a bed for Goncourt—"I threw myself on to it, fully dressed," he wrote—and at daybreak on Tuesday, after an insomniac night, he "fell into a sleep haunted by nightmares and explosions."

By now, May 23, most of Batignolles and Montmartre had fallen to Versaillais troops under the command of Ladmirault and Clinchant. The Communard resistance was disorganized. Louise Michel, who had played a prominent role in the events that triggered the Commune, led a squad of twenty-five women who fought bravely as they retreated from barricade to barricade along the Boulevard de Clichy. They were soon reduced to fifteen. By one p.m. the Versaillais troops had reached Butte Montmartre, where they reclaimed the cannons they had failed to seize in March. They pulled down the Commune's red flag from the Solferino Tower on the Rue des Rosiers and in its place hoisted the tricolor. Forty-nine Communards were captured, among them seven women and children. And now, in the very place where the two generals, Lecomte and (the retired) Clément-Thomas, had been executed then dragged into the street and kicked and urinated upon, the forty-nine prisoners were lined up and shot.

Thiers had just announced to the Assembly at Versailles that thanks to the forces now overrunning Paris, "the cause of justice, order, humanity, civilization has triumphed." His assertion was followed by the almost religious-sounding claim that "expiation" would soon be "complete" and that it would "take place in the name of the law, by the law, and within the law." But in the streets of Paris, actual law was abandoned as the idea of expiation took precedence. Atrocities on both sides fueled the macabre catastrophe that now unfolded, but the extrajudicial execution of those forty-nine prisoners began an awful, accelerating sequence of retributive murders, most of them committed by the Army of Versailles.

OVER THE PREVIOUS nine months, Joseph Vinoy had suffered many humiliations. Not only was he a senior general in the army crushed by Prussia; he also bore responsibility for the bungled operation to recapture the National Guard cannons, which in turn had led to the murders of Lecomte and Clément-Thomas. Vinoy was determined not to let the current operation suffer a similar fate, so he set about his work with special ruthlessness. His attitude undoubtedly filtered down to his subordinates. There was a sense in which the

vicious punishment that the Versaillais doled out was directed not just at the Communards but at Paris itself. The city had dared to set itself apart from the rest of the country. Its extravagance and venality under Napoleon III were manifestations of an arrogance that warranted more than just censure. It had to be taught a lesson.

In the arrondissements taken by the Versaillais, house-by-house searches led to thousands of arrests. Soldiers were sent down into the sewers and catacombs to hunt down any Communards who might be sheltering there. The Commune still held large parts of the city, but its grip was loosening by the hour. Its defenses on the Left Bank crumbled after National Guardsmen abandoned Fort de Bicêtre, to the southeast, and returned to the city to defend the quarters they lived in. The Communard commander at Fort de Bicêtre, Léon Meilliet, became convinced that members of a nearby Dominican order had been in cahoots with the Versaillais army, so as he withdrew, he took about forty of the clergymen and their staff prisoner. In the chaos, some were released or managed to escape, but the rest were taken to a temporary prison at the Place d'Italie. That afternoon they were ordered to join fourteen National Guardsmen, who had been imprisoned for disobedience, on the barricades. Despite protestations, the Dominicans and errant Guardsmen were herded together into the prison courtyard and then led through the gate. But as they emerged into the street, a combination of prison guards and Communard soldiers fired on them, felling thirteen, among them five clergy.

That same hilltop neighborhood, the Butte-aux-Cailles, fell to the Versaillais a short time later—although only after three attacks were repelled. It was the last Communard bastion on the Left Bank. Fifty-five captured Communards were forced by the Versaillais to stand on the bodies of their fallen comrades and then shot. Over the next few days, the Place d'Italie became "a veritable slaughterhouse," according to Julien Poirier, a soldier in the Versaillais army. Several thousand executions may have taken place there alone.

If order among the Communards had broken down, so had discipline among the Versaillais. The massacres carried out in Montmartre were not limited to revenge killings in the Rue des Rosiers.

One Communard, Camille Pelletan, described seeing twenty bodies lined up along the pavement in front of a house. Communards cut up with bayonets were left for dead at the Place de la Mairie. There was similar carnage outside the Moulin de la Galette. And at Château Rouge, more than fifty bodies were seen being carted into a school courtyard. "As many people defending the barricades," wrote Pelletan, "the same number of bodies." The two generals who retook Montmartre, Paul de Ladmirault and Justin Clinchant, were among the most scrupulous in the Versailles army. Clinchant, a republican, explicitly banned executions of captured Communards in the parts of Paris he controlled. And Ladmirault, who was from an old aristocratic family that had resisted the French Revolution, was exceptional in his eagerness to abide by standards of decency. He expressed sympathy for Parisians who had joined the National Guard in a desperate time to guarantee a daily wage of 1.5 francs, only to find themselves associated with an insurrection. Nonetheless, in the frantic heat and paranoia of street-by-street fighting, even responsible generals wielded limited powers over their officers' and soldiers' baser instincts. A kind of frenzy took hold.

Elsewhere in Paris, wounded soldiers were thrown into mass graves along with the dead. John Merriman recounts one story of laughing soldiers taking turns to throw stones "at a small arm that seemed to be moving in a pile of bodies until it stopped." Prisoners being frog-marched to Versailles were suddenly stopped and killed for no reason, in some cases by sword. One prisoner on just such a march couldn't keep up, so soldiers tethered his arms to a horse, which was then made to gallop. Reduced in short order to a bleeding wreck, his state was so wretched that onlookers begged the soldiers to shoot him. "One of the troopers halts his horse, comes up and fires his carbine into the moaning and kicking parcel of meat," wrote the novelist Alphonse Daudet, who witnessed the scene. "He is not dead. . . . The other trooper jumps from his horse, fires again. This time, that's it." A woman wearing a red belt was simply shot on sight. "Like other female victims," wrote Merriman, "she had managed to survive the Prussian siege without complaint only to be shot by a

French firing squad." In *La Débâcle*, the novel he wrote twenty years later, Zola described summary executions on the Rue de Richelieu and continuous firing squads in session at the Lobau barracks. "Men and children," he wrote, were "condemned on the strength of a single piece of evidence, that their hands were black with gunpowder or merely that they happened to be wearing army boots; innocents falsely denounced, victims of private vengeance, screaming out explanations, unable to make themselves heard . . . so many wretched people at one time that there weren't enough bullets for all of them and the injured had to be finished off with rifle butts."

To eyewitnesses in their homes, urban warfare is impossible to interpret. In central Paris, Goncourt and Burty were worried that soldiers might try to force their way into the Burtys' apartment and use it as a perch for sharpshooting, trampling books and papers in the process. They could hear the sound of gunshots getting closer. From the window, they looked down at a squad of frightened workers who, having received orders to build a barricade, were putting in a desultory effort, when suddenly the two writers heard bullets whizzing around them. The Communards vanished down the street. More soon appeared, however. At first, they headed south in formation along the Rue Vivienne. But the retreat soon degenerated, wrote Goncourt, into a "general stampede." Burty and Goncourt saw four men carrying "a dead man" by his arms and legs, "like a bundle of dirty washing." His head was covered in blood. They took him "from door to door without finding a single one open." At another point, the writers saw a National Guardsman and a lieutenant standing over a dead body under a small tree. A fusillade of bullets suddenly dislodged all its new green leaves, which rained down upon them. A woman nearby was lying flat on her stomach holding a peaked cap in one hand.

By the end of the day, that street was in the hands of the Versailles troops. But the taking of each street in this manner came at a terrible price. Even in recaptured territory, any soldier could be gunned down at any moment from the window of any apartment. The atmosphere of arbitrary terror surely contributed to the army's murderous bloodlust. Learning from the Communards' tactics, the Versaillais placed sharp-

shooters high up in the buildings surrounding the unfinished Opéra Garnier. From there they fired down upon Communards entrenched behind barricades. The tactic worked, and by evening, the Opéra was retaken. More executions were committed at the Madeleine. "I fear there is a very revengeful disposition among the regular troops, which is much to be regretted," wrote Alan Herbert, an English doctor living just behind the Madeleine.

That evening, venturing out onto the balcony to see the Versaillais troops, Goncourt and Burty were startled when a bullet struck the wall just above them. Their upstairs neighbor, they realized, had drawn fire by taking it into his head to light his pipe at his window. The two writers hurried back inside. Soon the shelling resumed, this time from Communards attacking the freshly won Versaillais positions. Goncourt and Burty's family moved farther inside, setting up camp in a less exposed anteroom. The little iron bed of the toddler Renée was pulled into a safe corner. Madame Burty sank into an armchair, and ten-year-old Madeleine "lay down on a sofa near her father, her face lit up," wrote Goncourt, "by the lamp and silhouetted against the white pillow, her thin little body lost in the folds and shadows of a shawl." Going to the window to look out over the boulevard, Goncourt saw a strange red glow emanating from the direction of the Tuileries. He returned to his chair, listening "to the heart-rending cries of a wounded infantryman who had dragged himself up to our door and whom the concierge, out of a cowardly fear of compromising herself, refused to let in." When he awoke the next morning, the body of the National Guardsman killed the previous day was still there under the small, bullet-strafed tree. Someone—Goncourt had no idea who— had covered it with snapped-off branches.

Meanwhile the city was ablaze. The morning air was weirdly illuminated as if by the ambient light of an eclipse. Venturing out from Burty's apartment, Goncourt was amazed to run into Pélagie Denis, his long-term housekeeper. Together they decided to try to return to Goncourt's home in Auteuil. They had heard that the Tuileries Palace was on fire and hoped to catch sight of it. But suddenly, at the Place de la Madeleine, a shell exploded "practically at our feet," and they were

forced to change direction. As evening came on, wrote Goncourt, "I watched the fire of Paris, a fire which, against the night sky, looked like one of those Neapolitan gouaches of an eruption of Vesuvius on a sheet of black paper."

Under the command of Brunel, surviving Communards in central Paris were stubbornly holding the Versaillais at bay. Brunel had established three barricades: in the Rue Royale, at the Place de la Concorde, and on the Rue Saint-Florentin. The latter barricade was positioned at the corner of the Tuileries and defended the Rue de Rivoli, which led in a straight line to the Commune's headquarters at the Hôtel de Ville. All three barricades were coming under heavy bombardment from the guns of the Versaillais general Félix Douay. Boom by shattering boom, they were slowly reduced to rubble, at the cost of dozens of lives. At the same time, Versaillais forces attacking from the direction of the Opéra threatened the Communards' flanks. Versaillais sharpshooters placed high up in buildings along the Rue Royale, perpendicular to the Rue de Rivoli, were even firing at the barricades from behind. To negate the threat, Brunel withdrew toward the Hôtel de Ville, ordering his men to set fire to the buildings on the Rue Royale as they fell back. His orders were carried out. The flames spread quickly. And then, as he retreated, Brunel saw an astonishing sight. The Tuileries Palace simply exploded.

Jules Bergeret, who had been imprisoned by the Commune for an earlier military failure and had only recently been released, had decided on his own initiative to burn it down. There was no pressing military reason. It was simply that the palace represented all that Bergeret loathed about the previous regimes, both royal and imperial. Its recent conversion into a concert venue for the people had not removed the stench of privilege and corruption. So with the end of the Commune well in sight, Bergeret jammed dozens of barrels of gunpowder under the central dome over the Salle des Maréchaux. When he ignited it, the dome was blown away, illuminating the sky over Paris like a mushrooming, end-of-days phantasm. The entire building then began to give way to voracious, roaring flames.

By the next night, May 24, the Hôtel de Ville, to which Brunel had

retreated, was abandoned and set alight. Other buildings engulfed by fire included the Légion d'Honneur, the Palais de Justice, the Conseil d'État, a large part of the Palais-Royal, the Prefecture of Police, and the Ministry of Finance. The latter was housed in the Louvre, so the museum and all the artworks Courbet had striven to protect were in imminent danger.

"The Louvre and the Tuileries are burning," reported *The New York Times*, which put the appalling news from Paris on its front page every day during Bloody Week. "They are said to have been ignited by the federals with petroleum. The Luxembourg has been partially blown up. The Palais Royal is still burning. A terrible explosion has just occurred in the center of Paris, and it is considered probable the Hotel de Ville has been blown up by the insurgents."

"The state of feeling now existing in Paris is beyond description," wrote Washburne to U.S. secretary of state Hamilton Fish. And indeed there were no words. Not even pictures could convey the teeming, ungraspable truth. As reports of what was taking place reached beyond France, the world responded with stupefaction and moral recoil. That Paris—that proud, exquisite city with no obvious equal on earth—could be reduced to a predicament so debased beggared comprehension.

"Paris Is on Fire"

THE VERSAILLAIS ARMY PRESSED ON, MEETING WITH MORE resistance than its soldiers anticipated, which only increased their ferocity. Thiers's retaking of Paris had been sold as a resolute action that would prevent the Commune from establishing a second Reign of Terror, but it had taken on the character of a holy war. "I shed torrents of [Parisian] blood," boasted Thiers in a speech that Thursday, as victory appeared at hand. "Over Paris hang pillars of dense smoke, so many that they cannot be counted," reported *The New York Times*. "Now and then a sudden sharp crack, followed by a dull thud, is heard; a convolvulus-shaped volume of smoke rises, as from Vesuvius in eruption, and Paris rocks to its center."

As news of the atrocities committed by the Versaillais filtered through, a group of appalled and frantic Communards told Rigault's new prefect of police, the twenty-five-year-old Théophile Ferré, that it was past time to shoot their hostage, Archbishop Darboy. The Commune's ferociously anticlerical leaders had converted many of the city's churches into club halls. Rigault, in particular, took every possible opportunity to show his contempt for the clergy. And yet his hostage, the archbishop, was no reactionary royalist. He had a proud record of reform, had openly opposed the Catholic doctrine of papal infallibil-

ity, and had once been refused a cardinal's hat by Pope Pius IX for his liberalism. Courageously, he had chosen to stay in Paris during both the siege and the Commune. Some even believed Darboy's liberal sympathies might have increased Thiers's willingness to sacrifice him. (Marx later went so far as to claim that Thiers was "the real murderer of Archbishop Darboy.") More likely Thiers believed, as he said at the time, that negotiating with the Commune was a mistake and that exchanging Darboy for Blanqui would provide the Communards not only with a leader but with an incentive to take more hostages.

In any case, Darboy's time was up. After so many weeks in captivity, he was gravely ill. Ahead of the Versaillais army's advance, he had been moved to the prison of La Roquette. A court-martial was now hastily improvised. A number of prisoners, including Darboy, were put on a list to be executed, and after much bureaucratic back-and-forth—a reprieve for one, bad luck for another—six names were settled upon. Rebukes ("You've done nothing for the Commune. You are going to die!") and insults ("Papists," "traitors") were flung at the prisoners as they were marched out of their cells and led down long, musty corridors. Darboy was so ill he could barely walk. What ensued could easily have been brief and mercifully decisive. But it was not to be. Like the execution of Emperor Maximilian in Mexico four years earlier, it turned into a protracted horror show.

The firing squad was made up of young volunteers, most of them doubtless eager to avenge fathers, brothers, uncles, and friends who had been killed or wounded by the Versaillais. Some were still teenagers. Naïve and vulnerable, they were now being ordered to kill six defenseless men of the cloth. In front of the condemned men, they discussed with their captain, Verig, the best place to do it—the exercise yard or the alley that led to the guillotine? They settled on the alley. The prisoners sang prayers in a low voice as they were led to the spot. At one point, Darboy raised his arm skyward, calling out, "My God! My God!" then knelt down with the others to say a prayer. He stood again to bless his companions. Amid shouts from onlookers to hurry up and get on with it, the prisoners were finally lined up against a wall.

Raising the sword he had been lent for the purpose by Ferré, Verig

gave the command. There immediately followed two ear-splitting volleys in quick succession. When the smoke cleared, dismayingly, Darboy remained alive. Felled by the first bullets, he got back to his feet once, then a second time, then—incredibly—a third time.

"This old bastard Darboy did not want to die!" one of the firing squad later said. "Three times he got up, and I began to be afraid of him!" The seconds ticked by. Darboy's heart pumped away in his bloodied chest, which expanded and fell back with each breath. Verig lurched forward and, according to his own account, used his pistol to deliver the coup de grâce. To make sure of it, the spooked men in the firing squad fell on his body with their bayonets, repeatedly piercing his chest. The dead men's bodies were left lying in pools of their own blood for six hours. Finally, at two a.m., they were carted to Père Lachaise Cemetery—which was about to become the final stage of a long night of ghastly theater—and thrown into an open ditch.

The demise of Darboy, the archbishop of Paris, was well documented, and the consequences of his murder were far-reaching. But similar scenes were playing out all across Paris. As the city burned, sending vast drafts of smoke into the sky, the danse macabre continued. By Thursday, the Versaillais were advancing toward the city's eastern arrondissements. Communards who hadn't been captured or killed had retreated to Belleville and Ménilmontant. Rigault wasn't among them. He was discovered that day in an apartment on the Left Bank, using a pseudonym and in the company of an actress. He was shot in the head, his body left on the street, to be spat on and kicked at by passersby. Victor Hugo, from his forlorn perch in Belgium, later condemned the killing of Rigault and his fellow Communard leaders; they should have been tried, he said.

But it was too late for that. The Versaillais side of the scales sank lower and lower. Bullets kept ripping through skulls and tearing through chests. Ferré, who had ordered Darboy's execution, would himself be shot by a government firing squad in the days after the Commune was finally extinguished.

———

"PARIS IS ON FIRE," wrote Cornélie in that day's letter to Berthe. "This is beyond any description!" And so it was. The previous day she had watched from the terrace at Saint-Germain-en-Laye, where strong winds carried charred papers, like a "swarm of black butterflies," as Zola later wrote. Some of these papers were still legible. Cornélie could hear continual explosions and detonations. "We were spared nothing," she wrote. Rumors had reached her that the insurrection had been crushed, "but," she added ominously, "the shooting has not yet stopped. Hence this is not true."

She was right. Some Communards were still holding out. But the shooting Cornélie heard was more likely the sound of summary executions. "New fires are bursting out in Paris," announced *The New York Times*. "The insurgents put boxes of petroleum everywhere. The Versaillists, since Tuesday, are killing all prisoners. I saw numbers of the Communist sympathizers killed, and among them was a young man, handsomely dressed, with hands tied and brains blown out."

By ten p.m., the fires seemed to have died down. But the next morning a dispatch arrived informing Cornélie of all the buildings that had been gutted. "The Tuileries is reduced to ashes," she told Berthe, "the Louvre survives, the part of the Finance Ministry building fronting onto the Rue de Rivoli is on fire, the Cour des Comptes is burned down. . . . Paris is strewn with dead."

Just writing those sentences must have had a stunning effect. Reading them was quite as shocking. The Louvre—for any French artist—was a kind of spiritual home. For Berthe, as a woman, it was the only place she could go to learn and mingle with her fellow artists on level terms. It was the place she used to visit with Edma and Rosalie Riesener to paint copies of Rubens; the place where she had been introduced to Manet. That it had only just survived . . . ?! It was hard to believe. The need to assign blame—a need that would soon consume the entire French nation—had already taken root in Berthe's mother's heart. Cornélie could not set aside the fact that Berthe's new painter friends, Manet and Degas, had expressed sympathies for the kinds of people who, in her mind, had caused all this. They were on the side of people who had turned on their country and held their

friend Thiers in contempt. And now just look where it had all ended! "Should Degas have got a bit scorched, he would have well deserved it," she wrote. How Berthe received her mother's commentary is not known. At this point, well practiced in discretion, she chose to reveal nothing of her opinions.

On Friday, after months of dry weather, there was a storm. The rain helped subdue the fires that had engulfed central Paris and was a decisive factor in saving the Louvre. Now that most of the city had been retaken, the Versaillais killing machine became at once more organized and more brutal. The army's soldiers were complemented by ordinary civilians acting as de facto military police. Sporting tricolor armbands, they responded to denunciations and followed up on rumors, making hundreds of arrests, often on the slimmest of pretexts. It is not clear how much Thiers and his top generals knew about the scale of the killings or how much they cared to curtail them. But plenty of evidence suggests they turned a blind eye. The killing was very nearly arbitrary. Gray-haired men were assumed to be veterans of 1848 and thus Communards. Men wearing watches were marked out as Communard leaders. Shirts were yanked open to reveal bare shoulders that might bear marks left by recoiling rifles. All were presumed guilty. Anyone known to have previously served in the regular army was assumed to have deserted and joined the Commune. And anyone with a foreign accent was similarly stained: they surely had ties to the International. Arrests led directly to executions.

ON THURSDAY EVENING, Delescluze had sat down to write a final letter to his sister. He was the radical journalist whom Gambetta had defended and who, since May 11, when he was made the civilian delegate of the war committee, had been the Commune's de facto military leader. "I no longer feel I possess the courage to submit to another defeat, after so many others," he wrote. He stood up, went outside, and made his way to one of the barricades. Walking with the slow, almost floating gait of one who fully expects to die, he deliberately wandered into an exposed position and was promptly shot. Four men rushed to retrieve his body. Three of them were also shot.

The Commune was now essentially leaderless. After almost a week of fighting inside Paris, Vinoy—perhaps following instructions from Thiers—appears to have issued orders to slow the executions. Prisoners, he told one underling, should no longer be shot "without careful examination" of each case. In reality, however, arbitrary executions continued for many more days. They were carried out openly, not only by the barricades that fell to the Versaillais but in places like the Jardins du Luxembourg, where thousands of men and women were lined up against a wall and shot over the course of the week. The bodies piled up. They were lifted into carts, rolled into trenches. The waters of the Seine—whose undulant, light-reflecting surfaces did so much to inspire the Impressionists—were streaked with blood. In retaliation, Communards removed fifty more prisoners from La Roquette and took them to the city's northeastern walls. There they were gunned down—not by a firing squad but by what amounted to a rabble taking potshots. Back at the prison, the remaining hostages, recognizing what fate had in store for them, took matters into their own hands. Improvising their own barricade within the prison, they managed to hold their captors at bay for many hours, despite an attempt to smoke them out with burning mattresses. They were eventually rescued by Versaillais forces sweeping eastward.

The fighting in Belleville and Ménilmontant, the last redoubts of the Commune, was especially savage. Entire families joined the fray, aware that they were engaged with an adversary that would show them no mercy. Thiers's forces lobbed round after round of artillery fire into Belleville, where every resident was assumed to be an enemy. As the noose tightened, the remaining Communards—about two hundred National Guardsmen with two batteries of guns—found themselves in the Père Lachaise Cemetery, amid the tombs and ornate headstones of France's wealthiest families and its most celebrated poets, novelists, architects, playwrights, composers, and painters. Blasting open the gates to the cemetery, the Versaillais poured in, hoping to overwhelm the remaining, exhausted Communards with sheer numbers. The cemetery was immediately transformed from a decorous resting place for the honored dead into a chaotic killing field. Much of the

fighting was hand-to-hand. The last resisting Communard was killed near Balzac's tomb.

But still the bloodletting was not over. When the dumped bodies of Archbishop Darboy and his fellow clergymen were discovered in an open hole, adrenaline and fear transmuted indignation into pure wrath. The cold-blooded murder of a spiritual leader—the Catholic archbishop of Paris, no less!—and the utterly disdainful treatment of his body were proofs of the enemy's barbarity. Ruthlessness was the only conceivable response. Communards captured alive were lined up by a deep ditch in front of a stone wall and furiously gunned down. Clemenceau said he heard the frenzied clatter of machine guns pumping bullets into flesh for half an hour without so much as a pause. The following day hundreds more captives were brought to the same spot, shot, and shoved into the same mass grave. Back at La Roquette, too, the tables had turned. Captured Communards were thrown into cells, and over the next two days as many as nineteen hundred were shot. Four hundred more were shot at Mazas Prison. Those who had been marched all the way back to Versailles were stuffed into small cells with no light, food, water, or air. Many died before anyone saw to them.

When the bookbinder Eugène Varlin, who had led Communard forces on the Left Bank before withdrawing to Belleville, was captured, he was taken up the hill to Montmartre, beaten and bloodied by the rifle butts of Versaillais along the way. One eye was dangling out of its socket by the time he reached the Rue des Rosiers, where the generals Clément-Thomas and Lecomte had been murdered. Unable to stand, he was placed in a chair in the garden and shot, a martyr to a lost cause.

CORNÉLIE RETURNED to Passy with her husband Tiburce one week later, on a Sunday. The windows of their house on the Rue Franklin were all broken, the exterior was scarred, and there were signs throughout that it had been occupied by soldiers. Much work had to be done. But to their great relief, the building was basically intact. The next day they took a barge down the Seine to get a sense of the city. What they saw was beyond their worst imagining. Many

of the buildings on the Rue Royale had already been demolished. Almost the entire Rue de Rivoli was a scorched ruin. The Hôtel de Ville was past saving, "ripped open from one end to the other!" as Cornélie noted. "It was smoking in several places, and the firemen were still pouring water on it. It is a complete ruin."

The battle to regain control of Paris had taken a week. No one produced a reliable tally, but between 20,000 and 30,000 insurrectionists and their supporters are estimated to have been killed—a number that surely included many noncombatants and disturbingly high numbers of women and children. Théodore Duret, the wealthy art critic and collector to whom Manet had sent his paintings at the start of the siege, only narrowly escaped execution. He had been out trying to inspect the aftermath of the fighting with his friend Henri Cernuschi, a banker, collector, and veteran of 1848. Versaillais troops, taking them for Communards, seized them and immediately put them before a firing squad. They were saved from death only at the last moment.

Degas's father, Auguste, witnessed the carnage after listening to what he described as "six days and six nights of incessant machine-gun volleys, shelling, shooting." He had seen piles of corpses bundled onto the large carpets customarily used to move household furniture and taken to the closest places for burial. Before they were collected, he wrote, "one had to climb over them in order to walk down the street." He couldn't erase the memory.

Thiers was unapologetic, saying, "May this dreadful sight serve as a lesson." Berthe's father took a similar tone. The debris, he muttered to Cornélie, should somehow be preserved "as a perpetual reminder of the horrors of popular revolution." Cornélie was more inclined to let her incredulity linger: "It's unbelievable, a nation thus destroying itself!" She described the wreckage of the Cour des Comptes (where her husband had worked as master auditor), the Hôtel de la Légion d'Honneur, the Orsay barracks, and the Tuileries. "One rubs one's eyes, wondering whether one is really awake."

Thiers maintained afterward that he had not condoned the drumhead courts-martial and that he had given orders urging restraint. But there is evidence that he gave instructions to kill anyone carrying

arms. What's more, he clearly should have acted sooner to curtail the catastrophe. Whatever his culpability, the scale of the slaughter became an international embarrassment.

The retaking of Paris was never going to be tidy, but by killing captured Communards on sight, the Versaillais had created a "nothing left to lose" mentality, turning a ragtag band of febrile ideologues and stubborn idealists into a group of suicidal desperadoes, deranged by fear, bent on maximum destruction. Fear, adrenaline, the panic induced by guerrilla warfare, and a powerful urge, rumbling beneath the surface, to avenge the humiliation of defeat by Prussia had all fed into a wave of irrational emotion overwhelming any impulse toward restraint. Many buildings could not be salvaged. Beyond those mentioned by Cornélie, there was damage to the Conseil d'État, the Gobelins, the Library of the Louvre, the Finance Ministry, the Prefecture of Police, the Theatre Lyrique, and parts of the Palais de Justice and the Palais-Royal. All this was in addition to the destruction wrought during the fighting with the Prussians, when bridges were blown up and the château at Saint-Cloud had been razed. Parisians now had to confront all this as they waited for the smoke to clear and the stench of decomposing bodies to abate. "A silence of death reigned over these ruins," wrote Gautier. "An incredible sadness invaded our souls."

Manet and Degas both came back to the city. Cornélie learned of their presence through her son, who had run into them on the street. She had them both down as Communards. She was surprised, she wrote, that they dared reveal themselves "at this moment, when they are all being shot." The two artists were "condemning the drastic measures used to repress" the Communards, Tiburce told his mother. "I think they are insane," Cornélie wrote to Berthe, "don't you?" Berthe offered no reply. Cornélie thought the two painters had not yet visited the Morisot house in Passy because they were ashamed to show their faces. But it was also true, as she admitted to Berthe, "that you are not here."

———

FRANCE ENTERED INTO a period of deep reckoning that would last decades. The scale of the disasters that had befallen first its army, then its political system and many of the institutions of its capital city, was so great that deep explanations were needed. Blame had to be apportioned. The apportioning was carried out not only at the political level but in private homes and community meeting places—at every level of society. Flaubert, who came back into the city to work in the National Library a few days after Bloody Week, told George Sand that he could smell the corpses. But breathing in such befouled air, he continued, "disgusted me less than the miasmas of egotism exhaled from every mouth. The sight of the ruins is as nothing compared with the immense Parisian stupidity."

Many, like Cornélie, had no doubt about who was responsible. For Berthe, however, and for Édouard, nothing was clear-cut. Each had a foot in both camps. Both came from wealthy families whose interests conflicted with the radical left, yet they were republicans, sympathetic to the radicals who had fought the authoritarianism of Napoleon III, regretted the surrender to Prussia, and simply wanted something better. But the debacle that had just unfolded could be neither undone nor ignored. It was a new lens through which, from now on, everything had to be seen. It allowed for no illusions.

Likely prompted by his encounter with Tiburce, Édouard sat down to write to Berthe, who was still with Edma in Cherbourg. It was June 10. This was the first communication between them for many weeks—certainly since the mayhem. Édouard told her he had tried to see her at Saint-Germain-en-Laye before she went to the coast, but she had been out that day. He admitted, too, that he had planned to visit her parents but hadn't yet managed to. Was it because he knew they would be at odds? Or was he simply overwhelmed as he tried to get his life back on track? "All of us are just about ruined," he wrote. "We shall have to put our shoulders to the wheel."

Édouard was not one to wallow. He finished, characteristically, on a positive note. He wanted Berthe to know that he missed her, and he implored her to return to Paris, to life: "I hope, Mademoiselle, that you will not stay a long time in Cherbourg. Everybody is returning to Paris; besides, it's impossible to live elsewhere."

PART IV

The Birth of Impressionism

CHAPTER 16

A New Way of Painting

THE MOST SHOCKING IMAGE TO EMERGE FROM THE COM-
mune, and from Bloody Week in particular, was not a painting by one
of the future Impressionists but a watercolor by James Tissot. He was
the society portraitist who, during the siege, had disgusted Degas by
drawing the dead body of their friend, Joseph Cuvelier, while fight-
ing in the Battle of Malmaison. Tissot had joined the Commune,
although more to protect himself than out of any political convic-
tion. He worked as a stretcher bearer during Bloody Week and in
that distressing role was eyewitness to a spate of summary executions.
The watercolor he made is dominated by a high brick fortification,
cropped so that we don't see its top. We do see one vertical edge of the
wall and to its right a sliver of green: the Bois de Boulogne. Below, at
the foot of the wall, thirteen corpses are grotesquely splayed on tus-
socky ground. In a detail that could have come straight from Goya,
who loved to draw tumbling bodies, a body is shown in midair as it
plummets, jackknifed and upside down, to the same ignoble fate as
the bodies already on the ground. Almost all have red stains on their
shirts. They are the bodies of executed Communards.

Just as he had drawn the corpse of Cuvelier, Tissot made a sketch
of this scene on the spot. Back in his studio, he worked it up into a

small watercolor. He also scrawled some notes, under the heading "Notes taken during the execution of the National Guards which took place in the Commune on 29 May 1871." "They fall like a rag doll," he wrote, "and one can see the sergeant rushing to give the coup de grâce." Having watched from afar, Tissot later inspected the actual scene of the executions, which were repeated the next day. "There is very little blood on the spot where they were executed but lots of brains as a result of the coup de grâce in the ear."

The Commune produced many photographs of barricades and bodies in coffins, but Tissot's watercolor, which remains in private hands and is little known, is one of very few contemporaneous artistic depictions of the events of Bloody Week. There was too much shame surrounding those events—even for artists inclined to truth-telling.

The buildings that had burned for weeks and would lie in ruins for years became a favorite subject for artists wanting to win admirers at the Salons, among them Édouard's former military superior and artistic rival Ernest Meissonier. *The Ruins of the Tuileries Palace*, Meissonier's most ambitious painting of the Commune's aftermath, was intended as a warning against revolution and "mob rule." The 1872 Salon included around ninety works dealing with the events of the previous year, but artists were more interested in depicting the war with Prussia—an identifiable enemy—than the fratricidal fiasco of Bloody Week. Their portrayals of the heroism of individual soldiers and small bands of troops holed up in improvised redoubts were part of a widespread attempt to, as Bertrand Trillier put it, "transmute defeat into moral victory."

Most artists who lived through the Commune or returned to Paris in its immediate aftermath had little interest in churning out propaganda or rhetoric. They were angry. Some wanted to bear witness. But as weeks and then months elapsed and the full extent of what had happened was brought home, their creativity seized up. Older artists like Moreau, Puvis, Gustave Doré, and Carpeaux slowed their production to a trickle. What little work they did produce tended to be on a smaller scale and in a subdued palette. Some artists retreated into solitude. Others left Paris entirely. Many were overwhelmed

and depressed. They spoke of being constantly tired and of wanting to be left alone. Flaubert, in a letter to his sister Caroline more than a year after the collapse of the Commune, wrote: "In Paris, I learned that several people (including, among others, the painter Gustave Moreau) were affected by the same disease as I, that is to say *the inability to endure crowds*; it is apparently a common affliction following our disasters."

Some took comfort in nature and in work. Jean-François Millet, who had fled to his hometown hamlet near Cherbourg at the beginning of the war, offered advice to a painter friend in Barbizon: "take . . . as much pleasure as you can in natural things; because there is always something solid there. I, for my part, strive to banish from my mind (but I cannot do it enough) all these horrors against which I can do nothing, in order to throw myself into work."

Despite pitting themselves against the conservative establishment before the war, the artists in Manet's circle seemed to feel similarly to Millet. Very few tried to depict the events of 1870–71. Tissot's action, after completing his watercolor of the executions, was revealing. Recoiling from the mad spasms of a maleficent body politic, he left Paris almost as soon as the Commune was crushed and made London his long-term home.

MONET, MEANWHILE, had struggled during his time in England. "England did not care for our paintings," he wrote, a sentiment echoed by Pissarro. "It is only abroad," he complained, "that one feels how beautiful, great and hospitable France is. What a difference here [in London]! One gathers only contempt, indifference, even rudeness. . . . My painting doesn't catch on, not at all." Duret had meanwhile informed Pissarro about the situation in Paris. "Dread and dismay are still everywhere," he wrote. "Nothing like it has ever been known. . . . I have only one wish and that's to leave." He did just that, leaving France with Cernuschi for an extended tour of Asia. Pissarro, however, having finally married Julie (against the wishes of his mother), was eager to return as quickly as possible to his home in Louveciennes, which the Germans had occupied and wrecked. "I've

lost everything," he lamented after receiving reports of the destruc-
tion of his property. "About 40 pictures are left to me out of 1500."
Some had been used as doormats, others stolen by villagers. "I now
have just a broken bed, no mattress or box springs, no crockery, no
cookware. . . . It's pitiful." He was back by June, hoping to start again
and fully expecting that France would "recover her supremacy."

Monet was in less of a hurry to return. At the beginning of June,
having learned of his father's death, he took Camille and their young
son Jean to Holland. He painted windmills and views of Amsterdam
and Zaandam and purchased his first Japanese prints. It was almost
six months before he returned to France, taking a studio at 8 Rue de
l'Isley near the Gare Saint-Lazare, a short walk from Manet's home on
the Rue de Saint-Pétersbourg. He kept the studio until 1874, but at the
end of 1871, he moved his family to Argenteuil, a town on the Seine
northwest of Paris. Argenteuil had been badly affected by the war but
was busy rebuilding and had become a destination for recreational
boating. Manet helped him to secure a house for rent from a local
landowner. Just down from the railway station, the property had a
large studio and enjoyed views of the Seine. Here, fired by optimism,
Monet was extremely productive. He was drawn to the town's indus-
try and traffic and the various leisure activities of locals and visitors,
all of whom seemed eager to get back on track after a terrible upheaval.
A local bridge, made from wood, which retreating French soldiers had
burned in September 1871, was being reconstructed. Monet painted it,
later selling the painting to Manet.

Alfred Sisley came to visit Monet and began painting some of the
same motifs. Sisley was a British citizen, but he had stayed in France
during the war. His father was in the silk business, but his company
had collapsed as a result of the conflict, and he died soon after, leaving
Sisley to support himself, his wife, and his two small children. Renoir
had meanwhile returned to central Paris, taking a studio around the
corner from Thiers's ransacked home on the Place Saint-Georges. He
was a frequent visitor to Monet in Argenteuil. When they could, the
group gathered again at the Café Guerbois. But fathers and mothers
had died, friends had perished, new babies were born, and the social

side of things was simply not the same as before. Increasingly, the emphasis was on work. They painted continually.

For Courbet, things were dramatically different. His mother had died in June. Four days later he was denounced and arrested, blamed for the destruction of the Vendôme Column. After several weeks' detention at the Conciergerie, he was sent to Mazas Prison. He protested his innocence and was adamant that he had proved it. He had not even been on the committee when it made the decision to pull the column down. What was more, he had made sure to preserve the sculptural reliefs. "I have nothing to blame myself for," he said. But his evidence was ignored, and he was sentenced to six months' imprisonment and fined 500 francs. Bemused by the judge's notion that he could pay such a sum ("They imagined me to be rich, it is a very widespread notion. I must look rich because I am fat"), he nonetheless had the self-awareness to grasp that some form of punishment was inevitable. "I know them and know how offended they are by the contempt that we showed them with our action in Paris," he wrote.

Throughout the second half of 1871, Courbet, under tremendous strain, saw his health deteriorate, and after serving three weeks in the Sainte-Pélagie Prison, where he had been transferred after his sentencing, he was put on parole and cared for at a clinic in Neuilly. There, early in the New Year, he was visited by Monet and Monet's old mentor Eugène Boudin. It was risky for anyone to be associated with Courbet at that time, so Monet's willingness to visit him, so soon after returning to France, spoke volumes both about his political sympathy for Courbet and about his compassion for an old supporter and mentor.

ÉDOUARD SUFFERED from depression after the events of 1870–71. Whole sections of Paris—the great metropolis with which he so identified—had been reduced to rubble or hollowed out by fire. The stench hung in the air for months. Prior to this, his city had been besieged over a long winter, and he had endured serious illness, cold, hunger, and fear. His anxiety had been for himself but also for his family and friends. He'd felt impotent. His two younger brothers

were in similar states of dismay. All three brothers shared the same political outlook. But what did it mean to have political "convictions" after such a fiasco? The republic that all three of them longed for had been realized, but at what cost? And realistically, what were its prospects now? Because undoubtedly, a reaction was setting in. France's status as a republic was precarious in the extreme.

Édouard had lost none of his republican convictions. What he seemed to have lost, at least temporarily, was his belief in a legible public sphere. It was no longer possible to give credence to political speech. Decades would pass before anyone would gain any sort of trustworthy perspective on what had happened, and those who had lived through it might never manage.

Just to think about the losses was a drain on morale. Bazille's death was particularly devastating. The young painter had been Édouard's most devoted long-term acolyte. Of all the new painters, he was the most ardent in his desire to overhaul France's conservative art establishment. Yet his friends and family had had no proper opportunity to mourn him. Only now, months after Bazille's death, did Édouard find himself processing all that had happened. Like a mill wheel threshing water, his mind kept turning over the events of Bloody Week. The Versaillais army's actions had been unconscionable. Thiers was clearly to blame. The more Édouard thought about it, the more indignant he became. But the Communards, too, had acted insanely. Their improvised experiment had been a debacle, he saw. They had all but invited disaster. Courbet's behavior had not been as egregious as that of other Communard leaders, but in many ways his naïve optimism and bullying bluster epitomized their errors. In the wake of Bloody Week, he wrote, Courbet had "behaved like a coward," attempting to save his skin by distancing himself from the Commune. He "is not worthy now of the least interest," he wrote. But his criticism of Courbet only cloaked his own impotence.

Having nowhere to put his conflicted feelings only deepened Édouard's malaise. In July he went to Versailles, hoping to paint Gambetta—"the only capable man we have," as he called him. But

the politician was too busy for his old friend, and Édouard came back to the studio scratching his head about how best to proceed. His favorite expression in these days was *totalement sincère*—"totally sincere." He no longer had time for the modes of irony and mischief that had underpinned his best painting in the 1860s: the quotations from the Old Masters, the winking love affair with Spain, the costumes and cross-dressing. He wanted to make clear statements. To show facts. But for the best part of a year, he barely painted anything. He no longer felt worthy of having students or acolytes. He wouldn't return seriously to painting until the spring of 1872.

When he did, his strong urge was to expose the ugliness of the army's actions during Bloody Week. For a while he toyed with the idea of making a history painting in the style of *The Execution of Maximilian*. He wanted to reactivate the excitement and energy that had coursed through him during the year he spent working on that series of paintings, aimed at exposing the folly and unscrupulousness of Napoleon III. And yet he wasn't sure what to paint. He felt a kind of moral paralysis.

When he had embarked on his *Maximilian* campaign, the talk had all been of Napoleon III's imperial regime loosening up censorship laws, allowing more freedom of expression, and perhaps in the process inviting its own demise. But in the event, Édouard's efforts had been censored. Almost no one had seen them. Now, after the fall of the Commune, three of the four painted versions of *Maximilian* were still with him in the studio—a constant reminder. If he took on Bloody Week, it, too, would surely be suppressed. It would certainly be understood as a direct attack on Thiers. That idea appealed to him, but he knew he would be playing with fire. He couldn't afford to be seen supporting the Commune. The atmosphere in Paris, and in France generally, was still fraught. The government was in no mood to forgive. Communards and their sympathizers were still being tried. Many languished in jail. Others were deported to New Caledonia. And then he had to think about his own close social circle. What would Berthe's family make of it? They supported Thiers. Berthe's brother, Tiburce, had participated in his vengeful crusade. . . .

Édouard had lately grown to love lithography, and before the year was out, he made a brilliant lithograph, titled *Civil War (Scene of the Commune of Paris)*. To make a lithograph, you draw on a dampened stone with a greasy crayon. For Édouard, the stone's surface was seductive. It captured the movements of his hand with the same immediacy as drawing. *Civil War* depicted a dead Communard beside a barricade of stones, partly reduced to rubble. Dignified in death, the soldier dominates the composition. He is shown in the same foreshortened pose as *The Dead Toreador*, the ravishing painting that Édouard successfully submitted to the 1864 Salon, when it was still part of a bigger bullfight composition. *Civil War* could have been worked up into something bigger, but Édouard knew a painted version of such a subject would only invite trouble with the censors, so he left it as a lithograph.

He also worked on another lithograph, *The Barricade*, which shows a firing squad in army uniform gunning down a desperate group of Communards. The composition is lifted straight from *The Execution of Maximilian*, its figures transposed from Mexico to a Paris street corner during Bloody Week. Édouard simply traced the outline of the figures from his *Maximilian* lithograph, made an ink drawing touched up with watercolor on the other side of the sheet, and finally made the lithograph.

In the meantime, he had to choose to submit something to the 1872 Salon. Since he had nothing fresh, he turned to a painting completed eight years earlier, in 1864. It was *The Battle of the USS Kearsarge and the CSS Alabama*, his dazzling depiction of a naval battle from the U.S. Civil War. Manet had recently sold the painting to Durand-Ruel, but after the jury accepted it, the dealer agreed to let it hang at the Salon. None of that year's reviews noted what seems conspicuous in retrospect: that Manet's painting depicted a Civil War battle in a city that had just experienced its own civil war.

BERTHE, TOO, WAS SLOW to get going again after the events of 1870–71. Her determination had not left her, but she was tired and dazed, her health still frail. She was the same age now that Edma

had been when she married Adolphe Pontillon and stopped paint-
ing. Of the two sisters, people used to say that Edma was likely the
more gifted. Now she was a mother of two, and posing for Berthe was
the extent of her involvement in painting. Berthe's need was more
urgent. On the other side of a great trauma, she had come to under-
stand that only the act of painting could dispel or dilute what she
called "my days of melancholy, my black days." Refusing to be known
either as a "lady amateur" or as an established male artist's promising
female protégé, she was determined to keep faith with her resolution
of March 23, 1871, as expressed in her letter to Edma: "I no longer
want to work just for the sake of working."

So gradually, like Édouard, she returned to art-making. At first,
lingering in Cherbourg with Edma, she worked in watercolors, trying
to find her way into a new language of lightness and evanescence—a
language based in close observation, devoid of rhetoric or hysteria. She
then made a portrait in pastel of Edma, dressed in black and seated
in an upholstered couch—the same couch with the pink flowers and
blue leaves that she had painted in *The Sisters* before the war. In the
new portrait, Edma gazes straight out at the viewer—at Berthe—
with dark, imperturbable eyes.

In this time of political tumult, Berthe found she was increas-
ingly drawn to French artists of the eighteenth century. These art-
ists of the Rococo had liked to work in pastels as well as oil paint
to depict scenes of intimacy, youth, and femininity. They embraced
happiness and grace, in ways that appealed deeply to Morisot. Léon
Riesener, himself a pastel specialist, had introduced Berthe, along
with his daughter Rosalie, to their works in the 1860s. Berthe had
often visited the Rieseners' home on the banks of the Seine, opposite
the Quai d'Orsay, where Léon had installed six tapestries from a suite
by François Boucher, who had been first painter to King Louis XV.

The French Revolution had changed forever the way the Rococo
painters were seen. So it was an odd sort of historical rhyme that on
March 15, 1870, on the eve of the Terrible Year, hundreds of works by
Antoine Watteau, a bequest of Louis La Caze, had gone on display
at the Louvre. Berthe loved Watteau's ability to convey a kind of ret-

icence and stillness (as in his depictions of the clown Pierrot) at the heart of vivid scenes of fluttering animation, in seasons and at times of day that always seemed in transition—threshold states. His paintings captured shimmering sensations of imminent loss. They spoke powerfully to her and inspired her to try to do something similar. She loved, too, Jean-Honoré Fragonard, with whose finesse, wit, and charm her own work would increasingly be compared over the years. And she looked hard at Boucher, Jean-Étienne Liotard, and Rosalba Carriera as well. These Rococo paintings were modestly scaled and made for domestic interiors—not for palaces and churches and vast exhibition halls. All this appealed deeply to Berthe. She was tired of grand public statements by men.

Over the following months, Berthe returned by increments to painting in oils. She felt she needed the stimulus of other artists, the buzz of studio life, so she made contact with Aimé Millet, a sculptor she had studied with ten years earlier, and for a while she became a regular in his studio. She had resolved to commit to a professional outlook, but her courage was in constant tension with her self-doubt. Who was she kidding? Was she as good as Manet? Could she draw like Degas? She had no clear reason to think so, and there were times, inevitably, when this infuriated her. When she began a new painting in 1871, she complained to Edma that "as a composition it looks like a Manet; I'm aware of it and it annoys me." Another time, when she hired a model, she found herself visualizing how Manet might paint the model. "As a result," she wrote, "I naturally found my own attempt all the less attractive."

IN THIS CRUCIAL PERIOD, Cornélie watched on with growing concern. She had seen Berthe suffer through the privations of the siege even as her own health deteriorated. And now Berthe's father was experiencing heart trouble. They consulted doctors, craving reassurances that never came. The outlook was grim. Confronting her husband's mortality made Cornélie more concerned to arrange Berthe's marriage, so she could have the security of her own family. A year had been lost. Berthe's sisters were meanwhile busy bearing chil-

dren: Edma gave birth to a new girl on the eve of Christmas Eve 1871. Yves gave birth to a boy the following year. What frustrated Cornélie, when she looked at Berthe, was the lack of urgency. A single woman, she knew, was considered "excess" in French society. She had failed to fulfill her womanly duty, so it was lazily assumed there must be something wrong with her. And if it wasn't something biological, it must be vanity. Or stubbornness. Or delusion. Such a woman could, for instance, be under the spell of someone unobtainable. Or perhaps she thought she had it in her to become a great artist? Speculations like this were liable to prompt pity—and that was something Cornélie could not abide. She could see for herself the pressure Berthe put herself under. But she felt obliged to treat her artistic ambitions with skepticism. "We must consider," she wrote to Edma, "that in a few more years [Berthe] will be more alone, she will have fewer ties than now; her youth will fade, and of the friends she supposes herself to have now, only a few will remain."

All of France had just lived through a catastrophe. It had been a year of terrible delusions. Many of the most wantonly deluded (in Cornélie's mind) had been the very artists who held sway over Berthe. It was past time for her daughter to wake up, face reality, and put an end to self-indulgent pipe dreams. Dreams of artistic success were all very well, but Berthe "should take care," wrote Cornélie, "not to yield to still another illusion, not to give up the substance for the shadow." What Cornélie dearly wished was for Berthe to put "all this turmoil of fantasy and feeling behind her" and to "steer her ship wisely and cautiously. . . . For when one has ruined one's life beyond reprieve one is only too eager to put the blame upon others."

Nor did Cornélie's advice stop there. She was determined to be honest—blunt, if necessary. So when Berthe returned to Passy from Cherbourg, she told her very plainly that she did not believe in her talent. Berthe, she recounted to Edma, "has not the kind of talent that has commercial value or wins recognition; she will never sell anything in her current manner, and she is incapable of painting differently." Worse, whenever her daughter received compliments from fellow artists, she observed, it went straight to her head. Were these artists really

sincere? Cornélie wondered. "Puvis has told her that her work has such subtlety and distinction that it makes others miserable, and that he was returning home disgusted with himself. Frankly, is it as good as all that? Would anyone give even 20 francs for one of these things?"

Berthe, to her great credit, was well defended against her mother's doubts and at times almost amused. Her response was simply to persist. Slowly, things began to turn in her favor. Her pastel portrait of a pregnant Edma was accepted by the Salon of 1872—the first Salon since the war. True, the jury accepted none of her recent paintings. But instead of eating away at her confidence, rejection only sharpened Berthe's sense of the Salon's shortcomings.

ISOLATED AND WEAKENED within Europe, France in the wake of the Terrible Year was still nominally a republic, but it could have become anything. Its destiny was up for grabs. German troops were still on French soil. The newly united nation had displaced France as Europe's foremost and most populous power. Napoleon III was still alive and in exile. He had his supporters, but he was desperately ill, and the acrid odor, the shame, of military defeat still hung about him. A Bonapartist revival was possible, but it was the least likely option. In the elections held in the immediate wake of the siege, royalists had won a majority in the Assembly, but it wasn't clear what kind of mandate they had. Were the French people signaling their support for a Bourbon restoration or for some kind of constitutional monarchy, with an Orléanist overseeing an elected assembly? Or had they been voting simply for peace and stability after almost a year of chaos and bloodshed? By-elections in the summer of 1871 saw a swing back to the republicans (and Léon Gambetta's return to the Assembly), suggesting the latter. These results spelled trouble for conservatives and lent urgency to the machinations of the various royalists. They worried their chance to effect a restoration might slip away if they didn't act quickly.

It was an intensely fraught period. And in that characteristically French way, some of the most passionate fights were waged over symbols. The Bourbon Comte de Chambord, hoping to be restored to the throne as Henri V, signaled that he was willing to entertain a consti-

tutional form of monarchy, but he was determined to have the white flag reestablished as France's national flag. The tricolor was too divisive, he declared: it represented revolution and should be abandoned if the French nation and the monarchy were to be properly united. But after all that had happened, the *comte*'s insistence was seen as fanatical and out of touch—even by those sympathetic to the Bourbon cause. To counter the royalist push, the left tried to elevate the tricolor as a unifying symbol. Inertia, meanwhile, allowed Thiers, who was now seventy-four, to continue as head of government. He may have personally favored a constitutional monarchy, but ever the pragmatist, he knew the royalists were divided and that the general mood was for stability. That meant maintaining a republic—the least divisive option. The Assembly appointed him president, and the fragile republic endured—at least for now. "The Republic," he pronounced, "will be conservative or it will not be at all."

Of course, Thiers's republic bore no resemblance at all to the kind of republic for which Manet had yearned. And since Manet was far from alone, Thiers's middle-of-the-road course was destined to run into trouble. Gambetta's triumphant return had stirred the hopes of more progressive republicans. Meanwhile, for a time, Thiers let the increasingly agitated royalists hope that he might usher in a full restoration. But when, in late 1872, pushing back against royalist maneuvering, he finally declared himself unambiguously in favor of keeping France a republic, the conservatives lost patience and passed legislation draining him of power. Within months, they forced his resignation. And on May 24, 1873, Marshal MacMahon, a strict Catholic and a Legitimist, replaced Thiers as president.

At this point, the republic seemed destined to end. In January 1873, Napoleon III died in Chislehurst, England, freeing thirty Bonapartist deputies in the Assembly to cooperate with the royalists against the republicans. The royalists suddenly looked to have a clear path ahead. MacMahon was convinced of the need to purge the government of republicans, whom he equated with revolutionaries. Across French society more broadly, he instituted what he called "the re-establishment of moral order."

———

AS MONARCHISTS' HOPES FLARED, the Catholic Church, too, enjoyed a conspicuous revival. The National Assembly approved a design for a new basilica for Paris. Intended as an act of collective atonement, Sacré-Coeur was to perch atop Montmartre, immediately above where Nadar's balloons had been launched and where the radicals' insurrection had broken out. Excavations began in early May 1874, the same month as Thiers's resignation. The original inspiration for the basilica was a speech given by Bishop Fournier back on the day the Third Republic was proclaimed, in the wake of Sedan and ahead of the Prussian siege. Fournier had interpreted the sudden collapse of the French Army as a form of divine punishment for a "century of moral decline." (The problems had begun, this implied, not with the Second Empire but with the original French Revolution.)

But the focus of the penance the basilica was intended to embody gradually shifted from the moral decline of French society in general to the despicable excesses of the Commune. In 1872 Archbishop Darboy's successor claimed to have had a vision as he climbed the Butte Montmartre. The clouds dispersed, and he realized that it was there, "where the martyrs" were (he meant the murdered generals Lecomte and Clément-Thomas), that a new church should be built. And when the Assembly voted to proceed with the construction, legislators specified that its purpose was to "expiate the crimes of the Commune." The construction of Sacré-Coeur provided a kind of moral drone note accompanying all the political and cultural developments that unfolded in Paris over the next few years.

So it was against this tense political backdrop—the imminent death of the republic, the likely restoration of a monarchy, and a conservative Catholic revival—that the first Impressionist exhibition took shape.

AN ART ESTABLISHMENT that had so recently been superintended by Gustave Courbet was no less eager than the Assembly to reassert its conservative credentials. Public calls to renovate French art—to

shun radical experiment, to recommit to patriotic subjects, to find again the value in tradition—grew ever louder. Establishment critics, leaders of the Academy, and Salon juries set out to champion noble, edifying forms of art that might help remove the stain of the past year. "Art," wrote the critic A. Delzant in a review of the 1872 Salon, "must produce virile and grand works, worthy of the task in front of us." Conservative commentators hearkened back to more glorious periods in French art history. They wondered in print why there were no longer any artists of the caliber of Ingres and Delacroix and, before them, Jacques-Louis David and Poussin—artists, that is, who were willing to depict historical events and address biblical themes, artists who could help elevate morals and shape France's national destiny.

In this reactionary climate, painters who dared to break with conservative notions of artistic excellence were inevitably suspected of political subversion. Thiers had appointed the old art critic Charles Blanc as the government's director of fine arts, and Blanc proceeded to clamp down on the all-important business of jury selection for the annual Salon. All the gains of the final years of the previous decade were now reversed. No longer would everyone be able to vote: only artists who had previously received medals and other honors. The experiment before the war with wider suffrage had proved a disaster, claimed the conservative painter Alexandre Cabanel: "It's just like in politics. It makes a fine mess of things."

News of Blanc's decisions stirred an immediate outcry among artists. Almost ninety of them, including Corot, Daubigny, and Manet, signed a petition, which was submitted to Thiers. But Blanc did not budge. When the makeup of the jury became known—and it was indeed deeply conservative—Manet led a fresh round of protests. Openly lamenting that Blanc's criteria would prevent younger, disenfranchised artists from showing at the Salon, he called for a new Salon des Refusés and was joined in his call by critics in the republican press.

But for Manet and his onetime followers, the government's reaction against Courbet was both instructive and alarming. Courbet's position on the Commune's leadership council and his own statements during the siege meant that, in the public mind, he bore responsibility for tearing

down the Vendôme Column. It was almost miraculous that he hadn't been executed during or immediately after Bloody Week. And yet he continued to pay a heavy price. Although he had already been imprisoned for nine months and fined 500 francs, the issue erupted again, and in 1873 MacMahon ordered him to pay the costs of rebuilding the column. Unable to afford it, he was forced into exile in Switzerland.

The most burning question for France's most original artists before the civil war and was still the most burning question after it: whether to break with the Salon or stick with it, trying to effect change from within.

Before the war, Frédéric Bazille had openly pushed for an alternative exhibition, a public display of new work by all the artists inspired by Manet, Courbet, and Delacroix. Bazille was now dead, and Courbet was in exile. But for the artists of Bazille's generation, the fundamental question had not gone away. Other artists now echoed his calls. They didn't want to have to jump through the hoops of the conservative Salon jury or pander to a discredited establishment just to have their work seen. They wanted to assert their freedom. Spellbound by light, entranced by modern life, they wanted to revolt against the inherited burden of a gloomy, moribund iconography. They wanted to paint what it felt like to be outside, liberated both from the artifice of the studio and from the humiliations of the past, to immerse themselves in a kind of perpetual present.

In the 1860s, Manet had been the clear leader of the new painters and the Batignolles district, their epicenter. But the Batignolles group had now dispersed and spread to the suburbs, especially to Argenteuil and Pontoise. The young painters still gathered socially in the city, but they tended to frequent the Café de la Nouvelle Athènes instead of the Guerbois. And as the group became more of a network or cooperative, Manet was displaced, to some extent, from his leadership role. From their perches on Paris's periphery, Monet, Renoir, Pissarro, and Morisot took to painting pleasure-seekers on the banks of the Seine, the gardens of bourgeois homes, and fashionable women and children enjoying leisure time. It wasn't all reassuring sunshine and pleasure, however. The new painters' vision of beauty was self-consciously mod-

ern, and they were not afraid to address darker, more complicated themes, especially when painting the city. The paintings of Degas and Manet, in particular, were laced with indications of class and gender relations. But the other painters, too, found all kinds of ways to register the tensions inherent in an urban economy that revolved around advertising, entertainment, sex, and spectacle.

By and large, Renoir, Monet, Sisley, and Pissarro as well as Degas, Manet, and Morisot were now depicting not just what they saw all about them but what they yearned for: a secular, open, and democratic society where nature, commerce, and industry were in a provisional, constantly evolving struggle for harmony, in configurations that were as changeable and unsettled as the weather. The crucial thing was that the new painters' work was rooted in the here-and-now rather than in exhausted mythologies, religious parables, or legends of the ancients. The society they portrayed and the way they painted it—in loose, unfinished-looking brushstrokes that captured colored light and sensations of transience—were pointedly at odds with the conservative establishment's program of national rejuvenation, which required artists to execute a moralistic vision with high degrees of finish and laborious displays of skill. It was in this increasingly stark opposition that the modern avant-garde was born.

Recent events were imprinted in the work of these new painters in many ways, but perhaps especially in the sense of impermanence that their paintings embodied. As if in instinctive response to a society in which everything seemed contested, they were unusually intent on capturing ephemeral, ungraspable phenomena—not just the play of light but the fleeting quality of social relations. Their paintings conveyed beauty and happiness but also, whether consciously or otherwise, an underlying sense of existential frailty. What mattered most to them—what approving critics (almost all of them openly republican) praised them for—was *sincerity*. The word was used widely to indicate a kind of honesty and integrity before the motif. This honesty, which entailed a forswearing of judgment was felt as a corrective to the subjective indulgence of Romanticism and, more pressingly, to the sentimental and ideological delusions of the political sphere.

Berthe Morisot with a Bouquet of Violets

IN THE PERIOD BETWEEN THE DEMISE OF THE COMMUNE and the first Impressionist exhibition in 1874, Édouard seemed to want to spend as much time as possible in the company of Berthe. He paid close attention to everything about her. She was not just depressed or bored, he realized. She was profoundly unsettled. "I am sad as sad can be," she had told Edma. "What I see most clearly is that my state is unbearable from any point of view."

The questions that had pressed on her before the war pressed even harder in its aftermath: *Who do I love? Who can I count on?* It both helped and hurt that Édouard was always around. If the upheavals of the previous year had too often deprived them of each other's company, the rapport between them had deepened. Their separate sufferings had bound them together. The hunger, fear, and isolation they had endured during the siege set them apart from most of the group who would become the Impressionists. Both had had to negotiate political divisions within their own families and straddle class divisions within their social circle. The strain had been acute. Political beliefs were not idle chatter, as events had shown.

Édouard felt he could trust Berthe more than anyone. They had so much to talk about—and so much to try to forget. At first, as if by

instinct, he resumed his old habit of sprinkling her with expressions of affection. In the aftermath of Bloody Week, for instance, before Berthe had returned from Cherbourg, he paid a visit to her parents in Passy, demanding to know from Cornélie whether Berthe was going to return to Paris or would "abandon all her adorers" because she had "found others." Cornélie probably rolled her eyes at such mischief. But she knew, too, that Édouard and Berthe were connected by tendrils of affection that had mysteriously thickened.

Now that Berthe was back in Paris and they were spending more time together, Édouard could hardly avoid noticing her artistic progress. She often sought his opinion. But she was no longer deferential. Her brushstrokes were getting looser and bolder by the month. Her sense of light's flickering fugitive quality became more pronounced. She was pushing further in this direction than even he had dared—further than Frans Hals, further than Delacroix, further even than Monet.

At the same time, Édouard could sense Berthe's solitude. Was it loneliness? Sometimes a fog seemed to envelop her. He wanted to lift it or somehow to generate enough heat to burn it off. Socially, as always, Berthe was captivating company—intelligent, surprising, frank. The poet Henri de Régnier would much later describe her as "tall and slim, with an extremely distinguished manner and mind." She seemed "aloof and distant," he wrote, "with an infinitely intimidating reserve." But her coolness somehow "communicated a charm to which it was impossible to remain indifferent." She "listened more readily than she spoke, and her taciturn nature sometimes caused uncomfortable silences in the conversation." This coolness in Berthe remained intensely attractive to Édouard. It was connected to a sadness that was always there, skittering beneath the social veneer like a rat behind the baseboards.

This mood became, in a sense, the condition of possibility for Berthe—a familiar psychological place to which she could retreat and against which she tested herself as she developed her art of intimacy and transience. Paul Valéry later observed how, in order to "dispel melancholy," Berthe could be "suddenly capricious." It was precisely this

mercurial quality that Édouard had captured before the war in *Repose*, his portrait of Berthe on a couch with the wildly animated Japanese print on the wall behind her. But it was more than capriciousness that Berthe had revealed of herself: it was a kind aliveness to circumstantial possibility, an erotic restlessness, an interest-within-intimacy to which Édouard was powerfully drawn. Here was a woman, he saw now, who wanted (as she herself had said) to taste life—not to be trapped demurely in anyone's sofa sipping tea, speaking softly, saying the right things.

PEOPLE LATER SAID of Claude Monet's series of thirty paintings of Rouen Cathedral, which he made over two winters in the early 1890s, that what he had painted was not the building itself so much as the envelope of air that swaddled it. Monet painted the cathedral thirty times because that envelope was always changing and he wanted to register the changes. A similar dynamic is at play in the series of portraits Édouard painted of Berthe in the two or three years after Bloody Week. They are paintings of intimacy, which is neither a subject nor an object but a zone, a threshold, a charge enlivening the psychological space between two subjects. Nothing one might want to say about intimacy, nothing that truly matters, is verifiable. After the fact, it is always engulfed by the roar of history. But it is no less real for that. And art is one of the methods invented by humans to record and rekindle it.

Édouard's depictions of Berthe are charged more by what is unknown and invisible than by anything known. Manet painted each of them swiftly, and when you look at them, they *feel* swift, like telling glances. Something about them seems veiled or coded. They're playful. They capture fleeting emotions: love, fear, hesitation, grief, arousal, and consciousness of mortality. All these subjective feelings and shared intimations toll together in Berthe's dark-eyed face.

How did the portraits come about? Not long after her return from Cherbourg in 1871, Berthe attended a Thursday-evening salon at the Manets'. Édouard, she wrote to Edma the next day, "finds me not too ugly and would like to have me back; I'm so bored I might

even suggest it to him myself." She was talking about posing for him again. She hoped that spending more time with him might relieve her melancholy—and that it wouldn't make things worse.

Posing for Édouard remained a complicated business, requiring considerable tact. He didn't want to compromise his marriage to Suzanne; nor did he wish to harm Berthe's reputation by setting tongues wagging. But their friendship had deepened—they were by now, in fact, palpably in love—and the bonds between the two families, though frayed by recent events, liberated them from some of the strictures that had constrained the sittings for *The Balcony*. There were now no others in the studio—no Léon, no Fanny Claus, no Antoine Guillemet. There was no chaperone. It was just Édouard and Berthe.

Almost all of Manet's portraits show their subjects with conspicuously neutral expressions. He liked to paint people with the kind of faces they adopt in public settings to prevent others reading their thoughts: bored, absent, at times almost stunned in their disconnection from context. Noticing this, some critics claimed that he had no talent for capturing psychological interiority. Théophile Thoré, for instance, accused him of cultivating "a sort of pantheism which places no higher value on a head than a slipper." But Édouard's post-1870 portraits of Berthe are very different. Unique in his oeuvre, they are private, engaged, and almost extravagantly expressive.

The first—and still the most famous—in the series was painted over two sittings in 1872. It shows Berthe in a black dress and black hat, with a bunch of violets. Where the light in most of Manet's portraits is frontal and bleaching, flattening his subjects' features, here the light comes in from one side. Berthe's dark eyes are boldly enlarged, amplifying the erotic challenge of her gaze. Her face expresses rapt, appraising attentiveness to the man portraying her, as if the two were in the midst of a lively discussion. We see the very beginning of a smile, inflected by the lightest touch of irony—and perhaps also of obstinacy, or grievance, or a slight nervousness. In fact, it's as if the sitter were unable to gather together her feelings for the man portraying her, a confusion he has somehow managed (perhaps accidentally) to capture. The painting has the air of something quickly dashed off.

Berthe's hat is little more than a pile-up of flat black shapes against an off-white ground. (You can tell Édouard has learned from his involvement in printmaking and from his interest in Japanese woodcuts.) The contour of Berthe's face on the side that catches the light is conveyed with utmost economy: a long arc inflected by a subtle indentation for her cheekbone. A loose latticework of rapid brushstrokes captures the stray strands of her brown hair and the ribbons of cloth that appear to be part of her headpiece. It is all so economical—as if the artist had wanted to convey the notion that a person's essence might be perceived by glancing.

Paul Valéry, who later married Berthe's niece Jeannine (the daughter of her sister Yves), loved this painting more than any other by Manet. It was more than just a portrait, he declared; it was a poem. The portrait's transparency and tenderness reminded him of Vermeer's *Girl with a Pearl Earring*. Édouard had managed to interweave a physical likeness of Berthe with "the precise cadence proper to" her. That "cadence"—by which Valéry meant Berthe's specific energy, her temperament, her liveliness—was captured in the immediacy and freedom of Édouard's brushstrokes, which gave the portrait its strange aura of contingency and elusiveness—what Valéry called its "presence of absence." "The modern moves swiftly," he wrote, "and would act before the impression fades."

In his next portrayal of Berthe, Édouard elected to keep her out of the picture entirely. What Manet painted was not Berthe but a love token. Valéry's "presence of absence" became an "absence of presence." *The Bouquet of Violets*, which sets the dark green and lavender of a bunch of flowers against the red lacquer handle of a closed fan, is a still-life-as-portrait. To make the matter clear, Édouard included a white handwritten letter, inscribed "A Mlle Berthe [Mo]risot"), placing it between a warm gray foreground and a shadowy background. The picture is suffused with a spirit of homage; an atmosphere of complicity; simple tenderness; frank affection.

ÉDOUARD HAD RECOVERED some of his vim. Seeing Berthe's progress and sensing her resolve, he now decided to help her get going.

He talked her up wherever he could. Having given her address to "a very rich gentleman" who wanted to have portraits of his children done in pastel, he told Berthe that if she wanted the client to respect her, she should "make him pay handsomely." The commission came through. "This is an extraordinary opportunity that I mustn't let slip," Berthe wrote to Edma. Tiburce, meanwhile, had met up with Édouard. Any animosity between the army officer who had fought under Thiers and the republican who loathed Thiers appeared to have been set aside, and at Édouard's urging, Tiburce tried to reinforce what Manet had been telling Berthe: "It is high time you make an independent life for yourself, and success in the form of money is the sole key to all freedom," he said.

Berthe took this seriously. In the spring of 1872, she asked Édouard if he would show some of her work to the dealer Paul Durand-Ruel. He was more than willing. Durand-Ruel was a Catholic and a Legitimist. On the face of it, he was out of sympathy with the new painters in Édouard's republican circle. But he was a new type of dealer who was having considerable success creating a private market for paintings outside the Salon system. He had begun buying and selling works by the Barbizon painters, including Berthe's teacher Corot, and was now turning to the new painters—the future Impressionists. His efforts had a transformative effect. He had just purchased twenty-two paintings by Manet. Hard upon Édouard's introduction, he bought an oil painting by Berthe for 300 francs and three watercolors for 100 francs each. It gave her a tremendous boost.

The following April, in 1873, Durand-Ruel purchased Berthe's *Seascape (The Jetty)* for 315 francs at an auction benefiting the resettlement of refugees from Alsace-Lorraine in Algeria, and when Berthe subsequently placed her *View of Paris from the Trocadéro* on consignment with Durand-Ruel with a 500-franc price tag, the dealer sold it the same day to the department store magnate Ernest Hoschedé for 750 francs. These sales boosted Berthe's confidence. They didn't free her from anxiety and frustration. ("I work hard without respite or rest, and it's pure waste," she complained to Edma.) But they allowed her to envisage a career for herself.

JUST AS ÉDOUARD CRAVED "total sincerity," Berthe was seeking a new kind of authenticity—a way to speak frankly about the truth of her life and to create art in the same vein. The experiences of 1870–71 had made her allergic to falsity. "Every day," she wrote, "I pray that the Good Lord will make me like a child. That is to say, that He will make me see nature and render it the way a child would, without preconceptions."

Berthe chose to paint Edma with her new daughter, Blanche, a few months after her birth at the end of 1871. *The Cradle*, which would become Berthe's most celebrated painting, showed Edma, seated and in profile, keeping watch over her sleeping infant's bassinet. A transparent muslin cloth extends down in a loose, tentlike shape, half-veiling Blanche's sleeping head. Edma wears a simple blue-gray house dress, with frilly trimming at the cuffs and décolletage and a black ribbon around her neck. Her nose is pert, her lashes long, and her expression carries almost the flicker of a smile. The connection between the mother's gaze and the infant girl's sleeping face has a calm, enduring quality. And yet the painting is no saccharine tribute to motherhood. Edma's slightly unkempt hair and the weight of her cheek, supported by her left hand, evoke a mother's exhaustion, even a kind of melancholy. The scene depicted—a mother keeping watch over her baby—is presented as the culmination of no special sequence of events. It foreshadows nothing. Past and future dissolve in its presence. It is a painting pure in its intimacy.

IN THE MEANTIME, a beguiling conversation was taking place between Berthe and Édouard, unfolding not only in the flesh but on canvas. Artists often converse with one another through paint. The medium exists, after all, to express things that can't be put into words. Emotional gambits that might seem inappropriate or awkward in conversation can feel permissible in art. In carrying on a secret dialogue on canvas, it was as if Édouard and Berthe were trying to come

to terms with all that had been lost, and all that had been impossible between them from the beginning.

Soon after the end of the Commune, early in 1872, Berthe painted two views out over Paris, one from her home in Passy, the other from the Trocadéro, just down the street. Both show one or two women and a child in front of vast, expansive views of Paris. Large parts of the city center were still in fact in ruins, but neither of Berthe's views shows any sign of the widespread destruction of Bloody Week. In fact, they seem to savor their distance from the city, which is reduced to a hazy blur, a strange, flat, barely legible pattern, punctuated by a few recognizable landmarks: the dome of the Panthéon, the Palais de l'Industrie, Notre-Dame, and Les Invalides. Berthe's *View of Paris from the Trocadéro* immediately calls to mind Manet's 1867 painting from the same location—the work he began during the Exposition Universelle and suddenly abandoned to begin work on his *Execution of Maximilian* campaign.

The watercolor *On the Balcony*, which is dominated by the figures of Berthe's sister Yves and her niece Paule (Bichette) in contrasting black and white garments, shows a narrow slice of more or less the same view, this time from the terrace of the Rue Franklin house. As Berthe worked on *On the Balcony*, she worried that it was beginning to resemble not exactly Édouard's similarly titled *The Balcony* but something else she imagined he might have painted, which discouraged her. But very soon it became clear that the influence was going both ways, because the following year Édouard made a picture that resembled two Morisots. *The Railway*— the most important painting he completed in 1873—was his final depiction of Victorine Meurent, the young woman and painter who had modeled for *The Luncheon on the Grass* and *Olympia*. It shows Meurent facing the viewer with a small girl standing beside her but facing away. The girl, wearing a white pinafore with a blue ribbon, is looking through iron bars down at the train tracks at the Gare Saint-Lazare, right next to Édouard's new home on the Rue de Saint-Pétersbourg (down the street from his earlier one). Meurent had been central to Édouard's career for more

than a decade, and Édouard couldn't resist leaving subtle clues about their shared history. The puppy in Victorine's lap in *The Railway*, for instance, is the same breed as the dog in Titian's *Venus of Urbino*, the Renaissance painting on which *Olympia* was based.

But *The Railway* also appears to have been a response to two paintings by Berthe that Édouard must have seen. All three paintings express—through the figure of a child looking at a view through the bars of a high fence or railing—yearnings in another direction. The first of them is Berthe's *On the Balcony*. The second, *Interior*, is one of Berthe's most beautiful paintings. It shows a seated woman dressed in black. Behind her, on the right, are gilded furniture, flowers, and the fronds of an indoor palm; on the left, delicately rendered in dappled white, is a full-length window draped with translucent white curtains. There, in bleaching light coming in from outside, a nanny stands over a young girl. Rendered more sketchily than the painting's main subject, the nanny has parted the curtains to help the girl look out over the balcony with its ornate cast-iron railing.

Berthe was fascinated by the motif of women and children looking out across thresholds. She had painted balconies and terraces before, and she went on to paint scores of pictures of girls, adolescents, and young women standing before windows, or at thresholds between indoors and outdoors, always looking out, always appearing to be imagining something else, something beyond. But until now, she had never painted the motif so freely, with such a powerful sense of the mobility and gossamer quality of visual perception.

The bars boldly striping the picture in *The Railway* can be thought of as Édouard's response to the chairs' vertical supports striping the picture in *Interior*, where Berthe complements the main, adult subject in the foreground with a young child looking across a threshold in the other direction. In both cases, the straight black verticals contrast with the cloudy, ethereal white of the curtains (in the Morisot) and billowing steam (in the Manet).

Another painting by Berthe from the same time appeared to deepen the dialogue. *Portrait of Marguerite Carré* shows the gently smiling sitter—whom Berthe had previously painted in *The Pink*

Dress—now in a white ballgown. *The Pink Dress* had been one of Berthe's first full-throated experiments with the quick, loose painting style that would become her signature. But the attempt to look effortless had caused her enormous problems. It was one thing to paint freely. But every brushstroke now had to do its work. Nothing could be fudged—it would just look slack and inept. So it was significant that she now returned to the same model, seating her in an upholstered chair in front of an indoor plant. Despite the ballgown, Carré's posture is strikingly informal. Holding a fan, she leans dreamily to the right, cutting a suave diagonal across the picture plane. Marguerite was the sister of Valentine, the young beauty to whom a smitten Édouard had begged Berthe to introduce him in the summer of 1870. For Édouard, the point of *In the Garden*, his first genuinely plein air painting, had been to show off his handling of white fabric in shifting outdoor light. Berthe must have had something similar in mind now as she painted Valentine's sister in *Interior*, deftly conveying the flowing movement of Marguerite's white dress and its undulating reflections of ambient light.

Not all of Berthe's paintings were set indoors. In the summers, her family loved to go to the Normandy coast, and so did the Manets. Both she and Édouard painted works titled *On the Beach* in the early 1870s. Édouard's painting showed Suzanne and Édouard's brother Eugène on a windy day at Berck-sur-Mer, south of Boulogne. Eugène, in a beret, semi-reclines in the same pose he had adopted a decade earlier in *Luncheon on the Grass*. The wind is almost palpable, conveyed as much by Édouard's brisk, dashing brushstrokes as by the taut, angled sails of the boat on the horizon. Two paintings by Berthe, also called *On the Beach*, were created along the coast at Fécamp. In one, the bodies of the group promenading on the boardwalk are reduced to smudges in the salty air. A triangle of turquoise sea is wedged between sky and receding boardwalk.

The conversation on canvas continued when the summer ended and Édouard set to work on a portrait of the salon hostess and musician Nina de Callias. De Callias was one of the liveliest, most vivid and dramatic women Édouard had ever encountered. Independently

wealthy and approximately the same age as Berthe, she was a gifted musician and an avowed republican. She had dared to express her support for the Communards and was known to have had various lovers, all bohemians mired in poverty. One of them was Edmond Bazire, who used to work with Rochefort on the republican paper *La Marseillaise*. (Bazire would go on to write the first book on Manet in 1884.) De Callias was prone to alternating bouts of euphoria and depression—she ended up drinking herself to death—and yet she presided over a salon attended by some of France's most celebrated poets, musicians, artists, and writers. Édouard painted her in his studio, but he decked it out with Japanese fans and bric-a-brac to make the setting resemble her Batignolles town house. In the finished painting (its background *japonisme* recalling *Repose*, Édouard's portrait of Berthe), de Callias is dressed in a black Algerian costume. Her expression is wonderfully animated. But what is most arresting about the picture's execution is Édouard's slashing, diagonal, often cross-hatched brushstrokes. They show just how far he had come since painting Victorine Meurent in a similar pose, for *Olympia*. Notably distinct from the signature marks of Monet, Renoir, or Pissarro, Édouard's brushstrokes are closest to Berthe Morisot's, leaving little doubt that Édouard was learning from her as much as she continued to learn from him.

Around the same time, as if in response to the portrait of de Callias, Berthe painted Marie Hubbard, a friend of her mother. Hubbard is shown full-length, dressed all in white. The fabric's flow and textures are brought out beautifully by Berthe's delicate use of impasto and her subtly varying touch. Here, too, it's clear that she is conversing with Édouard. On the one hand, she seems to be daring him to experiment with a bolder lack of finish: the background is made up of loose, cross-hatched brushstrokes that peter out into nothing. On the other, she pays him a form of homage that borders on the flirtatious: reclining in the same manner as *Olympia*, Hubbard stares out at the viewer with the same impassive expression as Meurent. One of her slippers even dangles off her foot—a clear nod to Meurent's dangling slipper in *Olympia*.

———

BY LATE 1873, Berthe's father Tiburce was gravely ill. Realizing his days were numbered, he requested that his position be made an honorary one. His wish was granted on January 6, 1874, guaranteeing the maximum pension for a public servant. Less than three weeks later he was dead.

Berthe could find no words for her grief. But on the first anniversary of his death, she wrote to her brother: "What heartache at the thought of those terrible last years, his long sufferings, and what regret to have been unable to make his last moments happier." As she mourned, it helped to spend time with Édouard. So in the late winter, still disheveled by grief, she sat for another portrait. This one was similar in format to *Berthe Morisot with a Bouquet of Violets*, but in style it was even looser, more "impressionistic"—more, in fact, like Berthe's own increasingly bold work. Édouard painted quickly, but the sittings were drawn out. It was as if capturing Berthe's likeness were incidental to something else going on between them—some mysterious alloy of intimacy and despair that together they had yoked to the activity of painting.

The "finished" painting, *Berthe Morisot in Mourning*, is unique in Manet's oeuvre. Berthe levels her large-eyed gaze at the viewer—or really at Édouard. But her cheek now rests against her black-gloved fist, and her black mourning veil gushes out from her headpiece like a dark waterfall, a distant rhyme with the mosquito netting that cascades from above in Berthe's *The Cradle*. The portrait's clear emotion, wrote the art historian Françoise Cachin, belies "all those blank faces that populate his pictures," instead catching "an expression—here at an extreme—that is never far from Berthe Morisot's face: a kind of wild sadness and anxiety that may have been a deeply ingrained personality trait, like a shadow of death over her beauty."

THE TALK DURING Berthe's sittings for these portraits continually circled back to two difficult subjects. In many ways they were subjects of Berthe's life. The first had to do with art; the second with marriage.

There was to be an exhibition at Nadar's old studio, a breakaway
show. It was to be just what Bazille had advocated for: an alterna-
tive to the Salon, a showcase for new art that was equitable, demo-
cratic, and enlightened where the Salon was exclusive, authoritarian,
and reactionary. Bazille's fellow avant-garde painters, the progeny of
Manet—among them Monet, Renoir, Degas, Sisley, and Pissarro—
were trying to bring their dead friend's vision to fruition. They were
disgusted by the reactionary turn in politics, first under Thiers and
now under MacMahon, and by a similar turn in the art world. The
Salon of 1872 had drastically turned back the clock. They were ada-
mant that something needed to be done.

In May 1873, a friend of Zola and Cézanne, Paul Alexis, had
publicly encouraged a breakaway exhibition in the journal *L'Avenir
National*, earning him a letter of thanks from Monet, which was
subsequently published. *L'Avenir National* was a republican organ (it
would be shut down by MacMahon five months later), and Alexis was
not so much an art critic as a labor reporter, motivated less by artistic
concerns than by his conviction that the new painters needed to orga-
nize, just like workers in other industries.

The artists agreed and banded together to form what they called
the Société Anonyme. In many ways, the society's agenda reflected a
wish to revive, in Courbet's absence, the original, decentralized ideals
of the Commune—but this time exclusively in the sphere of art. The
society's members signed a proudly egalitarian charter two days after
Christmas Day 1873. At Pissarro's insistence, it was based on a charter
for a bakers' union in his hometown, Pontoise. All members, male
or female, would have equal rights. What's more, there would be no
barriers to membership—just a fee of five francs per month. When it
came to exhibiting—the society's primary raison d'être—the space
allotted each artist was to be determined by drawing lots—an almost
comically uncomplicated method intended as a rebuke to the hierar-
chical displays at the Salon.

When Monet first announced plans for the show to the press in
May 1873, Berthe's name was not on the list of participating artists.
But by the end of the year, a new roster had been released, and this

time she was there, the only woman. Degas—who between October 1872 and March 1873 had spent almost six months in New Orleans, where his brothers were in the cotton trade—was one of the organizers. It was he who had invited her.

He tried, too, to recruit Édouard, blaming the negative influence of Fantin-Latour and "some self-induced panic" for his initial refusal, but Degas still hoped he would change his mind: "Nothing seems to be definitive on this matter yet," he told Bracquemond. However, by the time Berthe told Édouard that she had joined, his resolve had stiffened: he let her know that he was having nothing to do with either the society or the exhibition. Moreover, he told her she was making a grave mistake by getting involved herself and tried repeatedly to dissuade her. But Berthe had made up her mind and would not be budged. Teasingly, challengingly, she pressed Édouard to reconsider his own refusal.

Édouard was not alone in warning Berthe against the breakaway exhibition. Between signing the charter at the end of 1873 and submitting her work to the exhibition, she came under enormous pressure to withdraw. Her dilemma was acute. She was flattered to be invited—and by someone she took as seriously as Degas, no less. But she was also conscious that the whole endeavor was bound to be deeply controversial. A serious artist trying to forge a viable career had to worry about consorting with a group of self-declared republicans and mavericks whom the public associated with Communards. Although Édouard was the most conspicuous holdout, he was not the only artist who had declined an invitation. When Monet invited Henri-Michel Lévy to take part, Lévy declined, saying he was "scared of compromising himself."

What made the stakes especially high was that Berthe had lately been doing so well. Durand-Ruel had recently sold one of her paintings to her and Édouard's mutual friend Alfred Stevens for 800 francs, which was more than anyone had paid for a single painting by one of the future Impressionists. Others, too, were paying attention to her work. Part of Berthe would always struggle to believe in herself, but another part was quietly invincible, and at this moment, her confidence was as high as it had ever been.

Édouard was not a joiner of groups. He was a republican, of course, but he refused to be co-opted by people who might go further politically than he was willing to go. It was why he had refused to participate in Courbet's union of artists during the Commune, and it was why he refused to join the breakaway Société Anonyme. Having seen the fate that befell Courbet, he was terrified of political entanglements and determined not to fall prey to yet another set of illusions. On aesthetic grounds, too, Édouard was less than enthused about the makeup of the breakaway group. Although he was proud to have influenced so many of the younger generation, he was unimpressed by the caliber of those who had signed the charter. Certainly Degas, Monet, Renoir, Sisley, Cézanne, and Pissarro were all serious artists, and friends, too, but many of the others were Sunday painters, at best. The public and critics would see this for themselves. Exhibiting with them wasn't going to help his cause.

Above all, though, Édouard was convinced that in setting up an alternative exhibition, the breakaway artists were denying themselves the Salon's enormous audience and therefore a chance to capitalize on recent gains. Those gains were not illusory. Many in the breakaway group had seen their work sell at an auction at the Hôtel Drouot in January, three months before the exhibition. Pictures by Monet and Sisley went for 500 francs. Two paintings by Pissarro went for 700 and 900 francs respectively. And a painting by Degas (much to Degas's astonishment) sold for 1,100 francs. After years of struggle, these developments were extremely encouraging.

Pissarro wrote to Duret, crowing about the success of the auction, and was duly congratulated. But Duret was thinking ahead to the proposed breakaway show, and he chose this moment to issue Pissarro a stern warning. It was nice, he wrote, that a smattering of supporters was finally showing interest in Pissarro's work. But it was important, he advised, that they take an extra step and become known to a wider public. Their breakaway exhibition was simply not going to achieve this. It might attract fellow artists and the few patrons who already knew them, but the public would stay away. By contrast, several hundred thousand people would attend the Salon. If Pissarro could man-

age to get his paintings hung there, they would be seen by dealers, collectors, and critics "who would never otherwise seek you out and discover you."

In conclusion, Duret urged Pissarro to exhibit at the Salon. "You must succeed in making a noise, in defying and attracting criticism, in coming face to face with the great public."

Just as Edmond Duranty was in many ways a mouthpiece for Degas, Duret frequently repeated Manet's talking points. So there can be little doubt that Édouard was saying the same things in private to Berthe. When Duret spoke of "making a noise" and "defying and attracting criticism," he clearly had in mind Manet's torrid experience through the 1860s. Édouard had endured more insults and ignominy at the Salon than all the other members of the future Impressionist group combined. But his hard-won conviction was that you had to play the game to reap the rewards. If Manet abandoned the giant stage of the Salon for a smaller, more provisional one, all his tribulations would have been for nothing. Unlike the others, he had tasted real success at the Salon—with *The Spanish Singer*, back in 1861. He had had a rough ride in the decade since, but it was only at the Salon that a painting could have that kind of impact. Foreclosing this possibility just when things were beginning to turn your way, he believed, was a mistake, and what's more, a failure of nerve.

AS BERTHE SAT FOR HIM, Édouard tried to impress all this on her. He wanted her to see the danger in participating in an exhibition of works that most people would consider sketchy and unfinished, an exhibition that was explicitly presenting itself, moreover, as a rebuke to the establishment. It would be bad for her, and it would be bad for him. This was clear to Puvis, who now added his voice to those trying to dissuade Berthe from showing with the breakaway group. Despite all that had happened, Puvis had not given up on winning Berthe's hand. Neither Cornélie nor her late husband Tiburce had bothered to conceal their dislike of him. "I know that your family does not like me, and that their chief feeling toward me is a wish never to see me," he wrote to Berthe. And yet he hovered at the edges of her life, await-

ing a change of heart and hoping, perhaps, that Tiburce's death might have improved his prospects.

On April 7 he wrote her a letter in which he likened the proposed breakaway exhibition to "civil war." Given recent events, the phrase was inflammatory. "My dear Mademoiselle," he wrote, "this is . . . an idiotic war if ever there was one [and] unfortunately, you do not have the big guns on your side." He saw no point at all in what he called Berthe's "dangerous whim," and he cautioned her against holding a grudge against the Salon jury. "What you're trying to do has its defenders," he wrote, "but they are a minority.

"Plus," he added, "they want Manet's head and one way or another they'll get it."

This last was insightful. Puvis may have been politically conservative, but he wasn't naïve. He was letting Berthe know that Édouard's advice against her taking part was not just for her own sake. Everyone knew Manet was the unofficial leader of the new group. He may have declined to sign their charter or exhibit with them. But he would be associated with them regardless—and it pained Puvis to think that Berthe would become part of the brush used to baste him.

IN THE END, Berthe proved impervious to the warnings of Édouard and Puvis and all the other naysayers. She had said she would show with the Société Anonyme, and so she would. Her reasons were partly aesthetic. Her work, as it developed, had less and less in common with the kind of work favored by the Salon jury. It was getting more radical. She was becoming more and more interested in transience and in the intimate lives of girls and women. She was less concerned with meeting men's expectations of what constituted serious art, which made it less likely that she would do well on the Salon's big stage. She was of course receptive to Édouard and to all that he said. But she knew him well enough, and was sure enough of her own judgment, to separate what mattered to him from what mattered to her.

Her attitude was more proof of the obstinacy that so concerned her mother—an obstinacy that had sometimes gotten Berthe in trouble (as when, for instance, she refused to leave Paris ahead of the

Prussian siege). But it had also served her well. Hadn't she, after all, continued to paint—even after losing Edma, her comrade and confidante, to marriage, and even in the face of her mother's skepticism? Hadn't she resisted the pressure to marry just for the sake of having a husband—one who might jeopardize her desire to pursue art as a profession? She was already hardened against the consequences of breaking people's expectations for her. In truth, she hadn't needed Édouard or Puvis or anyone else to make her aware of the implications of joining the breakaway group. Given all that she, a daughter of the *haute bourgeoisie*, stood to lose by associating herself with "radicals" and Communard-sympathizers; given the distinct possibility that the entire experiment could backfire; and given her conspicuousness as the only woman in a group of thirty artists, Berthe's decision to participate was exceptionally audacious. Perhaps no female artist of the nineteenth century made a decision so consequential.

The fact that the invitation had come from Degas must have helped her decision. She and he were from the same social class. They had both lived through the siege. Against the prevailing opinion of their privileged peers, they had both felt a quiet sympathy for the Communards and were appalled by the ruthlessness of their suppression. Berthe was flattered by Degas's desire to include her. In terms of integrity and artistic seriousness, she had no better model to follow than him. In March, Degas wrote to Cornélie to explain the independent exhibition as reassuringly as he could. He didn't think the show would seriously compete with the Salon, he wrote, "but we might be a breath of fresh air once people see that it goes all right. If we bring in a few thousand visitors, that will be great. I will recommend it to [Berthe] because I'll be in it, and others too. . . . In addition, it seems to us that Mademoiselle Berthe Morisot's name and talent are too well suited to our mission to pass up."

HAVING THROWN IN HER LOT with the breakaway painters, Berthe now had to consider which of her works to exhibit. This time there would be no jury standing in her way. She chose *Reading*, her double portrait of Cornélie and Edma (the one Manet, in the guise

of being helpful, had reworked right in front of her in 1870). She still had mixed feelings about the painting, but in her mind it was a kind of tribute to her two closest confidantes during the trauma of the Terrible Year: Edma, her sister, and Cornélie, her mother, in whose company she had endured so much. She also chose *Cache-cache* (Hide-and-Seek), a painting of Edma with three-year-old Jeanne pausing to play by a small cherry tree in an open field. (Manet had briefly owned *Cache-cache* before selling it to Duret.) The third major painting Berthe selected was *The Cradle*.

Significantly, all three featured Edma. She painted her and her children repeatedly during these years, still trying to make up for all the time they had spent apart during the Terrible Year. In another canvas from 1874, *The Butterfly Hunt*, Edma is shown in a park carrying the long, thin handle of a butterfly net. She wears a white dress and black hat while her elder daughter, standing perhaps ten feet behind her, is attired in a black dress with a white hat. The greens in the painting are vivid, the brushstrokes sketchy and unresolved, the overall effect of flatness and looseness a kind of flouting of conventional expectations. People who knew the Morisots understood that Edma had once painted alongside Berthe and that her work had several times been displayed at the Salon. Now here she was, the subject of paintings by a sister who no longer sought government-sanctioned approval and wanted instead to use her increasingly bold technique to evoke shifting relationships and the perfume of intimacy, an artist as butterfly hunter who wanted to capture, as she put it herself, "something fleeting."

W W W

CHAPTER 18

𝄞 𝄞 𝄞

The Launch of Impressionism

ON APRIL 15, 1874, THE BREAKAWAY EXHIBITION DULY
opened. Advertised at the time as the first exhibition of the recently
formed Société Anonyme, it has become known to art historians—
and to an infatuated museum-going public—as the first in a series of
eight Impressionist exhibitions, held between 1874 and 1886. Berthe
Morisot was in all but one of them.

Anyone who wanted to see this first iteration was welcome. In
choosing the venue—the old studio of Nadar on the Boulevard des
Capucines—the Société Anonyme artists hoped that some of Nadar's
old luster, his flair for publicity, would rub off on them. They had also
wanted to steal a march on that year's Salon, so they set the opening
date for two weeks earlier. To make visiting as easy as possible, the gal-
lery was open every day from ten a.m. until six p.m., then again from
eight p.m. until ten p.m. The entrance fee was one franc, and catalogs
were available for fifty centimes. On that first day, about two hundred
people came, among them a handful of critics. After that, the exhibi-
tion averaged about one hundred a day. Visitors saw more than two
hundred works by thirty artists. The works were primarily paintings,
but there were also pastels, prints, watercolors, and a few sculptures.
The pictures were hung against velvety, flocked, reddish-brown walls.

Some of the artists in this first show had been denizens of the Café Guerbois and, more recently, Café de la Nouvelle Athènes. Among them were the critic Zacharie Astruc, the printmaker Félix Bracquemond (one of Manet's correspondents during the siege), and the painter Édouard Brandon, a Sephardic Jew who had studied with Corot and had lent to the show several works by his friend Degas (including his first-ever depiction of a dance class). Monet's former teacher Eugène Boudin, a painter of coastal landscapes, was one of the more established participants. But overall, it was a hodgepodge. Some of the artists were talented and becoming better known. Others were known as artists only by their friends. But about a quarter of the exhibited works were by a core group of seven artists who had been out of sympathy with the government-sanctioned art system for more than five years: Monet, Pissarro, Renoir, Sisley, Degas, Cézanne, and Berthe Morisot.

Recent history weighed on the show itself, although not in ways that were immediately obvious. The second edition of Victor Hugo's *The Terrible Year*, his emotional poem cycle recounting the events of 1870–71, had been published four days before the exhibition opened. It sold eighty thousand copies that week. The absence of Bazille, now dead three years, was the most poignant of many ambient reminders of the tragic events of the Terrible Year. At first the art, too, seemed to register those events almost entirely by their absence. None of the painters depicted battles or other scenes of suffering associated with the war, the siege, or the Commune. Instead, they showed blossoming trees and placid riverbanks. And yet many of the landscapes on view were, in fact, haunted by memories of the Terrible Year. Pissarro's *The Orchard*, for instance, was a plain view of blossoming trees at Louveciennes, just north of Versailles. Nothing could have seemed less martial. But it was at Louveciennes that Pissarro, returning from England after the war, had discovered his life's work destroyed by Prussian soldiers.

Similarly, Sisley's most beautiful landscape showed a row of trees along the banks of the Seine, their bright autumn leaves reflected in the tranquil river. The scene was Bougival, just to the east of Louveci-

ennes, and close to where ninety thousand men—many of whom had never previously fought on a battlefield—had poured out of Mont-Valérien on January 19, only to beat a retreat at day's end amid chaos, summary executions of deserters, and deaths by friendly fire. That day 3,500 had been wounded and 1,500 killed, among them the painter Henri Regnault, star of the 1870 Salon.

They may have painted landscapes that had recently witnessed terrible violence, but the Impressionists were disinclined to directly depict the realities of 1870–71. This, in retrospect, can seem stunning. Was it a collective act of psychological repression? Or was it an attempt, conscious or otherwise, at recuperation: an assertion of pacific values as an antidote to violence and trauma? Both, in fact, could be true. But the better explanation is simply that the Impressionist artists were in revolt against state-sanctioned hierarchies of art. Those old modes had placed a premium on depictions of edifying episodes from history or myth (including acts of martial valor). Paintings in this vein, often heavily allegorical, hogged all the space and attention at the Salon, and over the previous decade Manet and his followers had grown increasingly disgusted with them. To them, the rhetoric behind such paintings—much of it tied to state power and already looking played out in the final decade of Napoleon III's regime—had become intolerable. Now, in the wake of the Terrible Year, the young painters had recoiled from the delusional ravings of men, whether of the left or the right, who were willing to sacrifice sons and daughters, stability and security for absurd and hopeless causes. Morisot, Monet, Pissarro, Sisley, Renoir, and Cézanne were choosing instead to depict the world as it was—as it met their eyes in the here-and-now, without any sense of hierarchy.

That absence of hierarchy extended even to technical considerations: the Impressionists painted straight onto the canvas rather than with varnish layered over glazes layered over paint layered over drawing. Inspired by Japanese prints, they tried to avoid compositions that looked too calculated, picturesque, or sedately symmetrical. They welcomed overlapping visual phenomena, such as trees obscuring buildings. Over polarizing political rhetoric, they were choosing

to show a shared, promiscuously intertwined and authentic reality. They strove, too, to attain a kind of detachment or objectivity. They wanted to free art not only from the rhetoric of the political sphere but from the aesthetic styles of Romanticism, Classicism, and even Courbet's Realism (all of which had been tied to political ideology). So they focused on what was verifiable, right there before the painter's eye. They were not verifying old facts (except to the extent that they were continually changing). They were trying to depict this field, that building, that riverbank in this particular light in this season and at this specific time of day. Their focus was on the way the world—when subjected to a certain mental discipline and seen through a disinterested lens—could be translated into flat patterns of colored light. The flattening was one of the most notable effects of the new style. There was no shading, no modeling, and therefore no depth. Sometimes it was as if these landscapes were viewed from a great height—from a balloon, or by a person with one eye.

As if to reinforce the present-tenseness the new artists favored, one of the paintings submitted by Monet was a dazzling rendering, from an elevated perspective, of the very street—Boulevard des Capucines—along which visitors would have walked to get to the show. This boulevard had seen some of the most atrocious violence during Bloody Week, and visitors to the exhibition would have been conscious of this. But Monet's canvas included no reference to the recent civil war. It depicted the scattered, swarming crowd along one side of Haussmann's wide boulevard and, along a receding diagonal line, a row of carriages beneath late autumn plane trees. The brown leaves remaining on the trees create a kind of optical fuzz, obscuring the buildings behind—a pointer to another characteristic of the new painting: its interest in the effects of distance and the haziness of vision.

Another painting submitted by Monet was a loosely brushed harbor scene, painted from his window in Le Havre. That the haze made it hard to make out the forms was precisely what appealed to Monet. Jetties, the masts of boats at anchor, and what looks like a crane were all brushed onto the canvas in gray-blue hues against a flaming

dawn sky. The image was flat and graphically distilled, like a Japanese print. A rising sun—reduced to an orange disk—cast a rippling reflection onto the broken water. Three rowboats, silhouetted by the mist-muffled sun, receded along a diagonal, each vessel dimmer and more inchoate than the last. Asked to give it a title, Monet explained: "I couldn't very well call it a view of Le Havre. So I said: 'Put *Impression.*'" It was cataloged "Impression, sunrise."

Louis Leroy, the critic for the satirical illustrated magazine *Le Charivari*, wrote a review of the show in the form of an invented conversation with Joseph Vincent, a trained painter appalled by what he saw. Pissarro's *Ploughed Fields*, in Leroy's satire, made Vincent think the lenses of his spectacles were smudged until he realized, after wiping them, that he was looking at "palette scrapings . . . on a dirty canvas." The two companions proceed to one of Berthe's paintings, prompting Vincent to describe her, sarcastically, as "not interested in reproducing trifling details. When she has a hand to paint, she makes exactly as many brushstrokes lengthwise as there are fingers, and the business is done. Stupid people who are finicky about the drawing of a hand don't understand a thing about impressionism, and great Manet would chase them out of his republic." When the two companions came to Monet's *Impression, sunrise*, it was, wrote Leroy, "the last straw."

Four days later a review appeared by Jules Castagnary, an anticlerical republican who had long championed Courbet and was therefore wary of the new painters. "If one insists on characterizing [these painters] with a word which explains them, it will be necessary to create the new term of *impressionists*. They are *impressionists* in that they represent not the landscape, but the sensation produced by the landscape."

The name of a new movement, and of a new way of looking at the world, was thus born: Impressionism.

JOSEPH GUICHARD, the artist who had taught both Berthe and Edma, went to the exhibition at Nadar's to see what the fuss was about. It was Guichard who had warned Cornélie that his teaching

would make her daughters "painters, not minor amateur talents," and that this, in the *grande bourgeois* circles in which the Morisots moved, "would be a revolution, I would even say a catastrophe." That was ten years earlier. Returning home now from the Boulevard des Capucines, Guichard immediately wrote to Cornélie:

"I have seen the rooms at Nadar, and wish to tell you my frank opinion at once. When I entered, dear Madam, and saw your daughter's works in this pernicious milieu, my heart sank. I said to myself: 'One does not associate with madmen except at some peril; Manet was right in trying to dissuade her from exhibiting.'" The exhibition contained, he continued, "here and there some excellent things, but everyone involved was clearly deluded—more or less touched in the head. . . .

"If Mlle Berthe must do something violent," Guichard continued (not so subtly comparing Berthe to the so-called *petroleuses,* the female Communards accused of using petrol during Bloody Week in a campaign of wanton arson), "she should, rather than burn everything she has done so far, pour some petrol on the new tendencies." Guichard attributed Berthe's new turn to disappointment over earlier failures. He considered her abandonment of the Salon as "madness" and "almost a sacrilege." He finished with a "prescription," which he claimed to be offering as Berthe's fellow painter as well as her "friend and physician": Berthe was "to go to the Louvre twice a week, stand before Correggio for three hours, and ask his forgiveness." He signed off saying that Berthe "must absolutely break with this . . . so-called school of the future."

We don't know what Cornélie thought of Guichard's letter or whether she passed it on to Berthe. We only know that Berthe did not break with the Impressionists.

MANY PEOPLE AVOIDED the show for political reasons. Others came primarily to laugh. One person compared the new painters' method to loading a pistol with several tubes of paint, firing it at a canvas, and finishing it off with a signature. Another described the new style of painting as "an affirmation of ignorance and a negation of the beautiful as well as of the true."

The conservative press explicitly linked the artists with the Com-mune, so to be seen at the exhibition was to risk guilt by association. A critic for *Le Figaro* spoke of "the brutality of the Intransigents"; the critic Jules Claretie wrote that "the skill of the Intransigents is nil," and according to the conservative *Moniteur Universel* (responding to a positive piece in the republican journal *Le Rappel*), "the Intransi-gents in art [are] holding hands with the Intransigents in politics, nothing could be more natural." The term *Intransigent* was an explo-sive descriptor. Imported from the tumultuous political situation in Spain at the time, it originally referred to the anarchist wing of the Spanish Federalist Party, which, inspired by the Paris Commune, helped trigger the collapse of Spain's moderate government in 1873, leading to civil war. The Spanish Intransigents lost the war, and by the end of 1874, the Spanish Bourbons were restored to power. These events, which overlapped with the first Impressionist exhibition, were watched closely in France and with various degrees of alarm, so that in short order the term *Intransigents* entered French political discourse, where it was applied to unrepentant Communards. Clearly, it was not good for the new painters to be so described.

Nonetheless, most discussions of the show hinged on artistic questions rather than political ones. The reviews constitute the first published responses to Impressionism as a distinct new phenomenon. Those who came expecting a certain degree of finish in paintings were confounded: these were sketches, they declared, not paintings. None-theless, many were entranced by what they saw. In Ernest Chesneau's appraisal of Monet's *Boulevard des Capucines* in *Paris-Journal*, for instance, you can sense the tension felt by the movement's earliest audiences. In marveling tones, Chesneau wrote of the animation of the swarming crowd and the brilliant description of the trees in the street's dusty atmosphere. Never, he wrote, "has movement's elusive, fugitive, instantaneous quality been captured and fixed in all its tre-mendous fluidity."

To Chesneau, Monet's "sketch" painting seemed almost a master-piece, and he said as much. "But come close," he wrote (as if instinc-tively recoiling from his initial enthusiasm), "and it all vanishes. There

remains only an indecipherable chaos of palette scrapings." Eventually, this dynamic of close-up chaos and more distant resolution was exactly what audiences of Impressionism would come to relish. But this was an adjustment in taste and preconception that needed time to make. Something in the early responses echoed Gambetta's dismayed description of the view below as he floated over the Prussian lines in Nadar's balloon: "The earth had the appearance of a badly designed carpet, or rather of a carpet in which different colored wools had been woven entirely by chance. Light and vastness were deprived of the values which shade and proportion give them."

Dazzled as he was, Chesneau felt Monet had fallen short. He needed to go back, he said, and "transform the sketch into a finished work." Still, he concluded—as if his braver critical unconscious were offering advice to his more hidebound self—"What a bugle call for those who would listen carefully, how it resounds far into the future."

Sisley's painting of the Seine at Bougival was singled out for criticism in *L'Artiste* by the novelist Marie-Amélie Chartroule de Montifaud, writing under the pseudonym Marc de Montifaud. She thought Sisley's painting presented "too thin a section of nature." Variations of this idea were to haunt the reception of Impressionism for the next few decades, eventually flowing into the reactions *against* Impressionism by subsequent avant-garde artists, from Cézanne, Seurat, Gauguin, and van Gogh to Munch, Matisse, and Picasso. Fundamentally, the observation was true: the Impressionists had focused on colored light to the exclusion of all else. The emphasis on color over tone had the effect of reducing landscape to a mosaic-like pattern of purely optical phenomena. The effect was not only to obliterate the old conventions of landscape (all the methods of composing images and creating an illusion of depth); it was to hollow out art's potential to convey narrative and carry deeper meanings. But of course, this renunciation was deliberate. The Impressionists were tired of the old clichés, the old storylines, the layers of allegory, the no-longer-credible symbols. They wanted to transpose received ideas around the framing of views, the handling of spatial recession, and the orchestration of tonal transitions into pure optical sensation. When Cézanne later

said that Monet was "only an eye—but my God, what an eye," this was what he meant.

What, for the Impressionists, was the appeal of this new way of seeing, beyond its power as a kind of renunciation? It presented a paradox. On the one hand, something calming, almost meditative seemed to inhere in these works—not only in their lovely, sun-kissed, everyday subjects but in the way they were made. You could see each brushstroke, register each touch as a response to a phenomenon directly observed by the artist before the motif. They were, in other words, the result of a *process*—an unprejudiced, almost systematic reduction of the natural world and everything we know about it into flat accretions of colored light. The viewer's awareness of this process implied a sense of duration since it could have resulted only from an extended meditation on the motif *in its presence*.

Something about this felt generative, perhaps even reparative—especially in the context of the modern city's accelerated experience of time and its discontinuity. An Impressionist painting, then, was a way of submitting to something slower and more organic, a kind of immanence. To the extent that only immediate sensory phenomena could be verified, it was also an exercise in sincerity.

That so many Impressionist paintings depicted landscapes recently occupied by the Prussian Army—in many cases, close to sites of bloodshed and mayhem—only confirmed a sense of the new style as a kind of spiritual salve. The painters' favored locations, on the Seine between Argenteuil and Bougival, or on the Normandy coast (now easily accessible from the city by train), were sites of leisure and havens of natural beauty. They offered respite not only from the traumas of recent events and the scars still marking Paris itself but more generally from the stress and insecurity of living at the beginning of the modern age. But unlike many fearful responses to modernity, they were neither nostalgic nor backward-looking. They showed factories and bridges, street signs and railway stations, sailboats, fields of flowers, and riverbanks, all knitted into one continuous experience.

But there was also another way of looking at it. The very focus on

"impressions"—fleeting effects of light—suggested its own disconti-
nuity. The typical Impressionist painting captured instants abruptly
snatched from the flux of time by a single viewer, severed from any
common narrative or shared history. The movement paralleled the
rise of photography and was stamped with many of that medium's
well-known contradictions: its evidential authority but its transience;
its optical beauty but its arbitrariness.

However they were inclined to frame the new style intellectually,
early viewers of Impressionism increasingly came to appreciate the
simple surprise of familiar, taken-for-granted things seen freshly. They
responded, too—as viewers do today—to the consoling effects of nat-
ural beauty, color, and light. Residents of a city recently besieged, then
wracked by violent fratricide, must have felt it liberating to see young
artists rendering sparkling locations on the Seine, just beyond the
city's fortifications, painting factory chimneys and busy harbors that
spoke of the economy's swift rebound, and making use of France's
railways to paint a coastline once more accessible to day-trippers. The
potential appeal of such imagery was obvious. And many critics were
receptive. They only regretted that the style was so sketchy and one-
dimensional. It seemed . . . *unserious*, lacking in gravity. Emphasizing
"the good life," moreover, seemed frivolous and even "feminine" to
critics who had been urging artists to become more public-oriented,
edifying, and "manly."

Of course, there was no consensus on any of this. There were only
divisions. As French society tried clumsily to regain its footing, the
Salon reflected these divisions. Roiled by internal disagreements over
how it should be organized and what sort of art it should promote,
it seemed permanently mired in crisis. Those making trouble were
no longer just a small group of mavericks. A watershed moment was
fast approaching.

IN APRIL, WHEN the exhibition at Nadar's old studio opened,
Berthe was still grieving her father's death, still dressing in mourn-
ing black, still receiving letters of condolence. Under the law, Berthe
was now responsible for herself. Taking a husband would bring her

many advantages. She said as much to her brother Tiburce, but he was adamant that she should preserve her independence: "For the love of god," he wrote in a letter that stands out as one of the most stirring in the entire Morisot correspondence. Urging Berthe not to marry for the sake of convenience, he warned her of the danger of yoking herself to someone incompatible or unsympathetic. ("You could have done that at 18 when your character can be broken and your ideas sapped.") He told her not to fret about money. Compared to many, she had plenty ("My God! If you knew real poverty . . ."), and if Paris was too expensive, nothing was forcing her to stay. If she got herself hitched to "some millwheel," he continued, she would either feel compelled "to break it to bits tomorrow" or "have to submit to its rotation like a one-eyed horse with the delightful thought 'This is for life?'" And "if you do that," he wrote, "you'll only get half respect and half pity from me because you don't deserve any.

"For heaven's sake!" concluded Tiburce. "Are you so stuck like flies in oil in that miserable Passy that it's absolutely impossible to get free of your perpetual hesitations and finally crown yourself? I just don't understand. Once and for all—just do it for yourself."

"Do it for yourself." In one sense, this was exactly what Berthe needed to hear. Yet at the same time, it wasn't altogether realistic. Marriage *would* be worth it if it didn't derail her career. It offered the appeal of companionship, certainly—perhaps even love. But it was also a question of practicalities, of support. Tiburce did not perhaps grasp her predicament as a woman.

The deeper problem was that her heart was with a married man—with Édouard. Since the end of the Commune, their intimacy had only deepened. That they loved each other is evident to anyone looking at Édouard's portraits of her. The situation was painful. It was exquisite. It was unsustainable. There was no solution. Berthe would never belong to Édouard. She would never be part of his family, never take his name . . . unless, of course, another way existed. Unless a kind of compromise could be brokered.

During the summer of 1874, after the first Impressionist exhibition closed, Berthe and her newly widowed mother visited Edma,

who was now living at Maurecourt on the northwestern outskirts of Paris. From there they traveled to Fécamp on the Normandy coast. Berthe had made the same trip the previous year, and she had been productive. This year the Manet family rented a place nearby. Joining the party was Édouard's brother, Eugène. He had known Berthe almost as long as Édouard. And like Édouard, he knew what she had been through during the Terrible Year, having endured it himself.

At Fécamp, it seems, something was afoot. Given his brother's notoriety, Eugène might have avoided painting, but he actually enjoyed it. Now, away from Paris, he and Berthe spent time together painting outdoors. For Berthe, the dynamic she used to experience with Édouard was pleasantly reversed. Eugène did not, like his brother, presume to tell her how she could improve her work. On the contrary, he subordinated himself to her, respecting her expertise. Over those summer days, the feeling between them gradually thickened, and one day, when they were both sketching two boats under construction by the harbor, their hulls mounted on wooden scaffolds, Eugène marshaled his courage and proposed to her.

Berthe, who must already have entertained the idea, said yes. Her assent has struck many as nakedly calculated. Knowing she could not marry the man she truly loved, Berthe was opting for the next best thing, which was to marry his brother. Édouard, it has been suggested, loving Berthe but powerless to act, conspired to make the arrangement. It was a compromise, a marriage of convenience. But the relationship between Berthe and Eugène seems to have been less calculated and more subtly tender than that. No one knows whether Édouard played a part in Eugène's proposal, nor whether Berthe was in on any such conspiracy.

But Eugène was undoubtedly smitten by Berthe. From his point of view, there was nothing false about the situation. From Berthe's perspective, marrying Eugène meant that her transition from spinster to married woman would be far less dramatic than if the proposal had come from someone outside their circle. Eugène, most crucially, would not oblige her to stop painting. Nor would he remove her from

Paris. She could go on just as before. She would have to sacrifice nothing in the interests of appearing to perform her role as a wife. Moreover, he loved her.

So for both of them, a union made sense. It would cement the already existing bonds between the Manets and the Morisots. Berthe would have the security of a husband. And Édouard and Berthe, while respecting the marriage, would be able to continue enjoying each other's company.

In the event, Berthe saw less of Eugène during the period of their engagement than she saw of Édouard, who painted her four more times over the six months leading up to the wedding. It was as if they both knew that a curtain must soon fall on their period of intimacy and that after the marriage they would no longer have quite the same special access to each other. Eugène's letters to her during this period were fond and witty but straining for lightheartedness, as if he were worried about retaining her affections. Returning to Paris, he grew nostalgic for the warm days at Fécamp, when he and Berthe had painted and taken "charming walks" together. "When shall I be permitted to see you again?" he wondered. He was, he wrote, "on very short rations after having been spoiled."

His brother, on the other hand, was as if at a banquet and saw as much of Eugène's fiancée as time would allow. In one of Édouard's portraits of Berthe, she is dressed in a black gown and holds a fan. In another, she half-reclines. (The suggestion of intimacy is arresting.) In a third—the most playful of the four—Berthe hides her face behind a fan. A fourth was acquired by Degas, who took the occasion of the imminent wedding to paint his own portrait of Eugène, presenting it to the couple as a wedding gift.

The wedding took place at a church in Passy. Édouard was one of four witnesses when the marriage contract was signed at the sixteenth arrondissement's town hall. Eugène was listed as a landowner, the worth of his properties at Gennevilliers recorded as 150,000 francs. Berthe was listed as "without profession."

Berthe went into the wedding with no illusions. "I went through

that great ceremony without the least pomp," she wrote, "with a dress and a hat, like the old woman that I am, and without guests." But in the long run, Eugène proved an ideal partner for her.

WAS BERTHE HAPPY to be married at last—and to a Manet? "Happiness" per se was not quite the point. She felt, instead, on the right track. "I have entered into the positive side of life after living for years with insubstantial dreams that did not make me happy," she explained. After Tiburce's death, the Morisots had moved out of the house on the Rue Franklin into a nearby apartment at 7 Rue Guichard. Early in the New Year, with the temperatures plummeting, Cornélie gave the apartment to the newlyweds and went to stay with Yves at Cambrai.

By now she had tempered her opposition to Berthe's artistic ambitions. Her stubborn daughter had been selling more and more work. She wrote to congratulate her, both for her commercial success and for "the contentment that you seem to feel in your new life." She was mischievously indirect in her assessment of Eugène, whose character she still doubted. Referring to the last time they had been together, when ice covered the streets, she wrote: "You yourself seemed to be as sure-footed as a cat, but I was worried about Eugène. You know that in my opinion he is rather unsteady, and this made me wonder that day whether he could stand on his own two feet (!)."

Berthe was not, perhaps, as steady as Cornélie claimed. "I must not complain," she wrote to Tiburce, "since I have found an honest and excellent man who I think loves me sincerely. I am facing the realities of life after living for quite a long time in chimeras that did not give me much happiness." After the wedding, the portrait sittings with Édouard (the chimera in question) had necessarily come to an end, exacerbating Berthe's melancholy and prompting Cornélie to offer more unasked-for advice: Berthe, she wrote, had to fight against her predisposition to "excessive sensibility and melancholy." She owed it to Eugène "to dress well for him and to please others in order to please him more—for he would take great pleasure in seeing you enjoy yourself. Without being heedless, one must be young while one is young. There is my prescription."

In the summer of 1875, Berthe and Eugène went to England on a delayed honeymoon. On the Isle of Wight, where they stayed first, relations between them were tense. Out of their element, with virtually no English between them, they struggled to fill the days. Eugène was downcast and incommunicative ("even more than I," wrote Berthe). Although she endeavored to work, she was continually frustrated: "I made an attempt [to paint] in a field, but the moment I had set up my easel more than fifty boys and girls were swarming about me, shouting and gesticulating." If a plein air painter was a novelty in those days, a female plein air painter from France was clearly freakish. Berthe felt "horribly depressed . . . , tired, on edge, out of sorts."

Nevertheless, from inside their seaside lodgings, she managed to paint one of her masterpieces: *In England (Eugène Manet on the Isle of Wight)*. The picture, which resonates with Manet's painting of Suzanne and Léon in Arcachon after the French surrender in 1871, has something claustrophobic and uncomfortable about it. It shows Eugène—a restless model—twisting around on an indoor chair to gaze out, past drawn, gauzy curtains, flowerpots, and a fence, to a woman and child promenading beside a harbor. The composition is flat, the colors luminous, and the brushwork breezy and brisk, anticipating Matisse's views through hotel windows in Nice, more than four decades later. The picture's psychological charge (vacillation, longing, the pressure to be happy on one's honeymoon!) feels shifting, enigmatic, modern. *In England* signals a critical shift in the life of Impressionism—a move away from mere "views" of pleasant settings to pictures that tremble with social and psychological pressures.

In London, where the honeymooners went next, they fared better, but the city was "frightfully hot, . . . like being in a room without ventilation," as Berthe wrote to her mother. "I am tired out," she continued. "We race about like lost souls." The English honeymoon may have been an inauspicious beginning, but over the long term, Morisot found happiness with Eugène. He was financially supportive, interested in her work, defensive of her reputation, and by and large, cheerful in the face of adversity.

\\\/ \\\/ \\\/

CHAPTER 19

⋔ ⋔ ⋔

Bastille Day

THE SOCIÉTÉ ANONYME WAS DISSOLVED IMMEDIATELY
after the breakaway 1874 show, but two years later the rebel artists
staged a second exhibition. It was held at 11 Rue le Peletier, close to the
old opera house, which had burned down (breaking Degas's heart) in
October 1873. Berthe was once again involved, this time displaying no
fewer than twenty works.

Once again Édouard refused to participate, but he was soften-
ing in his attitude and no longer fretted about being associated with
the rebels. In fact, in the summer after the first Impressionist exhi-
bition, he had joined Monet and Renoir for some fruitful painting
sessions at Argenteuil. At the 1875 Salon, he had had a huge popular
success with *Le Bon Bock*, a portrait of a plump, gray-bearded man
smoking a pipe and drinking beer. Freshly optimistic, he had sub-
mitted two paintings to the 1876 Salon. One of them, *The Laundry*,
could almost have passed as a Morisot: in lively, skittering brush-
strokes, it showed a young child and her mother, both wearing sun
hats, in a garden filled with flowers. It was Édouard's most Impres-
sionist painting to date. Alas, both paintings were rejected. Worse,
an anonymous report in *Le Bien Public* explained that he had been
"blackballed" by the jury, whose members (including Édouard's old

nemesis Meissonier) apparently resented his popular success the previous year. According to the report, one of the jury members had exclaimed: "This is no longer necessary. We have given Manet years to mend his ways; he will not mend his ways. On the contrary, he digs in! Reject!" And so while his friends exhibited together at the Rue le Peletier, Édouard decided to open his studio to the public, a kind of solo Salon des Refusés. The show attracted throngs of people and laudatory reviews.

Thirty unrepentant Communards, or Intransigents, had just won seats in the March 1876 elections to the Chamber of Deputies. The conservative critics who came to the second Impressionist exhibition were quick to conflate the breakaway painters with these deputies. Initially, they were described as "plein air painters," wrote Marius Chaumelin, with palpable contempt, in his review of the show. They were then called "Impressionists," he continued, "which no doubt brought pleasure to Mlle Berthe Morisot and to the other young lady painters who have embraced these doctrines." But there was an even more suitable term, he declared: "Intransigents," who proselytized for the separation of Academy and State and for an amnesty for "the 'school of daubs,' of whom M. Manet was the founder and to whom they are all indebted."

Chaumelin's words were carefully chosen. Mention of "a separation of Academy and State" and an "amnesty" chimed with the new deputies' agenda: they were demanding an official separation of Church and State and an amnesty for Communard prisoners. In an infamous review in *Le Figaro*, the critic Albert Wolff used similar terms: "These self-proclaimed artists call themselves the Intransigents, the Impressionists. They barricade themselves behind their own inadequacy"—a reference to the barricades built during Bloody Week. He described the group as "five or six lunatics, one of whom is a woman." The clear reference to Berthe infuriated Eugène, who threatened to challenge Wolff, a longtime nemesis of his brother, to a duel. But Wolff had not been entirely negative about Berthe, whose work the critic returned to at the end of his review: "There is also a woman in the group, as is the case with all famous gangs. Her name

is Berthe Morisot, and she is interesting to behold. In her, feminine grace is preserved amid the frenzy of a mind in delirium."

BERTHE'S REPUTATION WOULD always be tied to the notion that her work expressed a "feminine" sensibility. Although framed as a pejorative, it was not untrue. She was a woman who painted (and not just by necessity) subjects that interested her: domestic interiors, enclosed gardens and private terraces, varieties of dressing up and dressing down, children at play, the lives of girls and women. She gave no credence to the idea that these subjects were inferior, as the official arbiters of quality in nineteenth-century art had held. Berthe was a poet of the ephemeral. She savored threshold states. She painted people looking out windows or hesitating in doorways, and she painted teenagers on the cusp of womanhood. Her touch was light, and with each passing year, her brushwork got looser. No Impressionist went further in this regard. In the 1870s, she painted a series of indelible works—*At the Ball* (1875), *Woman at Her Toilette* (1875/80), *Young Woman Watering a Shrub* (1876), and *The Psyche Mirror* (1876)—that are among the most beautiful images of young women from that era. And in the 1880s, she became ever bolder in her coloring and in her willingness to leave parts of the canvas untouched. Her ambition, she wrote, was "to capture something that passes; oh, just something! the least of things."

Berthe grasped—more powerfully, perhaps, than any other nineteenth-century painter—the fragility of youth. And she understood the implications of what Blaise Pascal had enigmatically called "the motions of grace, the hardness of heart, external circumstances." An almost excruciatingly poignant feeling of vulnerability and evanescence comes off her best work, like a fleeting perfume or a schoolyard chant: "Ashes, ashes, we all fall down."

IN THE SUMMER OF 1873, conservative hopes for a union of France's two monarchist parties—the Orléanists and the Bourbons—had come very close to being realized when private meetings between the Comte de Paris and the Comte de Chambord paved the way for the latter to assume the throne as Henri V. The country, which had

no settled constitution, was being led by a Legitimist (MacMahon), so the agreement that emerged from the meetings made it likely that France would revert to a monarchy. Royalists around the country began to prepare for the coming festivities. But the Comte de Chambord, his own worst enemy, chose this moment to reiterate his insistence that the tricolor, with its revolutionary associations, should be replaced by the white flag and the royal fleur-de-lis. There was, alas, no appetite for such a switch, and in the ensuing impasse, MacMahon had to continue as the reluctant president of a fragile republic.

The Assembly now had no choice but to establish a proper constitution, and in 1875, by a vote of 353–352, it voted for France to remain a republic. The vote could not have been narrower—or more momentous: France's new constitutional arrangement was to last for the next sixty-four years. The pendulum, which in the wake of the Terrible Year—and especially under MacMahon's regime of "moral order"—had swung far toward conservativism, now began to swing back the other way.

Gambetta was the most capable and stirring politician in France during this volatile period, and his leadership and oratory in the Chamber now helped the republican movement flourish as never before. MacMahon, however, was not yet finished. In 1877, alarmed by the growing power of radical republicans within the Assembly and wanting to appoint his own cabinet, he used emergency powers to suspend the Chamber. This sparked a constitutional showdown, the so-called Seize Mai (May 16) crisis. The ensuing elections failed to go MacMahon's way. By year's end, the Chamber was allowed to choose its own ministry, leaving MacMahon humiliated. Republicans added to their majority in the Chamber by winning a majority in the Senate, allowing them to fill the government's administrative posts with republicans and to replace MacMahon's former colleagues in the military. The old army veteran had had enough. He resigned on January 30, 1879, two years before his term was up.

IT WAS AN EXCITING PERIOD for Édouard, who had been deeply worried about the fate of the republic. It had frustrated him immeasurably that MacMahon, a royalist and a Catholic, had been

running France even after a republican form of government was entrenched in the constitution. In 1874 he made his first (and only color) lithograph—a caricature of MacMahon, who had commanded the army's suppression of the Commune, in the guise of Polichinelle, the commedia dell'arte character known for his cunning and physical ugliness. Now MacMahon was gone, martial law was lifted, the church had been forced to take a back seat, and Gambetta's star was on the rise. Incredibly, Gambetta and Thiers—once poles apart—had grown closer together. In the aftermath of the Terrible Year, Gambetta had moderated his republicanism, earning him recognition as leader of a new left-wing faction, the Opportunists, and Thiers had become a persistent thorn in the side of the royalists. Together the two men had performed a kind of pincer movement—one from the left, the other from the right—on royalists, Communards, and Bonapartists alike—with the result that the two politicians, one a family friend of the Morisots, the other an old friend of Édouard, had together secured for France the republic for which Édouard had so long yearned. Gambetta, however, lost his unlikely ally a few months after the Seize Mai crisis of 1877. Thiers's health had been in steady decline, and he died on the campaign trail.

As the republican movement thrived, links between Impressionists and republicans, as the art historian Philip Nord has shown, became ever more explicit. Earlier in 1877, ahead of the third Impressionist exhibition, Renoir had gone in person to the offices of Gambetta's organ, the widely read journal *République Française*, wanting to promote the show and solicit a review. His patrons, the publisher Georges Charpentier and his wife Marguerite, commissioned him to paint a portrait of the journal's editor, Jacques-Eugène Spuller. Spuller was Gambetta's right-hand man; he had floated over Prussian siege lines with Gambetta in the *Armand Barbès*. Édouard, meanwhile, opened his studio to a republican campaign meeting presided over by Spuller, whom he had known for years.

In 1878, with MacMahon's regime on its last legs, Paris was again preparing to host an Exposition Universelle. The government had accordingly declared June 30 a Fête de la Paix—a celebration of peace

and labor and of the country's recovery from the Terrible Year. Claude Monet marked the day with two nearly identical paintings of streets (Rue Montorgueil and Rue Saint-Denis) lined with tricolor flags. In one of the paintings, to make his sympathies as clear as possible, he inscribed the words *Vive la République* on a flag in the foreground.

Édouard, however, was less swayed by the occasion. With Mac-Mahon still in power, he remained skeptical. He worked on several views out onto the street from his studio at 4 Rue de Saint-Pétersbourg. The first shows the cross street, the Rue Mosnier, being paved in preparation for the Fête de la Paix celebrations. The second, painted on the day of the festival, shows the roadwork complete and the buildings lining the street adorned with dozens of tricolor flags. But the street itself looks bare in the summer sun and a hunched, one-legged man on crutches walks along it. Dressed in a workingman's blue blouse, he is likely a veteran of the Franco-Prussian War or the ensuing civil war. His forlorn presence fills the scene with futility.

AFTER MACMAHON'S RESIGNATION in January 1879, France at last had its first truly republican regime. And when the Chamber of Deputies, returning from Versailles to sit in Paris at the Palais Bourbon, granted a partial amnesty to ex-Communards, Édouard was closer to having something genuine to celebrate.

At the same time, the selection criteria for the annual Salon were relaxed: any artist who had received honors or even an honorable mention in the past would now be allowed to exhibit without having to submit to a jury. Édouard had been given an honorable mention in 1861 for *The Spanish Singer*, so he qualified. He chose to exhibit two of his freshest canvases, *Boating* and *In the Conservatory*. In the meantime, he moved into his final studio, on the light-filled upper floor at 77 Rue d'Amsterdam.

Determined to seal for posterity his identification with the city he had defended and always adored, he submitted a proposal to the prefect of the Seine: he wanted to decorate the Municipal Council Hall in the new Hôtel de Ville, which had been rebuilt after its destruction during Bloody Week. His approach would be unapologetically

modern: he would dispense with historical allegories and paint scenes of everyday Paris instead. He proposed a series of compositions representing "the public and commercial life of our day"—markets, railways, catacombs, racetracks, and gardens—garlanded by portraits of those "who, in the civic sphere, have contributed or are contributing to the greatness and the riches of Paris." It is intoxicating to think of Édouard Manet—heir of Delacroix, friend to Baudelaire, father to the Impressionists, and the first great painter of modern Paris—executing such a project. But his proposal never received a response.

Perhaps it was all a pipe dream in any case, because in the meantime, his health was deteriorating. One day that autumn, while leaving his new studio, he felt a sudden, piercing pain in his back and a wave of weakness in his legs. When he collapsed on the pavement outside, it was clear something was seriously wrong. His doctor, François Siredey, recommended he try hydrotherapeutic treatments, so he went to stay at Bellevue, in Meudon. He hated the intensive showers and massages, but he convinced himself that the rest was doing him good.

By year's end, he felt sufficiently energized to get to work on two portraits of Georges Clemenceau, the republican former mayor of Montmartre and future wartime president. Clemenceau had been driving calls for a general amnesty for ex-Communards, many of whom had been deported to New Caledonia. After years of failed attempts and a provisional partial amnesty in 1879, he finally won a general amnesty, formally announced in July 1880.

"I had such a good time talking with Manet!" recalled Clemenceau, when asked about the portrait sittings. "He was so witty!" Both portraits were based at least partly on photographs, but both were left unfinished. This may have been due to Clemenceau's limited availability, but it was more likely because in January 1880, Édouard's health once again declined sharply. His walking became uncoordinated—he had begun dragging his foot—and he suffered more lightning pains in his leg. He was almost certainly suffering from tabes dorsalis, or wasting of the back, which manifested itself as locomotor ataxia—a declining ability to control one's movements. This was the agonizing tertiary stage of neurosyphilis, the disease that

had killed his father, his dear friend Baudelaire, and Jules de Goncourt. Édouard tried hard to conceal his condition even after he was forced to carry a stick with him. But it affected his ability to control his paintbrushes and, inevitably, his social life. He despised the indignity. Once, when offered a seat in a shop, he snapped, "I want nothing to do with this chair, I am not handicapped."

In the summer of 1880, Édouard and Suzanne rented a small house, which also had room for his mother and Léon (now twenty-eight), in Bellevue, so that Édouard could submit to another course of hydrotherapy. Away from his home, he felt lonely and trapped. "The countryside only has charms for those who are not obliged to stay there," he complained to Astruc. The weather was wet and gray, he was banned from climbing stairs, and he suffered. "As for penance," he wrote to the actress, singer, and demimondaine Méry Laurent, "I am doing it as never before in my life." "You can't imagine how infuriating it is to be in this state," he wrote to Proust, having been captivated by the sight of a girl selling flowers. "If I were well, I'd have raced back home to fetch my paintbox." Unable to tackle anything ambitious, he passed the time by urging friends to visit and by writing brief, chatty letters to Nadar, Proust, Bracquemond, Astruc, Eva Gonzalès, and Henri Guérard (a printmaker who had recently married Gonzalès). He decorated the letters with exquisite watercolors of morning glories, periwinkles, briar roses, daisies, honeybees, green apples, peaches, irises, geraniums, laburnum, plums, and chestnuts, as well as cats, snails, shrimp, watering cans, handbags, and parasols. So he was clinging on to everyday things, most of them at once beautiful and ephemeral. He was short of funds—hydrotherapy was expensive—so he put considerable energy into drumming up sales for the unsold paintings back in his studio.

BUT ONE THING, in early July, had Édouard very excited: the upcoming festival to celebrate Bastille Day. With the French republic finally on a secure footing, the new government had made July 14 an official national holiday. The process had been tortuous. Gambetta had been convinced since 1872, when he had delivered two speeches

on the subject, that a day of celebration would help consolidate the new republic. He proposed July 14, but conservatives had resisted this idea for many years, even going so far as to ban the public from holding banquets on that day. Now that the republicans were in power, they wanted to be mollifying rather than divisive. Important dates in 1792, 1830, 1848, and 1870 were all floated, but all were linked to violent, polarizing events. (Rochefort was adamant that January 21, 1793—the date of Louis XVI's execution—should be the date.) More viable was 1789, particularly the storming of the Bastille, which Victor Hugo had persuasively cast as a victory of the people over arbitrary royal power. And yet this, too, was a day of bloodshed and class warfare and for that reason alienating to royalists.

Fortuitously, July 14 was also the date of a more conciliatory moment in French history, an event that had taken place the following year, 1790. It was a day of national unity, named the Fête de la Fédération. Although it had marked a year since the storming of the Bastille, no one mentioned that earlier, more contentious event at the official ceremony, which took place on the Champ de Mars in the presence of King Louis XVI and Marie Antoinette. Royalists and revolutionaries all attended, and the Marquis de Lafayette, having returned from fighting in the American Revolution, led a military procession from the Bastille to the Champ de Mars, where an estimated 300,000 people waited in the rain. Cannons were fired, music played, and Bishop Talleyrand led a mass. Both the National Guard and the newly formed Assembly swore loyalty to the nation, the law, and the king, promising to "remain united with all Frenchmen by the indissoluble bonds of brotherhood." In response, Louis XVI swore to uphold the (as yet unfinished) constitution.

This day of reconciliation had not averted violence and chaos. Far from it: the Terror was yet to come. But addressing the Chamber on July 6, 1880, Senator Henri Martin averred that the Fête de la Fédération was now, ninety years later, worth honoring in perpetuity. It had been a day of rare unity and optimism, he said—"the most beautiful and the purest of our history"—and could not be blamed "for having shed a drop of blood."

Martin's speech did the trick. The Assembly voted in favor of the proposal in May. The vote was ratified at the end of June, and the law was enacted just a few days before July 14, a date henceforth established as France's national celebration.

Édouard was thrilled. The establishment of the July 14 celebration was a vindication—symbolic yet profound—of what he had desired his entire adult life. His own health may have been falling apart, but the wounds of 1870–71 had healed, and July 14 gave him tremendous hope. Moreover, a full amnesty was to be granted to the survivors of the Commune. With a rousing speech, Gambetta had secured the measure's adoption in the Chamber. The day itself—the Fête nationale française—was to be celebrated with fireworks, alms-giving to the poor, concerts, and illuminations. Édouard anticipated the occasion with genuine excitement and planned to make a day of it. He and Suzanne had a good view of the city from their elevated position at Bellevue (so named for a reason). He urged Eva Gonzalès and her new husband to join them. "We'll at least have some entertainment to offer," he wrote. He tried to cajole others into coming, including Isabelle Lemonnier, the daughter of a Parisian jeweler and a recent model. "It seems we're very well placed to see the fireworks," he told her. Alas, she never replied, and he discovered only later that she had been seriously ill.

The inaugural July 14 ceremony took place not on the Champ de Mars but at the racetrack at Longchamp, across the Bois de Boulogne from Passy and about two and a half miles from Manet in Bellevue. Manet had painted a dramatic view at Longchamp in 1866: it showed horses and riders in a headlong blur headed straight at the viewer. A more sedate but historically significant ritual now took place on a dais erected in the racetrack's stands. It was not a religious ritual: Catholic clergy were pointedly absent, and neither the Mass nor the traditional Te Deum (a short thanksgiving service) were part of the program. Instead, in the presence of President Jules Grévy, the representatives of the people—Léon Gambetta, the president of the Chamber of Deputies; Jules Ferry, the president of the Council of Ministers; and Léon Say, the president of the Senate—performed a symbolic exchange

with mounted representatives of the military. They handed over flags and standards that had been embroidered with "French Republic" and "Honor and Country," the gilded tip of each pole stamped with the monogram "R.F." (République Française). In saluting the flags, the military brass—traditionally conservative—were pledging loyalty to a system of government they may not have favored. In compensation, receiving the flags was meant to dispel the humiliation of losing them in the defeat to Prussia in 1870.

Many conservatives and Catholics remained resistant to the republic. The faithful were urged to stay home and fast in silent protest. Many displayed religious symbols instead of tricolor flags. But at Longchamp that day, the ceremony went ahead as planned. A military parade passed by the gathered politicians and foreign dignitaries. A monument was unveiled at the Place de la République. Across Paris and throughout France, there were banquets, organized team sports, and music, and in the evening dancing, torchlit parades, and fireworks. Paris "is at this moment submerged beneath an ocean of waving banners," reported the *Daily Telegraph*. "Such a mass of bunting has probably never been seen before in any place." And two days later: "Never was a city more lavishly decorated or grandly illuminated. The flags and lamps were not confined to the more favored thoroughfares, but found their way to even obscure lanes and alleys. . . . Hundreds of thousands of people were out and about."

Deeply stirred but sadly isolated, Manet was desperate to share his excitement. "Long live the republic," he wrote in one letter that day, adorning the words with a quick watercolor sketch of the tricolor. And in a note to Lemonnier, "Long live the amnesty." The amnesty was important to all republicans—not just radicals. Gambetta had understood that it was necessary for France to move on. Any healthy nation, as Nietzsche wrote, had to be able to "forget at the right time" as well as "remember at the right time" and so Gambetta spoke of placing "the tombstone of oblivion over the crimes and traces of the Commune."

This, of course, was wishful thinking. Neither the Commune nor the crimes of the Versaillais would ever be forgotten. But in the

French national psyche, the disaster of the loss to Prussia, which had led to the formation of a greater German state, took precedence. The self-inflicted wound was never allowed to heal. Scratched and picked at, it was allowed to fester. Privately, Gambetta made it known that he thought attacking Germany in order to restore Alsace and Lorraine to France was madness. But in public, he was expert at keeping open the possibility of avenging the loss.

As the twentieth century approached, the stories that were told to explain the wound played a powerful role in sculpting France's national character and, in response, the postures of other European nations. Many of these stories skipped over certain realities: that France itself had declared war even though it was unprepared, that its performance on the battlefield had been inept, and that the humiliation of the army's loss had fed into a fratricidal bloodbath in Paris. Instead, the stories fueled myths of valor and purity, a search for scapegoats, and a carefully nurtured desire for revenge. Trouble undoubtedly lay ahead. But for now, the fleeting beauty of fireworks overhead provided an exquisite distraction.

W W W

EPILOGUE

⋔ ⋔ ⋔

THE CELEBRATIONS OF JULY 14, 1880, HAD AN IMMENSE
effect on Édouard's morale. In December, he met with Henri Roche-
fort, the radical republican who had set up *La Lanterne* and *La Mar-*
seillaise during the final years of the empire and who had endured
six months in prison for his role in the Victor Noir affair. Thiers's
troops had captured him while he was attempting to flee Paris during
Bloody Week. Victor Hugo had tried to keep Rochefort in France,
but he had been sentenced to life in prison and sent to New Caledo-
nia. In 1874, however, he had staged a dramatic escape, after which
he'd lived in exile in London and Geneva. The general amnesty now
permitted his return.

Rochefort's first action on arriving back in France, one week after
Bastille Day, was to establish a new publication, *L'Intransigeant* (The
Intransigent). He was introduced to Manet by Marcellin Desboutin,
a relative of Rochefort who was also an artist in the Impressionist cir-
cle. Édouard was excited to meet Rochefort, who was by now, among
republicans, a legendary figure. His portrait shows Rochefort in a bow
tie, arms crossed (as with Manet's earlier portrait of Clemenceau), with
an upswept shock of smoky gray hair. Rochefort declined Édouard's
offer to give him the portrait. Nevertheless, he agreed to cooperate
with Manet on a major painting of Rochefort's dramatic escape from
New Caledonia. The painting would be an automatic entry in the
Salon, since Édouard no longer had to submit to the jury. As part of
his preparations, he interviewed Rochefort, who told him that the
vessel he escaped in was a whaleboat, deep gray, carrying six men but

with just two oars. Rochefort had published a fictionalized account earlier that year, so Édouard also relied on his book when he painted two versions of the escape. In the end, however, he sent neither to the Salon, preferring to exhibit his more conventional portrait of Rochefort alongside *The Lion Hunter*. Both paintings ignited controversy, but Édouard was awarded a second-class medal for the portrait.

In the wake of this interlude, Édouard painted a series of ravishing still lifes and two of his finest paintings, the gorgeously fresh *Jeanne (Spring)* and the monumental and mysterious *A Bar at the Folies-Bergère*. He wanted the world to know that, in spite of his ailment, he was still capable of producing masterpieces.

THAT NOVEMBER JULES GRÉVY, who had replaced MacMahon as president, appointed Gambetta as prime minister. This was an astonishing turn of events—just ten years earlier, Gambetta had been widely shunned in the aftermath of the Commune. Gambetta in turn installed Antonin Proust, his and Manet's longtime friend, as minister of the arts. One of Proust's first actions was to make Manet a chevalier of the Legion of Honor. To Édouard, who cared about honors (Degas often teased him about it), it was a moving gesture, a powerful vindication after two decades of public scorn. That the honor was bestowed by Gambetta, the man who had escaped Paris in a balloon (just as Rochefort had escaped New Caledonia in a boat), made it all the more satisfying. He could place it on an imaginary shelf in the same part of his brain that celebrated the triumph of the republic and the declaration of the amnesty.

Sadly, Gambetta's cabinet fell after just sixty-six days. His determination to accrue the power he needed to enact reforms resulted in a bitter power struggle, pitting him against an unlikely coalition of radical republicans, royalists, Bonapartists, and disillusioned moderates. He lost. Later that year, he contracted acute peritonitis—a dangerous infection in the lining of the belly—and died on the final day of 1882, only forty-four years old.

Édouard's disease, meanwhile, had moved into its next, agonizing stage. Distressed, he consulted a celebrated professor, Pierre

Potain, who told him that his problem might be something other than syphilis and wrote a prescription for derivatives of ergot. Siredey, his primary doctor, was alarmed. He warned Manet against taking too much of the medicine—a fungus that can induce nausea and in sufficient quantities bring on gangrene, vision problems, convulsions, and death. Manet was desperate, though. Ignoring Siredey, he took ever-increasing doses, all the while insisting that he was getting better.

CORNÉLIE, WHOSE HEALTH had deteriorated steadily since the siege, had died at the end of 1876. Shortly before her death, Yves's husband, Théodore Gobillard, was discreetly placed in a mental institution. He had been awarded the Legion of Honor after his arm was amputated while fighting for the French in Mexico; now, less than ten years later, he was fired from his job "because of insanity." Yves was pregnant with their third child when they sent him away.

Two years later, after Edma had her last child—a boy—Berthe herself gave birth to her one and only child, Julie. Berthe, who loved her nieces as if they were her own, was now seized by maternal love. Julie Manet was a serene child. She "has not had the slightest upset since her birth and she is all plump," reported Yves. "Her mother is very proud of her. The first smile went straight to her heart."

Julie provided Berthe and Eugène with enormous joy and consolation. She was, according to Berthe, "a Manet to the tips of her fingers . . . she has nothing of me." This evidently pleased her. Édouard painted a small sketchy oil portrait of Julie as a chubby-cheeked toddler in 1880, and Berthe drew and painted her at every stage, from infancy to young girlhood and from adolescence to young womanhood. According to the art historian Richard Brettell, Julie was likely "the best documented of the Impressionists' children." But her birth had been difficult. The umbilical cord had been wrapped three times around her neck when she came out. She was unaffected. (According to Yves, she "went only a few seconds without breathing".) But the birth took a great toll on Berthe's health, which was fragile at the best of times. She could not, as a result, participate in the fourth Impres-

sionist exhibition in 1879—the only one of the eight Impressionist exhibitions she missed.

To add to her burdens, Berthe's friend Marcello died that summer. Primarily a sculptor, Marcello had taken up painting in 1869, and in 1875, less than a year after the first Impressionist exhibition, she had asked Berthe to sit for a portrait. They decided together to make the painting an homage to the eighteenth-century art of Fragonard and Boucher, artists they both loved. Over many sessions, they had sat together in Marcello's studio, while the sculptor made first a drawing, then a pastel, then a watercolor. She then picked out a large canvas and painted Berthe in a salmon dress and holding a closed fan as she sat sideways on a simple wooden chair, resting one long, bare arm on the seat back.

Now, four years later, Marcello was gone. In her grief, Berthe turned for consolation, as she always had, to her sister Edma. "Don't accuse me of being neglectful, my dear," she wrote. "I think of you and your children continually, but my life is becoming complicated, I have little time, and then I have my days of melancholy, my black days, when I am afraid to take up a pen for fear of being dull. The death of the poor dear duchess [Marcello] made me pass through one of these bad phases. Mme Carré told me the other day, laughing at my looks: 'I think you have lived too long.' Well, this is true. Inasmuch as I have seen everything that I have loved and known disappear, I have lived too long. The loss of friends can no longer be replaced at my age, and the void is great."

ALAS, THE VOID would grow greater.

Berthe had registered that her brother-in-law was ill, but she was loath to acknowledge the gravity of his state. Édouard had good periods and bad. But it was clear now that he was approaching the end. The man who had once upbraided Berthe, saying that "he would never risk playing the part of a child's nurse," was now in need of around-the-clock nursing. He was in constant, mind-deranging pain. Unfortunately, the medicine prescribed by Potain had begun to have effects that Siredey warned about: nausea, vomiting, and then,

in April 1883, a black spot appearing on Manet's left foot. It spread slowly. Gangrene.

Siredey saw no alternative: on April 20, 1883, Édouard's left leg was amputated. The operation, which was conducted without anesthetic in his home on the Rue de Saint-Pétersbourg, caused unspeakable pain and mental distress. And it improved nothing, as the gangrene had already spread farther up. After the amputation, Édouard experienced tormenting phantom pains where the leg had been. When Monet visited him and sat on the bed where his friend's leg would have been, Édouard shouted out in distress. Ten days later he was dead.

"These last days were very painful," Berthe wrote to Edma. "Poor Édouard suffered atrociously. His agony was horrible. In a word, it was death in one of its most appalling forms that I once again witnessed at very close range. . . . If you add to these almost physical emotions my old bonds of friendship with Édouard, an entire past of youth and work suddenly ending, you will understand that I am crushed."

The funeral was held in Passy on the third of May—a date that resonated with Goya's great execution painting of the same name, the inspiration for Manet's *Execution of the Emperor Maximilian.* The pallbearers were Proust, Duret, Zola, Monet, Stevens, and Burty. "The expressions of sympathy have been intense and universal," wrote Berthe. Manet's "richly endowed nature," she added, "compelled everyone's friendship; he also had an intellectual charm, a warmth, something indefinable, so that, on the day of his funeral, all the people who came to attend—and who are usually so indifferent on such occasions—seemed to me like one big family mourning one of their own.

"I shall never forget the days of my friendship and intimacy with him, when I sat for him and the charm of his mind kept me alert during those long hours."

THREE DAYS AFTER the funeral, Édouard's former pupil Eva Gonzalès died in childbirth. Her baby, however, survived. Berthe and Eugène, still processing the loss of Édouard, went immediately to

visit Gonzalès's father, who was inconsolable. They were shown Eva's body, which had been covered in flowers. They were in her hair, in her hands, and on her face, which was waxen but still beautiful. The baby was raised by Eva's husband, Henri Guérard, who had been Édouard's engraver, and by Eva's sister Jeanne, who later married Guérard (just as Berthe had married Eugène). Gustave Manet died in December the following year, 1884, leaving Eugène the sole survivor of the Manet brothers. Their mother, Eugénie, died less than a month later, and by the end of the following year, 1886, Eugène himself had become ill. He never really recovered and died in 1892.

Thus the shadow of death was always passing over Berthe's otherwise creative and elegant-looking later years. And yet through all the years of Eugène's illness, the couple maintained a place at the center of a beautiful and influential social circle. They had moved in 1881 to a new home near the Bois de Boulogne on the Rue de Villejust (later renamed Rue Paul Valéry, after the poet and critic who married Yves's daughter Jeannie Gobillard). Four years later, after the death of Cornélie, they began hosting Thursday night soirées there. Among the regulars were Renoir, Monet, Stéphane Mallarmé, and Degas.

In 1894 Berthe and Julie, now a lovely young woman with auburn hair and large, dark eyes, went to visit Suzanne, widowed and living in Gennevilliers. They sat together at a table and slowly leafed through a portfolio of Manet's drawings. Berthe had recently purchased Édouard's *Berthe Morisot with a Bouquet of Violets* from Durand-Ruel. *Repose*, too—the portrait Édouard had made of her just before the war—had become available, and she wanted to buy it. She couldn't afford it. So Jean-Baptiste Faure, the celebrated operatic baritone and art collector whom Manet had several times painted, purchased it instead. Perhaps to compensate Berthe, Renoir painted a portrait of her with Julie and presented it to her as a gift. Suzanne, in any case, was delighted to see Berthe and her beautiful daughter. The drawings they inspected together had special resonances for them all.

Berthe's own painting continued to develop and strengthen. She worked in watercolors, pastels, and colored pencils as well as oils. She painted a few self-portraits, all frank and direct but haunted with

melancholy, some left unfinished. She also painted dreamy, sparkling images of Julie reading, playing the violin, holding a cat, at play in the garden with Eugène, picking cherries, and scratching the chin of a grateful greyhound. Her colors became ever bolder, her drawing more curvingly tensile, and her willingness to leave parts of the canvas bare more arresting and expressive. She was admired and loved by all her Impressionist and post-Impressionist peers.

As time went on, Berthe seemed more and more determined to make her work communicate the transience of love, the brevity of youth, and the hesitations of being itself—all the things life had taught her. She seems to have grasped, perhaps even more viscerally than her Impressionist colleagues, life's one dependable fact—that everything that is beautiful and all that we love and care about will perish. Sigmund Freud, in his late essay "On Transience," wrote that when people develop this kind of awareness, they tend to respond either with despondency or rebellion. But there was a third possibility, Freud noted, a response that he believed was not only the most hopeful but also the most rational. It was to recognize that our awareness of the transience of things should *increase* their value to us, the way scarcity makes us value certain objects more. "Transience value," he wrote, "is scarcity value in time." Mourning was inevitable, Freud noted. But "once the mourning is over, it will be found that our high opinion of the riches of civilization has lost nothing from our discovery of their fragility."

BERTHE MORISOT WAS the late nineteenth century's great painter-poet of "transience value." As the critic Paul Mantz wrote in his review of the third Impressionist exhibition in *Le Temps*, in 1877, "There is but one real Impressionist in this group and that is Mme Berthe Morisot. Her painting has all the frankness of improvisation: it does truly give the idea of an 'impression' registered by a sincere eye and rendered again by a hand completely without trickery."

When the filmmaker Jean Renoir wrote his celebrated memoir of his father, he included a beautiful passage about the effect Berthe had had on the people around her. "In Berthe Morisot's day," he wrote,

"the Manet circle had been one of the most authentic centers of civilized Parisian life." Berthe "acted like a special kind of magnet on people, attracting only the genuine."

The magnet in Berthe's life was Julie. She was, wrote Berthe, "like a little cat, always in a good mood." But in 1895, when Julie was sixteen, she fell ill. She recovered, but while caring for her, Berthe contracted pulmonary congestion. Her frail immune system was unable to get the upper hand, and gradually it became clear that she wouldn't recover. Edma came to be by her side. Berthe's throat was so painful, she could barely speak. She tried to prevent Julie coming into the room, for fear of frightening her. It was all terrifyingly sudden. She had been laughing just days earlier.

Julie spoke with her mother for the final time at three p.m. Four hours later she went back into the room. But seeing her mother barely able to draw breath was too distressing, and she quickly left.

The night was terrible, but at some point, Berthe found time to write a note. "My dearest little Julie," it said, "I love you as I die; I shall still love you even when I am dead; I beg of you, do not cry; this parting was inevitable. I hoped to be with you until you married. Work hard, and be good as you have always been; you have never caused me one single sorrow in your little life."

The note instructed Julie to give paintings to Edma and Julie's cousins, as well as to Monet and Renoir. A painting she owned by Monet should go to another cousin, she wrote. "Tell Monsieur Degas that if he founds a museum he is to choose a Manet.

"Do not cry," she finished. "I love you more than I can tell you."

Berthe Morisot was only fifty-four when she died. Her last spoken word was "Julie."

RENOIR WAS PAINTING alongside Cézanne when he heard the news. Immediately he closed his paintbox and took the next train back to Paris. Julie later wrote that she had "never forgotten the way [Renoir] arrived in my room . . . and held me close to him; I can still see his white cravat with its little red polka dots."

Spring turned to summer and Julie, now an orphan, went to Brit-

tany with Renoir and his family. She flourished under the influence of Renoir's intelligence and compassion. But in October, she had to return to Paris (the city struck her as intolerably gray and drab) and reenter the family home. "I was seized," she wrote, "by a profound sadness on entering the apartment, which looked so desolate, where every object reminds me of Maman but just stresses the fact that she is no longer here."

The following spring, Berthe's fellow Impressionists got together to organize a posthumous Morisot retrospective at Durand-Ruel's gallery. Julie came to help hang the show, but not before visiting the cemetery in Passy, where Berthe had been buried beside Eugène under a slab bearing both their names. At the head of the tomb (still today) is a tall column inscribed with the names Édouard Manet and Suzanne Leenhoff, and atop the column is a sculpted bust of Édouard, its oxidized surface almost the same rich green that he used for his seascapes and for the railing and window shutters in his very first painting of Berthe, *The Balcony*.

As if trying to see through her mother's eyes, Julie observed the "yew trees starkly outlined against the blue sky dotted with wispy clouds," "the wreaths glittering on the tombs," and the azalea's "immaculate whiteness blending with the delicate meadowsweet."

"There is something reassuring about this place, which seems to whisper to me that Maman is happy," she wrote in her diary.

Later in the day, Julie went to Durand-Ruel's gallery, where Monet and Degas were helping to hang the exhibition. More than 160 of Berthe's paintings were spread out on the gallery floor, and they gave Julie the same feeling of brightness as the azalea. She received a tender kiss from Monet. Renoir soon arrived. Mallarmé had gone to the printer to pick up copies of the catalog, for which he had written an essay.

They had all forsaken their work to be there. Julie's presence made them all the more conscious of the weight of their responsibility to an artist they revered, a friend they wished to honor.

Returning on Tuesday, Monet, Renoir, and Degas worked throughout the day. And they were there again on Wednesday, when

Julie was accompanied by her aunt Edma and cousin Blanche. When they arrived, Degas was hanging drawings. Conversing with Edma, he suddenly asked her if she would like to meet a ballet dancer. Bemused, Edma said yes, whereupon Degas led her to a smaller room. A woman saw them come in and exclaimed, "Well, hello Degas, who's this lady then? She looks so like the one who died last year!"

Renoir and Monet arrived, and the work continued, with Julie pitching in. It was slow going. Conscious that time was running out, the artists tired and frayed. Degas had been hanging Berthe's drawings and watercolors on a screen. A debate now ensued as to whether the screen should be placed in the middle of the large gallery or in a separate room toward the back. Degas wanted it installed in the big gallery, as prominently as possible. (He adored Berthe's drawings.) But Monet and Renoir worried that the screen cut the room in two and would prevent people from getting enough distance from Berthe's larger paintings. It would interfere, they added, with the general effect of harmony.

Degas snorted. "Only imbeciles see a 'general effect.' What on earth is it supposed to mean when one writes in a newspaper that the 'general impression' of this year's Salon is much better than that of last year?"

Alive to the underlying emotion, and no doubt afraid of Degas's orneriness, Renoir and Monet tried to persuade him to at least consider moving the screen. Placing it in the smaller gallery, offered Mallarmé, would give it "an intimate, quite charming atmosphere. It will just confuse the public to see drawings in the middle of the paintings."

"What do I care about the public?" shouted Degas. "They see absolutely nothing." They were mounting this exhibition for themselves, he insisted: "You can't honestly mean that you want to teach the public to see?"

"I certainly do," replied Monet, "If we had put this exhibition on just for ourselves, it wouldn't be worth going to the trouble of hanging all these paintings; we could quite simply look at them on the floor."

By now it had grown dark outside. The argument spilled over into a debate about whether a couch should replace the screen in the big

gallery, so people could sit. Degas fumed. "I would stay on my feet for thirteen hours if I had to," he screamed.

The gallery staff were laughing now, as Monet got to his feet. The two men shouted at each other about who "adored" Madame Manet (Berthe) more. Mallarmé tried to cool the temperature, while Renoir, "totally exhausted, was sprawled on a chair."

At last, Degas agreed to have the screen moved, but only if Monet could assure him that he really believed the room would be better without it. Monet said that yes, this was his sincere opinion, and they seemed on the point of reconciliation. But then more arguing erupted, and Degas prepared to storm out. Monet rushed to place his body between Degas and the exit. A moment later, when they shook hands, Julie thought everything was settled. But then Mallarmé made the mistake of mentioning the couch again. This time Degas, apoplectic, really did storm out.

The next morning, with the exhibition due to open that evening, Julie was first to arrive. She had resumed her job of numbering the works when Monet and Renoir came in. "You can bet Degas won't be coming," joked Renoir. "'He'll be here later in the day up a ladder hammering away and will say, 'Can't we cordon off the entrance to prevent people from getting in?' I know him too well." Degas did indeed fail to materialize, and they moved the screen to the far room without him.

"At last," wrote Julie in her diary, "everything was ready and beautifully arranged; the exhibition looks marvelous."

For page after page in her diary, Julie now described, in succinct but loving prose, almost every work in the show. These paintings and works on paper, as she knew all too well, were the fruit of a decision by an artist of rare talent and rich sensibility to take herself seriously—a decision made amid political strife, violence, and anguish. These same works are now in the world's great museums and private collections, where they hang alongside paintings by Monet, Renoir, Cézanne, Pissarro, Sisley, Degas, and Manet.

Acknowledgments

THIS BOOK GREW INDIRECTLY OUT OF THE CHAPTER ON Manet and Degas in my 2016 book, *The Art of Rivalry: Four Friendships, Betrayals and Breakthroughs in Modern Art*. I am grateful to Matt Weiland, my editor at Norton, for his good judgment, humor, and patience, and to all his colleagues, especially Huneeya Siddiqui, at Norton. I am equally thankful to my brilliant and insightful agent Zoë Pagnamenta, of Calligraph, and to her colleagues Jess Hoare and, before her, Alison Lewis. And I would like to thank my publishers at Text (in Australia/New Zealand), Spectrum (in the Netherlands), Insel/Suhrkamp Verlag (in Germany), Rizzoli (in Italy), OneWorld Publications (in Great Britain), and Taurus (in Spain).

I owe a special debt of gratitude to MacDowell, the storied arts organization based in Peterborough, New Hampshire, where a fellowship allowed me to work on this book for two uninterrupted weeks in the fall of 2021. Moral support over a five-year period that included the hump of the Covid-19 pandemic was crucial as I worked on *Paris in Ruins*. For their encouragement, warmth, and camaraderie, I would especially like to thank my dear friends Jeremy Eichler and James Parker. I would also like to thank Ben and Judy Watkins, Meg and Joseph Koerner, Josh Ellsworth and Julia Gaviria, Seibel and Azita Bina-Seibel, Karen Naimer, Andrew Krivak and Amelia Dunlop, Pete and Lori Whiting, Kirstin Hill and Jonathan Schrag, Tony and Elsa Hill, and Steve Tourlentes and Amber Davis Tourlentes—all beloved friends in the Boston area—and Royal Hansen and Susan Hamilton,

Geordie Williamson, Matthew Spencer and Annabel Crabb, beloved friends living elsewhere. I would also like to thank William Cain at Wellesley College; George Shackelford at the Kimbell Art Museum in Fort Worth; Kristin Parker at the Boston Public Library; and Adam Gopnik, who all offered wisdom, practical help, and encouragement on more than one occasion. I have been fortunate to have a staff position as an art critic at *The Washington Post* during the writing of this book. For their support and collegiality, I offer my heartfelt thanks to my editors Janice Page, Amy Hitt, and Steven Johnson, to my many superb colleagues at the *Post*, and to my friend Marty Baron, who brought me to the *Post* from *The Boston Globe* and before that, from Australia to Boston.

Finally, and most of all, I would like to thank my parents Michael and Ann-Margrete Smee, my beloved sister Stephanie Smee (an acclaimed French-to-English translator who helped me in so many ways), my brother-in-law Paul Schoff, my niece and nephew Nina and Jasper Schoff, and especially the three people who (perhaps because they saw little choice) managed to remain patient, loving, and good-humored throughout: my wife Jo Sadler and my children Tom and Leila Smee.

I dedicate this book to Soren Hansen, with love.

A Note on Sources

IN WRITING THIS BOOK, WHICH IS AN ATTEMPT TO KNIT together art history, biography, and military and social history, I've placed myself in the debt of many historians, curators, biographers, and translators. Although I have relied on specialists in the field of art throughout my career as an art critic, I'm less well schooled in the social and political history of nineteenth-century France. And yet one nonart book I read, on my father's recommendation, in my early twenties—Alistair Horne's *The Fall of Paris: The Siege and the Commune 1870–71*—played a crucial role in stimulating, two decades later, my desire to write this book. I tried not to pick up Horne's book and its companion *The Terrible Year: The Paris Commune 1871*, until I was well into researching *Paris in Ruins*, but when I did, my pleasure and admiration were undiminished. Perhaps inevitably, these two books became an essential resource as I described many of the same events through a different lens.

Among the histories of the Terrible Year I relied on were Rupert Christiansen's *Paris Babylon: The Story of the Paris Commune*, Michael Howard's *The Franco-Prussian War*, John Merriman's *Massacre: The Life and Death of the Paris Commune of 1871*, Bertrand Taithe's *Defeated Flesh: Medicine, Welfare, and Warfare in the Making of Modern France*, Robert Tombs's *The War Against Paris 1871*, and J. P. T. Bury's *France 1814–1940*. I also drew on Edmond de Goncourt's journals (written after the 1870 death of his brother and co-author Jules) and—for an understanding of the origins of Bastille Day—Christopher Prender-

gast's *The Fourteenth of July and the Taking of the Bastille*. Important books about specific actors in the events described include Graham Robb's biography of Victor Hugo; J. P. T. Bury and Robert Tombs's *Thiers 1797–1877*; Adam Begley's *The Great Nadar: The Man Behind the Camera*; and the catalog for the Metropolitan Museum of Art's 1994–95 Nadar exhibition. My account of the balloon voyages out of Paris during the siege drew on many sources, but I am especially indebted to the tenth chapter in Richard Holmes's marvelous *Falling Upwards: How We Took to the Air*.

My understanding of Berthe Morisot's experience before, during, and after the Terrible Year came primarily from *Berthe Morisot: The Correspondence with Her Family and Friends*, compiled and edited by Denis Rouart and translated by Betty W. Hubbard. The lively, frank, funny, and anxious exchanges between the various members of the Morisot family and a few of their friends are novelistic in their psychological complexity. Reading them motivated me to write this book the way I have. I would also like to acknowledge, with gratitude, *Perspectives on Morisot*, a book of essays edited and with an introduction by T. J. Edelstein; Anne Higonnet's Berthe Morisot biography; and the expansive edition of Juliet Wilson-Bareau's *Manet by Himself*, a beautiful and scholarly illustrated selection of letters and other writings by Édouard Manet.

Two books (recommended by Adam Gopnik) that transformed my understanding of the link between the Impressionists and republicanism were Philip Nord's *Impressionists and Politics: Art and Democracy in the Nineteenth Century* and its companion *The Republican Moment: Struggles for Democracy in Nineteenth-Century France*. One of the best and most thoughtful overviews of the responses of artists to the siege is *Paris in Despair: Art and Everyday Life Under the Siege (1870–71)* by Hollis Clayson. Tremendously helpful, too, was John Milner's compilation of art from the Terrible Year, *Art, War and Revolution in France 1870–1871: Myth, Reportage and Reality*. My account of two artists who lost their lives during the Franco-Prussian War depended greatly on Marc Gottlieb's exciting and original *The Deaths of Henri Regnault* and the exemplary catalog for *Frédéric Bazille and*

the Birth of Impressionism, an exhibition at the Musée Fabre in Montpellier, the Musée d'Orsay in Paris, and the National Gallery of Art in Washington, D.C.

I relied on dozens of other exhibition catalogs. Probably the most important were the catalog from the 1983 Manet exhibition at the Metropolitan Museum of Art in New York and the Grand Palais in Paris, and the catalog accompanying *Berthe Morisot: Woman Impressionist,* an exhibition I saw in 2018 at the Musée National des Beaux-Arts du Québec before it traveled to the Dallas Museum of Art and the Barnes Foundation in Philadelphia. Three other books I relied on for insight into the Manet and Morisot circles were *Julie Manet: An Impressionist Heritage,* a catalog accompanying an exhibition at the Musée Marmottan Monet; the catalog of the great 1988–89 Degas exhibition at the Metropolitan Museum of Art, the Grand Palais in Paris, and the National Gallery of Canada in Ottawa; and (although my book was mostly written by the time it came out) the catalog accompanying *Manet/Degas,* the great 2023 exhibition at the Metropolitan Museum of Art and the Musée d'Orsay.

My understanding of Claude Monet's intersection with the events I describe was enriched by *Claude Monet: The Colour of Time* by my old professor Virginia Spate. My descriptions of Courbet made use of *The Letters of Gustave Courbet,* edited and translated by Petra tenDoesschate Chu (who is also the author of the indispensable *The Most Arrogant Man in France: Gustave Courbet and the Nineteenth-Century Media Culture*) and the catalog accompanying the 2008 Gustave Courbet exhibition at the Metropolitan Museum of Art.

Of the thousands of books about Impressionism, the ones I found most useful in helping me understand the movement's beginnings were John Rewald's *The History of Impressionism;* Robert Herbert's *Impressionism: Art, Leisure and Parisian Society;* Gary Tinterow and Henri Loyrette's *The Origins of Impressionism* (accompanying an exhibition at the Metropolitan Museum of Art); and *The New Painting: Impressionism 1874–1886* (accompanying an exhibition at the National Gallery of Art in Washington D.C., and the De Young Memorial Museum in San Francisco). I would like to note here that the transla-

tion of Marius Chaumelin's review of the second Impressionist exhibition in 1876 is by Stephen F. Eisenman and the translation of Ernest Chesneau's response to Claude Monet's *Boulevard des Capucines* is by Paul Tucker. I relied, too, on the catalog of *Impressionists in London: French Artists in Exile 1870–1904* and *Women Artists in Paris, 1850–1900*, a traveling exhibition organized by the American Federation of Artists (which I saw at the Clark Art Institute in Williamstown, Massachusetts). My grasp of the importance of Manet's infatuation with all things Spanish (and especially the art of Velázquez and Goya) was deepened immeasurably by the catalog accompanying *Manet/Velázquez: The French Taste for Spanish Painting*, a 2002–3 exhibition at the Musée d'Orsay and the Metropolitan Museum of Art (where I saw it). Details of these and the many other books that I relied on can be found in the Bibliography.

Bibliography

BOOKS

Allan, Scott, Emily A. Beeny, and Gloria Groom. *Manet and Modern Beauty: The Artist's Last Years*. Los Angeles: J. Paul Getty Museum, 2019.

Alsdorf, Bridget. *Fellow Men: Fantin-Latour and the Problem of the Group in Nineteenth-Century French Painting*. Princeton, NJ: Princeton University Press, 2013.

Begley, Adam. *The Great Nadar: The Man Behind the Camera*. New York: Crown, 2017.

Benfey, Christopher. *Degas in New Orleans: Encounters in the Creole World of Kate Chopin and George Washington Cable*. New York: Alfred A. Knopf, 1997.

Benjamin, Walter. *The Writer of Modern Life: Essays on Charles Baudelaire*. Edited by Michael W. Jennings. Translated by Howard Eiland, Edmund Jephcott, Rodney Livingston, and Harry Zohn. Cambridge, MA: Belknap Press of Harvard University Press, 2006.

Bethel, Paul, Anna Meakin, and Peter Clare. *Paris by Plaque*. London: Counting House Books, 2011.

Boggs, Jean Sutherland. *Portraits by Degas*. Berkeley: University of California Press, 1962.

Boggs, Jean Sutherland, Douglas W. Druick, Henri Loyrette, Michael Pantazzi, and Gary Tinterow. *Degas*. New York: Metropolitan Museum of Art, 1988.

Borchardt-Hume, Achim, Gloria Groom, Caitlin Haskell, and Natalia Sidlina. *Cezanne*. New Haven, CT: Yale University Press, 2022.

Brettell, Richard R. *Pissarro's People*. San Francisco: Fine Arts Museums of San Francisco and Williamstown, MA: Clark Art Institute, 2011.

Broch, Herman. *Hugo von Hofmannsthal and His Time: The European Imagination, 1860–1920*. Translated by Michael P. Steinberg. Chicago: University of Chicago Press, 1984.

Brombert, Beth Archer. *Edouard Manet: Rebel in a Frock Coat*. Chicago: University of Chicago Press, 1997.

Brooks, Peter. *Flaubert in the Ruins of Paris: The Story of a Friendship, a Novel, and a Terrible Year*. New York: Basic Books, 2017.

Brown, Frederick. *Zola: A Life*. London: Papermac, 1997.

Bouillon, Jean-Paul, ed. *Manet to Bracquemond: Newly Discovered Letters to an Artist and Friend*. Paris: Fondation Custodia/Collection Frits Lugt, 2020.

Buron, Melissa E., and Krystyna Matyjaszkiewicz. *James Tissot*. San Francisco: Fine Arts Museums of San Francisco, 2019.

Bury, J. P. T. *France 1814–1940.* London: Routledge, 2003.

Bury, J. P. T., and R. P. Tombs. *Thiers 1797–1877. A Political Life.* London: Allen & Unwin, 1986.

Butler, Ruth. *Hidden in the Shadow of the Master: The Model-Wives of Cézanne, Monet, and Rodin.* New Haven, CT: Yale University Press, 2008.

Butterfield, Paula. *La Luministe.* Raleigh, NC: Regal House, 2019.

Calasso, Roberto. *La Folie Baudelaire.* Translated by Alastair McEwen. New York: Farrar, Straus & Giroux, 2012.

Christiansen, Rupert. *City of Light: The Making of Modern Paris.* New York: Basic Books, 2018.

———. *Paris Babylon: The Story of the Paris Commune.* New York: Penguin Books, 1996.

Chu, Petra ten-Doesschate, ed. *Letters of Gustave Courbet.* Chicago: University of Chicago Press, 1992.

———. *The Most Arrogant Man in France: Gustave Courbet and the Nineteenth-Century Media Culture.* Princeton, NJ: Princeton University Press, 2007.

Clark, Christopher. *Revolutionary Spring: Europe Aflame and the Fight for a New World, 1848–1849.* New York: Crown, 2023.

Clark, T. J. *The Painting of Modern Life: Paris in the Art of Manet and His Followers.* Princeton, NJ: Princeton University Press, 1984.

Clayson, Hollis. *Painted Love: Prostitution in French Art of the Impressionist Era.* New Haven, CT: Yale University Press, 1991.

———. *Paris in Despair: Art and Everyday Life under Siege (1870–71).* Chicago: University of Chicago Press, 2002.

Cogeval, Guy, Stéphane Guégan, and Alice Thomine-Berrada, comps. *Birth of Impressionism: Masterpieces from the Musée d'Orsay.* San Francisco: Fine Arts Museums of San Francisco, 2010.

Corbeau-Parsons, Caroline, ed. *Impressionists in London: French Artists in Exile 1870–1904.* London: Tate, 2017.

Daudet, Alphonse. *In the Land of Pain.* Edited and translated by Julian Barnes. London: Jonathan Cape, 2002.

Denvir, Bernard. *The Thames and Hudson Encyclopaedia of Impressionism.* London: Thames & Hudson, 1990.

Doran, Michael, ed. *Conversations with Cézanne.* Translated by Julie Lawrence Cochran. Berkeley: University of California Press, 2001.

Doyle, William. *The French Revolution: A Very Short Introduction.* Oxford: Oxford University Press, 2019.

Elderfield, John. *Manet and the Execution of Maximilian.* New York: Museum of Modern Art, 2006.

Figes, Orlando. *The Europeans: Three Lives and the Making of a Cosmopolitan Culture.* New York: Metropolitan Books, 2019.

Fisher, John. *Airlift 1870: The Balloons and Pigeons in the Siege of Paris.* London: Max Parrish, 1965.

Flaubert, Gustave. *Madame Bovary* (1857). Translated by Lydia Davis. New York: Penguin Books, 2011.

Font-Réaulx, Dominique de, Laurence Des Cars, Michel Hilaire, Bruno Mottin, and Bertrand Tillier. *Gustave Courbet.* Ostfildern, Germany: Hatje Cantz, 2008.

Friedrich, Otto. *Olympia: Paris in the Age of Manet.* New York: HarperCollins, 1992.

Gautier, Théophile. *A Romantic in Spain.* Translated by Catherine Alison Phillips. New York: Interlink Books, 2001.

Glaisher, James. *The Aeronauts: Travels in the Air.* Brooklyn: Melville House, 2019.

Goncourt, Edmond, and Jules Goncourt. *Pages from the Goncourt Journals.* Edited and translated by Robert Baldick. New York: New York Review Books, 2007.

Gotlieb, Marc. *The Deaths of Henri Regnault.* Chicago: University of Chicago Press, 2006.

Goya, Francisco. *The Disasters of War.* New York: Dover, 1967.

Groom, Gloria, ed. *Impressionism, Fashion, and Modernity.* Chicago: Art Institute of Chicago, 2012.

Guégan, Stéphane et al. *Manet inventeur du moderne.* Paris: Musée d'Orsay and Éditions Gallimard, 2011.

Gullickson, Gay L. *Unruly Women of Paris: Images of the Commune.* Ithaca, NY: Cornell University Press, 1996.

Hambourg, Maria Morris, Françoise Heilbrun, and Philippe Néagu. *Nadar.* New York: Metropolitan Museum of Art, 1995.

Hamilton, George Heard. *Manet and his Critics.* New Haven, CT: Yale University Press, 1954.

Hanson, Anne Coffin, Charles S. Moffett, and Michel Melot. *Manet.* New York: Metropolitan Museum of Art, 1983.

Hatzfeldt, Paul. *The Hatzfeldt Letters: Letters of Count Paul Hatzfeldt to His Wife, Written from the Head-Quarters of the King of Prussia, 1870–71.* Translated by J. L. Bashford. Miami: HardPress, 2012.

Hénaut, Stéphane, and Jeni Mitchell. *A Bite-Sized History of France: Gastronomic Tales of Revolution, War, and Enlightenment.* New York: New Press, 2018.

Herbert, Robert L. *Impressionism: Art, Leisure, and Parisian Society.* New Haven, CT: Yale University Press, 1991.

Hibbert, Christopher. *The French Revolution.* London: Penguin Books, 1982.

Higonnet, Anne. *Berthe Morisot.* New York: HarperPerennial, 1990.

Hilaire, Michel, Kimberly Jones, and Paul Perrin. *Frédéric Bazille (1841–1870) and the Birth of Impressionism.* Paris: Flammarion, 2016.

Holmes, Richard. *Falling Upwards: How We Took to the Air: An Unconventional History of Ballooning.* New York: Vintage Books, 2013.

Horne, Alistair. *The Fall of Paris: The Siege and the Commune, 1870–71.* London: Penguin Books, 2007.

———. *The Terrible Year: The Paris Commune, 1871.* London: Phoenix, 2004.

Howard, Michael. *The Franco-Prussian War: The German Invasion of France, 1870–1871.* New York: Routledge, 2006.

Hubert, Robert L. *Impressionism: Art, Leisure, and Parisian Society.* New Haven, CT: Yale University Press, 1991.

Hughes, Robert. *Goya.* London: Harvill Press, 2003.

Kang, Cindy, Marianne Mathieu, Nicole R. Myers, Sylvie Patry, and Bill Scott. *Berthe Morisot: Woman Impressionist.* New York: Rizzoli Electa, 2018.

Kear, Jon. *Paul Cézanne.* London: Reaktion Books, 2016.

Kendall, Richard, ed. *Degas by Himself: Drawings, Prints, Paintings, Writings.* London: Time Warner, 2004.

King, Ross. *The Judgement of Paris: The Revolutionary Decade That Gave the World Impressionism*. New York: Walker & Co., 2006.

Kirkland, Stephane. *Paris Reborn: Napoleon III, Baron Haussmann, and the Quest to Build a Modern City*. New York: St. Martin's Press, 2013.

Kohlbauer-Fritz, Gabriele, and Tom Juncker, eds. *The Ephrussis: Travel in Time*. Vienna: Paul Zsolnay Verlag, 2019.

Locke, Nancy. *Manet and the Family Romance*. Princeton, NJ: Princeton University Press, 2001.

Loyrette, Henri. *Degas*. Paris: Librairie Arthème Fayard, 1991.

Loyrette, Henri, Leila Jarbouai, Kimberly A. Jones, and Marine Kisiel. *Degas at the Opéra*. Washington, D.C.: National Gallery of Art, 2020.

Madeline, Laurence, Bridget Alsdorf, Richard Kendall, Jane R. Becker, Vibeke Waallann Hansen, and Joëlle Bolloch. *Women Artists in Paris, 1850–1900*. New Haven, CT: Yale University Press, 2017.

Maloon, Terence, Richard Shiff, Joachim Pissarro, Peter Raissis, and Clare Durand-Ruel Snollaerts. *Camille Pissarro*. Sydney: Art Gallery of New South Wales, 2005.

Manet, Julie. *Growing Up with the Impressionists: The Diary of Julie Manet*. Translated and edited by Jane Roberts. London: I.B. Tauris, 2017.

Mathieu, Marianne, ed. *Julie Manet: An Impressionist Heritage*. Paris: Musée Marmottan Monet and Vanves: Éditions Hazan, 2021.

Maupassant, Guy de. *Alien Hearts* (1890). Translated by Richard Howard. New York: New York Review of Books, 2009.

———. *A Parisian Affair and Other Stories*. Translated by Sian Miles. London: Penguin Books, 2004.

McCullough, David. *The Greater Journey: Americans in Paris*. New York: Simon & Schuster, 2011.

McDonald, Mark. *Goya's Graphic Imagination*. New Haven, CT: Yale University Press, 2021.

McGrady, Patrick J., and Nancy Locke. *Manet and Friends*. University Park: Palmer Museum of Art and Pennsylvania State University Press, 2008.

McMullen, Roy. *Degas: His Life, Times, and Work*. Boston: Houghton Mifflin, 1984.

Merriman, John. *Massacre: The Life and Death of the Paris Commune of 1871*. New Haven, CT: Yale University Press, 2016.

Meyers, Jeffrey. *Impressionist Quartet: The Intimate Genius of Manet and Morisot, Degas and Cassatt*. Orlando, FL: Harcourt, 2005.

Milner, John. *Art, War, and Revolution in France, 1870–1871: Myth, Reportage, and Reality*. New Haven, CT: Yale University Press, 2000.

Moffet, Charles S., Stephen F. Eisenman, Richard Shiff, Paul Tucker, Hollis Clayson, Richard R. Brettell, Ronald Pickvance, Fronia E. Wissman, Joel Isaacson, and Martha Ward. *The New Painting: Impressionism 1874–1886*. San Francisco: Fine Arts Museums of San Francisco, 1986.

Muhlstein, Anka. *The Pen and the Brush: How Passion for Art Shaped Nineteenth-Century French Novels*. Translated by Adriana Hunter. New York: Other Press, 2017.

———. *Camille Pissarro: The Audacity of Impressionism*. Translated by Adriana Hunter. New York: Other Press, 2023.

Murrell, Denise. *Posing Modernity: The Black Model from Manet and Matisse to Today.* New Haven, CT: Yale University Press, 2018.

Nadar, Félix. *When I Was a Photographer.* Translated by Eduardo Cadava and Liana Theodoratou. Cambridge, MA: MIT Press, 2015.

Nochlin, Linda. *Courbet.* London: Thames & Hudson, 2007

Nord, Philip. *Impressionists and Politics: Art and Democracy in the Nineteenth Century.* London: Routledge, 2010.

———. *The Republican Moment: Struggles for Democracy in Nineteenth-Century France.* Cambridge, MA: Harvard University Press, 1998.

Pissarro, Joachim. *Cézanne and Pissarro: Pioneering Modern Painting.* New York: Museum of Modern Art, 2005.

Poňka, Anabelle Kienle. *Monet: A Bridge to Modernity.* Milan: 5 Continents, 2015.

Prendergast, Christopher. *The Fourteenth of July and the Taking of the Bastille.* London: Profile Books, 2008.

Rapport, Mike. *1848: Year of Revolution.* New York: Basic Books, 2009.

Reff, Theodore. *Degas: The Artist's Mind.* New York: Metropolitan Museum of Art, 1976.

———. *Manet and Modern Paris.* Washington, D.C.: National Gallery of Art, 1982.

Renoir, Jean. *Renoir, My Father.* Translated by Randolph Weaver and Dorothy Weaver. New York: New York Review Books, 2001.

Rewald, John. *The History of Impressionism.* New York: Museum of Modern Art, 1973.

Rey, Jean-Dominique. *Berthe Morisot.* Translated by Louise Rogers Lalaurie. Paris: Flammarion, 2018.

Robb, Graham. *Parisians: An Adventure History of Paris.* New York: W. W. Norton, 2010.

———. *Victor Hugo: A Biography.* New York: W. W. Norton, 1997.

Robins, Anna Gruetzner, and Richard Thomson. *Degas, Sickert, and Toulouse-Lautrec: London and Paris 1870–1910.* London: Tate, 2005.

Rodari, Florian, Pierre Georgel, Luc Sante, and Marie-Laure Prévost. *Shadows of a Hand: The Drawings of Victor Hugo.* New York: Drawing Center and London: Merrell Holberton, 1998.

Roe, Sue. *The Private Lives of the Impressionists.* New York: HarperCollins, 2006.

Ross, Kristin. *Communal Luxury: The Political Imaginary of the Paris Commune.* London: Verso, 2016.

Rouart, Denis, ed. *Berthe Morisot: Correspondence.* Translated by Betty W. Hubbard. Mt. Kisco, NY: Moyer Bell, 1987. First edition published by Lund Humphries, London, 1947.

Rubin, James H. *Courbet.* London: Phaidon Press, 1997.

Sauerländer, Willibald. *Manet Paints Monet: A Summer in Argenteuil.* Translated by David Dollenmayer. Los Angeles: Getty Research Institute, 2014.

Schivelbusch, Wolfgang. *The Culture of Defeat: On National Trauma, Mourning, and Recovery.* Translated by Jefferson Chase. New York: Picador, 2003.

———. *The Railway Journey: The Industrialization of Time and Space in the Nineteenth Century.* Oakland: University of California Press, 2014.

Shackelford, George T. M., Anthea Callen, Mary-Dailey Desmarais, Richard Shiff, and Richard Thomson. *Monet: The Early Years.* Fort Worth, TX: Kimbell Art Museum, 2016.

Shone, Richard. *Berthe Morisot*. London: JPL Fine Arts, 1990.

Spate, Virginia. *Claude Monet: The Colour of Time*. London: Thames & Hudson, 2001.

Spies-Gans, Paris A. *A Revolution on Canvas: The Rise of Women Artists in Britain and France, 1760–1830*. London: Paul Mellon Centre for Studies in British Art, 2022.

Steegmuller, Francis. *Flaubert and Madame Bovary: A Double Portrait*. New York: New York Review Books, 2004.

———, ed. *The Letters of Gustave Flaubert, 1857–1880*. Cambridge, MA: Belknap Press of Harvard University Press, 1982.

Stevens, Maryanne, Stéphane Guégan, Carol M. Armstrong, Leah Lehmbeck, Colin Bailey, and Lawrence W. Nichols. *Manet: Portraying Life*. London: Royal Academy of Arts, 2012.

Taithe, Bertrand. *Defeated Flesh: Medicine, Welfare, and Warfare in the Making of Modern France*. Lanham, MD: Rowman & Littlefield, 1999.

Tinterow, Gary, and Geneviève Lacambre, *Manet/Velázquez: The French Taste for Spanish Painting*. New York: Metropolitan Museum of Art and New Haven, CT: Yale University Press, 2003.

Tinterow, Gary, and Henri Loyrette. *Origins of Impression*. New York: Metropolitan Museum of Art, 1994.

Tombs, Robert. *The War Against Paris 1871*. Cambridge: Cambridge University Press, 1981.

Turner, Jane, ed. *From Monet to Cézanne: Late 19th-Century French Artists*. London: Macmillan Reference, 2000.

Valéry, Paul. *Degas, Manet, Morisot*. Translated by David Paul. Vol. 12 of *The Collected Works of Paul Valéry*. Princeton, NJ: Princeton University Press, 1989.

Varley, Karine. *Under the Shadow of Defeat: The War of 1870–71 in French Memory*. Houndmills, Basingstoke, Hampshire, UK: Palgrave Macmillan, 2008.

Walther, Ingo F., ed. *Impressionism, 1860–1920*. Cologne, Germany: Taschen, 2018.

Wawro, Geoffrey. *The Franco-Prussian War: The German Conquest of France in 1870–1871*. Cambridge: Cambridge University Press, 2003.

White, Barbara Ehrlich. *Impressionists Side by Side: Their Friendships, Rivalries, and Artistic Exchanges*. New York: Alfred A. Knopf, 1996.

Williams, Ellen. *The Impressionists' Paris: Walking Tours of the Artists' Studios, Homes, and the Sites They Painted*. New York: Little Bookroom, 1997.

Wilson-Bareau, Juliet, ed. *Manet by Himself*. Edison, NJ: Chartwell Books, 2001.

Wilson-Bareau, Juliet, and David C. Degner. *Manet and the American Civil War: The Battle of the U.S.S. Kearsarge and the C.S.S. Alabama*. New Haven, CT: Yale University Press, 2003.

———. *Manet and the Sea*. Philadelphia: Philadelphia Museum of Art, 2003.

Wolohojian, Stephan, and Ashley E. Dunn. *Manet/Degas*. New Haven, CT: Yale University Press and New York: Metropolitan Museum of Art, 2023.

Zeldin, Theodore. *Ambition, Love and Politics*. Vol. 1 of *France 1848–1945*. Oxford: Clarendon Press, 1973.

Zola, Émile. *La Débâcle* (1892). Translated by Elinor Dorday. Oxford: Oxford University Press, 2017.

———. *Looking at Manet*. Los Angeles: J. Paul Getty Museum, 2018.

JOURNAL ARTICLES

Barnes, Julian. "The Morisot Sisters." *London Review of Books* 41, no. 17 (September 12, 2019).

Curtiss, Mina. "Letters of Édouard Manet to his Wife During the Siege of Paris 1870–71." *Apollo* 113 (June 1981).

Dolan, Therese. "Manet's 'Portrait-Charge' of Émile Ollivier." *Print Quarterly* 17, no. 1 (March 2000): 17–26.

Labouchere, Henry du Pré. *Diary of the Besieged Resident in Paris.* (1871; reprint Project Gutenberg, 2006).

Pierre, Caterina Y. "'A New Formula for High Art': The Genesis and Reception of Marcello's *Pythia*." *Nineteenth-Century Art Worldwide* 2, no. 2 (Autumn 2003).

Tyre, Jess. "Music in Paris During the Franco-Prussian War and the Commune." *Journal of Musicology* 22, no. 2 (April 2005): 173–202.

Voves, Ed. "Berthe Morisot Exhibition at the Barnes Foundation. Philadelphia." *Art Eyewitness* (blog), November 6, 2018.

Illustration Credits

Fig. 14 Anonymous, *Cannons on the Heights of Montmartre* (1871), Musée Carnavalet, Paris. Courtesy of Musée Carnavalet, Histoire de Paris.

Fig. 15 Auguste Braquehais, *Les Communards devant les debris de la Colonne Vendôme le 16 mai 1871* (1871), Musée Carnavalet, Paris. Courtesy of Musée Carnavalet, Histoire de Paris.

Fig. 16 Reproduction of a painting by Léon y Escosura entitled *Rue de Rivoli, May 24, 1871* (1871), Musée Carnavalet, Paris. Courtesy of Musée Carnavalet, Histoire de Paris.

Fig. 17 Anonymous, *Barricades at the Rue des Amandiers near Père Lachaise Cemetery, 18 March 1871* (1871), Musée Carnavalet, Paris. Courtesy of Musée Carnavalet, Histoire de Paris.

Fig. 18 André Disdéri, *Dead Communards* (1871), Musée Carnavalet, Paris. Courtesy of Musée Carnavalet, Histoire de Paris.

Fig. 19 Édouard Manet, *The Barricade* (1871), National Gallery of Art, Washington, D.C. Rosenwald Collection. Courtesy of the National Gallery of Art, Washington.

Fig. 20 Berthe Morisot, *Eugène Manet on the Isle of Wight* (1875), Musée Marmottan, Paris. Album / Alamy Stock Photo.

Fig. 21 Édouard Manet, *Berthe Morisot with a Bouquet of Violets* (1872), Musée d'Orsay. Carlo Bollo / Alamy Stock Photo.

Fig. 22 Édouard Manet, *The Rue Mosnier with Flags* (1878). Getty Museum, Los Angeles. Courtesy of Getty.

Index